ART, PASSION
& POWER

THE STORY OF

THE ROYAL COLLECTION

MICHAEL HALL

FOREWORD BY
HRH THE PRINCE OF WALES

INTRODUCTION BY
JONATHAN MARSDEN

RCINs (Royal Collection Inventory Numbers) have been given for all works in the Collection.

1 3 5 7 9 10 8 6 4 2

BBC Books, an imprint of
Ebury Publishing
20 Vauxhall Bridge Road,
London SW1V 2SA

BBC Books is part of the Penguin Random House group of companies whose addresses can be found at global.penguinrandomhouse.com

This book is published to accompany the television series entitled *Art, Passion & Power: The Story of the Royal Collection* first broadcast on BBC Four in 2018.

Series producer: Sebastian Barfield
Executive producer: Judith Winnan

First published by BBC Books in 2017

www.penguin.co.uk

A CIP catalogue record for this book is available from the British Library

ISBN 9781785942617

Commissioning editor: Albert DePetrillo
Project editor: Bethany Wright
Copyediting: Anjali Bulley
Design: Linda Lundin

Printed and bound in Italy by
L.E.G.O. S.p.A

Penguin
Random House
UK

MIX
Paper from responsible sources
FSC
www.fsc.org
FSC® C018179

EXPLORE THE ROYAL COLLECTION AT
royalcollection.org.uk

ART, PASSION
& POWER

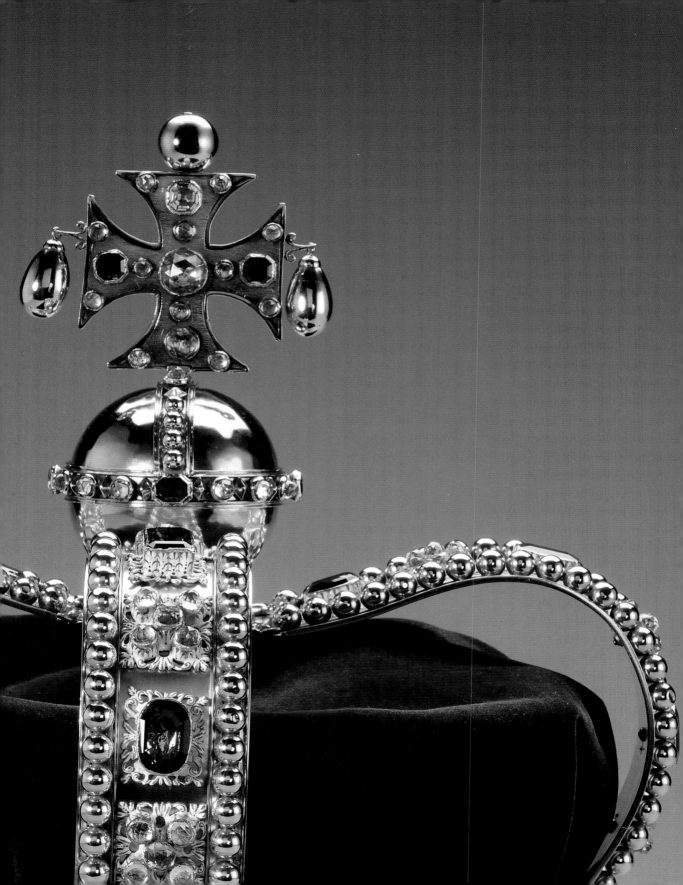

The idea of capturing the story of the Royal Collection, and illustrating its highlights, in a single book seems to answer a most obvious need, yet perhaps because the Collection is so very large and widely distributed it seems that nobody has yet attempted this.

Many will still recall the television series celebrating The Queen's Silver Jubilee in 1977, *Royal Heritage*, in which J.H. Plumb and Huw Weldon presented an overview of the Royal Collection and of the architectural heritage of the British monarchy. Though pioneering in its day, *Royal Heritage* was limited in its treatment of the Collection. Forty years on, this book is now overdue.

For someone, like myself, fortunate enough to have grown up surrounded by the Royal Collection, a glance through this book is like meeting a succession of old childhood friends of whose company one could never tire. But the book also enables us to marvel at the fortunes of these great works of art, most of them instantly familiar but others less so, which have come to reside together in The Sovereign's official and historic residences as part of our national heritage.

What Michael Hall has done so successfully is to weave a tapestry in which the Royal Collection and the history of our islands and their rulers are brought together as warp and weft. I feel sure that this beautiful book will serve its purpose as a companion to the Collection and that it will play its part in enabling ever-wider enjoyment of the treasures it describes.

INTRODUCTION

Jonathan Marsden

A book about the collections of any of the world's great museums, such as the Louvre, the British Museum, the Metropolitan Museum of Art or the Prado, would most likely be arranged according to the branches and periods of art and antiquities represented in the collection, illustrating in turn the highlights of the museum's holdings in each area. Although the Royal Collection of the United Kingdom includes a great number of works of art that would find a place in such a selection, studies of the Collection, including this one, always seem to favour an historical approach. Why should this be?

Firstly, and most obviously, the Royal Collection has been in existence for much longer than any comparable art collection in the world, and its range and scope are the products of this longevity. Secondly, museum collections have in general been formed by a combination of philanthropic collectors, scholars, curators, antiquaries and bureaucrats. The histories of these individuals, highly distinguished and interesting though they have often been, cannot compare with those of the kings, queens and princes whose tastes, means and choices helped to assemble the Royal Collection while they were on the stage of history. Any work of art that belonged to a prince is somehow a more interesting work of art.

Additionally, the longevity of the Collection creates its own internal history. We can observe how a painter such as Van Dyck in his 'Great Peece' (fig. 59) tackled precisely the same, specifically royal, task as the anonymous artist of the family group of Henry VIII (fig. 20) a century earlier; and then look a further two centuries forward to the response of F.X. Winterhalter to the same challenge (fig. 244). And the fortunes of works of art as they pass down through successive reigns provide an index of how such works were regarded in a given age. For example, the little painted terracotta portrait of a young prince (fig. 5) dating from just before 1500, can be found at Whitehall Palace in James II's time but disappears from view until 1815, when – mistaken for a portrait of a Chinese boy – it was sent to Brighton Pavilion. At the turn of the twentieth century it had come to rest in the Nursery Corridor at Buckingham Palace. Not the exceptional and rare treasure from the first great age of portraiture that we now see, but something for the nursery; a sort of doll.

Finally, a collection formed by generations of individuals on the basis of personal choice and taste, rather than a public duty to compose and

maintain a representative collection for the education of the public, is bound to be less coherent, indeed less representative of the history of art and less susceptible to the 'museum' approach. Thus, the shape of the Royal Collection, which in its present form dates for the most part from the seventeenth century, needs more explaining. It contains 30 oil paintings by Van Dyck but none by Poussin or Velázquez; French furniture by the greatest makers but surprisingly little by the greatest English maker, Thomas Chippendale; the largest and arguably the finest collection of French porcelain, but not of English porcelain. Eighty drawings, 15 miniatures and six oil paintings by Hans Holbein; 600 drawings by Leonardo da Vinci, but almost no sculpture or precious metalwork of the early Renaissance; 50 canvases by Canaletto but none by Guardi or Tiepolo. Seven paintings by Rembrandt but no drawings; nothing by John Constable; nothing by J.M.W. Turner; almost nothing by the Pre-Raphaelites or Impressionists. Faced on the one hand with an *embarras de richesses* and on the other with what might seem equally embarrassing gaps, any museum director worth their salt, urged on by their trustees or acquisitions committee, would not rest until they had tracked down works for their collection that could render it more properly representative. Yet at no point in the history of the Royal Collection has a monarch or official expressed the slightest unease about the towering peaks and deep troughs that characterise its holdings.

If those responsible for assembling the Collection over the centuries have not done so in a systematic way in order to educate the nation, what has been their motivation ?

In his new and lucid introduction to the subject, Michael Hall has managed to pin-point a moment when the notion seems to have become generally accepted right across Europe that rulers should surround themselves not just with gold, with weapons and other simple trappings of magnificence, but with Art. It was no longer simply, as Sir John Fortescue put it in *The Governance of England* (a treatise published posthumously in 1543) that:

> *If a king did not* [surround himself with treasure], *nor might do, he lived then not like his estate, but rather in misery, and in more subjection than doth a private person.*

From the early seventeenth century the wise monarch sought to surround him- or herself not simply with the trappings of wealth and conquest, but with allegory, mythology, *poesie*, illusion, brilliance and colour, and royal courts throughout Europe became the most important centres of cultural patronage. It was during the seventeenth century too that the display of art began to influence the design and planning of the British palaces, which hitherto had been based entirely on the management of degrees of access to the royal person. Long Galleries, for example, had featured in the palaces for generations, and many of them contained pictures, but their first purpose was to provide access to the right parts of the palace for the right people. Wren's great gallery at Hampton Court for the display of Raphael's tapestry cartoons of the Acts of the Apostles was the first purpose-built

picture gallery in a British palace, and proclaimed the importance that great works of art had begun to assume in providing a sufficiently magnificent backdrop for the whole business of monarchy.

But the Royal Collection today comprises not only those things that would be recognised anywhere as works of art, but in fact the entire contents of all the royal palaces, whether still in use by Her Majesty The Queen or not. It includes the beds that are slept in, the chairs that are sat upon, the plates, knives and forks and teaspoons. The responsibilities of the Surveyor of The Queen's Pictures, the Librarian and the Surveyor of Works of Art, while in most ways quite similar to senior curatorial roles in museums or libraries, are in other ways more like those of the office of the Great Wardrobe, the historic furnishing organisation of the royal household (abolished in 1782) which has its parallels in the *Garde meuble* of the French royal court (since 1870 the *Mobilier national*) and the *Hofmobiliendepot,* from which were issued the chattels of the Austro-Hungarian imperial household.

This reminds us of two important facts that arise from any comparison between today's Royal Collection and the typical art gallery or museum of our time. Firstly, the majority of the objects held by any great art museum were not created for display in a museum. In the case of the Royal Collection, very broadly speaking, the works of art are still disposed and deployed for the purposes for which they were created, and, in a large number of cases, in the very settings for which they were created. If we were to put this in the terms applied to the animal kingdom, whereas the works of art in a museum have been captured (in various ways) and placed in a zoo or reservation to be studied, those in the royal palaces, the Royal Collection, are still at large, 'in the wild'; for the most part 'in their natural habitat'. This is surely to be valued and celebrated.

Secondly, whereas in the largest of today's museums, for reasons of space, practicality and taste, only a fraction of the works held by the institution can be on display at a given time, the great majority of the works in the Royal Collection are in use, on the walls, furnishing rooms, even though this does not equate to 'on display to the public'.

For as long as museums have existed, the recording and registration of their collections have been undertaken in accordance with accepted practice, as soon as possible after an object enters the collection, in a process known as 'accessioning'. It might be imagined that in the case of the Royal Collection a great ledger was opened by – let us say – Edward the Confessor, in which every possession of the Crown from that time forward would be carefully entered by assiduous scribes. Such a tome or tomes would no doubt also record if, when and how an object ever left royal hands, as a gift perhaps, or simply because it was no longer admired. Although one of the great strengths of the Royal Collection is the extent of documentation, in the Royal Archives and beyond, that can shed light on the time and means of acquisition and subsequent fortunes of the majority of works in the Collection, this information has not been systematically recorded. It has

been sporadic, and this correlates with the degree to which a given monarch has been active as a collector.

The Surveyorship of Pictures dates from the reign of Charles I and the role has been filled more or less continuously since that time. Much more recently, in the first years of the twentieth century, an equivalent position was instituted for the oversight of – practically speaking – everything else, in the office of Surveyor of Works of Art. The records of the first Surveyor of the King's Pictures, Abraham van der Doort, set the standard for the documentation of the Royal Collection ever since, and from his inventories (although they are not comprehensive) a vivid picture can be formed of what could be found in the royal palaces in his time. But thanks to the *caesura* of the Commonwealth sales of 1650–1, the tracking of objects in and out of the Collection in subsequent reigns is far less easy, and the records more ambiguous. In later times, whereas George III and his son George IV, who both in their different ways enriched the Collection so greatly, were sufficiently engaged in the business of collecting and re-displaying art in the palaces to need to employ the clerical staff required to keep track of this activity, this was not the case with the first two Georges, or with William IV or Edward VII. Consequently the documentation, like the Collection itself, has gaps.

Michael Hall's book constantly reminds us of the international or supra-national character of monarchy, arising from territorial claims, wars, dynastic marriages and kinship, and state visits, which have all left their mark on the Royal Collection. Thus, many of the great masterpieces assembled by Charles I in London from across Europe soon found their way back into the hands of other European rulers and in later centuries to North America and Russia. Following the Restoration of Charles II in 1660, the States of Holland made a substantial gift of paintings, by no means all Dutch, to re-stock the Royal Collection.

The period of the greatest upheaval, from the 1790s until the 1840s, saw more great works from princely collections exchanging hands in a variety of circumstances than any other. With the importation of works of art on an unprecedented scale to Britain from the former aristocratic and royal houses of France it was a period of considerable enrichment for the Royal Collection here. It was also the period during which the royal collections of other European lands assumed their modern forms, usually as the direct result of constitutional change, nowhere more so than in France, where on the abolition of the monarchy on 10 August 1792 the possessions of the crown were declared the property of the new 'sovereign' – the people of France. The following day a commission of eight men was appointed to draw up an inventory of the '*biens de la Couronne devenus propriété de la Nation*'. Financial necessity and the desire to extinguish the '*gloire*' of the old regime led to extensive sales and dispersal of parts of the people's new property. In the same year, what became the Nationalmuseum in Sweden was founded on the basis of Gustavus III's collections.

Today the contents of the Swedish royal palaces are the property of the state, placed at the disposal of the king and managed by his household. In Denmark, reappraisal of the royal collections was undertaken in the 1820s, and on the introduction of the new constitution in 1849 it was established that the collections would pass to the ownership of the state, with the proviso that each new monarch on their accession could exercise the right to retain the use of such parts of it as they chose. The historic contents of the Rosenborg in Copenhagen were treated somewhat differently, to be held inalienably and passed from sovereign to sovereign, but under the control of (and maintained by) the state.

The *Nationale Konst-Gallerij* of the Netherlands was opened to the public in 1800 at Huis ten Bosch, and founded on what had been left of the Stadholder's collection following the depredations of the French invaders, combined also with the holdings of municipalities and guilds. After the final overthrow of Napoleon and the partial restitution of the gems of the royal picture collection, the Royal Cabinet of Paintings was established at the Mauritshuis in The Hague.

The case of Spain reflects more recent constitutional history. Here, the ownership and management of the royal collections were only established in law in 1982 with the foundation of the *Patrimonio Nacional*, whose objectives are to support the head of state through the preservation of the palaces and collections, and the provision of public access. The advent of the new Museum of the Royal Collections adjacent to the Royal Palace in Madrid, with provision for permanent displays and temporary exhibitions, provides yet another model.

It should not be forgotten that important, self-contained parts of the British Royal Collection have been alienated at different stages. The gift of the 'old' royal library to the British Museum by George II in 1757 was followed by that of George III's bibliographic collections by his son, George IV, in 1823. Queen Victoria's gift of George III's scientific collections brought about the establishment of the King George III Museum at King's College, London, in 1843. The Royal Music Library, which incorporated the manuscripts of G.F. Handel, was presented to the British Library by Her Majesty The Queen in 1957. What remains (a collection that runs to approximately one million items) is subject to the unique formulation: 'held by the sovereign in right of Crown, in trust for her successors and the nation.'

An important distinction, also apparently unique, and enabled by the formation of The Royal Collection Trust in 1993, is that every aspect of the maintenance and care of the Collection, including the encouragement and management of public access, is undertaken without recourse to the public purse.

This book has come about as part of a continuing effort to make the Collection and its story better known. On a previous occasion, the exhibition of 500 paintings at the Royal Academy of Arts in London in 1946, a leading article in *The Times* described the Royal Collection as:

'An inheritance which the nation can share with its owner as it can share no other private collection ... this is a treasure over and above the collection owned by the state, much of it always accessible, none of it unfamiliar to any serious student of art.'

Today it is hoped that this sense of familiarity will be felt not only by 'serious students' but by anyone who wishes to enjoy this precious part of our cultural and artistic heritage. With further advances in online accessibility this aim stands a better chance than ever of becoming a reality. As an institutional publisher of a hundred years' standing, Royal Collection Trust takes equal pride in the promotion of interest in the Collection through the medium of the printed page.

MAGNIFICENCE
From the Middle Ages to Elizabeth I

Only three years after his victory at Hastings, William the Conqueror's grasp on his new kingdom appeared to be failing. In the summer of 1069 Danish troops landed on the north coast, where they were joined by a large force of English rebels. William forced his army through to York, where he spent Christmas. From there he sent messengers south to fetch not arms, or more men, but his crown. Christmas was one of the three annual occasions – the others being Easter and Whitsun – at which the King of England appeared ceremonially at court, wearing his crown. This tradition, which went back to Charlemagne, and before him to the emperors of Byzantium, had been established in England in Saxon times. The Conqueror, eager to proclaim his legitimate claim to the throne, was punctilious in his observance of this ancient assertion of regal identity. It was far from surprising, therefore, that in the midst of war, and in a city that had been sacked by the Danes, William should care about his crown. His respect for royal ceremony was an important aspect of his campaign – by persuasion, as well as by force – to be accepted by the English as their king. He succeeded: the Danish army sued for peace, and William brutally suppressed all opposition in the north of England.

Throughout the centuries that followed, all monarchs understood that it was not enough to be a ruler – they had to look like one. An essential attribute of their public standing and authority was 'magnificence', or the visual expression of wealth and power. On one occasion, neglect of this imperative may have contributed to the loss of a kingdom. In the civil strife that has come to be known as the Wars of the Roses, Henry VI (1421–71), head of the house of Lancaster, was usurped in 1461 by Edward, Duke of York, who became Edward IV (1442–83). In 1470, shifting aristocratic allegiances led to Henry being restored, forcing Edward to flee to Burgundy, from where he returned a year later with an army. Henry's allies tried to rally support for him by taking him in procession through the streets of London. However, because it was Maundy Thursday, Henry was dressed in 'a long blew goune of velvet', an appropriately plain garment for a solemn day. That point was lost on the crowds, who thought he no longer had royal dress, which would have been gold, crimson and ermine. One supporter of Edward IV wrote that the procession was 'more lyker a play than the shewing of a prynce to wynne mennys hertys'.

Edward's army entered London unopposed, and he confirmed his victory by having Henry murdered. Edward didn't make his predecessor's mistake when it came to his appearance. Following the state opening of his first parliament after his return to the throne, Edward went in procession, wearing his crown, to Westminster Abbey. There he made offerings at the shrine of his namesake, Edward the Confessor, England's royal saint, whose feast day it was. Regal piety and liberality were combined with magnificence as a way of announcing that the new dynasty was here to stay.

Attributes of monarchy: the regalia

Any account of the Royal Collection should begin with the crown. It forms part of the regalia, or Crown Jewels, which are the fundamental physical attributes of monarchy. They are made of precious metals and jewels to symbolise the belief that the monarch is not only the supreme source of political authority but is also divinely consecrated by anointment at the coronation, on the biblical model of King Solomon, who was annointed by Zadok and Nathan, as Handel's coronation anthem *Zadok the Priest* reminds us. By extension, therefore, royal identity is embodied in objects of splendour appropriate to a monarch's sacred status: not just gold and jewels, but also magnificent apparel, imposing buildings and splendid possessions – the origins of the Royal Collection.

Although the regalia are most closely associated with coronations, the ceremonies enacted by William the Conqueror at York in 1069 and Edward IV at Westminster in 1472 demonstrate the stress that was placed on all displays of these signifiers of royal authority. There had been one important change in the four centuries between those two events. The crown and other regalia were kept at Westminster Abbey, the setting for every coronation since 1066. The abbey church had been built for Edward the Confessor (1003–66), who was buried there. In 1161 Edward was canonised, which meant that his tomb became a shrine and all objects associated with him were now religious relics. According to the monks of Westminster, the crown had been Edward's, and was, therefore, too sacred to be worn except for coronations. As a result, monarchs commissioned another crown for their ceremonial appearances, known as 'the great crown'. This arrangement, which survived the Reformation – and consequent dismantling of the Confessor's shrine and discarding of his relics – has continued to the present day. Elizabeth II was crowned in 1953 with St Edward's Crown, but has not worn it since. When she appears in state, most regularly for the opening of parliaments (in a tradition well established by the late Middle Ages), she wears the Imperial State Crown, made for her father, George VI, the 'great crown' of modern times (fig. 1).

Unlike William the Conqueror and Edward IV, Elizabeth II could not be crowned with Edward the Confessor's own crown, since in July 1649 it had

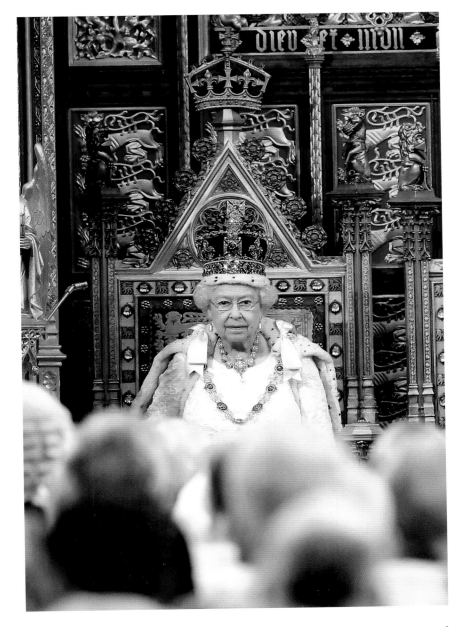

1. Queen Elizabeth II at the state opening of parliament, 2016.
The Queen, seated on the throne in the House of Lords, wears the Imperial State Crown, the collar of the Order of the Garter and a diamond necklace given to Queen Victoria to mark her Golden Jubilee.

been destroyed by order of parliament, six months after the execution of Charles I (1600–49). Whereas Charles I's art collections were largely sold in the new republic, the regalia were such potent symbols of royalty that they were singled out to be 'totally Broken and defaced'. St Edward's Crown was stripped of its jewels and melted down for its gold, to be used for making coins. The present St Edward's Crown (fig. 2) was made in 1661 for the coronation of Charles II (1630–85), following the restoration of the monarchy the year before. It is, therefore, as much a symbol of the severing of royal tradition as of its continuity.

Magnificence

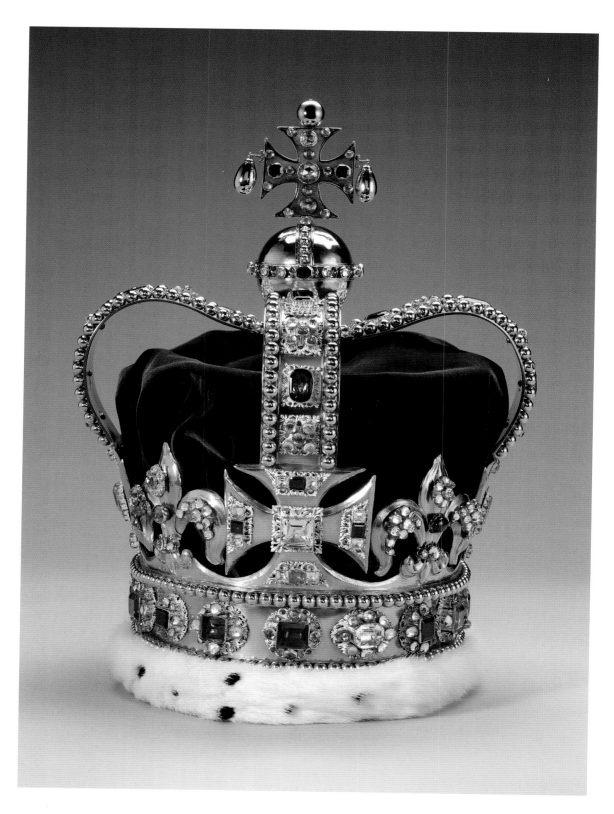

3. The Coronation Spoon.
The only surviving piece
of the pre-Civil War regalia.
Made by a goldsmith in
the second half of the
twelfth century, and so
commissioned by either
Henry II (1133–89) or
Richard I (1157–99), it has
by tradition been used to
hold the sacred oil before
the King's anointing at
the coronation.
RCIN 31733

2. St Edward's Crown.
Ordered by Charles II
in 1661 to replace the
medieval coronation
crown, destroyed in 1649,
it only loosely resembles
that crown, which was
believed to have dated
from the time of Edward
the Confessor. As in the
Middle Ages, the crown
was essentially a frame,
into which borrowed gems
were set when it was
needed, but for the
coronation of George V
in 1911, the crown was
permanently set with
rubies, amethysts,
sapphires and semi-
precious stones.
RCIN 31700

Only one piece of the medieval regalia has survived: the coronation spoon (fig.3). Made between 1150 and 1200 it is first recorded with St Edward's Crown at Westminster Abbey in 1349, when it was described as being of 'antique forme'. Although it is not mentioned in descriptions of medieval coronations, the spoon may have been used in the same way that it is today, to hold the consecrated oil immediately before the anointing: the unusual divided bowl seems designed for two fingers to be dipped into it. It was sold in 1649 (for 16s) to Clement Kynnersley, one of Charles I's yeomen of the wardrobe, who returned it to Charles II so that it could be used at his coronation in 1661, at which point pearls were added to the stem.

The placing of these pearls on this precious object has a symbolic value in the history of the Royal Collection. They mark the moment not just of the re-establishment of the monarchy but also the beginning of the continuous history of the Collection after it had been fractured in the Commonwealth. The year of Charles I's execution, 1649, was a disaster for not just the British monarchy but also its collections – with few exceptions, the King's treasures were sold or destroyed. Regret for that loss usually focuses on the paintings and sculptures that Charles had commissioned or bought, but the sale included almost everything he had inherited from his royal ancestors, stretching back to medieval times, with the significant exception of items he had himself sold, melted down or given away. Although from the moment of Charles II's restoration, items that had been in the Collection before 1649 began to return to royal hands, and although subsequent monarchs and their families up to the present day have occasionally bought back works of art dispersed after Charles I's death, it would be impossible to recreate the collection as it had evolved up to then. For that reason, telling the story of the Royal Collection is like reading from a book that has had the first half of its pages ripped out. The collection begins with a few items from the reigns of Henry VII (1457–1509) of England and James IV of Scotland (1473–1513); apart from the coronation spoon, there is almost nothing earlier of significance. Even the period of collecting from Henry VII to Charles I is represented only fragmentarily, although some of those fragments, including armour and tapestries as well as paintings and drawings, are amongst the great treasures of the collection. Since Henry's victory over Richard III (1452–85) at Bosworth in 1485 is traditionally held to mark

the end of the Middle Ages, and the beginning of the modern monarchy as first embodied by the Tudors, it could be argued that there is a symbolic value in the fact that the collection does not extend back much before 1500.

The Tudors

In 1486 Henry VII made a royal entry into York. Although nobody at the time would have noticed, there were parallels with William the Conqueror's arrival there just over four centuries earlier. Henry, too, had won the throne in battle and had to fight hard to retain it. Aware, like the Conqueror, of the need to impress the local populace with his legitimate royal status, Henry staged a crown-wearing ceremony in York on 22 April, and the following day, St George's Day, he held the annual feast of the Garter, England's royal chivalric order, founded in 1348.

Like his predecessors, Henry knew that he had to invest in the trappings of monarchy, partly as a way of retaining a throne on which he never felt wholly secure. The constant threat of invasion or usurpation by the claimants and pretenders who afflicted Henry's reign meant that, far from ending on the battlefield at Bosworth, the Wars of the Roses continued well into the following century. Before Bosworth, Henry's priority had been to keep out of the clutches of his enemies, most notably Edward IV. As a result, he had little direct experience of life at the English court in the fifteenth century, and so would have relied on the recollections of his wife (the eldest daughter of Edward IV) of the almost stupefying splendour that her father could summon up for state occasions. Henry VII not only matched but also, in many ways, exceeded the standards set by Edward IV. Whereas Edward had concentrated his public crown-wearing at a single ceremony on the Feast of the Epiphany, Henry multiplied this by five, appearing in his regalia at Christmas, Epiphany, Easter, Whitsun and All Saints' Day. He never neglected public appearances – after the death of his wife and eldest son, he often dressed in black, but always chose the most luxurious materials in this fashionable (and expensive) colour.

Henry's competitiveness with his predecessors was especially marked in an area eagerly scrutinised by contemporaries: piety. One of the very few works in the Royal Collection that can probably be traced back directly to the King is an altarpiece on panel that he may have commissioned in about 1502 (fig.4). It depicts Henry and Queen Elizabeth, with their seven children – only four of whom survived infancy – kneeling in prayer. Behind them, against the backdrop of a fantastical castle, St George rescues the Princess Cleodoline from the dragon. St George is the patron saint of England, and one of the three patron saints of the Garter (whose collar Henry is wearing).

Despite this emphasis on symbols of England, Henry turned to an Italian sculptor when commissioning the monument that would represent

4. *The Family of Henry VII with St George and the Dragon, c.*1503–9. This altarpiece, depicting Henry VII with his wife, Elizabeth of York, and their children, may have been commissioned by the King for his new palace at Richmond. The royal family are depicted inside tents, like those erected for tournaments. Embellished with the rose of the Tudors and the portcullis of Henry's mother's family, the Beauforts, the tents are striped in red and white – the colours of both the national saint and the Lancastrian dynasty, from whom Henry was descended. RCIN 401228

him to future generations. In his will, Henry VII specified that his tomb was to be made by the Modenese sculptor Guido Mazzoni (*c.*1450–1518), whose design he had approved three years earlier. Henry was no doubt influenced by the fact that since 1496 Mazzoni had been making a tomb for Charles VIII of France. A bust by Mazzoni depicting a laughing boy that appears always to have been in the Royal Collection may have been sent to Henry VII to show what the sculptor was capable of (fig.5). The suggestion that it depicts the young Prince Henry, later Henry VIII (1491–1547), is appealing, but there is no evidence that Mazzoni ever made the journey to England to capture such a startlingly realistic likeness. For unknown reasons, Henry VIII rejected Mazzoni's design for his father's tomb and chose the Florentine sculptor Pietro Torrigiani (1472–1528), now

Magnificence

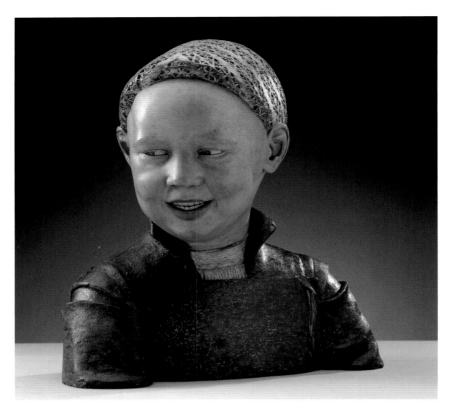

remembered primarily as the man who broke Michelangelo's nose during a fist fight in 1492. Since England was slow to accept the idea, originating in fifteenth-century Italy, that architectural design should be inspired by that of ancient Rome – an idea that is encompassed in our concept of 'the Renaissance' – it may seem surprising that an Italian artist of the calibre of Torrigiani should have frequented early sixteenth-century London. Yet he was far from alone. When the successful completion of Henry VII's tomb was followed by a commission for a tomb on a gigantic scale for Henry VIII himself (never to be finished), Torrigiani returned to Italy to recruit sculptors to help him. Benvenuto Cellini (1500–71) turned down the offer, but Benedetto da Rovezzano (1474–*c*.1554) and Giovanni da Maiano (1486/7–*c*.1542) travelled back to London with Torrigiani and had long careers at Henry's court, not returning to Florence until the 1540s. Work by Giovanni da Maiano (known to the English as 'John de Mayne') includes the roundels bearing heads of the Caesars on the exterior of Hampton Court, and Benedetto da Rovezzano fashioned the black marble sarcophagus intended for Henry VIII's tomb that now houses the body of Lord Nelson in the crypt of St Paul's Cathedral.

These sculptors' work also raises two important issues for the story of the Royal Collection in the sixteenth century, and to some degree beyond. The first is the reliance on foreign artists and craftsmen. This was nothing

new; when Henry VII's tomb was installed in the magnificent new chapel he had commissioned at Westminster Abbey, it took its place in a setting that was almost entirely furnished by foreigners, from its bronze screen by a Dutch or German smith named Thomas, to the stained glass (which does not survive) by the King's Glazier, Barnard Flower (d.1517), who was Flemish. It may seem odd that foreign craftsmen should have been preferred for a building designed for a monarch who, as the St George altar-piece reveals, was eager to link himself to assertions of English identity. It is doubtful whether Henry VII or Henry VIII would have recognised the argument. Like all great patrons of their time, they simply demanded work of the finest available quality. In his will Henry VII specified that all the vestments and other furnishings of his new chapel at Westminster should be of a quality 'appertaining to the gift of a Prince'.

The belief that in order to achieve the best it was necessary to employ foreign craftsmen and designers reflects an important aspect of royal magnificence: fashion, or novelty, an aesthetic imperative in the sixteenth century, just as it had been in the Middle Ages. It was an essential part of a monarch's image that he was as up to date as possible, and more so than his subjects, since he had privileged knowledge of the leaders of fashion abroad – the royal courts of Europe – through gifts, correspondence and diplomatic exchanges. English kings in the late fifteenth and early sixteenth centuries carefully matched their artistic patronage against the standards of the most admired courts in Europe – first, that of the dukes of Burgundy, and then, after the dukedom had been incorporated into France in 1477, the French court. Italian courts were influential also, thanks to the presence in London of not only artists but also merchants and diplomats from Italy.

The King's houses

From the mid-1490s onwards, when the political life of the nation was calmer, and the royal revenues were increasing, Henry VII spent considerable sums on new houses. In 1497 the favourite royal suburban palace, built by Henry V (c.1386–1422) at Sheen, on the Thames, west of London, was badly damaged by fire. Henry VII rebuilt and enlarged it, naming it 'Richmond' (before his accession he had been Earl of Richmond). In 1500–1 he demolished a royal manor house named Pleasaunce at Greenwich, east of London, and replaced it with a large new palace, fashionably built of brick and closely modelled on princely houses in Burgundy and the Netherlands. Its design was based on a 'platt' (a drawing) 'which was devised by the Queen', suggesting that Greenwich Palace's up-to-date forms reflected the tastes of Elizabeth of York as much as those of her husband.

Only small fragments remain of Richmond, and barely even that of Greenwich, following the demolition of both buildings in the seventeenth century, but contemporary descriptions of their interiors evoke the

splendour of Henry VII's court. A visitor to Richmond in 1501 recorded its tapestry-hung chapel and its great hall, on the walls of which were set 'pictures of the noble kinges of this realme in their harnes [armour] and robis of goolde', culminating in a portrait of Henry himself, in a blunt assertion of dynastic legitimacy. Beyond the chapel 'extendid goodly passages and galaris – payved, glasid and [ap]pointed, besett with bagges [badges] of gold, as rosis, portculles, and such othir'. Heraldic badges – the Tudor rose and the portcullis of Henry's mother's family, the Beauforts – were clearly prominent, as on almost all royal commissions. The emphasis on galleries in this description is especially interesting in the context of the Royal Collection. Designed for exercise in bad weather, and to provide views out over gardens from their many windows, they were a fashion imported by Edward IV from Burgundy, and by the sixteenth century were customarily hung with portraits and other paintings.

Even Henry VII's ambitious programme of palace building was eclipsed by his son. Thanks to the financial security bequeathed him by his father and, from 1536, the vast revenues from the dissolution of the monasteries, Henry VIII was enormously rich. Much of his money was squandered on war, but a great deal was spent on buildings, their decoration and furnishings. He made designs for buildings (as well as armour, armaments and jewellery), and there are references to him being sent architectural drawings for his many projects.

By the end of his reign, in 1547, Henry VIII had built, bought, been given or had expropriated 60 houses. The court had always needed more than one residence because it moved throughout the year, mostly in carefully planned formal progresses, designed to give parts of the country outside London easier access to the court. It has been estimated that in the course of Henry's 38-year reign the court moved 1,500 times – this mobility explains why, as in medieval times, the royal houses were, in effect, shells, since they were fully furnished with portable furniture, precious plate, tapestries and costly fabrics only when the court was in residence. Many of these items were carried on horse-drawn carts that transported the household to each new residence – in 1541 the French ambassador noted that between 4,000 and 5,000 horses were needed for a move from London to York, where Henry was to meet James V of Scotland.

Henry VIII

Few monarchs have ascended the throne of England in such happy circumstances as Henry VIII. Just short of his eighteenth birthday, tall, athletic and handsome, and soon married companionably to his late brother's widow, Katherine of Aragon, he was fortunate to inherit not only a full treasury but also advisers capable of carrying the main burden of royal administration, leaving Henry to the princely pursuits of jousting, feasting and making war.

6. Armour of Henry VIII for the field and tilt by Erasmus Kyrkenar, c.1540.
This steel garniture powerfully conveys a sense of the King's imposing presence in the last decade of his life. To accommodate his growing obesity, the armour's backplate was subsequently extended by about 5 cm on each side.
RCIN 72834

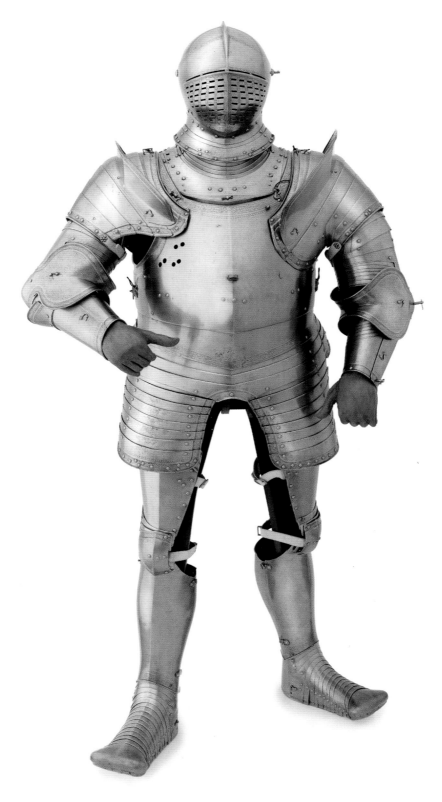

Magnificence

Among his early priorities, therefore, was to establish a royal armoury. In common with other crafts, the best came from abroad. Henry's finest early armour was made in the imperial workshops at Innsbruck, and was tailored to him using his doublet and hose, which were sent to Germany for measurements to be taken. By 1511, the King had two armourers of his own, recruited from Milan, who were given a forge at Greenwich. In 1515 their number was bolstered by 11 'Almains' (meaning Germans or Dutch) under the mastership of Martin van Royne. Although most of Henry's armour

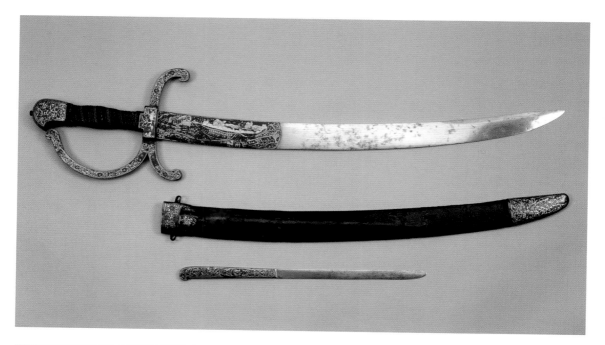

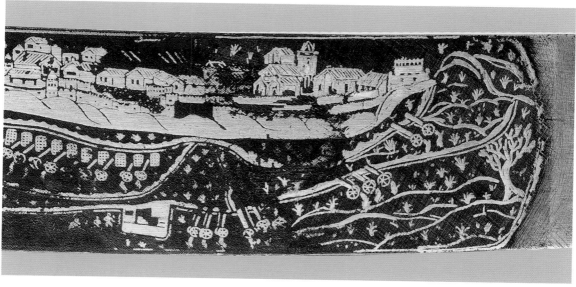

was sold for scrap after 1649, a few significant pieces survive in the Royal Armouries and there is also one whole garniture (an armour with interchangeable pieces for different occasions) in the Royal Collection. Mounted and on display at Windsor Castle, it provides an almost unnervingly immediate sense of Henry's presence (fig.6). It was made in 1540 by one of the great armourers of the age, Erasmus Kyrkenar (c.1495–1567), possibly for the tournament that celebrated Henry's marriage to his fourth wife, Anne of Cleves (1515–57). Thought to be of German origin, Kyrkenar (or Kirkener) was appointed armourer for the King's body in 1519 – at an annual salary of £10 – and 20 years later replaced Van Royne in charge of the royal workshops at Greenwich. The design of the engraved decoration on the armour has been attributed to Giovanni da Maiano, a reminder that leading artists contributed to this costly craft.

The level of artistry that could be involved is demonstrated by a hunting sword (fig.7), which, with its accompanying knife, can probably be identified in the inventory of Henry VII's possessions made after his death in a group of weapons described as 'iij longe woodknives ij of them of Dego his makinge'. 'Dego' was a Spanish decorator of arms, Diego de Çaias (active c.1530–52), who was employed by Henry from 1543 to 1547. Decorated with a depiction of the siege of Boulogne in 1544, the sword is part of a long tradition of Henry commissioning representations of military and diplomatic events of significance to his dynasty, most prominently as large-scale decorative schemes in his houses. The most extravagant way to do this was in tapestry, such as the enormous example, nearly 120 feet long, named the *Comyng into Englonde of King Henrye VII*, which has not survived. Quite apart from the huge expense of such a one-off design, it cannot have been straightforward to provide precise instructions for the Netherlandish weavers. It was easier to control craftsmen at hand, and in 1532, for example, two painters from either France or the Netherlands, Isaac Labrun and John Rauffe, painted a long mural in a gallery at Whitehall representing Henry VIII's coronation. Other such subjects from recent history were on panel. In the Royal Collection are a pair of paintings by anonymous artists depicting Henry's meeting with the Holy Roman Emperor, Maximilian, in France in 1513, and their joint victory over the French King, Louis XII, at the Battle of the Spurs. Better known are two paintings that depict the events surrounding Henry's celebrated summit meeting with Louis's successor, François I, at the Field of the Cloth of Gold at Guînes, near Calais, in June 1520. The painting of the King's departure from Dover (fig.8) exhilaratingly captures the flamboyance and *joie de vivre* of the occasion, as well as the King's pride in his navy. Its companion (fig.9) depicts the extraordinary splendour of the setting for the meeting, which included a temporary palace of wood and canvas to accommodate the King and Queen, the King's sister, Princess Mary, and Cardinal Wolsey. Since neither painting is listed in Henry's inventories of portable possessions, they were probably originally set into panelling.

7. Hunting sword, by-knife and scabbard by Diego de Çaias, 1544.
These are among the few surviving works by Henry VIII's Spanish decorator of arms. The sword commemorates one of the King's last military victories, the siege of Boulogne in 1544. Boulogne appears on the right, and on the left is the mound on which the English artillery was stationed. The blade is inscribed with a poem in Latin celebrating Henry's triumph. RCIN 61316

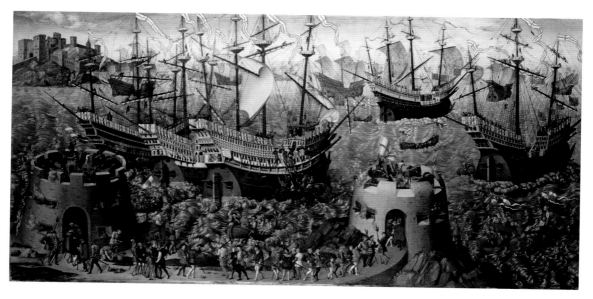

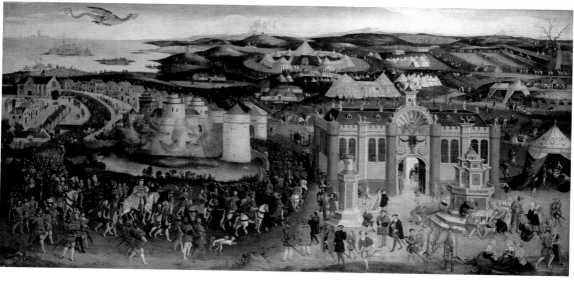

 According to the chronicler Edward Hall, every room in the palace at the
Field of the Cloth of Gold was hung with tapestries 'wroughte of golde
and silke, compassd of many auncient stories'. It is not quite true to say that
Henry's most valuable possessions were his tapestries, woven with gold and
silver thread – on great occasions even these glittering works of art would
have been outshone by the displays of his gold and silver-gilt. Yet only a
single piece of precious plate made for Henry has survived, a rock-crystal
bowl and cover, mounted in gold, enamel, gems and pearls, dating from the
1530s and now in the treasury of the Residenz at Munich. Since Henry's
tapestries incorporated precious metals they risked sharing the fate of his
plate, but as they were also needed to furnish rooms their survival rate

is much higher. About 120 of the 2,450 tapestries and wall hangings that Henry possessed at the time of his death have survived.

Great care was taken of these costly works of art. The King had his own tapestry works, primarily for making heraldic tapestries and borders, but also for maintaining and repairing the collection. When not in use, tapestries were placed in specially made canvas covers to protect them against dust and moths, and were moved into purpose-built store rooms, fitted with cupboards, racks and ladders, which were kept heated by charcoal burnt in pans, as it was understood that wood or coal smoke damaged tapestries. Efforts were also made to protect tapestries when they were hung: household regulations emphasised that courtiers were not to wipe their hands on them.

Tapestries seem to us intrinsically old-fashioned, and although that is not how they were regarded in the sixteenth century, some of the King's tapestries must have been regarded as heirlooms: he had inherited 400 to 500 pieces, some of which were at least a century old. It is notable that by the end of the King's reign, many of the older tapestries were hung at Windsor Castle (always regarded as the most venerable of the royal houses) and so were perhaps already being deployed with antiquarian intent. A similar spirit guided Henry's major addition to Hampton Court, the great hall built in 1532–4. Such halls were obsolete in terms of their original function, the place where lords dined with their households – Henry never ate there – but they were still potent symbols of an ancient tradition of lordship and hospitality that he wished to acknowledge. Tapestries were an intrinsic part of a hall's decoration, and it seems likely that a ten-piece set depicting the story of Abraham, made in 1543–4 to a design that may have been commissioned by Henry VIII, was intended for the hall at Hampton Court, where it hangs today.

Although the hall is medieval in its forms, such as the hammerbeam roof, the details of its ornament are classical. There was nothing novel in this by the 1540s; since the 1520s Henry's palaces had been decorated with painted marbling and moulded friezes imitating Roman carving. Especially fashionable was the painted or carved ornament called 'antik', or antique, and usually now referred to as 'grotesque', from its origins in the painted ornament in the 'grottoes' or underground rooms of Nero's palace in Rome, rediscovered at the start of the sixteenth century. Tapestries were one important way that Renaissance ornament reached England: for example, in 1542 Henry bought a set of what were called 'Antique' tapestries depicting classical gods and heroes woven from a design made for Pope Leo X in about 1520 (fig.10). Also in 1542, Henry bought a set of the tapestries depicting the 'Acts of the Apostles' woven from designs made by Raphael (1483–1520) in the late 1510s for the Sistine Chapel. Henry's set was sold in 1649 and, having been acquired by the Kaiser Friedrich Museum in Berlin, was destroyed in the Second World War, but it remains a presence in the Royal Collection thanks to Charles I's acquisition of seven of Raphael's original cartoons.

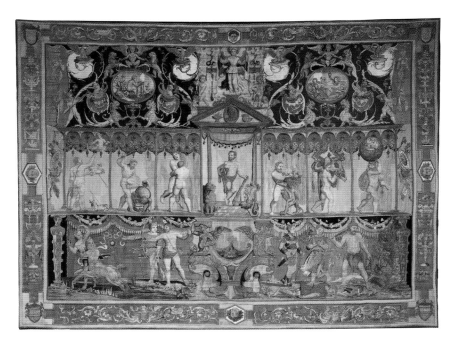

10. *The Triumph of Hercules, c.*1540.
This is one of a set of seven gold-thread tapestries of classical deities and heroes in elaborate settings that was acquired by Henry VIII in 1542. They are the earliest surviving weaving of these designs, made by Giovanni da Udine for Pope Leo X in about 1520. As well as demonstrating the way that tapestries were a vehicle for Renaissance ornament and design to reach England, they also reflect Henry's desire to be seen as a modern incarnation of such heroes, most notably Hercules. RCIN 1363

One of Henry's aims in buying these very modern – and very expensive – works of art was to emulate the splendours of the new palace at Fontainebleau commissioned by his old rival, François I. In about 1538 one of the French King's artists, Nicholas Bellin (*c.*1490–1569), born in Modena, moved to London to work for Henry. He had been employed in Mantua, possibly under Raphael's former assistant Giulio Romano, and had worked at Fontainebleau with such major Italian artists as Rosso Fiorentino (1494–1540) and Francesco Primaticcio (1504/5–70). Bellin may well have advised Henry about the purchase of his 'Antique' and 'Acts of the Apostles' tapestries, in which case it is possible that Henry knew who Raphael was. As major works of Renaissance art, the tapestries would seem less isolated in their Tudor context if the decorative work that Bellin carried out at Whitehall Palace and Henry's lavish new house at Nonsuch in Surrey, begun in 1538, had not so completely disappeared. The quality of work that northern monarchs obtained from Italian sculptors is evident in an extraordinarily rare treasure, a small bronze satyr (fig. 11) by one of the most famous of all Renaissance sculptors, Benvenuto Cellini (1500–70). It was made as part of a model for his proposed bronze 'Porte Dorée' or 'Gilded Doorway', which François I commissioned him to make for Fontainebleau in 1542. This would have been Cellini's first large-scale bronze, but the project was abandoned. It is not known when the satyr entered the Royal Collection, but it may have been soon after Cellini returned to Florence in 1545; its counterpart is now in the J. Paul Getty Museum, Los Angeles.

11. *Satyr* by Benvenuto Cellini, *c.*1545.
A model for one of a pair of bronze satyrs commissioned by François I for his palace at Fontainebleau, but never executed, this sculpture may have come to England soon after it was made, when Henry VIII was emulating François's patronage at his new palace, Nonsuch in Surrey. RCIN 94784

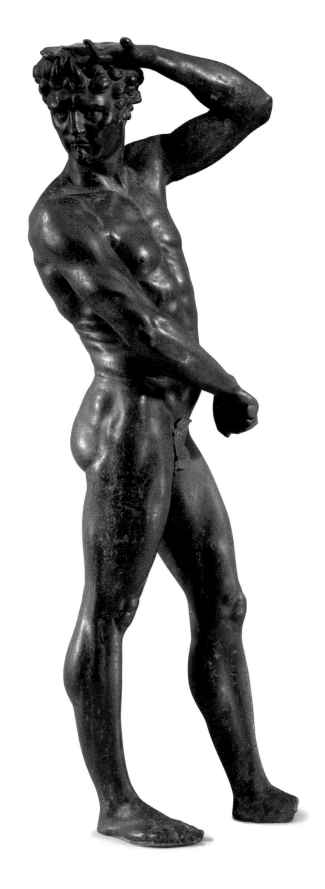

Paintings at Henry VIII's court

In the early years of Henry's reign, painters were employed mainly for decorative and heraldic work, often for the temporary buildings and installations required for tournaments or other festivities, of which the palace at the Field of the Cloth of Gold was an exceptional example. In 1527 there were major festivities at Greenwich to celebrate a treaty between England and France. Among the artists employed was a 'Master Hans'. This was Hans Holbein (1497/8–1543), who, as well as painting a large mural of a battle, was responsible for decorating a ceiling with a depiction of the heavens designed in collaboration with the King's astronomer, Nikolaus Kratzer. His two stays in London, from 1526 to 1528, and from about 1532 until his death from plague in 1543, brought him, if not great fortune, then certainly great fame.

When Holbein first visited London, the most important painter at court was the Flemish-born Lucas Horenbout (c.1490–1544), who may have begun work for Henry as a 'pictor maker' in 1525. 'Pictor making' refers to painting on a large scale, but, as it is recorded that Holbein learned

12. *Henry VIII* by Lucas Horenbout *c.*1526–7.
Horenbout, a son and pupil of Gerard Horenbout, Court Painter to Margaret of Austria, Regent of the Netherlands, arrived in England in the mid 1520s and was appointed King's Painter in 1534. His workshop carried out manuscript illumination, from which the genre of miniature portraits developed. This example, 4 cm in diameter, is one of the earliest surviving independent portrait miniatures.
RCIN 420010

the art of miniature painting from a 'Meister Lucas' in London (fig.13), it is possible that a very early group of miniature portraits of Henry VIII are by Horenbout (fig.12). They are very close to depictions of Henry in manuscript illuminations. Henry clearly thought highly of Horenbout: his appointment as King's Painter was renewed after ten years, and Henry recorded his appreciation of his 'science and experience in the pictorial art'. The high esteem in which Horenbout was held marks the point at which it began to be widely understood by Henry and his courtiers that painting had achieved a new pre-eminence in the visual arts that went beyond its decorative or documentary functions. The promise of Horenbout was to be more than amply fulfilled by Holbein.

There was an immediate demand in London for Holbein's strikingly realistic half-length portraits, partly because of the fame of one he had painted of Erasmus in 1523. He may have obtained his well-paid work for the 1527 Greenwich festivities thanks to a letter of introduction from Erasmus to one of his regular correspondents, Sir Henry Guildford (1489–1532), comptroller of the royal household, who was in charge of all the arrangements at Greenwich. It is exceptionally appropriate, therefore, that Holbein's 1527

13. *Portrait of a Lady, perhaps Katherine Howard*, by **Hans Holbein**, *c.*1540.
Fifteen miniatures by Holbein survive, of which five are in the Royal Collection. The sitter is wearing a ruby, emerald and pearl pendant that is known to have belonged to Jane Seymour, supporting the suggestion that she is Henry's ill-fated fifth wife, Katherine Howard. Like Fig. 12, this is in one of the standard frames ordered for the royal collection of miniatures by Queen Victoria and Prince Albert. RCIN 422293

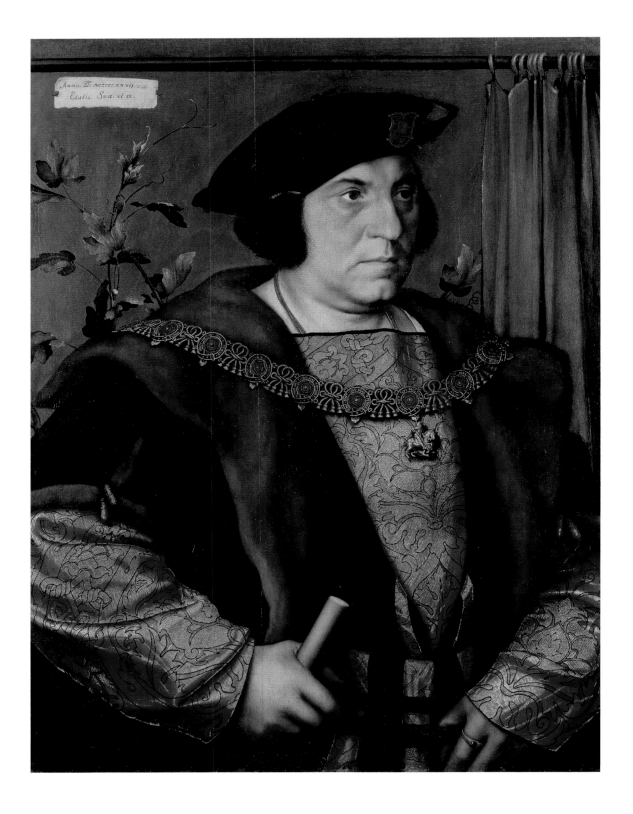

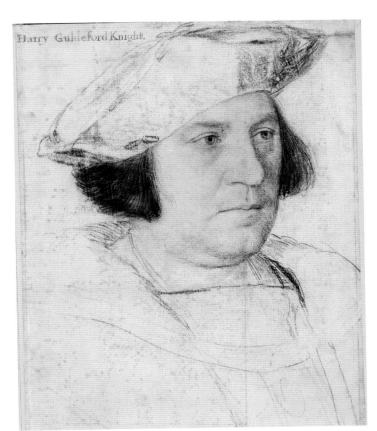

Harry Guildeford Knight.

portrait of Guildford and the preparatory drawing for it are in the Royal Collection (figs 14 and 15). The drawing is one of 80 by Holbein that were collected together in Henry's reign, probably immediately after the artist's death, and are first recorded in the Royal Collection in the reign of Edward VI. They were already regarded as a major source for knowledge of Henry's court, since Edward's tutor, Sir John Cheke (1514–57), went through the drawings, annotating each with the sitter's name.

As well as their intrinsic beauty, the drawings possess great importance as documents of Holbein's working method, since, so far as is known, all were made in preparation for painted portraits. The drawing of Guildford, for example, only summarily indicates major parts of his final portrait, notably the collar of the Order of the Garter. Unusually, the painting is not a precise tracing of the drawing: Holbein manipulated the outline on the panel to make Guildford's face look longer and leaner, almost certainly on his sitter's instructions. The drawings are also precious as records of paintings that have been lost. Holbein's major commission on his first visit to London (1526–8) was a group portrait of Henry's Chancellor, Sir Thomas More, with his family and household. The painting was destroyed in a fire in the eighteenth century, but a group of Holbein's studies for the individual portraits survives. They include some of the most sensitive portraits of

14 and 15. *Sir Henry Guildford* and its preliminary drawing by Hans Holbein, 1527. Sir Henry Guildford (1489–1532) was comptroller of the royal household. In the painting, Guildford holds a white staff, symbol of his office, and wears a hat badge representing a clock and geometrical instruments. RCIN 400046 and 912266

female sitters by any artist of his time, such as the drawing of More's ward and future daughter-in-law Anne Cresacre (fig.16).

One of the puzzles of Holbein's career is the length of time that it took Henry VIII to get round to sitting for him, despite the fact that the King gave him important commissions, such as designing a table fountain to be given to Anne Boleyn in 1533–4. Although Henry is one of the most recognisable monarchs in English history, he was slow to show interest in his own portraiture – he had been on the throne for 20 years before he bothered to replace his father's image on the coinage with his own. The portraits of himself that he commissioned, such as the Horenbout miniatures, and 'my picture set in bracelets' that he gave to Anne Boleyn before their marriage, suggest that small portraits for his intimates counted for more than large-scale, more public paintings.

That all changed thanks to the events that Henry's desire to marry Anne Boleyn so dramatically precipitated: the severance in 1534 of England's links with the papacy and the King's new status as head of the Church in England. Now there was a major incentive for Henry to seek images of himself that would promote this controversial change. The arguments that Henry used to justify his actions are embodied in the only original portrait of the King by Holbein in the Royal Collection, which dates from around 1534 (fig.17). Painted with ravishing delicacy in expensive colours – ultramarine and gold – on vellum, it depicts the Queen of Sheba, a symbol of the Church, addressing Solomon, who has the features of Henry. She is telling him that his royal power comes from God alone, and thus, by implication, does not depend on any other source, such as the papacy. This was a message that people close to Henry, who were sympathetic to Church reform, wanted him to hear, so it is likely that the painting was commissioned as a gift to him.

From then on, Holbein was kept busy painting portraits for the King. After the death of Henry's third wife, Jane Seymour, in 1537, the artist was despatched all over Europe to draw and paint potential brides. Holbein's portraits of Anne of Cleves encouraged Henry to marry her in 1540, but, so far as we know, the artist took none of the blame for the King's disappointment when he set eyes on her in the flesh. Two years earlier, Holbein had painted a striking full-length portrait of another candidate for Henry's hand, Christina, Duchess of Milan, a daughter of the Danish King. Although nothing became of those negotiations, Henry retained the painting, the only

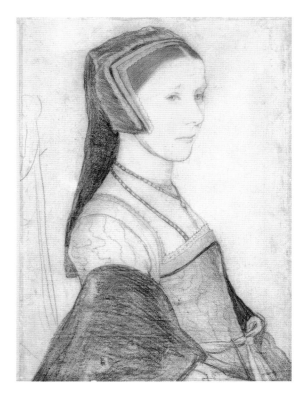

16. *Anne Cresacre* by Hans Holbein, *c*.1527.
Holbein made this preliminary drawing in black and coloured chalks for a lost portrait of Sir Thomas More and his family. The sitter, Anne Cresacre, then about 16 years old, was engaged to More's son John, whom she married in 1529.
RCIN 912270

17. *Solomon and the Queen of Sheba* by Hans Holbein, *c*.1534.
Probably made as a gift to the King from a courtier who supported Church reform, this miniature painting uses the biblical narrative of the Queen of Sheba to assert the authority of Henry (depicted as Solomon) over the Church.
RCIN 912188

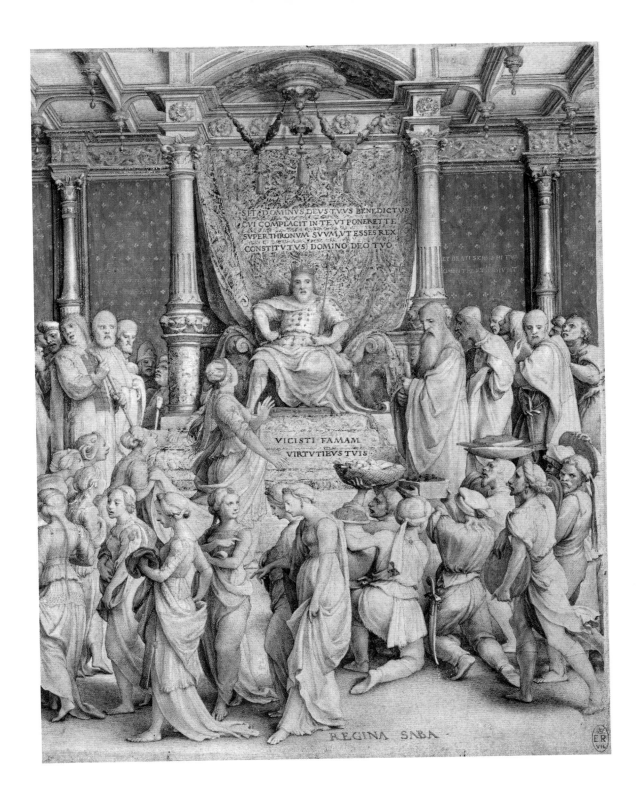

SI.T.DOMINVS.DEVS.TVVS.BENEDICTVS.
CVI.COMPLACIT.IN.TE.VT.PONERET.TE.
SVPER.THRONVM.SVVM.VT.ESSES.REX.
CONSTITVTVS.DOMINO.DEO.TVO.

VICISTI FAMAM
VIRTVTIBVS TVIS

REGINA SABA

Magnificence

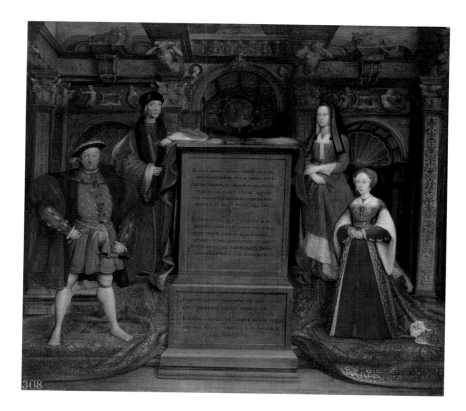

portrait by Holbein listed in the Royal Collection when the King died (it is now in the National Gallery, London).

Holbein's most celebrated portrait of the King has not survived. This was a life-size mural depicting Henry VIII with Jane Seymour and his parents, painted on a wall at Whitehall Palace, probably in the King's Privy Chamber. It dated from about 1537, and so may have been created to celebrate the birth of the son that Henry had for so long desired, the future Edward VI (1537–53). The four figures, set in a richly decorated classical interior, were grouped around a large stone monument that proclaimed Henry VII as the bringer of peace to his country and his son as the bringer of religious reform: 'The great debate, competition and great question is whether father or son is the victor. For both, indeed, were supreme.'

The mural was lost in the fire that destroyed Whitehall in 1698, despite desperate efforts to hack it off the wall, but most fortunately in 1667 Charles II had it copied in a small painting by the artist Remigius van Leemput (1607–75), the only complete record of Holbein's masterpiece (fig.18). Miraculously, the left-hand part of his cartoon – the full-size drawing used to transfer the design to the wall – has survived, and is now in the National Portrait Gallery, London. This reveals that Holbein originally drew Henry looking towards Jane Seymour, but in the finished painting he stared straight out to the viewer in an intimidating depiction of royal authority and majesty. In a biography of Holbein written in 1603–4, Karel van Mander described

the portrait as 'so lifelike that anyone who sees it gets a fright; for it seems as if it is alive'.

Other aspects of Henry's art collections reflected his new status as absolute ruler of not only England, but also her Church. It seems likely, for example, that the choice of such subjects as the story of David, which featured in the tapestries at all the major palaces, was intended to project an image of the King as patriarch of his people. A few of the paintings also promoted messages of religious reform. Among them is a depiction of the Pope being stoned by the Evangelists (fig.19), painted with a refinement that almost seems inappropriate to the violent subject matter by another Italian artist employed by Henry, Girolamo da Treviso (active c.1497–1544). It is interesting for another reason: this is the only surviving painting that belonged to Henry of which we can be sure exactly where it was displayed. It was hung in the gallery at Hampton Court, which was on the second floor, designed to provide views over the garden and river. Inventories of Henry's possessions reveal that portraits were juxtaposed with religious and historical subjects without any particular programme; presumably the visitors to Hampton Court who were admitted to this private room of the King's were expected simply to admire the skill displayed by the artist and perhaps draw a moral, or learn a lesson from the subject. We know that paintings could be moved, since some had specially made leather cases, but usually they were left in place when a palace was not in use, protected by curtains – a mark also of the veneration in which images were held. The curtains at Hampton Court were green and yellow, creating a decorative effect even when the paintings were concealed.

19. *A Protestant Allegory* by Girolamo da Treviso, c.1538–44.

An inventory of Henry VIII's possessions made after his death in 1547 included this painting, described as 'the bushopp of Rome and the four Evangelists casting stones upon him'. The sprawled pope – who does not appear to be a portrait – is flanked by female figures labelled 'AVARA' (avarice) and 'YPOCRYSIS' (hypocrisy). The painting resembles woodcuts in the first Bible in English, published in 1535. Girolamo, who moved to England to work for Henry as a military engineer, was killed during the English siege of Boulogne in 1544. RCIN 405748

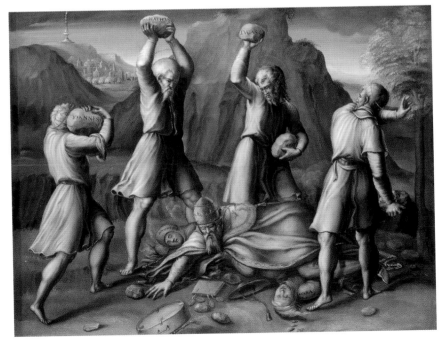

Accounts later in the century record the maintenance of pictures: in 1588, for example, payments were made for varnishing the paintings in the Presence Chamber at Whitehall 'with a special Varnishe without sente'. Among the paintings listed for this treatment was 'a greate table [painting] containing King Henrie, Price Edwarde and the ii ladies his daughters'. This painting of Henry VIII and his family, some 11½ feet wide, is by an unknown artist clearly influenced by Holbein (fig.20). It depicts an interior, specially arranged for the painting, at Whitehall Palace, with views out to the Privy Garden. The combination of a painted plaster floor, partly covered by a carpet, with carved and painted decoration and embroidered hangings suggests the almost claustrophobic richness of the interiors of Henry's private apartments. Less assertive as a dynastic statement than the Whitehall mural, it reflects the calmer tone of Henry's court under his sixth and last Queen, Katherine Parr. She endeavoured to improve relations between the King and his two daughters, Mary (1516–58) and Elizabeth (1533–1603). Although, like saints in a Renaissance altarpiece, they are depicted separated from their father by columns; it is in this painting that the two women who were to rule England for the second half of the century take their first steps into the spotlight.

The heirs of Henry VIII

Henry's death on 27 January 1547 was quickly followed by a meeting of his Privy Council. The possibility of selling works from the Royal Collection to raise money for paying the King's legacies was discussed, but it was agreed that the royal possessions were so important as representations of the wealth of England that any sale of them would be interpreted by foreign powers as weakness. Henry's children had no pressing motive, therefore, to add to his collections, and in any case it must soon have become apparent that the vast number of houses that he left behind were greatly more than they would ever need.

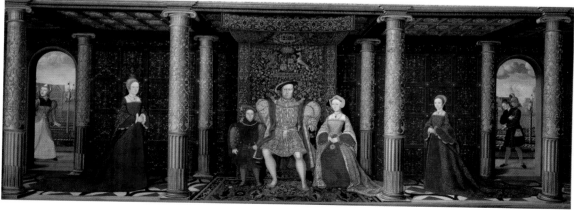

Although both Edward VI, who inherited the throne at the age of nine, and his eldest sister, Mary, who succeeded him in 1553, had a major impact on the country, as the pendulum of religious obedience swung forcibly toward Protestantism, and then was dragged back to Catholicism, neither lived long enough to leave much mark on the Royal Collection. Edward, clever and precociously interested in theology, as his Protestant revision of the regulations of the Order of the Garter reveals, was never able to commission major works, as he died before reaching the age of majority. An imposing, but sensitive, portrait of Edward, painted for Henry VIII by an anonymous artist. shows the prince in a pose that echoes that of his father in Holbein's Whitehall mural (fig.21). In retrospect this is poignant, since the indications are that Edward, strongly interested in sport and military matters as well as religion, would have grown up to be unmistakably his father's son.

Mary, by contrast, had to overcome the disadvantages of being the first female monarch since Matilda, daughter of Henry I, in the twelfth century – not a happy precedent, since Matilda's claim had never been universally recognised. More difficulties were created by the way the Queen courted unpopularity, firstly by her religious reforms and then by her marriage in 1554 to Philip (1527–98), heir to the King of Spain and Holy Roman Emperor, Charles V. Nonetheless, this alliance with the Habsburg dynasty was a diplomatic triumph, and it brought Mary's court firmly into the mainstream of European culture. The fine paintings of herself she had commissioned from the Flemish artist Hans Eworth (c.1520–74) were now matched, if not eclipsed, by portraits by Philip's official painter, Anthonis Mor (c.1520–c.1576), although none of these paintings are now in the Royal Collection.

So that the Queen could see an image of her future husband, Philip's aunt Mary of Hungary, governor of the Netherlands, sent her a portrait of him by Titian (c. 1490–1576). She specified that it was to be returned, because she valued it so much, and no work by Europe's most famous painter entered the Royal Collection during his lifetime. However, one outstanding work of Habsburg portraiture produced during Mary's reign is preserved at Windsor, a bronze bust by the Italian sculptor Leone Leoni (1509–90) of Philip in armour, wearing the collar and badge of the Order of the Golden Fleece (fig.22), which was bought for the Royal Collection by George IV. An inscription on the base describes Philip as King of England, a reminder of a time, often forgotten, when England was jointly ruled by a Habsburg, and Spanish was spoken at court. The terms of Philip's marriage settlement meant that he had no right to continue as King after his wife's death. When it became clear that Mary was terminally ill, Philip did his best to smooth the way for Elizabeth's accession, preferring a Protestant princess to her cousin, the Catholic Mary, Queen of Scots, who was allied to his enemy, France. Elizabeth succeeded her sister in 1558, and one of her first actions was gracefully to refuse Philip's offer of marriage.

20. *The Family of Henry VIII*, c.1545.
Commissioned by Henry VIII, this large painting of his family by an unknown artist was displayed in the Presence Chamber at Whitehall Palace. Henry is shown with Prince Edward and Edward's mother, Jane Seymour, who had died in 1537. This is the earliest surviving life portrait of Elizabeth, his daughter by Anne Boleyn, who stands on the right; on the left is her sister, Mary, daughter of Katherine of Aragon.
RCIN 405796

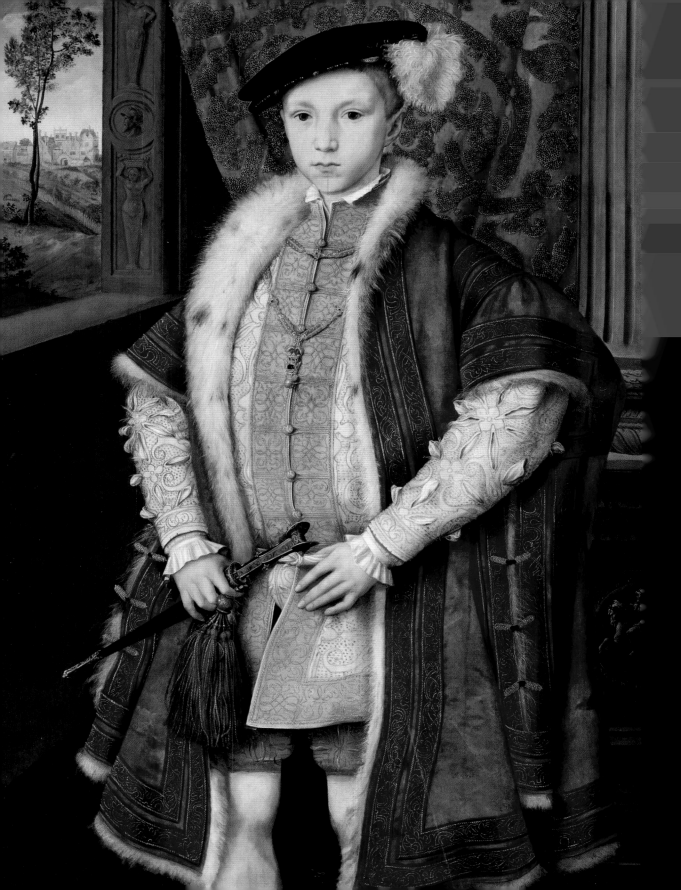

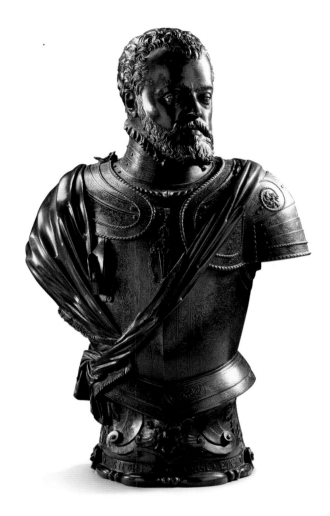

22. *Philip II* by Leone Leoni, *c*.1555.
Commissioned by the celebrated Habsburg general Fernando Álvarez de Toledo, 3rd Duke of Alba, the magnificent bronze depicts Philip II as King of England, following his marriage to Mary Tudor in 1554.
RCIN 35323

21. *Edward VI*, 1546.
The pose of Edward, Prince of Wales, the future Edward VI, echoes Holbein's paintings of his father. His left hand draws attention to his codpiece, which has been interpreted as a sign of the Prince's intention to continue the Tudor dynasty. The view through the window shows one of his residences, Hunsdon House in Hertfordshire. The painting has been attributed to William Scrots, a Netherlandish artist who was employed by Henry VIII from about 1545 and continued to work at court under Edward VI.
RCIN 404441

Gloriana

Despite the great cultural achievements of England during Elizabeth's long reign, particularly in literature, music and architecture, and despite the fact that she ranks with her father as one of the most immediately recognisable monarchs in history, her contribution to the Royal Collection did not equal his. She never enjoyed his enormous wealth, but of more significance was the fact that as an unmarried woman she came to avoid visual promotions of her dynasty since, almost to the moment of her death in 1603, its future was in doubt. Instead, more strongly even than Henry VIII, she developed a cult of personality – of the Virgin Queen or Gloriana, for which portraiture was an essential ingredient.

The many celebrated paintings of Elizabeth that incorporated allegory and symbolism were made as gifts or were commissioned by her courtiers, and there are very few in the Royal Collection. Among them is a painting

dated 1569, which represents a version of the Judgement of Paris (fig.23). The Queen is shown emerging from a palace-like interior to judge the three goddesses Juno, Minerva and Venus, who are nonplussed since Elizabeth outshines them all. This piece of flattery has a double meaning. Its centre is occupied by Juno, who beckons the Queen to follow her. Since Juno was the goddess of marriage, the painting seems to be urging Elizabeth to find a husband. This suggests that it must have been a gift, and it has been proposed that it was commissioned by the Queen's main counsellor, William Cecil, who was her Secretary of State in 1569. If that is the case, the painting may reflect his anxieties to secure the kingdom at a time of rebellion and plots by Catholic enemies.

The painting is attributed to Hans Eworth, and its assured deployment of allegory reflects his work for Elizabeth as a designer of court festivities: for example, he was one of the artists responsible for a masque staged in 1572 in honour of the French ambassador. Yet, on his death in 1574, the Queen did not replace him, despite the need to control how she was represented, and in spite of requests for her portrait from suitors and foreign rulers; in 1564 the Regent of France, Catherine de' Medici, was so eager

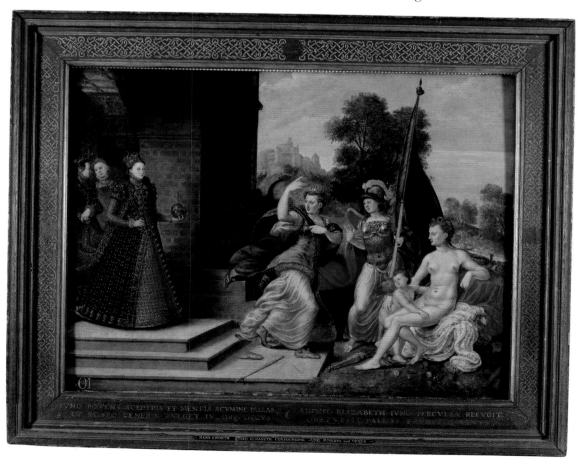

to obtain a good portrait that she offered to send her own court painter to London. One evident change in Elizabeth's reign is the disappearance of the Italian artists who had been such a familiar feature of her father's court. Several reasons have been offered for that, such as the growing hostility of Catholic countries, or the decline in Italy's importance as a trading partner with England. An equally plausible explanation is simply the fact that the Queen was a much less active and generous patron of the arts than Henry VIII had been. When a leading Italian painter, Federico Zuccaro (1540/2–1609), visited London in 1574, he was granted a portrait-sitting by the Queen, but the only result was a drawing (now in the British Museum) that had no influence at all on the way she was portrayed in England.

This suggests that Elizabeth had no deep interest in the visual arts, a supposition that is strengthened by the only contemporary account we have of her sitting for a portrait. The artist Nicholas Hilliard (1547–1619) recalled that when she had first sat for him, she asked why Italian painters did not use shadows in their paintings. This reveals a remarkable lack of knowledge, since subtle manipulation of shadow and light – or chiaroscuro – was one of the fundamental elements for which Italian artists were most admired. Hilliard, who seems to have been equally ignorant about Italian art at this early stage in his career, replied that 'hard shadows' were only important for large paintings designed to be seen from a distance, whereas they weren't necessary for the small ones, in which he specialised, which were intended to be seen 'in hand near unto the eye'. Prompted by this observation, the Queen suggested that she should sit for him out of doors 'in the open ally of a goodly garden, where no tree was neere, nor any shadowe at all'. The result was the even light and emphasis on line rather than modelling that distinguish Hilliard's series of miniatures of the Queen. Dating from the 1560s to after her death (since he executed posthumous portraits of her), they form the only sequence of portraits of the Queen by a leading artist that can be compared in significance with those that Holbein had made of her father. They allow us to trace the way the Queen chose to be represented, from a young woman, little different from any aristocrat of her time (fig.24), to the bejewelled icon of her later years. In a glittering miniature painted by Hilliard in the final decade of her reign she appears as Astraea, the classical goddess who presided over the Golden Age (fig.25).

Such portraits are also records of what were arguably the Queen's greatest contributions to the Royal Collection, although almost nothing survives of them – her jewels and clothes. An inventory taken in 1587 recorded that she owned 628 pieces of jewellery, most of which would have come to her as gifts, and at her death the royal wardrobe contained some 2,000 dresses. Among the few jewels that do survive are cameo portraits of the Queen. These were common – jewellers in London kept them in stock – and, in settings of precious stones, they were worn by the Queen and her courtiers, perhaps inspired by Roman descriptions of the cameo portraits worn by emperors. The finest examples appear to come from a single workshop that

23. *Elizabeth I and the Three Goddesses* by Hans Eworth, 1569. Still in its original frame, this is the first in a long line of allegorical depictions of the Queen. In a restaging of the Judgement of Paris, the Queen takes the place of Paris (holding an orb in place of his apple) in the contest between Juno, Minerva and Venus – who, naturally, concede primacy to the Queen. RCIN 403446

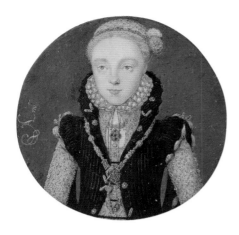

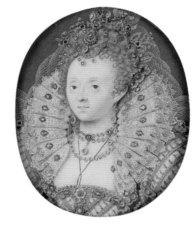

24 and 25 (top right and left). *Elizabeth I* by Nicholas Hilliard, *c*.1560–65 and *c*.1595–1600
Hilliard made portraits of Queen Elizabeth throughout her life, which allows us to trace the changing way she chose to be presented. The miniature dating from the early 1560s shows the Queen aged about 30. Her identity is proclaimed by the Tudor symbols of the red and white roses she wears in her hair. The later miniature represents the Queen as the virgin goddess of justice Astraea. It is a depiction of semi-divine majesty with no hint of Elizabeth's real age.
RCIN 420944 and 421029

26 (bottom left). *Elizabeth I*, *c*.1575.
This is one of a small group of exceptionally large (6.7 x 5.5 cm) and fine sardonyx cameos of the Queen that were made by an unidentified Italian (or Italian-trained) craftsman, probably for her to give as presents. Such cameos, set in gold and jewels, were worn by her courtiers.
RCIN 65186

27 (bottom right). *Mary, Queen of Scots* by François Clouet, *c*.1558.
A miniature of Mary, Queen of Scots (1542–87), painted by the French court artist François Clouet in about 1558, on the basis of a drawing he had made of Mary three years earlier. This is probably the miniature of Mary that was shown to the Scottish ambassador by Queen Elizabeth in 1564.
RCIN 401229

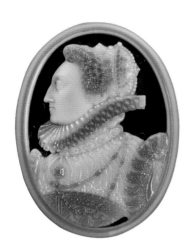

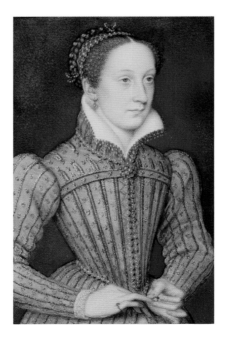

must have been patronised by the Queen, but its identity remains a mystery (fig. 26). Painted miniature portraits were also customarily set in jewelled cases. An intriguing glimpse of the way they were stored is provided by the Scottish ambassador Sir James Melville, who in his *Memoirs* described how, in 1564, Elizabeth took him 'to her bed-chamber and opened a little cabinet, wherein were divers little pictures wrapt within paper, and their names written with her own hand upon the papers'. She unwrapped a portrait of Mary, Queen of Scots, 'and kissed it'. This was probably the exquisite portrait painted by the French court painter François Clouet (*c.* 1520–72) on the occasion of Mary's marriage to the future François II of France (fig. 27).

Melville's visit to the Queen's private apartments was a privilege, since men were only rarely admitted. Elizabeth was over-supplied with accommodation in the large number of houses she had inherited from her predecessors, and as result she built very little. One of the few major alterations to her residences was the addition in 1583 of a gallery at Windsor Castle. Approached through her bedchamber, this was one of her most private rooms, and although it was converted into the Royal Library in the 1830s, it still preserves a sense of her presence (fig. 28). The ceiling, in

28. *The Long Gallery at Windsor Castle* by **Joseph Nash, 1848.**
Although much altered when it was converted into the Royal Library for William IV in the 1830s, as shown in this lithograph, this is recognisably the private room in which the Queen discussed matters of state, read and made translations from the classics.
RCIN 817132

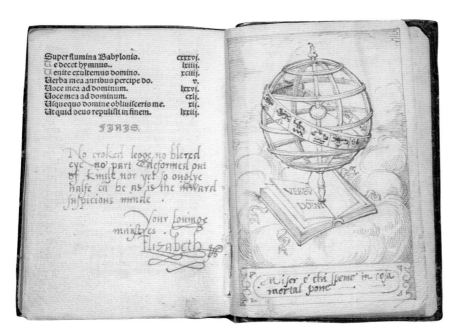

moulded plaster (a new fashion in the 1580s) is a replica of hers, and her original magnificent stone chimneypiece survives; it was perhaps designed by her architect at Windsor, Henry Hawthorne. The Queen used the Gallery for official business – a couch that she sat on when consulting her ministers was pointed out to a visitor in 1600. It was also a room for reading, and almost certainly contained part of the Queen's library. Among the treasures of the Royal Library now preserved here is a volume of psalms translated into French and published in the late 1520s (fig.29). Elizabeth has inscribed it with a short poem and the form of signature she used before her accession in 1558. On the opposite page is a drawing of an armillary or celestial sphere, a mechanical representation of the heavens, placed on an open bible, inscribed 'Verbum Domini', or 'The Word of God' – the apparently mutable created universe is sustained by eternal God. Elizabeth adopted the armillary sphere as one of her emblems, and the possibility that the drawing is by her is strengthened by technical analysis that reveals it is in the same ink as the inscription below it, in her elegant italic handwriting: 'Miser é chi Speme in cosa mortal pone' (Wretched is he who places hope in a mortal thing), a quotation from the Italian poet Petrarch.

The Queen would have used her gallery for private study, and so it is likely that it is here that she made the translations from classical literature that occupied her into old age. This was not just a hobby, but an important part of the Queen's public persona. As a woman, she could not participate in the chivalric and military pastimes that preoccupied her father and brother, but she could share – and exceed – their reputation for scholarship, an admired quality in a prince. Thanks to the excellent education she had received from her tutor Roger Ascham, she was fluent in Latin, Italian, French and Spanish

and could read Greek. Her learning was acknowledged in the classical symbolism and allusions employed in the masques, ceremonies and festivities that were an increasingly significant part of life at Elizabeth's court. In the second half of her reign, the cult of the Virgin Queen as a national symbol was promoted ever more eagerly, partly in defiance of the country's increasing vulnerability and isolation following the excommunication of the Queen in 1570 and the conflict with Spain that worsened from 1580.

Great artistic energy was poured into the ceremonial tournaments, or tilts, that were staged at Whitehall every year on 17 November, the anniversary of the Queen's accession. The Royal Collection possesses a

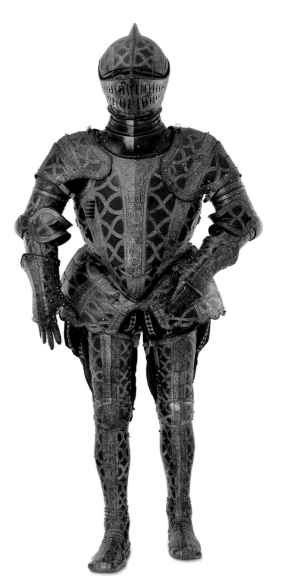

beautiful armour intended for these occasions that was commissioned by one of Elizabeth's handsome favourites, Sir Christopher Hatton (c.1540–91; fig.30). Made by Jacob Halder (active 1576–1609), Master Workman at the royal armoury at Greenwich, it is strikingly decorated with etched and gilt vertical and diagonal bands, scrolls, military trophies, figures and heraldic roses. The temporary sets, decorations and costumes made for the tilts must have been similarly elaborate, but nothing of them survives beyond what can be deduced from a fashion for portraits of the participants in their costumes. One example, painted by the Flemish artist Marcus Gheeraerts the Younger (1561–1636) in the late 1590s, evokes the complex symbolism enjoyed by the Queen. This portrait of an unidentified woman in Persian dress, the stag, tree, and even the birds and flowers, all had specific meanings, now mostly lost (fig.31). It has been suggested that the portrait is linked to the entertainment given by Sir Henry Lee, the Queen's Master of the Armouries and Champion of the Tilt, when Elizabeth visited him at Ditchley, near Oxford, in 1592. This occasion was commemorated in the famous 'Ditchley' portrait of the Queen, also by Gheeraerts, now in the National Portrait Gallery.

When Elizabeth died, aged 70 in 1603, she had been on the throne for nearly 45 years and few people had clear memories of her predecessors. Her death led to an immediate demand for her portrait, of which the most popular was commissioned by the London publisher Hans Woutneel from the Cologne-based engraver Crispin de Passe. Showing the Queen full-length, dressed as

she appeared at the state opening of parliament, it is based on a drawing of great refinement in pen, ink and wash attributed to the miniature painter Isaac Oliver (*c.*1565–1617; fig.32). The most copied portrait of Elizabeth ever made, the print became an embodiment of nostalgia for what soon seemed a lost golden age of concord between monarch and people.

31. *Portrait of an Unknown Woman* by Marcus Gheeraerts the Younger, *c.*1590–1600.
The sitter's Persian costume and the symbolic tree and stag by which she is accompanied, have led to the suggestion that she is a participant in an Elizabethan court entertainment. The poem in the cartouche, bottom right, identifies her as a melancholy lover. It concludes: 'My Musique may be plaints, my physique [medicine] teares/ If this be all the fruite my love tree beares.'
RCIN 406024

32. *Elizabeth I*, attributed to Isaac Oliver, *c.* 1603.
Made in the year of the Queen's death, this drawing shows her as she appeared at the state opening of parliament. It was the source for a highly popular print engraved by Crispin de Passe in Cologne. The Queen is shown holding the sceptre in her left hand as the design would be reversed in the engraving process.
RCIN 452477

Magnificence

PIONEER COLLECTORS
The Early Stuarts

In January 1636 Charles I asked his wife, Henrietta Maria (1606–69), whether she had heard any news of a group of paintings that Cardinal Barberini was sending from Rome. 'I'm afraid,' she said, 'that they're not coming any more.' Seeing his face fall, she burst out laughing – 'that's because they're already here!' According to the Queen's confessor, Fr Philip, who witnessed the exchange, 'the King was delighted with this joke'. After the paintings had been unpacked, the Queen had them brought to her bedroom at St James's Palace. As each was shown to her and to the papal agent, Gregorio Panzani, who had arranged the gift, she and her ladies praised them, particularly ones said to be by Leonardo da Vinci and Andrea del Sarto. Alerted by a message from the Queen that the paintings could at last be seen, Charles went straight to her bedroom, accompanied by the architect and designer Inigo Jones (1573–1652), described by Panzani as 'a great connoisseur'. 'The very moment Jones saw the pictures,' wrote Panzani to Barberini, he 'put on his eye-glasses, took a candle and, together with the King, began to examine them very closely'. Panzani was amused by Jones's boastful assertion a few days later of how he had been able to attribute the paintings correctly to their artists, despite the King having removed the labels that Panzani had helpfully attached to them.

This vivid story marks a turning point in the history of the Royal Collection. Barely half a century after Queen Elizabeth had unwittingly revealed to Nicholas Hilliard her ignorance of Italian art, the King and his artistic adviser were examining a gift of paintings from Rome like well-seasoned experts. Charles's behaviour bore out Panzani's earlier advice to Barberini that the King had a 'good nose' for painting and would probably appreciate old works rather than modern ones, because of their comparative rarity. This change since Tudor times in the appreciation of art broadly coincided with Elizabeth's death in 1603 and the inheritance of the crown of England by the royal house of Scotland, the Stuarts, but that was largely a coincidence. Far more important was the development, since the mid sixteenth century, in the princely courts of Europe of a competitive fashion for collecting works of art, not purely for their subject matter but as examples of the achievements of admired masters.

From the fifteenth century onwards, study of classical authors had revealed that the ancient Romans eagerly collected works by famous artists,

such as the painter Apelles and sculptor Praxiteles. This led scholars and collectors both to look for surviving works by these masters and to seek out their modern equivalents. Paintings and sculptures became a special focus of interest partly because, unlike gold and silver plate, or tapestries woven with precious metal thread, they appealed primarily to people with a knowledge of art and antiquity. Such an understanding was comparable to the ability to read the works of Latin and Greek authors, a skill that, by the sixteenth century, princes were expected to possess, as Queen Elizabeth's linguistic expertise had demonstrated.

This new appreciation of the visual arts as a continuation of classical traditions of collecting and display was first evident in the courts of Italy, which helps to explain why in the second half of the sixteenth century Italian painting and sculpture achieved a pre-eminence that has never subsequently been questioned. By the turn of the century, monarchs and princes throughout Europe were seeking to emulate the example of such celebrated dynasties of collectors as the Medici in Florence. The standards to which they aspired were embodied by Isabella d'Este, the Marchesa of Mantua, who between 1490 and her death in 1539 had spent much energy and large sums of money in acquiring not only classical antiquities and works by her court artists, Mantegna and Costa, but also paintings, drawings and sculptures by many of the most famous Italian artists of her time, including Perugino, Bellini, Leonardo da Vinci, Michelangelo, Correggio and Titian. She would not have been surprised to know that after her death her treasures would be eyed covetously by the monarchs of Europe, but she would surely have been startled to learn that they would leave Mantua not for Rome, Paris or Madrid, but for far-off London, to adorn the palaces of a dynasty of which Isabella would have known almost nothing.

A Scottish dynasty

Monarchs of Scotland since the late fourteenth century, the Stuarts were firmly tied into north European dynastic politics by marriage. James III (1451–88), who reigned from 1460 to 1488, married Margaret, a daughter of Christian I of Denmark, a union that is celebrated in the finest fifteenth-century portraits in the Royal Collection (fig.33). Painted in 1478 by Hugo van der Goes (c.1440–82), one of the leading artists in the Netherlands, the King and Queen are shown on two panels of a triptych that was originally focused on a now lost panel of the Virgin and Child. As a document of royal patronage, however, the opulent beauty of these paintings gives a misleading impression: the triptych was not commissioned or paid for by the King, but by the man who is depicted on the reverse of one of the panels, Sir Edward Bonkil, an Edinburgh merchant who traded with the Netherlands. The young prince who also appears in the painting succeeded his father as James IV. Although he was a patron of architecture – an interest shared by

33 Panels from the *Trinity Altarpiece* by Hugo van der Goes, 1478. These panels formed part of a triptych altar-piece commissioned by the Edinburgh merchant Sir Edward Bonkil for the city's collegiate church of the Holy Trinity, of which he was Provost. James III of Scotland and Queen Margaret, accompanied by St Andrew and probably St George, originally faced a panel depicting the Virgin and Child, which does not survive. The boy kneeling behind the King is the couple's eldest son, James, born in 1473, who succeeded his father as King in 1488. RCIN 403260

his son James V (1512–42) – the early Stuarts could not equal the artistic achievements of the Tudors: Scotland was simply too poor (its population is estimated to have been only half a million in 1500, less than a quarter the size of England's) and too politically unstable. Since 1406 every monarch had succeeded as a child, and this pattern was maintained on the death of James V, whose heir was his week-old daughter, Mary, Queen of Scots.

The trajectory of Mary's tragic story, from her brief reign as Queen of France, through a stormy six years as a Catholic Queen of Presbyterian Scotland, to abdication and eventual execution in 1587, hinged on the lurid events of 9 February 1567. Two years earlier she had married her cousin Henry Stuart, Lord Darnley (1545–67), but despite the birth of a son,

the future James VI, in 1566, Mary was deeply unhappy with her volatile husband, and refused, to his fury, to grant him the status of king. It was undeniably to her advantage that on that February night he was found dead in the garden of the Old Provost's Lodging in Edinburgh, after the house itself had been wrecked by an explosion. Mary's subsequent marriage to the Earl of Bothwell, who was assumed to have murdered Darnley on her behalf, was a major factor in her downfall. Darnley himself was lamented only by his parents, the Earl and Countess of Lennox, whose grief and anger were distilled into a large painting showing their infant grandson, James VI (1566–1625), kneeling before an altar (the Lennoxes were Catholic), with the Earl and Countess and their younger son behind him (fig. 34). Darnley is shown on a tomb in effigy, in gilded armour. An inset painting bottom left depicts the events at Carberry Hill in 1567, when Mary's army submitted to forces hostile to Bothwell, the event that led the Queen to flee to England. According to one of its many inscriptions, the painting was commissioned by the Countess of Lennox for her grandson, so that if she and her husband did not live long enough to tell him to take revenge on his father's murderers, the painting would do it for them. Libellous inscriptions referring to Mary's part in Darnley's murder have been expunged, perhaps at the wish of James VI, who after he succeeded to the throne of England rehabilitated his mother's memory by having her buried in Westminster Abbey.

Although the painting belongs to a genre in Scottish art known as the 'revenge painting' – an embodiment of the factionalism and blood feuds

34. *The Memorial of Lord Darnley* by Livinus de Vogelaare, 1567. Commissioned by the Earl and Countess of Lennox, who are shown kneeling on the right with their younger son, Charles Stewart, the painting demands revenge for the murder in 1567 of their eldest son, Henry, Lord Darnley, husband of Mary, Queen of Scots. He is depicted as an effigy in gilded armour on a tomb. The kneeling boy at the centre is Mary and Darnley's son, James VI, who says 'Arise, O Lord, and avenge the innocent blood of the King my father ...'. RCIN 401230

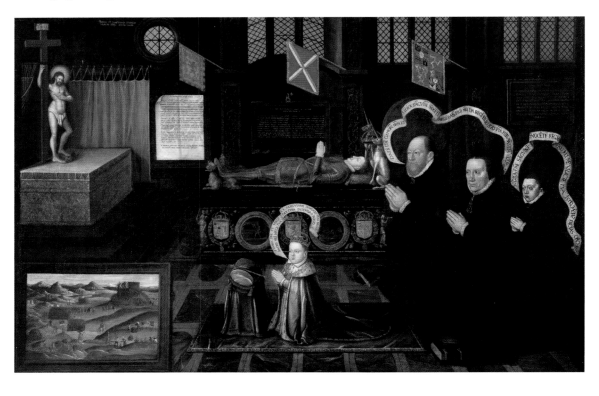

of aristocratic life in Scotland – it was executed in London by an immigrant Fleming, Livinus de Vogelaare (fl. *c*.1551–1600), whose only known painting this is. Thanks largely to the links between the Stuarts and France in the sixteenth century there are fine portraits of the Scottish royal family in the Royal Collection, including the miniature of Mary, Queen of Scots by François Clouet illustrated in the previous chapter, as well as a version of the same artist's full-size head-and-shoulders of the Queen, which her grandson Charles I hung in his Cabinet Room at Whitehall. As in England, however, the development of a native tradition of portraiture depended on immigrant artists from northern Europe. Among the earliest was Arnold Bronckorst (fl.1565–85), who in the late 1570s arrived in Scotland to prospect for gold on Crawford Moor in Lanarkshire, a venture bankrolled by his friend Nicholas Hilliard. He found gold, but was prevented from exporting it by the Regent of Scotland, the Earl of Morton, who instead drew Bronckorst into service to execute the first known portraits of James VI.

After Bronckorst returned to London in 1583, he was replaced by another Dutchman, Adrian Vanson (d. *c*.1604), who executed decorative projects as well as portraits for the King. Ambitions for promoting a native school of painting may be reflected in Vanson being made a burgess of Edinburgh in 1585 on the condition that he instructed apprentices. Nonetheless, when, in 1603, his royal master inherited the English crown, Vanson joined him in London, where his last recorded work is a commission from the Dutch community for decorating a triumphal arch at the Royal Exchange for the new King's ceremonial entry into the city. As he came within sight of the arch, devoted to the theme of religion and peace, James I was greeted by a boy who proclaimed that God 'teaches thee the art of ruling; because none but he made thee a King', a platitude that was to resonate in the half century to come.

James I and VI and Anne of Denmark

James declared that his first years on the English throne were 'Christmas time'. In Scotland he had enjoyed an income of barely £50,000 a year, but in England during the first year of his reign he spent £47,000 on jewels alone. To some degree, James had no choice about spending more than his notoriously frugal predecessor: unlike her, he had a family, and his wife, Anne of Denmark (1574–1619), and three children, Henry, Elizabeth and Charles, had their own households. James also fully recognised the need to maintain kingly state in public. In 1598 he had written a book in three parts on kingship, *Basilkon Doron* (Royal Gift), pitched as a code of conduct for his heir; among the advice he gives is 'that a King is as one set on a stage, whose smallest actions and gestures, all the people gazingly do behold'. In England that entailed a level of display impossible in Scotland. In 1610 James's secretary of state, Robert Cecil, Earl of Salisbury, calculated that

the combined costs of Elizabeth's funeral, James's ceremonial entry into London, his coronation and the reception in London of his brother-in-law, Christian IV of Denmark, had amounted to half a million pounds. These were one-off costs, but the King did not neglect his regular public appearances. In particular, he continued the Elizabethan tradition of enacting the Garter ceremonies with splendour.

Nonetheless, James did not place great stress on the visual arts as a way of projecting royal virtue. He did not participate in the court entertainments that so appealed to his wife, and was a reluctant sitter for portraits. He was not a great builder, either, but he did not need to be, as Henry VIII's legacy of royal houses was more than any of his successors needed, and the Stuarts, like Elizabeth I, occupied a much reduced number. James gave Somerset House on the Strand to his wife, and it was subsequently renamed Denmark House in her honour. She also had the use of the palace at Greenwich and the house at Oatlands in Surrey that had been built by Henry for Anne of Cleves. James showed no great appetite for metropolitan life, preferring to spend his time informally in his hunting lodges at Royston and Newmarket. Sport was also the major attraction of Windsor, which the King visited almost every year to hunt both before and after his summer progresses. Its appearance in his time is recorded in a superb survey of the Castle and its parks and forests drawn in 1607 by John Norden (*c.*1547–1625; fig.35). This was a gift to the King rather than a commission, and James's interest in the Castle did not extend to making changes to it. His greatest legacy was not a building, or a work of art, but his sponsorship of the 'King James' translation of the Bible. As this suggests, scholarship was at the centre of his cultural endeavours, and no other British monarch has been so prolific an author. He had received a thorough – and frequently bruising – education from one of the leading scholars of classical learning

35. *A Description of the Honor of Windesor* by John Norden, 1607.
As a gift to help the new King understand the nature and extent of Crown lands in Berkshire, John Norden produced this beautiful manuscript survey of Windsor Castle and its estate, or 'honour'. He was Surveyor of Crown Woods and Forests in southern England, as well as an eminent cartographer. The survey includes this ambitious bird's-eye view of the Castle, which depicts many details that have disappeared, such as the large mid sixteenth-century fountain in the centre of the Upper Ward (on the left), which is shown criss-crossed by paths.
RCIN 1142252

in Europe, George Buchanan, and by 1583 he already had a substantial library, ranging from classical works to political theory, theology, mathematics and languages. Famously, he once remarked 'they gar me speik Latin ar I could speik Scotis'.

James was unusual among European monarchs in that he had travelled outside his kingdom for peaceable reasons. In 1589 he sailed to Oslo to marry Anna (known as Anne in England), a sister of the Danish King, Christian IV (1577–1648). Both Anne and her brother, who visited London in 1606 and 1614, were deeply interested in music and the arts and there was significant cultural exchange between the two courts. The rise in interest in the visual arts in the early Stuart court initially owed much to Anne. A forceful personality, proud of being the daughter, sister and wife of kings, she broke with precedent by insisting that her eldest son, Henry, born in 1594, join her in England after her husband's accession in 1603 rather than remaining at Stirling Castle under the guardianship of the Earl of Mar, as was customary for the heir to the Scottish throne. As result, the Prince was, to an unusual degree, brought up by his mother, and his precocious interest in the arts owed a great deal to her example.

Anne also began a tradition at the Stuart court of masques, spectacular one-off theatrical events, performed as part of the court's Twelfth Night entertainments at Whitehall. Most were designed by Inigo Jones, who had worked his way up from a humble start in the London building trade to become first, from 1610, surveyor to Prince Henry, and then, from 1615, Surveyor of the King's Works, which gave him overall responsibility for all royal building projects. Jones had gained a deep knowledge of continental art, architecture and languages through several years of travel. As early as 1605 one of his friends expressed a belief that, thanks to Jones, 'sculpture, modelling, architecture, painting, acting, and all that is praiseworthy in the art of the ancients will soon find their way across the Alps into our England'.

Anne was Jones's first significant patron, for architecture as well as theatre design. Her interest in modern Italianate classicism was alluded to in two full-length portraits of her by the Flemish immigrant Paul van Somer (c.1576–1622), both painted in about 1617. In one, in which she is dressed for the chase, there is a view of Oatlands in the background, in which the new classical gateway that Jones had designed for its vineyard is prominent. In the other she is shown against a backdrop of an imaginary classical building (fig.36). Yet, intriguingly, the portrait also looks backwards: the Queen's dress, a farthingale, evokes Elizabeth I – at Oatlands she hung a portrait of herself next to one of the late Queen – and she deploys jewels with an elaboration that Elizabeth would have appreciated. On her collar are diamond brooches in the form of 'S', for her mother, Sophia of Mecklenburg, and 'C4' for her brother, Christian IV. She wears a diamond cross prominently at her breast; it was an open secret that by 1600 she had converted to Catholicism.

Shortly before this painting, in 1616, Anne had commissioned the Queen's House at Greenwich, in which Jones introduced to England the austere

classicism of the Italian architect Andrea Palladio (1508–80). Jones's major royal building was the Banqueting House at Whitehall (built in 1619–22), which served a dual purpose as a setting for masques and a throne room for James to receive important guests. Its classicism may well, therefore, have been conceived of as 'European' rather than English, reflecting James's diplomatic ambitions to be seen as an arbiter of continental politics, steering a middle course between Catholic and Protestant powers. Its style, echoing ancient Rome, may in addition have been intended to embody one of the King's political obsessions, his 'imperial' role as the head of a new polity created by the union of the Scottish and English crowns. To his frustration, he could never persuade parliament in either country, both proud of their political independence, to grant him the title of King of Great Britain. The Banqueting House's significance to James as a projection of his political ideals may be deduced from its prominent incorporation in a full-length portrait by Van Somer showing the King in his robes of state (fig.37). To modern eyes there is an odd contrast between the old-fashioned way the King is depicted, like an image on a medieval seal, and the up-to-date architecture of the Banqueting House, but to James they were simply different aspects of his image as King.

On the leaded window behind the King are engraved or painted the words '*Dieu et Mon Droit*' (God and my right), the English royal motto since the time of Henry V. The motto had a specific resonance for Henry as an embodiment of the English claim to France. To most English people in James's reign the idea that England might have an empire referred to rule over Britain and Ireland, with perhaps a memory of the continental

36. *Anne of Denmark* by Paul van Somer, *c.* 1617–18. One of the last full-length portraits of Anne, this painting depicts the Queen in a farthingale with elaborate jewels. The imaginary building in the background alludes to her patronage of the latest classical architecture, as practised by the Surveyor of the King's Works, Inigo Jones. Paul van Somer, who was born in Antwerp, had settled in London by 1616. Most of his portraits were for Anne and her court, and it was probably thanks to her recommendation that he painted the King. RCIN 405813

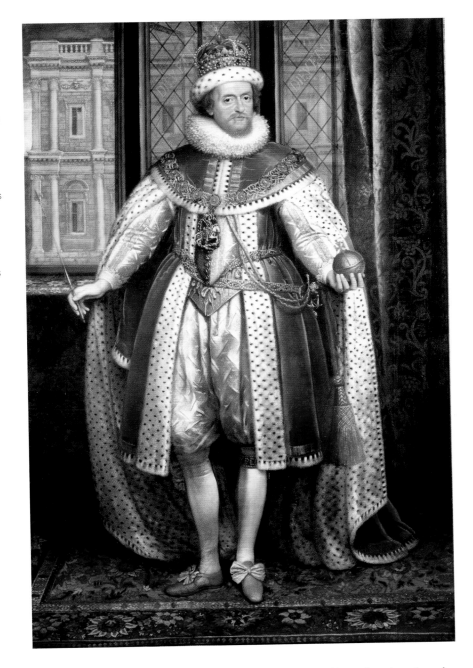

37. *James I & VI* by Paul van Somer, *c.*1620. Depicting James in his state robes and regalia, together with the collar and badge of the Garter, Van Somer's portrait recalls the crown-wearing ceremonies of medieval monarchs. Through the window is the Banqueting House at Whitehall, commissioned from Inigo Jones in 1619. Since it was not completed until 1622, Jones must have supplied a drawing for Van Somer. This explains why the painting differs from the finished building, which is simpler in its decorative details. RCIN 404446

conquests of medieval monarchs. Yet it was during James's reign that the first English overseas colony was established, at Virginia in 1607, the event that is usually taken to mark the foundation of the British Empire. Well before that, trade had established a British presence in many parts of the world – the East India Company received its royal charter from Queen Elizabeth in 1600 – with important consequences for the Royal Collection. Among the collection's earliest surviving major acquisitions made as a result

of trade is a fine Japanese armour by Iwai Yozaemon (fig.38). It was sent as a gift to James from the shogun, Tokugawa Hidetada (1579–1632), in 1613 as a result of a visit to Japan by Captain John Saris of the East India Company to negotiate trading rights, and so is a precious relic of the brief period of direct commercial contact between Britain and Japan that ended with the imposition of isolationism by the shogun in the 1630s, and which was not to resume until 1854.

Art collectors: Queen Anne and Prince Henry

The growth of royal interest in acquiring works of art was stimulated by a new fashion for collecting among a small circle of English aristocrats and courtiers. European travel had become easier, partly as a result of the King having made peace with Spain and France at the outset of his reign, and partly because increased tolerance of Catholics at court eased relations with Italy. Queen Anne's enthusiasm for paintings struck old-fashioned members of court as eccentric – when Robert Cecil, Earl of Salisbury (1563?–1612), criticised her for spending too much time with 'dead pictorres', she replied that she was 'most contented amongst those hermles pictures in the paltry Gallery, then [he was] with [his] greate imployments'. Confined to Hampton Court in her final illness in 1619, she had some religious paintings brought to her bedside from Oatlands, evidence not just of her Catholic faith but also her devotion to images. Unfortunately, the inventory made of her possessions after her death does not specify the artists of her paintings, but there are clues about the quality of her collection, which included an unusually large number of subject pictures. A painting of nymphs listed in the inventory of Oatlands was probably *Diana and her Nymphs Spied on by Satyrs*, a collaboration between Peter Paul Rubens (1577–1640) and Frans Snyders (1579–1657) painted in about 1616 that is still in the Royal Collection. Another early Rubens, *Judith with the Head of Holofernes* (c.1616), owned by Charles I when he was Prince of Wales, may have been inherited from his mother. Anne was also independent in her choice of portrait painters. Although her husband remained loyal to the now elderly Nicholas Hilliard, the Queen preferred the less linear, more naturalistic style of Isaac Oliver, who in 1605 was appointed the Queen's 'limner' or miniature painter. It is likely, therefore, that she commissioned the small drawings by Isaac of mythological and religious subjects that are recorded in the Royal Collection in Charles I's reign, of which one survivor is *Nymphs and Satyrs*, a scene of bacchanalian eroticism executed with all the delicate precision that Oliver brought to his portraits (fig.39).

Oliver was also the miniature painter preferred by Anne's eldest son, Henry, Prince of Wales (1594–1612), which may be evidence of the influence his mother had on him. He certainly shared her enthusiasm for masques and at the age of only 11 was applauded for his outstanding

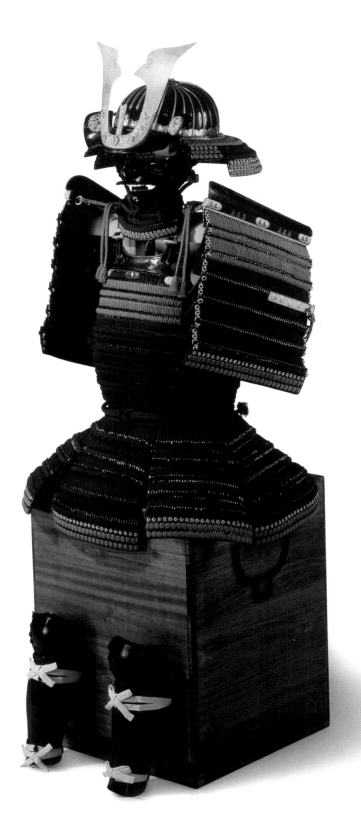

38. Armour by Iwai Yozaemon, *c.* **1610.**
In 1613 the East India Company's ship *The Clove*, captained by John Saris, became the first English ship to reach Japan. It carried a letter from the King to 'the highe and mightie Prince the Emperour', the start of a short period of contact between the English and Japanese courts. Saris returned in 1614 with gifts for James, which included folding screens and two suits of armour, of which this is one. James was intrigued by Japan, and sought information from the Company's officers about how the country was governed.
RCIN 71611

dancing in Ben Jonson's masque *Hymenaei*, performed in January 1606. In 1610 Henry was installed as Prince of Wales, which gave him financial and domestic independence. The two years that followed came to be looked back on as an unprecedented flowering of cultural patronage at the English court. In some ways this was unexpected, since, as he entered his teens, Henry seemed more interested in sport. He excelled in the stylised fights of the tilts and barriers: in 1606 the French ambassador described how he 'studies two hours a day, and employs the rest of his time in tossing the pike, or leaping, or shooting with the bow, or throwing the bar, or vaulting'. Henry also developed a passion for the courtly exercise of the *manège*, in which horses, in effect, dance on the orders of their riders. Taught to Henry by a Frenchman, M. de St Antoine, it was a skill that was regarded as distinctively royal because it symbolised the relationship between ruler and ruled.

The Prince's athletic prowess attracted gifts: for example, in 1608 Sir Henry Lee (1533–1611), who had been Queen's Champion and a favourite of Elizabeth I, gave him a splendid garniture for field, tilts and barriers made in the Greenwich armouries (fig.40). One courtier, John Chamberlain, thought it a waste of money to give such expensive armour to a boy who would soon grow out of it, commenting waspishly that Lee 'went to present the prince with an armour that stood him in £200 and within a yeare or two will serve his turne neither for jest nor earnest'. That is unlikely to have bothered Henry, who simply acquired more armour as he grew up. Around 1610 he was painted by Oliver in a masterly large miniature (13.2 cm tall) showing the prince wearing field armour, its black ground strikingly embellished with gilt bands of classical ornament (fig.41). In the background is a

39. *Nymphs and Satyrs* by Isaac Oliver, c.1605–10.
A child of Huguenot immigrant parents, Isaac Oliver was trained as a miniature painter by Nicholas Hilliard. It is not known who the patron was of a small number of ambitious drawings by Oliver in chalk, pen and ink, designed to be framed and hung, of which this is one. Unusual in its explicitly sensual nature, it may have been inspired by Italian prints, but its style reveals Oliver's knowledge of contemporary Netherlandish art. RCIN 913528

40. Armour of Henry, Prince of Wales by Jacob Halder, c.1608.
This armour was given to the 14-year-old prince by Sir Henry Lee, Master of the Armouries. Its first recorded use was in the 'barriers', a form of tournament, in the Banqueting House at Whitehall on Twelfth Night, 1610. It is lavishly etched with fleur-de-lis, roses and thistles as well as the Prince's monogram. Henry's fondness for the armour was remembered after his death, since he is shown wearing it in a posthumous portrait commissioned by Charles I from Van Dyck in about 1633.
RCIN 72831

41. *Henry Frederick, Prince of Wales* by Isaac Oliver, c.1610.

One of Oliver's most ambitious portraits, this miniature shows the Prince wearing a black and gilt armour of around 1580 together with the riband and badge of the Garter. In the background is a military encampment with artillery. This may reflect the courtly entertainments in which the Prince participated, as a classical hero or an Arthurian knight, but it may also evoke growing hopes that he would champion the Protestant cause in Europe.
RCIN 420058

military encampment. The portrait captivatingly evokes Henry's aspirations to be a warrior in both the chivalric and classical traditions.

According to one apocryphal story, when James berated his eldest son for not spending as much time at his books as his brother Charles, Henry is said to have replied 'we'll make him archbishop of Canterbury'. However, by the time he became Prince of Wales he had begun to demonstrate a strong interest in scholarship. In 1609 he acquired the most celebrated private library in England, formed by one of his tutors, the collector and bibliophile John Lumley (1533–1609). To this new enthusiasm for books, he soon added an acquisitive interest in coins, medals and gems. To accommodate his growing collection, he fitted out a new library at St James's Palace, which, with Richmond, had been allocated to him for his household. The work was supervised by Inigo Jones, whose appointment as Henry's surveyor was another link with Queen Anne's patronage, but the prince never

gave him a substantial commission, even when planning an elaborate water garden in the Italian style at Richmond. Instead, Henry recruited a Huguenot hydraulic engineer, Salomon de Caus (1576–1626) – who taught him the art of perspective – and a Florentine painter and architect, Costantini de' Servi (1544–1622), and Jones was sidelined.

This confident deployment of continental patronage may reflect the influence of courtiers in Henry's household with a interest in the visual arts. Among the most significant was Thomas Howard, Earl of Arundel (1585–1646), who was to become the outstanding English aristocratic collector of his generation and already had a high reputation for his knowledge of painting. Henry also employed people with a specialist knowledge of art, and in 1612 offered the post of keeper of his cabinet room to a Dutch artist, Abraham van der Doort (c.1575/80–1640), who had worked for a great collector, Emperor Rudolf II (1552–1612). Henry made improvements to the gallery at St James's, which became the setting for a substantial collection of paintings. His first recorded acquisition was in January 1610, when one of Arundel's servants was paid £2 for delivering 'a great picture to his highness'. A group of paintings, including works by Palma Giovane (1544–1628) and Tintoretto (c.1518–94), was bought for him in Venice in 1610 and he snapped up pictures from visiting Dutch dealers. Diplomats were quick to realise that Henry would be pleased with gifts of works of art, and in 1610 the States General of the new republic of Holland presented him with works 'painted on purpose to adorn one wall of his gallery'. In 1611 paintings were sent by Cosimo II, Grand Duke of Tuscany (1590–1621), following a request from the prince for portraits of famous Italians. The Grand Duke's representative in London, Ottaviano Lotti, sent back a description of Henry being shown the newly unpacked paintings: he was particularly impressed by a picture by the Mannerist Domenico Beccafumi (1486–1551), 'which he wanted to place in a particular room so that it could be seen to better effect … His Highness asked me several times about the decoration of their Highnesses galleries and if there were subject pictures and what kind of statues'.

There was more than diplomatic courtesy behind the gift. For some time there had been hopes at the Tuscan court that Cosimo's sister Caterina de' Medici might marry Henry despite the difference in religion. A second Medici gift – of 15 small bronze statues after models by the Medici court sculptor Giambologna (1529–1608) – was hurriedly assembled in Florence in December 1611 when it seemed at last that the marriage might go ahead. The sculptures arrived at Richmond on 28 June 1612, and were shown to the Prince in his gallery. Cosimo's representative, Andrea Cioli, wrote an account of what happened. The Prince was so delighted with them that he kissed the first one that he picked up. While he was lovingly examining them in detail, it was suggested that he might like to give a small bronze horse to his brother, Charles, to which he replied sharply, 'No, no, I want everything for myself.' After dinner, Cioli was told that the Prince had taken

the sculptures to one of his cabinet rooms, where he had arranged them with great care. Henry was so delighted with the gift that he asked if he might have more such bronzes, including 'a David by Michelangelo'.

When, barely four months later, the young Prince Charles was taken to his dying brother's bedside, he sought to comfort Henry by giving him to hold a bronze horse from the Florentine gift. Van der Doort must have heard this story from Charles. Many years later, when he catalogued the 'little horse' in his inventory of works of art at Whitehall he described it as the one 'which your Majesty did send for to Richmond in the last sickness time and there your Majesty gave it with your owne hands to the Prince'. A fine bronze of a pacing horse that is still in the Royal Collection may conceivably be this very sculpture (fig.42).

Charles, Prince of Wales

Henry's death transformed Charles's life. The 12-year-old was now the heir to the throne, although he had to wait four years to become Prince of Wales since his grief-stricken parents knew the ceremony would bring back painful memories of his brother. Conquering a stammer and a physical disability probably caused by childhood rickets, Charles sought to emulate his adored brother's prowess in the tiltyard, the *manège* and in courtly entertainments; Henry's interest in art was to be an even more significant influence.

As with his brother, the issue of who Charles would marry became a matter of long, drawn-out debate. In 1623, at the age of 22, Charles travelled incognito to Madrid with George Villiers, Earl (and later Duke) of

42. *Prancing Horse* attributed to Pietro Tacca, 1600.
Gifts sent to Prince Henry by Grand Duke Ferdinand I of Tuscany included 15 small bronzes that fulfilled a request by the Prince for sculptures by the Medici court sculptor Giambologna. This is thought to be the only survivor of the bronzes in the Royal Collection. Cast by one of the sculptor's former assistants, it derives from Giambologna's equestrian monument in Florence to Grand Duke Cosimo I (1599). RCIN 35467

Buckingham (1592–1628), to meet the Spanish Infanta, Maria, daughter of Philip III. Although the marriage negotiations were a failure, the six months that Charles and Buckingham spent in Spain had a deep influence on them both, since the royal palaces there contained the largest, and probably the finest, collection of paintings in Europe, celebrated, above all, for its canvases by the great Venetian artists, and in particular Titian. Charles sat for his portrait by Diego Velázquez (1599–1660) – tantalisingly, it has been lost – and returned home with some extraordinary gifts from the 18-year-old Philip IV (1605–65). These included a *Holy Family with Saint John the Baptist* by Correggio (1489–1534), and two masterpieces by Titian, *The Emperor Charles V with a Hound* and *Jupiter and Antiope*, usually known as the *Venus del Pardo*, after the Spanish palace in which it had hung. He was also given the only monumental marble sculpture by Giambologna outside Italy, *Samson Slaying a Philistine*, which he presented to Buckingham; now in the Victoria and Albert Museum, it is the only part of Philip IV's gift remaining in Britain. Charles also ordered copies to be made of paintings in Spanish collections and made important purchases in Spain, most entrancingly Titian's *Girl in a Fur* (1535), now one of the great treasures of the Kunsthistorisches Museum in Vienna. These Spanish acquisitions transformed the status of Charles's hitherto modest collection: in 1621 he had owned only 21 paintings.

While in Spain, Charles concluded one of the most celebrated acquisitions in the history of the Royal Collection, when he agreed to pay £300 for seven of the ten cartoons commissioned by Pope Leo X in 1515–17 from Raphael (1483–1520) and his workshop for tapestries for the Sistine Chapel (fig.43). Charles would have known what they looked like, since a set of the tapestries bought by Henry VIII were in the Royal Collection (see p.29). He was also aware of the artist's status – he later swapped his album of portrait drawings by Holbein for a small painting by Raphael, *St George and the Dragon* (1504–6), that belonged to the Earl of Pembroke. However, the cartoons were not acquired as works of art in their own right, and were never displayed as such in Charles's lifetime, because they had been cut into metre-wide strips for use by tapestry weavers on their looms. Charles's principal motive in buying them was to have them as models for tapestries to be made by workshops at Mortlake, near Richmond, founded in 1619 as one of the few artistic enterprises encouraged by his father, who had granted it a monopoly on tapestry production in England for 21 years. Designed to compete with the finest tapestries woven in Brussels and Paris, the workshops were set up by Sir Francis Crane (c.1579–1636), a courtier who had served successively on the councils of Prince Henry and Prince Charles. All the weavers were brought in from Flanders, and the workshop's principal designer was a German painter, Franz Klein (d.1658), known in England at Francis Cleyn, who had been employed by Christian IV in Copenhagen.

The Raphael cartoons were kept in storage at Whitehall and loaned to Mortlake when needed for copying by Cleyn (the originals did not go onto the looms). Their importance to the factory was emphasised by

Crane's unsuccessful attempts to buy two cartoons that had not formed part of Charles's purchase. Charles had a set of the tapestries woven at Mortlake, but only one, *The Blinding of Elymas the Sorcerer*, survives in the Royal Collection. The level of excellence that the workshops achieved is demonstrated by a partial set of *The Twelve Months*, ordered by Charles for £500 in 1623, probably for Hampton Court (fig.44). Since Crane's family did not wish to continue the business after his death, they were bought out by the Crown in 1638. Tapestry weaving continued at Mortlake until 1703, the only English enterprise that can be compared with the French royal manufactories, such as the tapestry works at Gobelins or the porcelain factory at Sèvres. The close interest that Charles took in the venture (in 1625 he promised it an annual subsidy of £2,000) is a reminder that despite the significance of the paintings he acquired, the dominant visual medium at court was still tapestry, just as it had been in medieval and Tudor times.

The Raphael cartoons had probably ended up in Genoa because of trading links between the city and Brussels, where they had been kept throughout the sixteenth century. While in Genoa they were copied in a series of

43. *The Miraculous Draft of Fishes* by Raphael and his Workshop, c.1515–16. This is one of seven full-scale drawings or cartoons in the Royal Collection from a set of ten made by Raphael and his workshop for tapestries for the Sistine Chapel. They depict the acts of St Peter and St Paul. RCIN 912944

44. 'January' from a set of 'The Twelve Months' tapestries woven at Mortlake, 1623.
A family warms themselves before a fire in this depiction of January from a set of Mortlake tapestry woven for Charles I when Prince of Wales. The figures are in sixteenth-century dress, as the design was based on a set of Flemish tapestries first woven in about 1535.
RCIN 64108

now lost paintings by Rubens. An early tradition that he recommended that Charles should buy the cartoons may well be true, since by 1623 Rubens had significant links with the English court. These are first documented in 1620, when Lady Arundel and members of her entourage had their portraits painted by Rubens while they were in Antwerp, en route for Italy. The initiative in acquiring a painting by Rubens for Prince Charles (who had by then inherited from his mother one or possibly two paintings by the artist) was taken by Henry Danvers, later Earl of Danby (1573–1643), a rich courtier who had earlier served Prince Henry. Using as his agent Sir Dudley Carleton, ambassador in The Hague, he bought from Rubens a painting of a lion, tiger and leopard hunt to give to the Prince. The crucial information that the painting was for Charles was not communicated to Rubens, since the canvas that he agreed to sell was largely by his studio. When it arrived in London, Danvers wrote in distress to Carleton that everyone agreed it had been 'scarce touched' by Rubens's hand, 'and the postures so forced, as the Prince will not admitt the picture into his Gallery'. Rubens, who had thought Carleton was buying the painting for 'a friend', was mortified, and agreed to paint another hunting picture 'entirely of my own hand'. This never materialised, almost certainly because Danvers finally grasped that Charles did not like such violent subject matter. The incident also reveals that the Prince had access to advisers who could immediately distinguish an autograph from a workshop painting.

In 1622 Danvers made up for his mistake by commissioning a self-portrait from Rubens to give to Charles, 'every part of it wrought with his owne hand', in Danvers's words (fig.45). Rubens was flattered by the request, writing afterwards to a friend, 'it did not seem fitting to send my portrait to a prince of such high rank, but he overcame my modesty'. Originally hung at St James's Palace, it was moved after Charles's accession to Whitehall, and hung in a place of honour with a group of portraits of artists in the 'Little Bi-Room between the King's Withdrawing Room (also called the Breakfast Chamber) and the Long Gallery'. Writing to Charles at the time the painting was delivered, Rubens remarked that, 'I confess myself to be, by a natural instinct, better fitted to execute works of the largest size rather than little curiosities. Everyone according to his own gifts.' He no doubt hoped to encourage the idea, first mooted at about this time, that he should provide paintings for the ceiling of the Banqueting House. Rubens's hope that Charles would offer bigger commissions accurately reflects the growing ambition of royal patronage in the first half of the 1620s as the Prince's reputation as a connoisseur began to spread throughout Europe. In January 1625, just three months before King James died, Rubens had written to a friend – and so with no intention of flattery – that 'the Prince of Wales has the greatest love of painting of any prince in the world', but even he might have been surprised if he could have foreseen with what brilliant success Charles would demonstrate that love once he was King.

45. *Self-Portrait* by Peter Paul Rubens, 1623. Commissioned as a gift for Prince Charles, this portrait does not proclaim Rubens's status as an artist, except in the most telling way, by being a masterly exercise in oil painting. Charles hung it in the 'Little Bi-Room between the King's Withdrawing Room (also called the Breakfast Chamber) and the Long Gallery' at Whitehall Palace.
RCIN 400156

Chapter 3

THE QUEST
FOR BEAUTY
Charles I and Henrietta Maria

Immediately after Charles's accession in 1625, his master of music, Nicholas Lanier, who was also a painter and a noted expert on art, visited the court of Ferdinand Gonzaga, Duke of Mantua. He brought a letter of introduction from Daniel Nijs, a Flemish merchant, art collector and dealer based in Venice, who had long experience in helping the English buy works of art in Italy. As Nijs wrote in his letter, Lanier 'travels under pretence of attending the Holy Year in Rome in order to buy pictures; he is greatly favoured by the King'. Built up by the Gonzagas over nearly two centuries, and in particular by the Marchesa of Mantua, Isabella d'Este, and her son, Federico Gonzaga, first Duke of Mantua, the family's collection was very famous. It encompassed works by successive court artists, Andrea Mantegna (1431–1506), Lorenzo Costa (1460–1535), Giulio Romano (1499–1546) and Domenico Fetti (1589–1623), antique sculptures and modern bronzes, and nearly 2,000 paintings that included masterpieces by many of the leading artists of sixteenth-century Italy, notably Titian, of whose works the Gonzagas had assembled the largest collection in Italy. Charles could have learned about these treasures from many sources in England, including Rubens, who had worked for the dukes of Mantua between 1600 and 1608, and Inigo Jones, who visited the city during a tour of Italy with Lord and Lady Arundel in 1613–14.

Lanier returned from his visit to Mantua, in Nijs's words, 'in estasi'. It was almost certainly now that a plan was conceived, as Nijs was later to recall, 'to induce the Duke Ferdinand of Mantua to sell me his pictures, who bit at it'. After the matter had been discussed between Lanier and the King in London, and a budget agreed, Nijs made an approach to Ferdinand. Negotiations were interrupted by the Duke's death in October 1626 and the succession of his brother Vincenzo II Gonzaga, but – as he was no less strapped for money – the sale of a large group of paintings eventually went ahead for 68,000 *scudi*, or about £15,000. At a stroke, Charles had acquired a collection worthy to be ranked with those of almost any European monarch. This was a tremendous coup, and when news eventually leaked out about the purchase it aroused bitter anger in Mantua as well as jealousy amongst the King's rival collectors in the courts of Europe.

The paintings were sent in secret to Nijs's warehouse on Murano for onward shipment to England early in 1628. He decided to send some of

46. *The Triumph of Caesar: The Elephants* by Andrea Mantegna, c.1484–92. One of the most famous treasures of the Gonzaga collection bought by Charles I in 1627–9 was a sequence of nine canvases depicting a triumph of Julius Caesar painted by Mantegna, who had worked for the court in Mantua from 1460 until his death. As the subject encompasses a great variety of figures and objects – soldiers, standard-bearers, musicians and spoils of war, including weapons, sculpture, gold vases and exotic animals – Mantegna was able to demonstrate his archaeological knowledge of Roman life. This is the fifth canvas in the sequence, and one of the best preserved. RCIN 403962

the paintings, notably those by Correggio, overland to London, since he was concerned that 'they would not have brooked the sea'. This proved to be a wise precaution, since the shipment of paintings was damaged as a result of a storm that caused another part of the cargo, containing mercury, to spill. When the paintings were unpacked in London several had turned black and had to be restored by removing their varnish. It is not clear why some paintings suffered more than others; one that was recorded as having been blackened, *Allegory of Charity and Justice Reconciled* by Giovanni Baglione (1566–1643), which is still in the Royal Collection, was successfully restored, but four of the Titian emperors were regarded as too badly affected to be hung, and one was 'utterlie spoyled' (Van Dyck later painted a replacement). Nonetheless, the accident did not seriously reduce the impact of this astonishing shipment, which contained also Mantegna's *Lamentation of Christ* and *Death of the Virgin*, a *Holy Family* by Raphael and Giulio Romano (known as 'La Perla' after a subsequent owner, Philip IV of Spain, declared it the pearl of his collection), Titian's *The Entombment of Christ*, *Venus and the Lute Player* and *Supper at Emmaus* and groups of paintings by Giulio Romano and Dosso Dossi. There were also works by modern artists, notably *Death of the Virgin* by Caravaggio (1571–1610).

More was yet to come. The purchase had not included some of the most famous elements of the Gonzaga collections, the classical sculptures, the

sixteenth-century bronzes by Antico (1460–1528) and other artists, and Mantegna's sequence of nine paintings depicting a triumph of Julius Caesar (fig.46). These enormous canvases were regarded as one of the most richly detailed and accurate evocations of the ancient world achieved in modern times, and, virtually uniquely for fifteenth-century paintings, had retained their fame into the seventeenth century. Even the cash-hungry Vincenzo II Gonzaga had baulked at selling such a famous ornament of his family, but he died in 1627 and was succeeded by a cousin with less family pride. Nijs seized his chance, and in 1629 struck a deal to buy the sculptures and Mantegnas for £10,500, writing to London that 'the best informed persons told me that I had left the most beautiful behind, and that, not having the Triumph of Caesar I had nothing at all; this touched me to the core'. The final shipment reached London in 1632. Almost everything that had been left behind in Mantua was looted or destroyed by German troops when they sacked the city in 1630 and 1631.

Charles gave great thought to displaying the paintings. Between 1631 and 1636 the King's Serjeant Painter, John de Critz (1551–1642), was paid for making or decorating carved and gilt frames, a new fashion in England, where plain frames, painted or stained brown or black, had until then been the norm (sadly, it is not certain whether any of Charles's frames survive in the Royal Collection). The remaining Titian Caesars were hung in the gallery at St James's Palace, together with a group of paintings of emperors by Giulio Romano's workshop that had been painted to accompany them in the Ducal Palace in Mantua. Most of the other Titians and the Correggios

47. *The Muses* by Jacopo Tintoretto, 1578.
Tintoretto's virtuosic depiction of female nudes from so many different angles reflects the painter's use of small clay or wax models from which he could study poses. He suspended some models in the air, as may be demonstrated here by the swooping figure at top left.
RCIN 405476

were hung in Charles's privy chambers at Whitehall. Mantegna's *Death of the Virgin* was placed in his Cabinet Room there, with other especially precious paintings, including Raphael's *St George and the Dragon* and Leonardo da Vinci's *St John the Baptist*, which Charles had obtained from a collection in France in exchange for paintings by Titian and Holbein. Mantegna's *The Triumph of Caesar* was probably sent at once to one of the few palaces with space to accommodate it, Hampton Court, where it remains today, the most significant survivor of the Gonzaga purchase in the Royal Collection. Many of the most famous works, by Raphael, Titan and Correggio, left the country during the Commonwealth. However, a number of outstanding paintings from Mantua remain in the Royal Collection, including the Giulio Romano emperors and works by Dosso Dossi (*c*.1490–1542), Girolamo Savoldo (*c*.1480–*c*.1548) and Agnolo Bronzino (1503–72), as well as two magnificent survivors of the incomparable group of Venetian paintings, Tintoretto's *The Muses* (fig.47) and *Esther before Ahasuerus*.

The Gonzagas' collection of classical sculpture, which was regarded at the time as equal in quality to the family's paintings, has now largely been forgotten, principally because it has proved almost impossible to identify surviving pieces. However, perhaps because most of the sculptures were placed in the royal gardens, and were therefore more publicly visible than Charles's most important paintings, they were widely praised at the time. In 1634 Henry Peacham, one of the first English writers on art to discuss the collecting of antiquities, wrote that Charles had demonstrated 'a Royall liking of ancient statues, by causing a whole army of old forraine Emperours, Captaines, and Senatours all at once to land on his coasts, to come and doe him homage, and attend him in his palaces of St James, and Somerset-house'. Among the very few survivors of the Gonzagas's classical sculptures in the Royal Collection today is a second-century AD Roman version of a well-known Hellenistic sculpture, *Crouching Venus* (fig.48). There is no evidence that it had been especially valued in Mantua, but in England it was much admired, perhaps because of the praise lavished on it by Nijs, who claimed that it represented Helen of Troy. Charles hoped to supplement the Gonzaga sculpture with further purchases in Italy, but unsuccessful attempts to buy famous statues in Rome made him realise that he would have to settle for casts, beginning with his acquisition in Rome of moulds of the *Borghese Gladiator*. He had it cast in bronze in London in 1629–30 by the Paris-born sculptor and bronze-founder Hubert Le Sueur (*c*.1580–1658), who had

48. *Aphrodite (Venus)*, second century AD. Among the few survivors in the Royal Collection of an extensive group of Roman statues from Mantua is this Roman copy of a Hellenistic original. Its complex pose appealed to artists: the statue was particularly admired by Rubens, and after the execution of Charles I, it was sold to the painter Peter Lely, who returned it to the Royal Collection at the Restoration. RCIN 69746

49. *Boy with a Thorn in his Foot* cast by Hubert Le Sueur, 1636–7.
Le Sueur was sent by Charles to Italy in 1631 to bring 'from thence the moulds and patterns of certain figures and antiques there'. Among them is this copy of a celebrated Roman bronze, the 'Spinario', cast in bronze from a marble statue made by Agasias around 100 BC, in the Palazzo dei Conservatori in Rome. This statue was installed in Henrietta Maria's garden at Denmark House.
RCIN 26319

moved to England in 1625. This was such a success that Charles sent Le Sueur to Italy to make moulds of other sculptures, of which casts survive at Hampton Court and Windsor Castle (fig.49).

Among the sculptures acquired by Charles from Mantua was a work that has become far more famous than any of his classical works, although it has vanished. Since Nijs bought the sculptures from the Gonzagas without direct authority from Charles, he sent drawings of them to London to encourage the King in the purchase. Among these sketches, in the Royal Library, is a sheet depicting three sculptures of sleeping Cupids, described by Nijs as 'above price, and ... the rarest things which the Duke possessed' (fig.50). One was an ancient work optimistically attributed to Praxiteles in the fourth century BC, another was by the Venetian sculptor Jacopo Sansovino (1486–1570), and the third may have been the celebrated *Cupid* carved by the 20-year-old Michelangelo in 1495, which was passed off at the time as an antiquity. After the truth had been revealed, it was acquired in 1502 by Isabella d'Este, who wrote that 'for a modern piece it has no equal'. The cupids were displayed by Charles at St James's Palace, although puzzlingly there is no contemporary reference to him owning a sculpture by Michelangelo, suggesting that the Cupid was never identified as such after its arrival in London. All these sculptures disappear from history after the Commonwealth sale, and it is assumed that they were destroyed in the fire at Whitehall Palace in 1698.

Cupido
che dorme
n.º 39 piedi 2

Cup
che
n.º 2

50. *Four Antique Statues*,
c.1629.
Among the sculptures
bought from the Gonzagas
was a Cupid carved in
marble by the 20-year-old
Michelangelo that was
almost certainly destroyed
by the fire at Whitehall
Palace in 1698. It may be
the sculpture top right,
numbered '28', in this
sheet of drawings sent to
Charles from Italy to show
him what he was buying.
RCIN 908914

Henrietta Maria

In 1625, following the collapse of the negotiations for a Spanish match, and shortly after his father's death, Charles married the 15-year-old French princess Henrietta Maria, the youngest daughter of Henri IV of France and Marie de' Medici. It was unprecedented for a Catholic princess to marry a Protestant monarch, and so the marriage settlement included concessions that Henrietta Maria would be able to practise her religion, with Catholic chapels in every English palace. She was responsible for a strong move at court towards French fashions in not only clothes and jewellery (a new,

refined reticence replaced the conspicuous display of James's reign) but also in interior decoration, thanks to the energy she devoted to altering and redecorating her houses, in particular Greenwich and Denmark House. Gardens were a particular interest and she imported not only French plants and fruit trees but also French gardeners, who carried out major schemes for her and Charles at Denmark House and St James's Palace. At St James's, the garden made an appropriate setting for some of the Mantua sculptures and at Denmark House the Queen commissioned two fountains from her countryman Hubert Le Sueur. She picked up many of the threads of Queen Anne's patronage, including lavish masques and plays: a ravishing miniature

51. *Queen Henrietta Maria* by John Hoskins, *c*.1632. The Queen is in a costume that has been indentified as the blue star-spangled dress she wore for Aurelian Townshend's masque *Tempe Restored*, staged at the Banqueting House at Whitehall in 1632, with sets and costumes by Inigo Jones. She descended to the stage in a golden chariot to dance the role of 'Divine Beauty'. RCIN 420891

The Quest for Beauty

of her, painted by John Hoskins in about 1632, depicts her in masquing costume (fig. 51). She also followed Anne in her employment of Inigo Jones, who was commissioned to complete the Queen's House at Greenwich.

Jones also designed her chapels at St James's Palace, which survives, and Denmark House – the King, by contrast, showed little interest in architectural patronage. For Denmark House, the Queen commissioned a spectacular monstrance over the altar from the French sculptor François Dieussart (1600–61): 12 metres high, it depicted Christ surrounded by angels. The altarpiece itself was a very large *Crucifixion* by Rubens, a gift from Charles to his wife. Henrietta Maria's involvement in the patronage of artists became more marked after the assassination in 1628 of the Duke of Buckingham. As Charles's closest friend, and companion on his adventure in Madrid, he had been a significant influence on the development of the King's artistic interests – among his major commissions, for example, had been an equestrian portrait of himself by Rubens. The gap left by Buckingham as a fellow admirer of the arts was filled by the Queen, to whom – after a rather rocky start to the marriage – the King became devoted. The relationship was strengthened by the births of six surviving children, beginning with the future Charles II in 1630.

The usual assumption that the collection dispersed after Charles's death was entirely his creation neglects Henrietta Maria's involvement: it was described at the time as the 'goods and personal estate of the late King, Queen and Prince [of Wales]'. Although when the papal representative in London mentioned the possibility of a gift of paintings from Rome, the Queen wryly replied that 'she would not be able to keep them, as the King would steal them from her', her collections had an independent identity and by 1641 she was employing her own keeper for her paintings, the Dutch artist Daniel Soreau (d. 1643).

Importing artists

In a tradition that went back at least to Holbein's work for Henry VIII, Charles and Henrietta Maria attempted to attract leading European artists in all media to work at court. In sculpture Charles employed not only Le Sueur and Dieussart but also the Florentine-born Francesco Fanelli (*c*.1590–*c*.1653), who specialised in small bronzes, and the Frenchman Nicolas Briot (1579–1646), who worked as a medallist, designer of coinage and engraver of seals. He also employed a Swiss artist, Jean Petitot (1607–91), to paint miniatures on enamel, an innovatory technique brought to perfection at Charles's court. In addition, the King took into his service Christiaen van Vianen (*c*.1600–67), a member of the leading dynasty of Dutch goldsmiths, who in 1637 made a complete set of altar plate for the Garter services in St George's Chapel, Windsor. At Whitehall, paintings were juxtaposed with reliefs by, or after, Christiaen's uncle Paulus

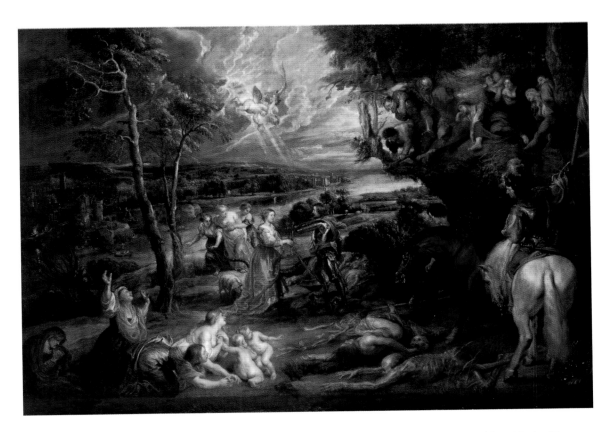

van Vianen, who had been Emperor Rudolf II's goldsmith in Prague: for example, a set of seven of his bronze reliefs of scenes from Ovid's *Metamorphoses* were in the Cabinet Room at Whitehall by 1637. A series – either this set or perhaps a copy – survives at Kingston Lacey. The altar plate lasted only five years before being melted down.

Although the number of foreign painters employed by Charles and Henrietta Maria is often held to reflect badly on the standard of English art at this time, almost all European courts imported painters, especially from the traditional centres of the Netherlands and Italy. Rubens is the best-known example – as well as his native Antwerp, he worked in Mantua, Genoa, Paris, Madrid and London – but many other artists were scarcely less peripatetic. Such willingness to move between courts helps to explain why artists sometimes also worked as diplomats. In 1625 the Duke of Buckingham drew Rubens into the negotiations to end the war between Spain and England that had followed the failure of Charles's proposed marriage to the Infanta. After Buckingham's assassination in 1628, Rubens visited London to negotiate the exchange of ambassadors with Madrid, and he stayed for nine months. His letters reveal that he was greatly impressed by the royal and aristocratic collections he saw in London.

As a parting gift for the King, Rubens painted his allegory *Minerva Protects Pax from Mars (Peace and War)*, now in the National Gallery, London,

The Quest for Beauty

which expresses his aspirations for harmony between Spain and England. For himself, as a 'monument to his abode & employment' in England, he painted the *Landscape with St George and the Dragon* (fig. 52). While he was in London, the decade-old idea that Rubens might provide paintings for the ceiling of the Banqueting House in Whitehall was revived (fig. 53). By the time he left London in March 1630, having received a knighthood, he had probably produced a sketch for Charles's approval, based on a programme supplied to him. The nine canvases, which cost £3,000, were shipped to England in 1635. A glorification of the reign of James I, they celebrate the King's achievements in bringing peace to his kingdom and uniting the crowns of Scotland and England (fig. 54). The only decorative paintings by Rubens to remain in their original setting, these sumptuous canvases are one of the climaxes of royal patronage in England.

There was never any likelihood that Rubens would stay permanently in London, but Charles did his best to attract other artists of international reputation to his court. His brother Henry had offered a post in his household to the Dutch painter Michiel van Mierevelt (1567–1641), who showed no enthusiasm for abandoning his lucrative portrait practice in Delft. Similarly, the Bolognese painter Guercino (1591–1666) declined an invitation from Charles, commenting privately that he didn't like what he had heard of the English climate, and in any case he wasn't prepared to work for heretics. The Duke of Buckingham had more success with the Dutchman Gerrit van Honthorst (1592–1656) and the Florentine Orazio Gentileschi (1563–1639), both of whom had worked in Rome, where they had in different ways been influenced by Caravaggio. Honthorst spent most of 1628 in London, where he painted a large allegory of the Duke of Buckingham as

53. The Banqueting House, Whitehall.
Completed in 1622, the Banqueting House was both Inigo Jones's most important royal commission and the building that definitively established a British tradition of classical architecture on modern Italian models. It was intended for court ceremonies and entertainments. After Rubens's paintings were installed on the ceiling in 1635, masques were no longer staged here for fear that smoke from torches would damage them. When the room was in use, tapestries were hung from the galleries.

54. *The Union of the Crowns of England and Scotland* by Peter Paul Rubens, 1632–4.
Rubens's ceiling paintings for the Banqueting House are a glorification of the reign of James I & VI. This panel represents one of the major achievements of his reign: James leans forward from his throne to bless a new-born child who symbolises a new entity, 'Great Britain', above whose head Minerva holds the twin crowns.
RCIN 408417

55. *George Villiers,
1st Duke of Buckingham
and his Family* by Gerrit
van Honthorst, c.1628.
Buckingham formed a
close friendship with
Charles when they
travelled together to
Madrid in 1623. He was
also a friend of Rubens,
who may have recom-
mended that Gerrit van
Honthorst should be
invited from Utrecht to
London, where he painted
this family portrait. In
August 1628 Buckingham
was assassinated, having
been blamed for military
failings in the early part
of Charles's reign.
RCIN 406553

Mercury presenting the Muses to Apollo and Diana in the form of Charles and Henrietta Maria. Charles offered Honthorst a pension, but the artist returned to his native Utrecht immediately after Buckingham's assassination. Soon after his friend's death Charles obtained Honthorst's portrait of the Duke and his family, probably painted in London, which he hung in his bedroom at Whitehall (fig.55).

Although he talked about returning one day to his native Tuscany, and resented being overshadowed by first Rubens and then Van Dyck, Orazio Gentileschi remained in London from 1626 until his death in 1639. After Buckingham's death his principal patron was Henrietta Maria, for whose mother, Marie de' Medici, he had worked in Paris in 1626–8. He was the dominant artistic presence in the Queen's House at Greenwich, for which he painted a cycle of canvases, *An Allegory of Peace and the Arts* (c.1635–8), for the ceiling of the Great Hall (now at Marlborough House). The Queen also hung at Greenwich three large paintings by him on Old Testament subjects, of which *Joseph and Potiphar's Wife* remains in the Royal Collection (fig.56). It embodies Gentileschi's limpid style, in which clarity of narrative is united with rich colour and sensuous attention to texture. In 1638 the King invited Gentileschi's daughter Artemisia (1593–1652), a celebrated painter in her own right, to come to London. After Orazio's death (he was given the great honour of burial below the altar in the chapel in Denmark House) Artemisia

stayed on in London until about 1641. Charles owned eight paintings by her, of which the only definite survivor in the Royal Collection is her startlingly original *Allegory of Painting* (fig. 57), which she probably painted in England.

Van Dyck

Among the artists attracted to England by the efflorescence of royal and aristocratic artistic patronage was a Dutchman, Daniel Mytens (*c.*1590–1647). He is first recorded in London in 1618, when he had already been working for some time for the Earl and Countess of Arundel. He was influenced by Van Mierevelt, whose pupil he may have been, and was related to the royal portrait painter Paul van Somer, so was perfectly qualified to appeal to English taste. Almost as soon as he moved to London he was confronted by a formidable rival, a Flemish pupil of Rubens, Anthony van Dyck (1599–1641), whose talent had also been spotted by the Arundels. In 1620 Van Dyck travelled to London, where he painted works for the Duke of Buckingham and Earl of Arundel, and was paid £100 by James I for an unexplained 'speciall service'. The sight of Italian works of art in Arundel's collection seems to have persuaded him in 1621 that he must travel to Italy, and he did not to return to London for 12 years. This left the field clear for Mytens whose elegant, but highly naturalistic, style based on fine draughtsmanship and a delicate sense of colour dominated English royal portraiture for the next decade. In 1624 James I granted him an annual pension of

£50 – in effect, a retainer – in return for an undertaking that he would not leave the country. Mytens continued in royal service after Charles's accession, and produced a great number of portraits of the King and Queen. Charles's high estimation of him is revealed by the placing of a self-portrait of Mytens alongside portraits of Van Dyck and Rubens at Whitehall.

In 1632 Van Dyck returned, was appointed 'principall Painter in Ordinary to their Majesties', and was knighted. The following year he was awarded an annual pension of £200, far more than any other artist in Charles's service apart from the medallist Nicolas Briot. In addition, he was given a house on the river at Blackfriars, providing easy access to the principal London palaces. His collection of paintings by Titian and other masters became famous, and in 1635 a landing stage was constructed so that the King could visit 'to see his Paintings in the months of June and July'. Apart from a year back in Antwerp in 1634–5, he was based in London until his death in 1641, the year after he had married an Englishwoman, Mary Ruthven, a lady-in-waiting to the Queen.

From the moment that Van Dyck returned, bearing gifts of paintings for the King, Mytens must have realised that his days as the leading court painter were numbered, but the point was brought home to him in a humiliating way. In 1632 he was commissioned to paint a double portrait of the King and Queen, but by the time it was completed Henrietta Maria had seen Van Dyck's infinitely more flattering portrait of her, and so the head painted by Mytens was replaced with a copy of Van Dyck's (fig. 58). That proved insufficient, however, and the painting was discarded in favour of one by Van Dyck. By 1634 Mytens had returned to the Netherlands for good. He

58. *Charles I and Henrietta Maria* by Daniel Mytens, c.1630–32.
Then the leading artist at court, Mytens depicts the Queen handing Charles a laurel wreath, a symbol of their marriage. Innovatory in its conception, it is also unusual in its long oblong format, suggesting that it was to be placed over a chimney-piece at the Queen's London palace, Denmark House. The head of the Queen was repainted to imitate a portrait of her by Van Dyck, foretelling the way that he was to replace Mytens.
RCIN 405789

could not compete with the extraordinary talents that Van Dyck had developed in Rubens's studio and refined in Italy: an ability to convey movement, and a magically fluent handling of paint, as effortless in the evocation of flesh as in the depiction of luxurious fabrics. To these skills Van Dyck allied an ability to convey a sitter's personality with both vivid immediacy and enticing glamour. The result was a sequence of portraits that have fixed for ever in the public mind an image of the court of Charles I; the history of art can offer few other examples of such a perfect identification between sitter and artist.

Van Dyck began his work at court with a portrait of Charles and Henrietta Maria with their two eldest children. By virtue of its size – in its frame it is almost three and a half metres tall – and prominent setting in the Long Gallery at Whitehall by the entrance to the King's privy chambers, it was known as the 'Great Peece' (fig. 59). In conception, the painting looks back to representations of the Tudor dynasty, notably Holbein's Whitehall mural (see fig. 18), and it incorporates symbols of kingship, ranging from the regalia

59. *Charles I and Henrietta Maria with their two eldest children, Prince Charles and Princess Mary* by Anthony van Dyck, 1631–2. This was Van Dyck's first royal commission following his appointment as Charles I's court painter in 1631. Although an official work on a heroic scale, it is intimate in impact, a depiction of a loving and united family. In the background is a view of the Thames and Westminster, with Parliament House and Westminster Hall both visible. RCIN 405353

The Quest for Beauty

to the column that rises behind Charles. However, it breaks with the traditions of royal portraiture by introducing notes of informality: the Queen holds Princess Mary on her lap, while looking up at her husband, the infant Prince Charles holds onto his father's knee and two small dogs play at their feet. For the first time in England, a portrait was being used to express the concept of a royal family as much as a royal dynasty. The view of Parliament House in the background makes clear the political implications: the King is father of his people, and so should be honoured and obeyed. Van Dyck's reformulation of tradition in this painting had long-lasting consequences: its effects were felt, for example, in portraits in the Royal Collection of the Hanoverians by George Knapton and Johan Zoffany, and the 'Great Peece' continued as a model in the minds of artists into the twentieth century.

In 1633 Van Dyck followed this work with a painting on an equivalent scale that presents Charles I even more emphatically as an embodiment of kingship (fig.60). *Charles I with M. de St Antoine* depicts the King on horseback with his riding master. A rider's control of a horse symbolised the authority of a prince over his people, a tradition that went back to Roman times, and had been revived in painting in the sixteenth century. By portraying the King riding through an arch, Van Dyck evokes the triumphal arches of Rome; the prominent keystone denotes the King's position in the structure of his kingdom. The painting was placed on the end wall of the gallery at St James's Palace, where the paintings of Roman emperors by Titian and Giulio Romano brought from Mantua were hung. The illusionistic sense of the King riding towards the spectator must have provoked a frisson like that of Holbein's mural of Henry VIII at Whitehall. By now Van Dyck had all but a monopoly of royal portraits; in 1633, for example, he was paid £444 for 'nine pictures of our Royall self and most dearest Consort the Queene'. Because of the exceptional quality of his work, it is easy to read Van Dyck's portraits of Charles as embodiments of an exceptional belief in the divine right of kings. However, Charles's ideas about kingship were not unusual. All his predecessors had believed in their divine right to rule, and it took two revolutions in seventeenth-century England to provide any sustained challenge to the idea.

In addition, although he is not remembered for a sense of humour, Charles was not beyond subverting the image of regality that Van Dyck so effortlessly projected. When in 1637 Van Dyck delivered his much admired portrait of the royal children, *The Five Eldest Children of Charles I* (fig.61), Charles placed it in his Breakfast Chamber, where it was framed to hang as a pair with one of his Mantua purchases, Giulio Romano's *A Mermaid Feeding her Young*, in which a mermaid feeds her seven mer-children from her five breasts (fig.62). The juxtaposition was probably intended humorously to evoke the moral of the Aesop fable 'The Eagle and the Owl', that everybody thinks their offspring beautiful, but it may also have been an amused reflection by the King and Queen on the cost of their increasingly large family. The Giulio Romano is not the sort of painting that appeals much to

60. *Charles I with M. de St Antoine* by Anthony van Dyck, 1633.

This enormous painting – it is 3.7 metres high – was hung at one end of the gallery at St James's Palace, where it must have seemed to spectators that the King was riding into the room. M. de St Antoine was the riding master who had been sent to Charles's brother, Henry, in 1603 by Henri IV of France. He taught both Henry and Charles the skill of managing horses in the complex movements of the *manège*.
RCIN 405322

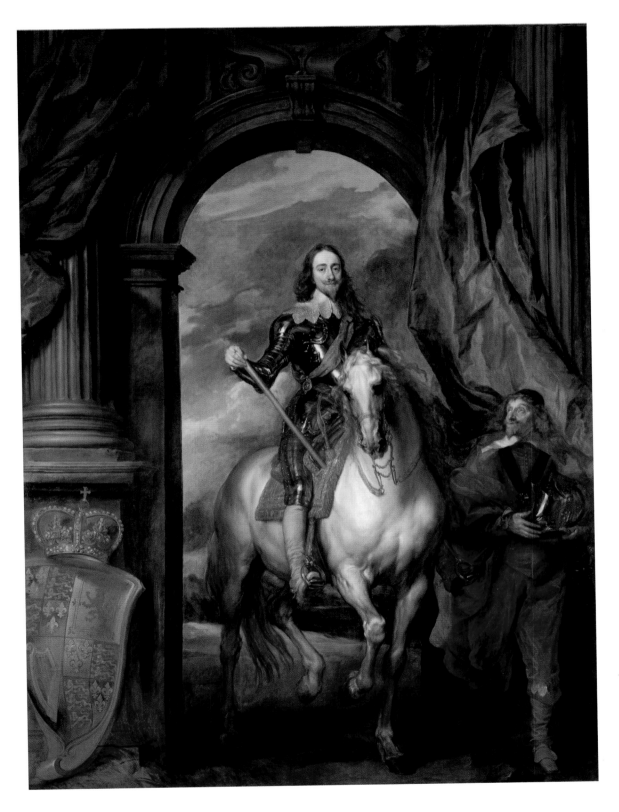

The Quest for Beauty

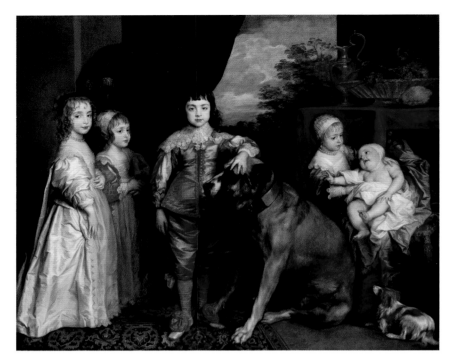

61. *The Five Eldest Children of Charles I* by Anthony van Dyck, 1637. The future Charles II's hand rests on a large mastiff, symbol of his authority. With him are, left to right, Princess Mary, future mother of William III; Prince James, the future James II, not yet breeched; Princess Elizabeth, who died in parliamentary captivity in 1650; and the short-lived Princess Anne.
RCIN 404405

62. *A Mermaid Feeding her Young* by the Workshop of Giulio Romano, *c.*1520–40.
Among the many paintings by, or after, Giulio Romano acquired with the Gonzaga collections is this extraordinary depiction of a five-breasted mermaid suckling her young. The King hung it in his Breakfast Chamber at Whitehall as a pair (in matching frames) with Van Dyck's portrait of his five children.
RCIN 402918

contemporary taste, and its pairing with the Van Dyck portrait is, therefore, a useful reminder that modern ideas of 'connoisseurship' are inadequate for understanding what Charles's collection meant to him.

He did, of course, appreciate works of art for their aesthetic merits, although the concept of beauty may to him have had an intellectual, and even philosophical, significance less obvious today. Few paintings of its time – or any time – are more lyrically beautiful than the sole known mythological canvas painted for Charles and Henrietta Maria by Van Dyck, the delicately seductive *Cupid and Psyche* (fig.63). Cupid has come upon Psyche (almost certainly modelled on Van Dyck's mistress, Margaret Lemon), who is under a spell placed on her by Venus so that she sleeps as though dead; he will rouse her by pricking her with one of his darts, and take her to Olympus, where they will be married. The story embodies the Platonic concept that desire for beauty awakens love, which achieves fulfilment in God, an idea familiar from the poetry, masques and pastoral plays enjoyed at court. The painting may have been made specifically for Henrietta Maria if it can be indentified with the 'pièce pour la maison a Grunwitz' (Greenwich) for which Van Dyck invoiced the King in 1638.

63. *Cupid and Psyche*
by Anthony van Dyck,
1639–40.
Given Charles's great admiration of Venetian painting, it is surprising that he owned only this one mythological painting by Van Dyck, since it is clearly inspired by Titian. It may in fact have been intended for Henrietta Maria. Cupid alights on the earth ready to awaken the sleeping Psyche. The contrast between her slumbering form and Cupid's fiery energy is emphasised by the juxtaposition of the trees in the background, one bare and the other bursting with leaf.
RCIN 405571

Cataloguing the collection

Charles worked hard at being king and had a bureaucrat's liking for tidiness and order. Although this was to prove a fateful weakness when dealing with religious and political divisions, it served him well at court, where he imposed the formality and ceremony that he had admired in the palaces of Madrid. It also helps to explain his concern that his collections should be catalogued, which has left a legacy of documents that have greatly enlarged our knowledge of the works he owned and the way they were displayed.

Most of this work was carried out by Abraham van der Doort, who had been invited to be keeper of Prince Henry's collection. After the Prince's death he had been employed by James to make boxes and cases for portraits, among other tasks, and he established a relationship with Charles through gifts, including a volume of the woodcuts made for *Four Books on Human Proportion* by Albrecht Dürer (1471–1528). On his accession, Charles appointed Van der Doort keeper of his cabinet rooms, first at St James's Palace and then at Whitehall. These were the rooms in which the King kept most of his small objects, including miniatures and bronzes. The appointment was designed to make the best use of Van der Doort's specialised knowledge of coins and medals – he was to become one of the most prolific designers of coinage during Charles's reign. He was also given responsibility for the general upkeep of the King's collections and maintaining a register recording movements or loans of works. As an anecdote reveals, he soon discovered that the task of keeping track of the collection was not always helped by his master. One day Charles and Van der Doort went into one of the cabinet rooms at Whitehall, the Chair Room, where the King saw some gold medals lying on a table. When he asked, 'Look, Abraham how comes these here?', Van der Doort could only say, 'I see by this that there is more keys than one which your Majesty hath given to me', to which the King replied, 'Yes, I have one.'

In 1637 Van der Doort embarked on an inventory of the collections, written in a version of English that preserves the sound of his Dutch accent – 'itm a siting schliping kupid wit wings and a bow in his lifft hant' is one memorable example. By 1640 the catalogue had described only the collections at Whitehall in full, although there are also summary lists for Greenwich, Nonsuch and St James's Palace (perhaps not all executed by Van der Doort or his scribes). Van der Doort records provenances – each Gonzaga item is listed as 'a Mantua peece' – and he is judicious in his attributions. Of one painting, for example, he writes that it 'is said to be done by Correggio & by Some esteemed to be a very good old coppie'.

Van der Doort's work confirms that Italian art was central to the collection. As well as the celebrated Titians, of which only two minor examples attributed to the painter remain in the collection, Charles owned, for example, at least nine paintings by Correggio (fig.64) and no fewer than

64. *The Holy Family with St Jerome* by Correggio, c.1519. Charles's admiration for Correggio led him to own the largest group of his paintings outside Italy, ranging from erotic mythologies to small devotional works such as this tender altarpiece, painted shortly after the artist had settled in Parma. It was hung by the King at Greenwich Palace. RCIN 400029

The Quest for Beauty

24 by the Venetian Jacopo Bassano (*c.*1517–92; fig.65). The catalogue's notes on provenance support the view that Charles pursued early northern painting less keenly. When, for example, in 1635 the States General of the Netherlands presented him with two major fifteenth-century panel paintings by Geertgen tot Sint Jans (*c.*1465–95) he immediately gave them away. Two of his three paintings by Dürer – *Self-Portrait* (1500) and *Portrait of the Artist's Father* (1497) – were not purchases but were given to him by the city authorities in Nuremberg in 1636. Although the paintings had a prominent place in the Chair Room at Whitehall, it may be fitting that the one Dürer owned by Charles I to survive in the Royal Collection, the portrait of Burkhard of Speyer, is Italian in feel (fig.66). The same is true of many of the modern Dutch paintings Charles bought by such artists as Cornelis van Poelenburgh (1594–1667) and Hendrick ter Brugghen (1588–1629). However, Charles's most significant contemporary Dutch paintings were gifts. They included three paintings by, or attributed to, Rembrandt that were given to the King by his Keeper of the Privy Purse, Sir Robert Kerr, who had accompanied him to Madrid. Among them was a self-portrait (now in the Walker Art Gallery, Liverpool) and *An Old Woman Called 'The Artist's Mother'* (fig.67).

The inventory confirms that the King did not own many drawings, but that is not unexpected, since serious collectors of drawings – of whom Arundel was one – were then so few. It is more surprising, especially given

65. *The Adoration of the Shepherds* by Jacopo Bassano, *c.*1546.
The pastoral landscape is the artist's native Bassano, near Vicenza, from which he took his name.
RCIN 405772

66. *Burkhard of Speyer* by Albrecht Dürer, 1506.
This is one of the portraits of the German community in Venice painted by Dürer when he lived in the city from 1505 to 1507. Although it is influenced by Bellini, Dürer has used a German technique of painting on a reddish-brown under-layer, which led Van der Doort to describe the painting in his inventory of Charles's collection as a 'red faced mans picture'.
RCIN 404418

Van der Doort's expertise in the field, that Charles showed little interest in collecting gems, and never employed a hard-stone cutter.

Van der Doort's work for the King ended tragically. He was prone to neurotic worry, in particular about the apparent disappearance of agates and other gems that had been in Prince Henry's collection, where his investigations were hampered by his difficulties in getting access to private rooms at court. In fact, there had simply been a delay in transferring the gems to Whitehall, but that anxiety was followed by a crisis in which Van der Doort discovered that one of the miniatures in the cabinet rooms was missing – ironically, it was a copy of a painting described as *The Parable of the Lost Sheep*. In despair at being unable to track it down, on 23 June 1640 he hanged himself. The miniature was found by his executors, and Van der Doort was mocked in cruel poems by courtiers amused by the irony of the manner in which the man responsible for hanging pictures had taken his life.

Thanks to Van der Doort's inventory, it is possible to work out where most of the works of art at Whitehall Palace were displayed. Although many of those that are now well known were on display in the King's privy lodgings, and so accessible only to those who had business with him, or were in private spaces such as his bedroom and Breakfast Chamber, where they would have been seen only by his family and household, almost every visitor to the palace would have encountered an aspect of the collection. Yet there are no descriptions by contemporaries of the impact it made.

Art historians' appreciation of the collection's range and quality would have been shared at the time only by the King and Queen, a few aristocratic collectors and a handful of experts such as Inigo Jones and Van der Doort. The one major exception was foreign ambassadors. The immediate European interest in the news that the royal collections were to be sold following Charles's death in 1649 reveals that his acquisitions were appreciated abroad more than they were at home.

The King's bust

One advantage of Henrietta Maria's Catholicism and links with the papal court (Pope Urban VIII was her godfather) was that she provided a conduit for gifts from Rome that could not have been made directly to a Protestant monarch. Since Charles's own religious beliefs were opaque – he never brandished his faith in the way his brother had – there was hope in Italy that he might convert. For that reason, Cardinal Francesco Barberini, a nephew of Urban VIII and the official protector of the English nation, responded positively to a request from the Queen in 1635 that the leading sculptor in Rome, and chief architect of St Peter's Basilica, Gian Lorenzo Bernini (1598–1680), might carve a portrait bust of the King. The sculptor had already designed a reliquary for one of Henrietta Maria's chapels, but providing a drawing for someone else to execute was very different from

67. *An Old Woman, called 'The Artist's Mother'*, by Rembrandt van Rijn, *c*.1627–9. This was part of a gift to Charles of three paintings by, or attributed to, Rembrandt that are the earliest recorded works by him in an English collection. Rembrandt was in his very early twenties when he painted it. As much a study of old age as a portrait, it is typical of his meticulously detailed and strikingly lit studies of human character that were so eagerly sought after by collectors. RCIN 405000

carving a bust, especially as it would be the first such portrait Bernini had executed for a sitter outside Rome.

In March 1636 Charles wrote in the most flattering terms to Bernini, enclosing the model from which he was to work, Van Dyck's celebrated triple portrait of the King (fig.68). Perhaps inspired by a painting in Charles's collection, *Portrait of a Man in Three Positions* by Lorenzo Lotto (*c.*1480–1556/7), then thought to be by Titian, Van Dyck transformed a utilitarian commission into a dazzling masterpiece. When the bust was delivered to Oatlands in July 1637 it was received with rapture. The Queen sent Bernini a diamond worth £800 and sat to Van Dyck for three portraits that could be used by the sculptor as a basis for a portrait of her, a project that was overtaken by events in England (and would not have been welcomed by Bernini, who disliked working from paintings). The bust of the King was displayed in the Queen's House at Greenwich. Made simply because Charles wished to own a work by the most famous living sculptor, it was regarded as one of the greatest treasures of the Royal Collection, a status that it would undoubtedly possess today, had it not been destroyed by the fire at Whitehall in 1698 that also consumed Michelangelo's *Cupid*.

68. *Triple Portrait of Charles I* by Anthony van Dyck, 1635–6.
In 1635 the Pope agreed to Henrietta Maria's request that Gian Lorenzo Bernini would execute in Rome a marble bust of her husband, based on a portrait to be sent from London. Knowing that the painting would be scrutinised by the art world in Rome, Van Dyck produced an exquisitely finished work that far transcends its immediate purpose. It is easy to understand why the myth arose that Bernini saw in the King's expression a foreshadowing of his fate. RCIN 404420

In 1638 a young sculptor from London, Nicholas Stone (1618–47), visited Rome. He was introduced to Bernini, who questioned him about the bust, and how it had been received in England. He also asked 'if nothing was broke of itt in carryage and how itt was preserved now from danger'. He was pleased to hear that it had arrived undamaged – 'but I tooke (sayth he) as much care for the packing as studye in making of itt'. Stone explained that at Greenwich the bust was protected by a cover made of silk, 'getherd together on the top of the head and drawne together with a strink under the body with very great care'. Bernini was impressed, commenting that 'in my time of doing of itt I did cover itt in the like manner to keepe itt from the flyes'.

Back in Britain, Charles was engulfed in the war in Scotland that had been provoked by his religious reforms. In 1642 the ensuing conflict with parliament led him to abandon London, leaving his palaces and their collections to their fate. Since nobody could yet conceive that the monarchy might not survive, most of the King's precious possessions were left untouched until almost the moment of his return to London as a prisoner in 1648. The Queen's House was then shuttered and silent, and it is poignant to think of the bust by Bernini at its heart, covered by its silken case like a statue in a church at Lent. It would not remain there for much longer.

DISPERSAL
The Collection in the Commonwealth

In the early afternoon of 30 January 1649 Charles I walked from the Banqueting House to his execution on a scaffold erected in Whitehall. The choice of Inigo Jones's building as a backdrop for the King's death was deliberate. This symbol of the Stuarts' authority, embodied in particular in its ceiling paintings by Rubens, was to be transformed into a theatre of royal penance and popular retribution. This did not quite go to plan. Charles took control of the proceedings: wearing two shirts to avoid shivering, he dressed in dark clothes so that his Garter star and badge would stand out from a distance. A large crowd listened attentively to the King's reprimands in his speech from the scaffold, and the executioner had to wait for a sign from him before proceeding. 'I am the martyr of the people,' Charles declared, and his words were fulfilled only moments afterwards, as soldiers on the scaffold rushed forward to dip their handkerchiefs in his blood and take locks of his hair as relics.

Early the following month, a book, *Eikon Basilike* (The Image of a King), was published in London. Purporting to be Charles's spiritual testament to his people, and almost certainly written at least in part by him, it was a sensational bestseller, with no fewer than 38 editions in its first year. Among the 70 copies in the Royal Library, ranging from deluxe editions to tiny versions that could be worn like a talisman, is a copy of the twenty-fifth edition, published in late March 1649, which has four lengths of light blue silk ribbon attached to its binding (fig.69). According to an eighteenth-century inscription, the book had belonged to Sir Oliver Fleming, 'Master of the Ceremonies to King Charles the First, together with ye ribband strings which were the Garter his Majesty wore his George on'. Charles wore such a ribbon and badge when in public: they can be seen, for example, in the last portrait of him made from life, painted by Edward Bower in the month before the King's execution (fig.70).

Technical analysis, including radiocarbon dating made when the book was conserved in 2013, has revealed that the ribbons, which are the right colour and width to be Garter ribbons, date from 1631–70 and were inserted in the book shortly after it was bound in 1649. There seems no reason why this should have been done unless the ribbons were believed to have belonged to Charles. Fleming's role at court meant that he could have acquired the ribbons, but since he was a cousin of Oliver Cromwell and continued in his

post during the Commonwealth, it would be surprising if he had created such a memento. Nonetheless, the volume is a telling demonstration of the way that Charles's memory was revered, and *Eikon Basilike* undoubtedly sustained the support for the Stuarts that led to his son's restoration in 1660.

Almost of more impact than the book's text was the frontispiece, engraved by William Marshall, which was also circulated independently. It shows the late King at prayer, surrounded by emblems of his fate: he clutches a crown of thorns and looks up to an eternal, heavenly crown. Such an image deserves the name of propaganda. Parliament's strenuous efforts both to answer and suppress the book, combined with its tearing down of images of the King in public places, raise the question why it did not turn destructively against the portraits by Van Dyck and others that celebrated the monarchy. The fact that parliament, led by Oliver Cromwell (1599–1658), simply sold them undoubtedly demonstrates that it placed the need for cash above any objections to royal imagery, but it may also suggest that the collection had in fact played little or no role in shaping public perceptions of the King. This is hardly unexpected, since access to it had been limited.

Given the deep antipathy of his enemies to Charles's religious policies, it is also telling that the collection's many paintings of foreign, Catholic origin depicting Christian subjects also seem not to have been a matter of concern. Only extreme Puritans objected to the domestic display of religious images.

69. *Eikon Basilike*, **published 1649.**
Charles I's spiritual testament, published a month after his death, was an immediate bestseller. The lengths of blue ribbon inserted into this copy shortly after it was bound in 1649 are from a Garter ribbon similar to that worn by Charles in his portrait in fig.70, and conceivably may have been his. The frontispiece engraving depicts the King as a martyr, gazing at his eternal crown. In the background, the resilience he brought to his life on earth is symbolised by a rock pummelled by waves and a palm tree with heavy weights hanging from its branches. RCIN 1080417

Among the paintings reserved for Cromwell's use as Lord Protector were the mid sixteenth-century *Assumption of the Virgin* by Luca Cambiaso (1527–85), admittedly cut down to remove the figure of the resurrected Virgin, as well as unidentified paintings with such subjects as 'Madonna with many angels and one with scourge'. That tolerance was, however, in sharp distinction to attitudes to the display of such works in a liturgical context, which virtually all shades of Protestant opinion in England found unacceptable. The paintings in Charles's palaces were left untouched when he fled from London in 1642, but those in Henrietta Maria's chapels did not survive in place for long. In March 1643 the parliamentary authorities expelled the Capuchin friars who maintained her chapel at Denmark House. One of them left an account of the ensuing destruction of the chapel's altarpiece by Rubens and Dieussart by troops led by a notorious iconoclast, Sir John Clotworthy: 'he climbed on top of the altar table ... Calling for a halberd, he struck Christ's face in contempt with such offensive words it would be shocking to repeat them. His second blow was at the Virgin's face with more hateful blasphemies, and then thrusting the hook of his halberd under the feet of the crucified Christ, he ripped the painting to pieces.'

Disposing of the collections

With the death of the King, followed by a statute abolishing the monarchy, the question of what do with the royal collections became pressing. Converting them into cash was more or less inevitable, since parliament was in urgent need of money to pay the army and navy, and to settle the royal household's debts. In July 1649 an Act was passed 'for sale of the goods and personal estate of the late King, Queen and Prince', and a system was put in place for accomplishing this with the same bureaucratic efficiency that parliament had brought to its military affairs. It appointed a board of nine trustees to inventory the royal possessions, a formidable task largely completed in just nine months. The trustees included men from livery companies with experience of the furnishing trades, together with people who already knew the collections, notably the Dutch painter Jan van Belcamp (1610–53), who since 1640 had been Keeper of the King's Pictures. Before that he had worked under Abraham van der Doort, but there is no evidence that he had access to Van der Doort's records. The balance of the trustees' skills is reflected in the quality of the inventory – for example, the luxury textiles are expertly catalogued, whereas the antique busts are listed perfunctorily, but that difference was also a result of the estimations of their respective values.

The sale to Charles of the Gonzaga collections had been strongly criticised in Mantua, but there is no evidence of a similar reaction in London. The works of art that the King had acquired himself had mostly been in England for no more than 20 years, but the fact that there was no hostile

response to the sale of earlier works is yet further evidence of how little public knowledge there was of the collection. The one exception had been a muted antiquarian challenge in the House of Lords in 1644 to the order to melt down the King's plate in the Tower of London: it was argued that the 'the fashion of it and the badges upon it' had 'more worth than the plate itself'. There was never any likelihood that objects so easily transformed into cash would be spared, but parliament did make important exemptions from the sale. It reserved goods up to the value of £10,000 to furnish buildings for the use of the state (a sum that eventually rose to £53,000), and it kept back not only the Raphael cartoons but also Mantegna's *The Triumph of Caesar* (see fig.46) for use as models for tapestry. Furthermore, it was agreed that as St James's Palace was temporarily wanted for barracks, the sculptures there could be transferred to the gardens at Whitehall for the sake of their 'antiquity and rarity'. This suggests a sense that works of art could have a public benefit, an idea that is reinforced by the order in 1648 that the King's 'Books, Manuscripts, and other Antiquities, in the Library, Chairhouse, and His Majesty's Cabinet at Whitehall' should be moved to the library at St James's, 'there to remain for a Public Use'. This collection was subsequently referred to as the 'Publick Library', making it a forerunner of the national library at the British Museum, founded just over a century later, but it did not survive the Restoration.

Once inventoried, the former royal possessions were brought to Denmark House for sale by commissioners appointed under the 1649 Act. They were not auctioned but were divided into batches and priced. To reassure buyers that they were getting good title, receipts were provided stating that their purchases were 'their own proper Goods and Chattels for ever'. The most expensive paintings were all from Mantua: they included Raphael and Giulio Romano's *The Holy Family*, valued at £2,000, and Correggio's *Allegory of Virtue* and *Allegory of Vice*, which were £1,000 each. Titian's *Venus del Pardo* was valued at £500 (it was eventually sold for £600). Some foreign buyers complained that the prices were too high. The trustees had a difficult balancing act when making their valuations – parliament wanted as much money as possible as quickly as possible, yet the market for such goods was depressed because of the effects of war, and, so far as art was concerned, there had never been many purchasers in England for works of this quality. Moreover, they were not easy to see. At the outset of the sale, Denmark House must have been crammed to the rafters, and although efforts were made to hang pictures in the great hall and galleries, potential buyers found that they could not view them properly. A Dutch visitor, Lodewijck Huygens, saw in one of the galleries, 'a very large number of beautiful paintings but so badly cared for and so dusty that it was a pitiable sight', and the Spanish ambassador, Alonso de Cárdenas, failed to spot a Raphael that he was looking for as 'it was hung high up, and quite covered by dust'. These comments reflect not just conditions at Denmark House but also the neglect of the collection since the King's departure from London in 1642.

70. *Charles I at his Trial* by Edward Bower, 1648. This is the last portrait of Charles made from life. Edward Bower probably based it on sketches made during the King's trial in Westminster Hall in December 1648. It shows Charles as he appeared after 14 months' imprisonment in Carisbrooke Castle, his beard now grey. The King's cloak, prominently embroidered with the Garter star, may be the one he wore on the scaffold a month later. The painting was bought by Queen Elizabeth in 1951. RCIN 405913

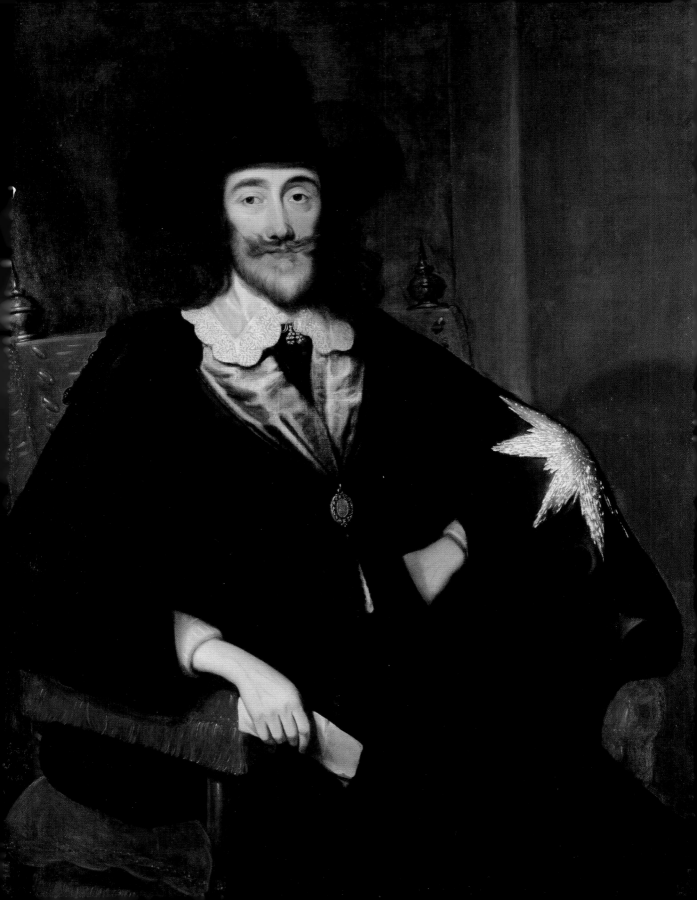

In the face of such difficulties, it is not surprising that the sale initially proved disappointing. The level of parliament's expectations were shown by the instruction that the first £30,000 raised was to be loaned to the Treasurer of the Navy, where money was urgently needed, but by May 1650, when the sale had been under way for six months, items worth just £35,271 had found buyers, and creditors were being asked to accept part-payment of debts in goods. In 1651 parliament passed a second Act, ordering the disposal of the possessions of the entire royal family, and not just the King, Queen and Prince of Wales. Unlike the previous Act, however, this speci-fied what was to be included: 'Jewels, Plate, Furs, Hangings, Statues, Medals, Pictures, Wardrobe-stuff, and all other Household stuff'. The books and other material ('medals, rings, globes and mathematical instruments') in the library at St James's Palace were again exempted.

At the same time, a new, more streamlined technique for settling the royal debts was instituted. Creditors were placed in a number of syndicates, each headed by an individual empowered to act on its behalf. Each syndicate was allocated by ballot goods with values amounting to around £5,000. It was then up to the members of each syndicate how the goods were distrib-uted among themselves, the assumption being that they would sell them in settlement of the monies owing to them. As a result, great masterpieces

71. *Allegory of Marriage* by Peter Oliver, 1629. This is one of several copies of paintings in the Royal Collection made by Peter Oliver for Charles I. The original, painted by Titian in 1533, was bought in London at the Commonwealth sale by Cardinal Mazarin's banker, Everhard Jabach, from whom it was acquired in 1662 by Louis XIV. It is now in the Louvre. RCIN 452459

were temporarily in the ownership of some unlikely people, such as the Royal Plumber and Royal Glazier, although such men ran large enterprises in the building trade and were not workmen, as is sometimes assumed. This new method of distribution was a success, and by 1653, when the sale was brought to an end, goods to the value of £184,717 5s 3d had been disposed of, and it was calculated that only about £4,500 worth remained.

Dispersal abroad

One reason why the trustees may have felt confident in their valuations is that there was a lot of foreign interest in the sale. This was, however, slow to manifest itself at Denmark House because many of the diplomats who were the agents for purchases by foreign courts were hampered by parliament's insistence that they had to seek fresh accreditation in order to make it clear that their masters recognised the new republic. Most foreign monarchs, and especially the Catholic powers, were in no hurry to comply. In addition, they didn't want to be seen to profit from the execution of a king. Even after Philip IV of Spain – who had known Charles personally – had provided accreditation for Alonso de Cárdenas, he instructed the ambassador to make purchases on behalf of the King's chief minister, Luis de Haro, who would then give them to Philip, so keeping the royal hands (and purse) untainted by Stuart blood. Cárdenas set to work with determination and among the works he acquired was *The Holy Family* by Raphael and Giulio Romano, Dürer's *Self-Portrait*, Mantegna's *Dormition of the Virgin* and the sequence of portraits of the Caesars by Titian.

Other major purchases were made by a Paris-based banker, Everhard Jabach (1618–95), who was not constrained by the problems faced by diplomats; he bought Caravaggio's *Death of the Virgin* and Titian's *The Entombment of Christ* and *Allegory of Marriage*. Once Cardinal Mazarin had recognised the republic on behalf of Louis XIV (1638–1715; then a minor), a number of paintings were bought by his ambassador, Antoine de Bordeaux, including Correggio's *Allegory of Vice*. Most of the paintings acquired by Philip IV are now in the Prado (with the sad exception of the Titian Caesars, destroyed in 1734 when the Alcázar palace in Madrid burnt down) and the purchases by Jabach and Mazarin can now mostly be seen in the Louvre. These and other paintings have left a poignant trace in the Royal Collection in a group of reduced copies of paintings by Titian, Raphael and Correggio (figs 71–4) that were commissioned by Charles I from Peter Oliver (son of Isaac). A surprising failure of connoisseurship by none other than Diego Velázquez led to one of the paintings recorded by Oliver finding its way back to England, although not to the Royal Collection (fig.72). At £800, Correggio's *Venus with Mercury and Cupid*, sometimes called *The School of Love*, was one of the most expensive paintings on offer and Cárdenas was pleased to have bought it. However, when it was unpacked in Madrid, Velázquez declared it

to be a copy, and so Philip IV rejected it. The painting was retained by Luis de Haro, in whose name it had been bought, and so did not enter the Prado with most of the other Spanish acquisitions from Charles I's collection.

This was the greatest sale of works in art in Europe to date. No accumulation of Italian Old Master paintings comparable to the King's was to appear on the market again until the dispersal of aristocratic collections after the French Revolution. For that reason, the character of royal collecting, as of British collecting in general, was to be different from Charles's in the century and a half that followed his death.

The world turned upside down

One monarch was unable to make purchases; Charles II could only look on impotently as his own possessions, as well as those of his parents, were disposed of. He had been proclaimed King in Scotland immediately after his father's death, but his attempts to use Scottish troops to continue the fight against parliament finally collapsed at the Battle of Worcester in September 1651. In years to come, Charles would delight in telling the story of his narrow escape, aided by a network of royalists who kept him hidden, most famously in an oak tree at Boscobel, until he was able to reach safety in France. One of the houses in which he sheltered was Bentley Hall, near Wolverhampton, home of Colonel John Lane. From there Charles travelled south with Lane's sister Jane, disguised as her servant. As a token of his thanks he gave her a beautiful rock-crystal and silver-gilt fob watch (fig.75). Charles's future then looked bleak. He moved in with his mother, who had been granted apartments in the Louvre, and she supported him from

her pension, topped up by occasional donations from royalists at home. Following a treaty between England and France in 1655, he was forced to leave Paris and with the promise of support from Spain settled in Bruges in the Spanish Netherlands.

Despite his definitive rejection of the crown in 1657, Cromwell was monarch in all but name and he lived like one, surrounded by furnishings and art from the Royal Collection. He took over the King's apartments at Whitehall and the Queen's at Hampton Court. In 1656 the diarist John Evelyn (1620–1706) recorded, 'I ventured to go to Whitehall, whereof for many years I had not been, and found it glorious and well furnished.' A few of Cromwell's supporters did not approve. Following his decision to move

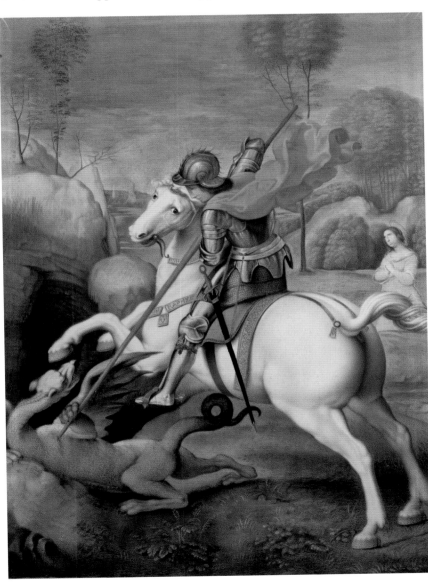

74. *St George and the Dragon* by Peter Oliver, *c*. 1634.
The original by Raphael passed through a number of French aristocratic collections before being bought in 1772 by Catherine the Great of Russia. In 1931 it was sold by the Soviet State to the banker Andrew Mellon, who gave it to the National Gallery of Art in Washington.
RCIN 452455

some of Charles's sculptures of classical figures, including Venus, Adonis and Apollo, to Hampton Court, a Mrs Mary Netheway wrote beseeching him 'to demolish those monsters which are set up as ornaments in Privy Gardens, for whilst they stand, though you see no evil in them, yet there is much evil in it, for whilst the groves and altars of the idols, remained untaken away in Jerusalem, the wrath of God continued against Israel.' In 1659 a Quaker cook broke into the gardens at Whitehall, and with a black-smith's hammer smashed statues valued at £500. Although he was arrested, his bail was paid by rich sympathisers.

These were the words and actions of extremists, and Cromwell ignored them, but it still seems surprising that images published to promote his role as Lord Protector should so blatantly have adopted royal precedents. Prints described him as 'Olivarius primus' and one, dated 1655, reproduces a celebrated icon of the Stuart monarchy, Van Dyck's portrait of Charles on horseback with M. de St Antoine, simply substituting Cromwell's head for the King's (fig.76). When Cromwell died in 1658 he lay in state at Denmark House, where, as was customary at royal funerals, an effigy of him was displayed, robed in purple, gold and ermine, in front of a chair of state on which was placed a crown. When the effigy was moved to Westminster Hall to be viewed by the public in advance of the funeral, the crown was placed on its head. European powers assumed they were witnessing the creation of a new royal dynasty and Louis XIV's court went into mourning for Cromwell. But there was to be no Olivarius secundus.

SERENISSIMUS AC POTENTISSIMUS PRINCEPS OLIVARUS CROMWEL REIPUBL·ANGLIÆ·SCOTIÆ·ET HIBERNIÆ·PROTECTOR·

Cernitur hic Victor Regnis et honoribus auctus Hic Tutela bonis Iovæ qui dogmata servant Qvo vivo, vivet Grex Lex sincera vgebit. Nullius arma timet quam Iovæ nonne virebit
 Qvi Patriæ mira dexteritate præest. Iauixi firma speq, fideq, Deo. Et subito Meretrix de Babylone cadet. Perpete honore solo perpete amore Polo.

M K Delin. C. V. W. Londini

RESTORATION
Charles II and James II & VII

On 23 May 1660 a vast crowd gathered on the beach at Scheveningen in Holland to watch the departure of Charles II for England, which he had last seen nine years before. Emphasising the suddenness of his change of fortunes, the ship sent to collect him was HMS *Naseby*, named for one of the great parliamentarian victories. The King immediately rechristened it the *Royal Charles* and would no doubt have been amused to learn that its figurehead, of Oliver Cromwell, had been sawn off before the ship left England. His setting out was recorded in an ebullient painting by Johannes Lingelbach that Charles may have commissioned (fig.77). The figures in the foreground are covering their ears from what one eye-witness, Samuel Pepys (1633–1703), described in his diary as the 'infinite shooting off of the guns' and the smoke from them rises to a scattering of sunlit clouds. As Pepys wrote, 'with a fresh gale and most happy weather we set sail for England'.

In the three weeks that had elapsed since the proclamation of the Restoration on 8 May, frantic work had been carried out in London to provide adequate accommodation for the King. Much had changed since his father's death: Richmond had been demolished, Greenwich was uninhabitable, Denmark House badly battered and both St James's Palace and Windsor

77. *The Embarkation of Charles II at Scheveningen* by Johannes Lingelbach, *c*.1660–70.
An enormous crowd on the beach, including people with telescopes, watches the departure of the fleet on 23 May 1660, bearing the newly restored Charles II back to England. Scheveningen is visible to the left; at the centre smoke billows from a celebratory barrage of guns. A German-born artist who lived in Amsterdam, Lingelbach specialised in large crowd scenes, usually depicting piazzas and ports in Italy. RCIN 404975

Castle were barracks. That left only the residences used by Cromwell – Whitehall and Hampton Court – in a state fit to receive Charles. However, even at Hampton Court the King's apartments, which Cromwell had not used, were virtually empty. When a Dutch visitor, Lodewijck Huygens, saw the rooms in 1653, he noted that 'the furniture had all been removed, except for the tapestries which had been behind the good ones to protect them from the damp of the walls'.

At both Whitehall and Hampton Court, the department of the Royal Wardrobe, under the direction of Clement Kynnersley (who retained the post he had been given by Cromwell) set to work refurbishing the rooms. At Hampton Court, everything remaining from Cromwell's time was replaced by new furniture, including a state bed hung with gold-fringed velvet, suites of velvet-covered furniture, 20 Turkey carpets and 10 Persian carpets. At the same time, the architect John Webb (1611–72) supervised the reinstallation of works of art, which were flooding into royal hands, as gifts and purchases as well as by the forced return of the collections dispersed in 1649–53.

Among the first of the royal possessions to be given back was the medieval spoon that Kynnersley had acquired in 1649 when the rest of the regalia was melted down (see fig. 3). He voluntarily returned it in time for Charles's coronation, on St George's Day, 1661, described by the Venetian ambassador as 'certainly the most conspicuous solemnity that has ever been seen

78. Alms dish by Henry Greenway, 1660–61.
Made for Charles II's coronation on 23 April 1661, this large dish was placed at the centre of the altar in Westminster Abbey. It depicts the Last Supper, with the royal arms just to the right of Christ's head. On the rim are other scenes from the gospels. Its maker, Henry Greenway, a goldsmith who began his independent career in 1648, was subcontracted to make the dish by the Royal Goldsmith, Robert Vyner, who was commissioned to supply the regalia and plate for the coronation. The dish now forms part of the altar plate for the Chapel Royal at St James's Palace.
RCIN 92012

in this realm'. Almost everything for the coronation had to be made specially, including the magnificent silver-gilt alms dish that was placed at the centre of the altar in Westminster Abbey (fig.78). The King's appearance at his coronation is evoked in a majestic portrait of him by John Michael Wright (1617–94) in his robes of state with the regalia (fig.79). Although not painted until some years after the event, the old-fashioned formality of the frontal pose, which recalls the royal image on seals, embodies the essence of the King's instructions for his coronation. He wished, he told his Lord Chancellor, Edward Hyde, later Earl of Clarendon, that in order 'that the Novelties and new Inventions, with which the Kingdom had been so much intoxicated for so many years altogether, might be discountenanced and discredited in the Eyes of the People ... the Records and old formularies should be examined ... and all Forms accustomed to be used that might add Lustre and Splendour to the Solemnity'.

As well as solemnity there were to be festivities, as the King's choice of St George's Day for the coronation – an anti-Puritan gesture – had made clear. He revived the practice of holding a banquet after the coronation in Westminster Hall, where a spectacular display of plate was made up in part of costly gifts to the King, both new and old pieces. Among the latter was a salt in the form of a silver-gilt castle, which had been purchased by the city of Exeter from the royal goldsmith Robert Vyner (1631–88) to give to the King (fig.80). Vyner – who also commissioned the new crown, orb and sceptre for the coronation – oversaw the salt's embellishment with gemstones, including amethysts, rubies, emeralds and sapphires. The gift was a propitiation: during the Civil War Exeter had backed parliament.

80. The Exeter Salt by Johann Haas, *c*.1630.
This container for salt and spices is one of many pieces of gold and silver plate that made a dazzling display at Charles II's coronation banquet. The only known surviving piece by Haas, a Hamburg goldsmith, it was acquired by the British Resident in the city, Richard Bradshaw, perhaps originally as part of an intended diplomatic gift from Oliver Cromwell to the Tsar of Russia. Instead, it was sold by the Royal Goldsmith, Robert Vyner, to the City of Exeter for £700, to form a gift for the new King.
RCIN 31772

Reconstructing the collection

On 9 May 1660 the House of Lords appointed a Committee for the Recovery of the King's Goods. Moving quickly, the committee published an order that 'All persons that have any of the King's goods, jewels, or pictures' had to return them within seven days and it placed an embargo on the export of any such objects. The proclamation was backed up by powers of forcible search and seizure, and, from August, by the offer of rewards for information about goods 'wilfully concealed'. Thanks in part to the detailed records that had been made at the time the goods were dispersed, a large number of Charles I's possessions were recovered in a surprisingly short time; by the middle of June 1661 over 1,000 paintings had been returned or seized. No compensation was paid, as sale of the goods was exempted from the 1660 Act of Indemnity and Oblivion, which declared a general amnesty for acts committed during the Commonwealth.

In the seven years since the sale had been completed, the King's goods had become widely scattered. Many had been acquired in payment of debts and so had been sold on; some people who still had them on their hands must have regretted not having disposed of them more quickly. Many such owners claimed that they had in fact simply been taking care of the King's goods during his absence. Among them was Emanuel de Critz (1608–65), son of Charles I's Serjeant Painter John de Critz. Although he had headed up no fewer than three of the syndicates to which goods had been allocated for sale, there could be no doubt about his family's loyalty to the Crown – his elder brother, John, had been killed fighting for the King. In 1660 De Critz returned some major works, including Bernini's bust of Charles I and Van Dyck's portrait of Charles with his family, the 'Great Peece' (fig.59). It is plausible that the reason that he had kept them in his house in the City of London was, as he explained, to preserve them, 'with great care and danger'. Nonetheless, the fact that he had earlier disposed of Correggio's *Allegory of Vice* to Cardinal Mazarin, and was storing royal possessions that had been acquired by others, suggests that he was in part a dealer, and would have contemplated selling these treasures if the circumstances had been right.

Some people in England acquired royal goods in order to create their own collections, demonstrating that Charles I's appreciation of art had been influential on more than an inner circle of aristocratic supporters. The best known, thanks to a memoir of him published by his widow, Lucy, is the parliamentarian soldier Colonel John Hutchinson (1615–64), who had been one of the judges at Charles I's trial. He was the single largest cash purchaser at the sale, where he acquired tapestries, sculptures and some 20 paintings for £1,349. Among them was Titian's *Venus del Pardo*, for which he paid £600. The painting was eagerly coveted by both the French and Spanish ambassadors, and in 1653 Hutchinson sold it on to Mazarin for a staggering £7,000. This implies that he had made his purchases as an investment, but the fact that so many royal paintings were still in Hutchinson's possession in 1660

is evidence that his wife was justified in claiming that he 'had greate judgment in paintings, graving, sculpture, and all excellent arts, wherein he much delighted'. In 1660 the Committee for the Recovery of the King's Goods managed to prise from him some of his major acquisitions, including a *Holy Family* then thought to be by Titian but now attributed to Palma Giovane, and a masterpiece by Hans Holbein, a portrait of Johannes Froben that had been a gift to Charles I from the Duke of Buckingham (fig.81). However, many of Hutchinson's acquisitions cannot be traced, making it doubtful that he returned everything.

81. *Johannes Froben* by Hans Holbein, *c*.1522–3. Painted in Basel four years before Holbein first visited England, this portrait of the printer Johannes Froben was acquired in France by the Duke of Buckingham, who gave it to Charles I. It was originally attached to a copy of Holbein's portrait of the scholar Desiderius Erasmus (also in the Royal Collection) that Froben may have commissioned as a record of their close friendship. RCIN 403035

82. *David with the Head of Goliath* by Domenico Fetti, c.1620.
Fetti was court painter in Mantua from 1614 to 1622, and so was well represented in Charles I's purchases from the Gonzaga collection. This painting was acquired by the King's Brewer, Robert Houghton, at the Commonwealth sale, when it was valued at £20. He then sold it on to Viscount Lisle. RCIN 404731

Hutchinson must have been reluctant to hand over his possessions to a regime that he had never supported – he was lucky not be executed after the Restoration – and the same was probably true of Philip Sidney, Viscount Lisle (1619–98), who had sought to build a substantial collection on the back of the sale of the King's goods. The son of the Earl of Leicester, Lisle had been Lord Lieutenant and Commander-in-Chief in Ireland under the Commonwealth, but, having refused to be a judge at Charles I's trial, was pardoned at the Restoration. Nonetheless, that did not help him retain the largest haul that any English person made from the Commonwealth sales: some 60 paintings, including works by Mantegna, Holbein, Titian, Bassano, Giulio Romano, Orazio and Artemisia Gentileschi and, surprisingly, since they were less highly regarded, an equal number of antique sculptures. All bought through agents, these were not for resale, but to furnish a large house that Lisle had built at West Sheen. Although he owned up to possessing these works shortly after the Restoration, he waited until almost the final deadline before returning them. Analysis of his purchases has suggested that they may reflect his political beliefs – he didn't buy any royal portraits, and classical sculpture may have seemed appropriate to him for a republic that looked back to Rome as an ideal. Even such a painting as Domenico Fetti's *David with the Head of Goliath* may have taken on a new resonance in a republican context, since the subject often symbolised liberation from tyranny (fig. 82).

Enlarging the collection

It is no great criticism of Charles II to say that he was not the collector that his father was, since very few monarchs were. He had a practical bent – he was very knowledgeable about ship design, for example – but intellectually he was a dilettante. The only foreign language he spoke was French, but

he found writing it a struggle. Although, like many contemporaries, he maintained a laboratory, he showed no deep interest in the scientific and mathematical advances made under the aegis of the Royal Society, founded in 1660. Charles II's enjoyment of music and theatre was unintellectual and the same was probably true of his appreciation of art, but he was keenly aware of the lustre his father's collection had given to the British monarchy, and made many efforts to build on what he had inherited.

The first major addition to the Royal Collection during his reign was arranged before he had even embarked from Scheveningen. At the farewell dinner for the King it was announced that the States of Holland wished to present him with 'a number of rare objects'. These consisted of a magnificent bed with embroidered hangings and a matching suite of bedroom furnishings, together with 24 paintings and 12 pieces of antique sculpture, all of which Charles received in the Banqueting House at Whitehall in November 1660. The artist and dealer who was entrusted with making

83. *Andrea Odoni* by Lorenzo Lotto, 1527. Andrea Odoni was a Venetian merchant and collector of paintings and classical antiquities. In this dynamic portrait, Odoni holds out a statue of Diana of Ephesus while gesturing to a crucifix worn round his neck, perhaps as a reference to the triumph of Christianity over pagan religions. RCIN 405776

the selection, Gerrit van Uylenburgh (c.1625–79), in collaboration with the sculptor Artus Quellinus (1609–68), must have taken advice about what would please the King, since no fewer than 20 of the paintings were Italian Old Masters – including Titian, Giulio Romano and Parmigianino (1503–40) – who had been prominent in Charles I's collection. Among them were some outstanding works, including one of the most famous depictions of a Renaissance collector, Lorenzo Lotto's *Andrea Odoni* (fig.83). Collections of Italian Old Masters were rare in Holland, so Uylenburgh was lucky that a major example, formed in Venice by two Dutch merchant brothers, Jan and Gerard Reynst, had become available with the death of the surviving brother, Gerard, shortly before the Restoration. Uylenburgh negotiated the purchase from their estate of 20 paintings for 80,000 guilders.

The other four paintings presented to the King were Dutch. Considering that he lived through what is now regarded as the golden age of Dutch painting, Charles made few significant acquisitions in this field; the Royal Collection's extraordinary holding of works by Rembrandt and other Dutch masters was largely due to George IV. However, that doesn't mean Charles was indifferent to the country's artists. When he received the gift he praised in particular a work by Gerrit Dou (1613–75) as well as one by Titian. This was more than diplomatic courtesy to the Dutch envoys. Dou's small, highly finished genre scenes had a high reputation in England, and Charles made an unsuccessful attempt to persuade him to move to London – prompting a satirical poem in the artist's native Leiden, 'How now, Oh Dou? Shall Stuart drag thee, beacon-light of brushes, to Whitehall? Do not proceed to Charles's court. Do not sell out thy freedom for smoke, or wind, or dust. He who seeks Royal favours must play the serf and flatterer.' The King was no more lucky with his efforts to entice Caspar Netscher (1639–84) from The Hague. However in 1672, when the Dutch economy was deeply depressed, Charles II's formal invitation to the country's craftspeople to move to England led Jan Griffier (c.1645–1718) and the marine painters Willem van de Velde (1611–93) and his son, also Willem (1633–1703), to settle in London. Charles also gave work to the leading Dutch still-life painter of the mid century, Simon Verelst (1644–1721), who had moved to London in 1669 (fig.84).

In April 1660, while the King was still in Holland, an art dealer named William Frizell passed him a list of 72 paintings for sale, which Charles annotated, 'Frizill keepe these picktures till I send for them'. They were eventually delivered in 1662, after which Charles paid Frizell

84. *A Bunch of Grapes* by Simon Verelst, c.1670–75. A specialist in flower painting, Verelst was persuaded by Charles II to take up portraiture, but his career was cut short by mental illness. This masterly work reveals why Samuel Pepys so admired the artist. In 1669, Pepys was shown a painting by Verelst: 'A little flower-pot of his doing, the finest thing that ever, I think, I saw in my life; the drops of dew hanging on the leaves, so as I was forced, again and again, to put my finger to it, to feel whether my eyes were deceived or no.' RCIN 405506

£2,686. Frizell is a tantalisingly elusive figure – his dates are unknown – but he was active in the art market in Europe as early as the 1630s, working for both Lord Arundel and the King. Among the paintings Charles I obtained from him (all of which were Italian) was Caravaggio's *The Calling of Saints Peter and Andrew*, which is still in the Royal Collection (see fig.306). Frizell's ability to supply outstanding paintings is equally evident in the list he offered Charles II, which included works that had belonged to Emperor Rudolf II and Queen Christina of Sweden. Many were Italian, but there were also major paintings by northern painters, notably *The Massacre of the Innocents* (fig.85) by Pieter Bruegel the Elder (*c.*1525–69).

Charles also acquired paintings as documentary records. For example, the paintings he commissioned of his escape from England in 1651 by Robert Streeter (1621–79), his Serjeant Painter, and Isaac Fuller (1606?–72), as well as of his triumphant return in 1660, hark back to the tradition of Henry VIII's paintings recording the Field of Cloth of Gold (see figs 8 and 9). Charles also asked the Dutch landscape painter Hendrick Danckerts (1625–80) to paint 'all the sea-ports of England and Wales' (fig.86), a project that clearly had a practical as well as an aesthetic purpose. In 1674 Charles arranged for Willem van de Velde and his son to be given an annual pension of £100 each, together with a studio in the Queen's House at Greenwich for the father to make drawings of recent 'seafights' and for his son for 'putting

85. *The Massacre of the Innocents* by Pieter Bruegel the Elder, *c.*1565–7. Bruegel intended this painting to be a comment on the harsh rule of the Spanish in the Netherlands. Soon after it was painted, the panel was acquired by Emperor Rudolf II, who ordered its subject to be changed from the *Massacre of the Innocents* to a scene of plunder by overpainting the slaughtered infants with animals and other possessions. RCIN 405787

86. *A View of Tangier* by Hendrick Danckerts, 1669.
A Dutch landscape painter who moved to England during the Commonwealth, Danckerts was commissioned by Charles II to paint views of the royal palaces and of British ports. Tangier had formed part of the dowry of Catherine of Braganza on her marriage to Charles. Danckerts probably based the painting on drawings made on the spot by Wenceslaus Hollar earlier that year. Finding it impossible to defend, the British abandoned Tangier in 1684.
RCIN 402578

87. *The Attack on Shipping in Tripoli 24 January 1676* by Willem van de Velde the Elder, c.1676.
As Lord High Admiral, Charles II's brother James, Duke of York, later James II, commanded the fleet during two naval wars with the Dutch, in 1665–7 and 1672–4. In 1675 Charles commissioned the Van de Veldes to paint a sequence of large canvases depicting British successes in these wars and in the campaigns against Barbary corsairs. This canvas shows rowing boats commanded by Lieutenant Cloudesley Shovell setting light to the corsairs' ship in the harbour at Tripoli on 24 January 1676. The view is taken from the position of the British fleet, anchored just outside the harbour.
RCIN 406557

the said Draughts into Colours' (fig.87). Among the tasks Charles set them was to design a set of tapestries depicting the Battle of Solebay of 1672. This was the last major royal commission for the Mortlake factory. Like the Van de Veldes' paintings, the tapestries were in part designed to glorify Charles's brother, and heir presumptive, James, Duke of York, who had put his life at risk against the Dutch at Solebay.

The King's pride in his collection has been doubted, given the story that he decided to make a gift of the Raphael cartoons to Louis XIV for use in the royal tapestry workshops, the Gobelins. He changed his mind after a

protest from his Treasurer, the Earl of Danby, who was no friend to the French. However, it should be remembered that the cartoons, which were still cut into strips, had not been valued by Charles I as independent works of art. Charles II's attitude to the cartoons was, in any case, quite different from the determination he brought to reclaiming paintings that his mother had taken with her when she retired to France in 1665, which included, as well as family portraits, Orazio Gentileschi's *Joseph and Potiphar's Wife* (see fig.56). Following Henrietta Maria's death in 1669, her art collection was claimed by her daughter, the duchesse d'Orléans, but Charles's love for his sister did not stop him fighting a legal battle for their mother's goods, which he won.

Charles also made efforts to acquire works from the estates of artists who had worked for his father. When he heard that Peter Oliver (1594–1648) was dead, he visited his widow, Anne, and offered her a pension in return for a group of her husband's miniatures. Hearing that he had passed some on to his mistresses, Anne declared that if she had known that he had intended to give them 'to such whores, bastards or strumpets, the King should never have had them', whereupon Charles cancelled the pension. Similarly, when he heard that Cosimo III, Grand Duke of Tuscany, wished to purchase the miniatures that Samuel Cooper (1609–72) had left in his studio after his death, he intervened to claim a group of works that included some of Cooper's finest royal portraits (figs 88 and 89). They were taken to his cabinet rooms at Whitehall to join the large collection that Charles had both inherited and commissioned, but even so, as he wistfully told a visitor, the room contained 'not half of what his father had owned'.

88 and 89. *Catherine of Braganza, c.*1662, and *The Duke of Monmouth, c.*1664–5, by Samuel Cooper
These miniatures painted on vellum are sketches, probably from life, that were retained by Samuel Cooper to form the basis for finished works. The portrait of Catherine shows her shortly after her arrival in England, aged 23, to marry Charles. According to her husband, her 'face is not so exact as to be caled a beuty, though her eyes are excelent good'. The portrait of the Duke, Charles's oldest illegitimate son, shows him aged 15 or 16 and captures the handsome looks that impressed contemporaries.
RCIN 420644 and 420645

Drawings

90. *The Head of St Anne*
by Leonardo da Vinci,
***c.*1510–15**
This is a study in black
chalk for Leonardo's
painting *The Virgin and
Child with St Anne* in the
Louvre. Probably commis-
sioned by Louis XII of
France in 1499, the
painting was worked on for
many years by Leonardo,
and was still not complete
at his death in 1519, which
makes it difficult to date
the dozen or so drawings
for it that survive. The
painting retains the form
of the headdress in the
drawing, but Leonardo
made many subtle
alterations to the face.
RCIN 912533

Charles II can also take the credit for laying the
foundation of one of the glories of the Royal
Collection, its drawings by Renaissance and
modern masters. Although it is not certain how
many drawings his father had owned, it is clear
that Charles I showed no sustained interest in col-
lecting them. There were very few connoisseurs
of drawings in pre-Civil War England, notably
the Earl of Arundel, but after the Restoration
the market grew rapidly. Charles's collection, the
oldest formed in Britain to have survived to the
present day, was sufficiently well known for artists
to request loans: in February 1677, for example,
Charles Beale, husband of the painter Mary Beale
(1633–99), noted that he had 'borrowed 6 Italian
drawings out of the King's collection for my sons
to practice by'. There is no evidence that Charles
II had a specialised interest in drawings, and so
his ownership of them may simply reflect the
influence of prominent artists at court, notably
Peter Lely (1618–80), who formed a large and dis-
tinguished collection of his own. It was almost
certainly during Charles's reign that the album of portrait drawings by Hans
Holbein was returned to the Royal Collection, this time for good – by what
route is not known. Other drawings acquired by Charles II include sheets by
Raphael and Michelangelo, but even these are overshadowed by the extraor-
dinary group of over 600 drawings by Leonardo da Vinci, which although
not recorded in the Royal Collection until after Charles's death are presumed
to have entered it during his reign.

The first reference to them in royal ownership was made by William III's
Dutch secretary, Constantijn Huygens, who noted in his diary that on 22
January 1690 at Whitehall he went 'to the rooms underneath the King's
Closet, where we saw four or five books with drawings, among others
Holbeins and Leonardo da Vincis'. Long since disbound into individual
sheets – the original binding survives with the drawings in the Royal Library
at Windsor – the album that Huygens saw covered a large span of Leonardo's
career and almost the entire range of his interests, from working drawings
for paintings and sculpture to maps and fortifications, scientific studies and
designs for costume. There are drawings that allow us to trace the evolution
of some of his most famous works, from *The Last Supper* (14–8; Santa Maria
delle Grazie, Milan) to *The Virgin and Child with St Anne* (now in the Louvre,
Paris; fig.90). His sketches also draw us into his fascination with human
physiognomy and expression and natural phenomena, such as whirlpools

and storms. The collection contains almost all his surviving anatomical drawings, works of exceptional beauty (fig.91).

Leonardo bequeathed all his papers that were with him when he died in Amboise to a favourite pupil, Francesco Melzi (*c.*1491–*c.*1570), who took them to his family home near Milan. The collection includes a drawing by Melzi that is the only indubitably authentic portrait of Leonardo (fig.92). When Melzi died the collection was sold by his son to the Milanese sculptor Pompeo Leoni (*c.*1533–1608), who pasted the drawings into several albums, of which only one other is known to survive, in the Biblioteca Ambrosiana in Milan. Leoni died in Madrid, where his possessions were dispersed. It is not known how the Royal Collection album came by 1636 to be owned by the Earl of Arundel, nor how it was acquired for Charles II following Arundel's death in Padua in 1646. It is possible that the existence of the drawings was originally made known to English collectors by Rubens, who had studied them while they were in Leoni's possession in Milan.

Portraits and politics

On 10 January 1662 John Evelyn (1620–1706) recorded in his diary that while at Whitehall, he was 'call'd to his Majesty's closet when Mr. Cooper the rare limner, was crayoning of the King's face and head, to make the stamps by, for the new mill'd money now contriving. I had the honour to hold the candle whilst it was doing, he choosing the night and candle-light for the better finding out the shadows. During this his Majesty discours'd with me on several things relating to painting and graving.' This drawing is probably the chalk profile by Samuel Cooper – the King's 'limner', or miniature painter – of which two versions survive in the Royal Collection (fig.93).

The King had an amused interest in his portraiture – when shown a portrait of himself by John Riley (1646–91) painted in about 1680 he commented, 'Is this like me? then oddsfish, I am an ugly fellow!'– but although a great number of portraits were produced in Charles II's court, paintings of the King himself are not prominent in the Royal Collection. One reason is that Charles's marriage in 1662 to the Portuguese princess Catherine of Braganza (1638–1705) was childless, and so there was no need for depictions of a royal family of the type that Van Dyck had so memorably created for Charles's parents. It is more difficult to understand why he did not retain portraits of himself by Peter Lely, who did more than any another artist to create the enduring images of Charles's court – a place of luxury and pleasure focused on female beauty. Although it was recorded of Lely that the King 'took grate Pleasure in his Conversation, which he found to be as agreeable as his Pencil', Charles II sat to him no more than three times.

Born in Westphalia to wealthy Dutch parents, and trained in Haarlem, Lely moved to England in about 1643, possibly because he saw an opening following Van Dyck's death two years before. In 1647 he painted a group portrait of three of Charles I's children – Princes James and Henry with Princess Elizabeth – now at Petworth House, Sussex, which was probably commissioned by their father. Lely steered a careful political course during the Commonwealth. As one of a group of artists who in 1653 offered to paint for Cromwell a series of canvases for Whitehall Palace depicting 'the most remarkablest Battails' of the civil wars, he made portraits of the Lord Protector and acquired eight paintings from Charles I's collection for himself, notably Van Dyck's *Cupid and Psyche* (see fig.63), but he maintained links with royalist patrons as well. His pre-war contact with the royal family served him well, for as early as June 1660 he was sworn in to the post of the

93. *Charles II* by Samuel Cooper, *c*.1660–72.
Black haired, with brown eyes, Charles had a dark complexion that his contemporaries thought unusual; it may perhaps have been derived from the Italian blood he inherited from his grandmother Marie de' Medici.
RCIN 914040

King's Principal Painter, with an annual pension of £200 'as formerly to Sr A. Vandyke', but he had to wait much longer for a knighthood, received just before his death in 1680.

Lely is best remembered for his paintings of women at court, and in particular for 'the Windsor beauties', 11 three-quarter-length portraits assembled by Charles's sister-in-law, Anne, Duchess of York, around 1662–5. Originally hung together in her apartment at St James's Palace, they were on display for many years at Windsor Castle before being moved to Hampton Court, where they remain. All but one are entirely by Lely's own hand; he usually painted only the heads in his portraits, leaving the rest to be completed by the assistants in his large studio. However, the fascination of the 'Windsor beauties' extends well beyond their merits as works of art. The prominence of depictions of beautiful living women was something new in England. In part this is a reflection of the growing public participation of women in cultural life after the Restoration. They could now perform on the stage, have literary careers, and be painters: James II sat to Anne Killigrew (1660–85), a poet as well as an artist, and to the miniature painter Susannh-Penelope Rosse (1652–1700). However, Lely's portraits also embody an erotic courtly culture that was encouraged by the King. There were plenty of paintings of attractive nude women at Charles I's court, but they were mythological or religious subjects depicted by Old Masters, and the King himself had an irreproachable private life. Since James I's interests were predominantly homoerotic, it is necessary to go back to Henry VIII for a time when a monarch's affairs with women were so much a matter of public knowledge, and, by comparison with Charles II, Henry was fastidious in his physical relationships.

By 1660 Charles already had four illegitimate children, each by a different mother. This was no secret: in 1662, his eldest son, James, born in 1649 following a short-lived affair with a woman named Lucy Walter, was made Duke of Monmouth. As King, Charles had a succession of mistresses, who were openly acknowledged, not simply by his behaviour – he was often observed in public fondling his current lover – but by granting them apartments at court, money and titles. His first long-term mistress, Barbara Villiers (1640–1709), a married woman who gave birth to her first child by the King in February 1661, became Countess of Castlemaine later that year when her compliant husband was ennobled, and in 1670 was made Duchess of Cleveland in her own right. Charles's appointment of her in 1662 to the household of Catherine of Braganza outraged the Queen but she had to submit. A woman of forceful personality, but never entirely confident of her status at court, especially given the King's roving eye, Villiers made ample use of Lely's talents to promote herself as both a beauty and a fit companion for the monarch. In the Windsor beauties series she is depicted as Minerva, goddess of Wisdom (fig.95), and in other paintings as a Madonna and a Magdalen. These paintings were much copied, suggesting that her deployment of portraiture as a form of self-promotion was successful.

Painting at court

Villiers's use of Lely's skills indicates that depictions of beautiful women at Charles's court cannot simply be seen as projections of male lust. One of the Queen's maids of honour, Frances Stuart (1647–1702), was depicted by Lely with a bow, almost certainly as the virgin goddess Diana (fig.94), and it seems unlikely to be a coincidence that it was painted at a time when this famous beauty was warding off the King's strenuous attempts to make her his mistress, finally foiled by her marriage to the Duke of Richmond and Lennox in 1667. The complexities of why she should have chosen – very unusually – to be depicted dressed as a soldier in a portrait of about 1664 that she probably gave to Charles II have never been unravelled (fig.96).

94. *Frances Stuart, Duchess of Richmond* by Peter Lely, before 1662.
A Maid of Honour and later Lady of the Bedchamber to Catherine of Braganza, Frances Stuart was one of the first women at court to be painted by Lely for the 'Windsor beauties' series. According to Pepys, Stuart – 'the greatest beauty I ever saw, I think, in my life' – inspired the design for the figure of Britannia that was to be used on the coinage for the next three centuries.
RCIN 404514

95 (right). *Barbara Villiers, Duchess of Cleveland* by Peter Lely, c.1665.
Charles was not alone in his admiration for Barbara Villiers, his most significant mistress in the 1660s: 'I can never enough admire her beauty,' wrote Pepys in 1661. This painting of her at the height of her influence over the King forms part of the 'Windsor beauties', a collection of portraits by Lely of women at court assembled in the early 1660s.
RCIN 404957

It may be significant that Frances Stuart commissioned the portrait not from Lely, associated with the King and his mistresses, but from the Flemish immigrant Jacob Huysmans (*c*.1633–96), who was the Queen's preferred painter. Lely's role as official (and Protestant) court painter was never as uncontested as Van Dyck's, but that was partly for reasons of religious politics. It seems likely that Catherine of Braganza favoured Huysmans because of his faith – he is assumed to have been Roman Catholic. He portrayed the Queen as a shepherdess with lambs, perhaps alluding to her desire for children, and as her name saint, St Catherine of Alexandria. Several women at court chose to be painted with the attributes of St Catherine as a tribute to the Queen, but when Barbara Villiers ordered from Lely two portraits of herself as the saint, her motive was surely fuelled by rivalry. Like her mother-in-law Henrietta Maria, Catherine was provided with Roman Catholic chapels in the royal palaces and in 1683 Huysmans painted the cupola and high altar in the Queen's Chapel in St James's Palace. The chapel was already furnished with a sequence of paintings commissioned in 1675 by the Queen from another immigrant artist, Benedetto Gennari (1633–1715), a nephew of the painter Guercino, whom Charles I had unsuccessfully attempted to lure to England.

The Catholic presence at court was further enlarged by the marriage in 1673 of James, Duke of York (1633–1701), to a D'Este princess, Mary of Modena, following the death in 1671 of his first wife, Anne. When James acknowledged his conversion to Catholicism in 1676, the prospect that Charles – who had no legitimate children – would be succeeded by his Catholic brother precipitated a political crisis. Parliament sought to exclude James from the succession, a move that Charles defeated only after a long struggle, helped by the fact that James's children, Mary and Anne, were Protestant.

Gennari's Italian nationality and religious affiliation made him a natural choice to work for the Duke and Duchess of York, and he was informally given the post of the Duke's first painter, a role in which he continued after James's accession in 1685. None of his work for James and Mary survives in the Royal Collection, but there are examples of the very different sort of paintings that he provided for Charles II, which were mythological and erotic. They included a nude *Danaë* for the King's new apartments at Whitehall, which evokes the world of Titian's mythologies, a sequence of paintings of classical love stories for the King's dining room at Windsor (fig.97) and even more explicit canvases for what Gennari described as Charles's 'appartamento segreto' at Whitehall. It may have been in that room that Charles kept a portrait of his most notorious mistress, Nell Gwyn (1650–87), 'naked with a Cupid', which was hidden behind 'a sliding piece' – presumably a more decorous painting.

Another strand in the cultural politics of painting at Charles's court was French. In 1670 Charles's sister, Henrietta, duchesse d'Orléans, visited England as a cover for the signing of the secret Treaty of Dover, whereby

96. *Frances Stuart, later Duchess of Richmond*, by Jacob Huysmans, *c*.1664. On 26 August 1664 Pepys recorded a visit to Jacob Huysmans's studio, in which he admired this portrait of Stuart, 'in a buff doublet like a solder', but does not explain why the Queen's Maid of Honour should have wished to be depicted in a military outfit, especially as the painting was probably a gift for the King. It may be an extension of a mid 1660s fashion for women to wear hunting dress with periwigs as day attire, or was perhaps a fancy-dress costume. RCIN 405876

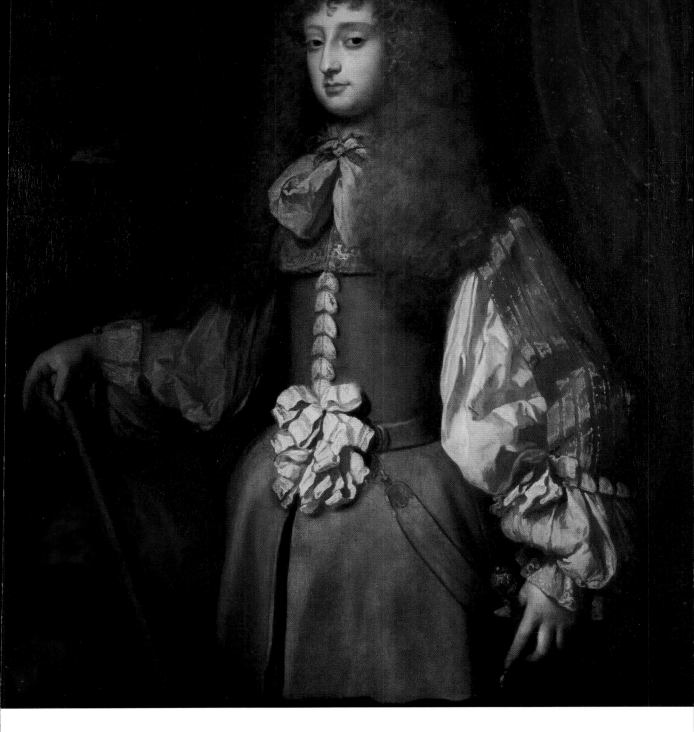

97. *Venus and the Sleeping Adonis* by **Benedetto Gennari, 1677–8.**
Trained in Bologna, Gennari moved to London in 1674, where he was employed largely on religious works for prominent Roman Catholics at court, including the Queen, James, Duke of York, and Mary of Modena. In 1688 he left England to join James and Mary in exile. He was also commissioned by Charles II to paint erotic mythological subjects – *Venus and Adonis* is among the more discreet examples.
RCIN 407150

Charles promised military support for Louis XIV against the Dutch in return for a financial subsidy. Charles's eye was caught by one of her maids of honour, Louise de Kéroualle (1649–1734), who, following Henrietta's sudden death later that year, was taken into Catherine of Braganza's household. By the following year she had become Charles's mistress and, having borne him a son, in 1673 was made Duchess of Portsmouth in her own right. A woman of ingratiating charm, she succeeded Villiers as the lover closest to the King, and was soon very rich, with a pension of £8,600 a year and an apartment of 24 rooms at Whitehall.

Louise de Kéroualle's cultural patronage had a French flavour, exemplified in her portrait of around 1673 by Philippe Vignon (1638–1701), which shows her holding a garland of flowers, her hair dressed in a French style

98. *Louise de Kéroualle, Duchess of Portsmouth and Aubigny* by **Philippe Vignon**, *c.*1673.
Philippe Vignon worked in London during Charles II's reign. His portrait of the King's favourite mistress of the 1670s captures both her vivacity and taste for fashionable French luxury.
RCIN 405882

99. Silver candlestand (one of a pair), *c.*1670.
These candlestands, engraved with Charles II's monogram, were originally accompanied by an ensuite silver pier table and mirror. Although probably made in Holland, their style is French and they reflect the fashion for silver furniture at Versailles.
RCIN 35298

(fig.98). When in 1682 Louis XIV – who used the Duchess of Portsmouth as a diplomatic intermediary – gave Charles a set of eight tapestries depicting French palaces, the King passed them straight on to his mistress. They were seen by John Evelyn, whose description of De Kéroualle's rooms at Whitehall in his diary of 4 October 1683 evokes a luxurious combination of tapestries and paintings with furniture of precious metal and Japanese lacquer: 'Here I saw the new fabrique of *French Tapissry*, for designe, tenderness of worke, & incomparable imitation of the best paintings, beyond any thing I had ever beheld … then for *Japon Cabinets*, Skreenes, Pendule Clocks, huge *Vasas* &c. of wrought plate, *Tables*, Stands, Chimny furniture, *Sconces*, *branches*, *Braseras* [braziers] &c. they were all of massive silver & without number, besides of his Majestie's best paintings.' It is tempting to think that the furniture that so impressed Evelyn included a surviving pair of silver candlestands acquired by Charles II in about 1670 (fig.99). In fashionable French taste, and designed to be ensuite with a silver table and mirror, they would not have looked out of place in the apartments of the King's mistress or, for that matter, at Versailles.

Charles's palaces

In October 1664 John Evelyn, 'being casually in the Privy Gallery at Whitehall', spoke to the King about plans for rebuilding the palace. Charles borrowed some paper from Evelyn, and 'laying it on the window stoole, he with his owne hands, designed to me the plot for the future building of Whitehall, together with the Roomes of state & other particulars.' Charles's drawing was based on a design by John Webb for replacing the palace with a vast classical building on the model of the Louvre, which the King knew well from his years of exile. The idea of rebuilding Whitehall went back to the time of Charles I, but neither funds nor political will were ever sufficient to realise the dream, and Charles II did little more than build new apartments for himself, and convert the Tudor hall into a theatre 'for masking plays, and dancing'.

100. Cabinet on stand (one of a pair), 1660–5. Standing nearly two metres high, these imposing cabinets are made of oak veneered with oyster-cut cocus wood imported from the Caribbean. They are inset with silver mounts, two of which bear monograms of Henrietta Maria, suggesting that the cabinets were supplied for the refurnishing of her principal London residence, Denmark House, in 1660–2. Although influenced by French furniture, the cabinets were probably made in England.
RCIN 35297

Charles also failed to realise ambitious plans for Greenwich. Following her return to England in 1662, Henrietta Maria moved back into Denmark House and the Queen's House at Greenwich, both of which had been repaired and altered for her by Webb. A pair of large and very splendid cabinets on stands of around this date that bear her monogram suggests the luxury with which the Queen Mother could now surround herself after years of penurious exile in France (fig.100). Charles had by then ordered the demolition of Greenwich Palace in order to make the Queen's House the centrepiece of an entirely new building by Webb, with a formal garden designed by Louis XIV's gardener, André Le Nôtre. The project was put on hold in 1669 when only one range had been partially completed (now known as the King Charles Building), and did not resume until the 1690s.

The one surviving royal palace built in Charles's reign is Holyrood, which, having been a barracks during the Commonwealth, was reconstructed to a new plan between 1671 and 1678. The King had considerable involvement in the design of the palace, built under the direction of William Bruce (1630–1710), the King's Surveyor General, working with his Master Mason, Robert Mylne. Undertaken by the King's Council in Scotland in anticipation of Charles coming to Scotland, which he never did, the building and furnishing was overseen on the King's behalf by the Secretary of State for Scotland, the Earl of Lauderdale. Holyrood's decoration with rich plasterwork and carved woodwork probably resembled Charles II's new interiors at Whitehall: the King's principal bedroom in both palaces was given a painted ceiling, that at Holyrood depicting *The Apotheosis of Hercules* (1675), by a Dutch artist, Jacob

101. Interior of the Gallery, Holyrood.
The reconstruction of Holyrood for Charles II in 1671–8 incorporates this enormous gallery, which runs along almost the entire length of the palace's north range. It is furnished with an extraordinary dynastic display: portraits of every monarch of Scotland from the mythical Fergus (who is supposed to have ruled in about 330 BC) to James VII. All were painted for the room by Jacob de Wet II.

de Wet II (1641–97). There is, however, no precise English equivalent for the decoration of Holyrood's vast long gallery, onto the walls of which were set no fewer than 111 paintings of the kings of Scotland, all by De Wet, of which 79 bust-length and 18 full-length portraits survive (fig. 101). Far more than the sum of their simple parts, they are a powerful assertion of the antiquity and legitimacy of the restored Stuart line.

A similar desire to assert the historical authority of the monarchy was one of the motives for Charles II's remodelling of Windsor Castle, which having been left virtually unaltered for a century was, from 1678, transformed into a palace of exceptional grandeur. The work, which was designed by Hugh May (1621–84), the surveyor of the Castle, eventually cost some £200,000, which the King could afford thanks in part to the secret subsidy from Louis XIV. May's work encompassed new lodgings for the King, Queen and Duke and Duchess of York, as well as the complete rebuilding of the chapel and St George's Hall. The King's apartment extended into a new range on the north front, looking out across the Thames Valley. This was known as the Star Building, because it was decorated with a gilded Garter star, 12 feet wide, which alluded to the story of the daytime star (now believed to have been a supernova) that had appeared on the day the King was born. The building is shown illuminated by a burst of sunshine in one of a pair of views of the reconstructed castle commissioned by Charles from the Dutch landscape painter Johannes Vorsterman (1643–1719; fig. 102).

As at Whitehall and Holyrood, the interiors were fitted out with carved woodwork, the finest of which was undertaken by Grinling Gibbons (1648–1721), a protégé of May. The role of painted decoration was enormously expanded from the relatively modest ceilings of those two palaces to encompass the most extensive programme of architectural painting ever commissioned by the Crown, carried out by a team of painters under

102. *A View of Windsor Castle* by Johannes Vorsterman, 1676–82. This is one of a pair of views of the Castle painted by Vorsterman, a Dutch landscape painter based in London, which records Charles II's remodelling of the Castle. In this canvas, a burst of sunlight picks out his major addition, the Star Building, which housed the King's privy lodgings. It sits above a large extension to the north terrace, which is enclosed by steep walls. RCIN 405265

Antonio Verrio (*c*.1639–1707). Born in Lecce, Verrio moved in about 1670 to Paris, where his work caught the eye of the English ambassador, Ralph Montagu, later 1st Duke of Montagu (1638–1709), who encouraged him to move to England. Charles's first thought was to hire Verrio to make designs for Mortlake tapestries, which may be significant, as the painted decoration at Windsor was a cheaper (and quicker) substitute for suites of tapestry, still the preferred way of decorating grand interiors. Inspired by the illusionistic painted decoration of Roman palaces and churches by such Baroque artists as Pietro da Cortona (1596–1669), Verrio's work at Windsor – which included 20 ceilings and two large staircases, as well as the chapel and St George's Hall – occupied him for a decade. He was paid nearly £8,000 on completion of the work, and was further rewarded by being appointed the King's 'first and chief painter' in succession to Lely.

Just three ceilings and a few fragments survive from Verrio's schemes, but their impact is recorded in watercolours by Charles Wild and J.P. Stephanoff, made as illustrations for W. H. Pyne's book *The History of the Royal Residences*, published in 1819, just before most of the paintings were swept away in the great rebuilding of the Castle for George IV. Something of the impression they made can also be experienced today in the schemes

Verrio's work inspired at such houses as Chatsworth, Derbyshire, and Boughton, Northamptonshire, as well as the Painted Hall at Greenwich. The climax of the decoration at Windsor was St George's Hall, both a throne room on the model of the Banqueting House at Whitehall and a setting for the ceremonies of the Garter (fig.103). On the north wall, opposite the windows, Verrio painted a triumph of the Black Prince over the Scots and French. Alluding to the medieval, chivalric traditions of the Garter, it was inspired by Mantegna's *The Triumph of Caesar* (see fig.46), with the figures all in Roman costume.

Verrio looked to Raphael's cartoons as a model for the scene of Christ healing the sick on the north wall of the chapel (fig.104). The choice of subject reflected the chapel's use for the ceremony of touching for the King's evil. It had long been believed, in France as well as England, that scrofula, a disfiguring infection of the lymph nodes, could be cured by the monarch laying on hands, but Charles practised the ceremony with unusual elaboration and frequency: in 1682 alone he touched nearly 9,000 people. Like the decoration of Windsor, this was an assertion of the divine character of an anointed king, which in the last decade of Charles's reign had become a subject with urgent political significance. His determination that his brother would succeed him divided the nation, but by promoting himself as the champion of established religion, he ensured an unchallenged succession for the Duke of York following Charles's unexpected death at Whitehall from kidney failure in February 1685.

104. *Christ Healing the Sick* by Antonio Verrio, c.1678–82.
Although representing Verrio's murals in the King's Chapel at Windsor Castle, this painting includes elements, such as the steps, that would have been precluded by the architecture of the room. It is probably a free copy of the scheme, painted for Charles as an independent work of art. The standing figures in the niche on the right are portraits of Verrio and the architect of the Castle's remodelling, Hugh May. RCIN 404052

James II & VII

Charles's brother inherited a full treasury, a compliant parliament in England and peace in his other two kingdoms, Scotland and Ireland. With the over-confidence that this inspired, and encouraged by the ease with which his army stamped out a rebellion by his Protestant nephew, the Duke of Monmouth, James almost immediately began to lift the civil restrictions on Roman Catholics. From the start he attended Mass in public, in the belief that, as King, he was not constrained by the laws against Catholic worship. He ordered the building of a large new chapel at Whitehall, designed by Christopher Wren (1632–1723). Decorated with wall paintings by Verrio, it was furnished with an altarpiece by Gennari depicting the Annunciation (now in the Ringling Museum of Art, Sarasota), which was set in a marble reredos incorporating sculptures of angels and cherubs by Grinling Gibbons and his assistant Artus Quellinus III (1653–86).

105. Sconce by Robert Smythier, *c.*1670.
In November 1686 six silver-gilt sconces, of which this is one, were delivered to the deputy keeper of the new Council Chamber at Whitehall Palace, the setting for meetings between the King and his Privy Council. These sconces were subsequently altered to include William and Mary's monogram at the top. Their opulence appealed to the Prince Regent, who had them regilded in 1812 for use at Carlton House. RCIN 51539

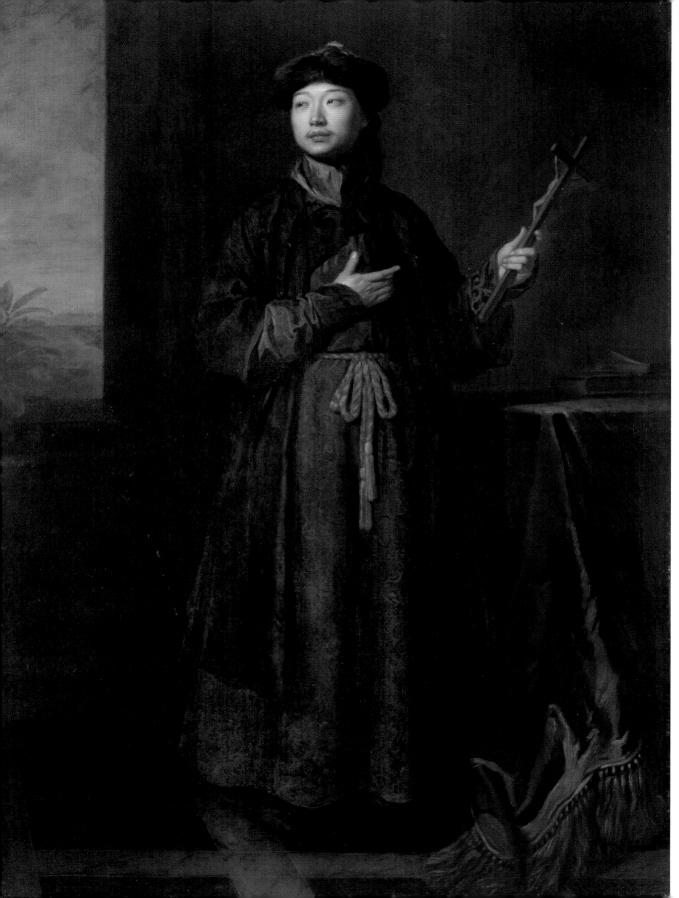

The chapel was part of a set of substantial additions to Whitehall undertaken by Wren for James, partly as a consequence of the new King deciding to abandon his brother's unfinished palace at Winchester. Wren provided a new council chamber for James, completed in 1687, and embarked on new state apartments for Mary of Modena that were not to be completed until the next reign. Among the furnishings that survive from this scheme are some spectacularly ornate silver sconces from the council chamber (fig.105), which incorporate reliefs depicting the Judgement of Solomon – the ideal, if not the reality, of the King's political ambitions.

In terms of artistic patronage, the longest-lasting consequence of James's brief reign was the establishment of Godfrey Kneller (1646–1723) as the leading portrait painter at court. Born Gottfried Kniller in Lübeck, he had been trained by Rembrandt in Amsterdam and had travelled in Italy before settling in England in 1676. According to a contemporary writer on art, Marshall Smith, Kneller had been prompted to visit London by a 'longing to see Sir Anthony Van Dycks works, being most ambitious of imitating that great Master'. His early full-length portraits of the Duke of York and Duchess of Portsmouth brought him a commission from Charles II to paint Louis XIV, for which he travelled to France in 1684. For James II he painted a portrait of Shen Fu-Tsung that Kneller thought one of his finest achievements (fig.106). Shen (c.1658–91), born in Nanjing in China, had been converted to Christianity by Jesuit missionaries. He visited England in 1687 as part of a European tour to promote the work of the mission and was given an audience by the King. Kneller depicts him in Chinese dress holding a crucifix, looking up to the light, powerfully suggesting the spiritual rewards of conversion – rewards that James vainly hoped his subjects would be eager to acquire for themselves.

In June 1688 Kneller received his most politically sensitive commission, when he was commanded to paint the King's newly born son, James, Prince of Wales (1688–1766). The painting does not survive, but is known from a print that was immediately published, intended to help check the rumour that the baby was an imposter, smuggled into Mary of Modena's bedroom in a warming pan. The birth of a male heir, and the consequent prospect of not just a Catholic monarch, but a Catholic dynasty, on the throne was the final element that united the opposition to James. Within six months of the Prince's birth, James had lost his crown to the invading forces of his Protestant nephew and son-in-law, William of Orange (1650–1702).

A King in exile

James re-established his court at the château of Saint-Germaine-en-Laye, which had been the principal seat of Louis XIV before his move to Versailles in 1682. It was expensively refurnished by Louis to make it suitable for its new royal occupant. After James's attempt to reclaim the throne by means

106. *Michael Alphonsus Shen Fu-Tsung* by Godfrey Kneller, 1687.
In March 1687 representatives of the Jesuit mission in China visited James II. Among them was Shen Fu-Tsung. Shen discussed Confucianism with James, who had asked him 'whether the Chinese had any divinity'. He also visited Oxford, where he translated Chinese books and documents in the Bodleian. This portrait, one of Kneller's finest, was commissioned by James. RCIN 405666

of an invasion of Ireland was defeated by William III's troops at the Battle of the Boyne in 1689, he hardly left Saint-Germaine. Hopes for a restoration became focused on his son who, when James died in 1701, was recognised by the French as James III & VII, but is remembered by the British as 'the Old Pretender'. He is depicted in a group portrait of the exiled Stuarts by Pierre Mignard (1612–95), Premier Paintre du Roi to Louis XIV, that harks back to Van Dyck's paintings of Charles I's family (fig.107). The six-year-old Prince James, dressed in armour and wearing a Garter sash, points towards a crown and a sword resting on a cushion, asserting an intention to reclaim by force the inheritance of which his father had been deprived. His mother holds the arm of his sister Princess Louisa, who was born in exile; she clutches a rose, an emblem of England.

Prince James and his son, Charles – Bonnie Prince Charlie (1720–88) – were to be a threat to the British monarchy for another half century. In Britain, opposition to the regime established in 1688 went underground as the Jacobite cause, with its own repertoire of imagery and symbolism. This has its origins in representations of James II & VII, of which one of the most mysterious is a cabinet bought in 1937 by Queen Elizabeth, first recorded in the early nineteenth century (fig.108). It consists of a large (100 cm

107. *James II and Family* by Pierre Mignard, 1694. James and Mary of Modena are depicted as the dispossessed royal family of Great Britain, with the King in Garter robes, and his son, the Prince of Wales, gesturing to the crown, which is his rightful claim. The juxtaposition of the boy with his mother may be designed to reinforce their physical similarity, countering rumours that he was not her child. The painting is a finished sketch for the portrait, which is in a private collection. RCIN 400966

high), finely carved ivory sculpture of James, crowned and enthroned, below cherubs holding aloft the coronation crown. It looks like a model for a funerary monument to be made in marble, but if its attribution to the Flemish sculptor Mathieu van Beveren (1630–90) is correct, it must have been carved between James's accession in 1685 and the death of the sculptor in 1690. The sculpture is contained within a cabinet on a stand that was put together from older elements, probably in the 1830s, when the Jacobite cause had long since passed from political threat into romantic legend.

108. *James II* by Mathieu van Beveren, *c.*1685–90. James is shown as a crowned sovereign, surrounded by symbols of naval power, supported by Strength and Wisdom and with Peace proffering him a palm. These motifs suggest that it depicts him as Lord High Admiral, a role he had as Duke of York in 1660–73 and then again as King. The purpose of the sculpture is unknown, although it has been suggested that it was commissioned by James after his flight to France as a gift for Louis XIV. RCIN 21633

REVOLUTION
From William III and Mary II to Queen Anne

Early in Charles II's reign a new fire-fighting regime was instituted at Whitehall Palace, with orders that a leather bucket had to be kept filled with water next to every chimney. Instructions were issued about what to do if a fire was discovered, including: 'clap a wet sheet very close against the Mantle and jambes'. In 1691 these precautions proved inadequate when a serious fire destroyed several buildings, including the rooms that had once been so glamorously occupied by the Duchess of Portsmouth. The remainder of the palace was saved only by dynamiting parts of it to stop the fire spreading. Then, on the afternoon of 4 January 1698, some linen that had been left to dry in front of a fire set alight, and within little more than 12 hours most of the palace, with the major exception of the Banqueting House, was destroyed. About a dozen people were killed, but despite the efforts of looters most of the portable works of art and furnishings belonging to the Crown were saved. The major losses were sculpture: Bernini's bust of Charles I perished, together with, it is assumed, Michelangelo's *Cupid*.

It is likely that the damage to the Royal Collection would have been even more severe if it was not for the fact that many of the most important works of art had already been moved elsewhere. At the time of the fire, Whitehall Palace had not been fully occupied by the court for a decade. Its destruction confirmed what was already a major break with the past. In the reign of William III (1650–1702) and Mary II (1662–94) many of the familiar settings for the Tudor and Stuart collections were abandoned: Whitehall and Denmark House (now known again as Somerset House) were never again to be occupied by a royal household, and, at Mary's suggestion, Greenwich Palace, which had been left unfinished by Charles II, was completed as a hospital for the navy. Even Windsor Castle entered on a long period of neglect, leaving only St James's Palace as the major link with the past. Instead, ambitious building projects at Hampton Court and Kensington Palace created new settings for the Royal Collection that have continued in use to the present day.

The new monarchs

William and Mary's joint acceptance of the crown in 1689 solved the constitutional crisis that had arisen when James II fled the country in the face of William's invading army. As far as his enemies were concerned, James had abdicated. On the assumption – almost certainly untrue – that the King's newborn son was an imposter, the rightful heir was deemed to be Mary, James's eldest daughter. Since 1677 she had been married to William, Prince of Orange and Stadholder of the United Provinces of the Netherlands, who, as the only child of James II's sister Mary, was himself third in line to the throne. The joint monarchy was an unprecedented arrangement, but it worked, thanks in part to Mary's sister, Anne, agreeing to let William take precedence over her in the succession. For the double coronation at Westminster Abbey on 11 April, new regalia and a replica of the medieval throne were made for Mary (fig.109).

William was as decisive about his future homes as he had been in seizing the crown. Although he ordered Christopher Wren to complete the new apartments at Whitehall Palace that had been started for Mary of Modena, he decided that he would not live in the palace. The official reason was that the smoky atmosphere of central London exacerbated his asthma, but it may also be wondered whether he felt comfortable with the palace's embodiment of the Stuart monarchy. He had got on badly with both his uncles, Charles II and James II, and found their emphasis on their divine right to rule uncongenial. By contrast, on a visit to Hampton Court just a few days after his coronation he saw at once its potential as an alternative to both Windsor and Whitehall. In March he and Mary began to make preparations to move there, and the following month Wren was instructed to prepare designs for rebuilding it. When it became clear that they intended to make Hampton Court their main seat, there were complaints at court about its distance from central London. This prompted William to look for a convenient residence that he could use when business necessitated him being at Whitehall, and so just before Christmas he bought the Earl of Nottingham's early seventeenth-century house at Kensington, only a short ride from central London, but outside the smog. Wren set to work at once on remodelling a house that was intended to be only a residence. The future Kensington Palace initially had no provision for court ceremony or entertaining – neither of which William enjoyed.

When Mary arrived in England she sent for the designer Daniel Marot (1661–1752), a French Protestant, who had supervised the creation of the gardens at the couple's hunting lodge in Apeldoorn, Het Loo. Marot's first recorded work in England was a design for a new parterre at Hampton Court, dated 1689; soon afterwards he was describing himself as 'Architecte des appartments de sa Majesté Britanique'. In all the media in which Marot designed – from silver and furniture to textiles, painted decoration and gardens – his inspiration was the court taste of Louis XIV. Given that almost

109. Queen Mary II's Orb, 1689.
William and Mary's unique coronation as joint monarchs meant that the Royal Goldsmith, Robert Vyner, had to supply an additional orb and sceptre, to be used by the Queen at the coronation on 11 April 1689. The jewels supplied for the orb were replaced immediately afterwards with paste gems. The orb, whose maker is not known, has been used only once since, when it was placed on Queen Victoria's coffin for her funeral in 1901. RCIN 31719

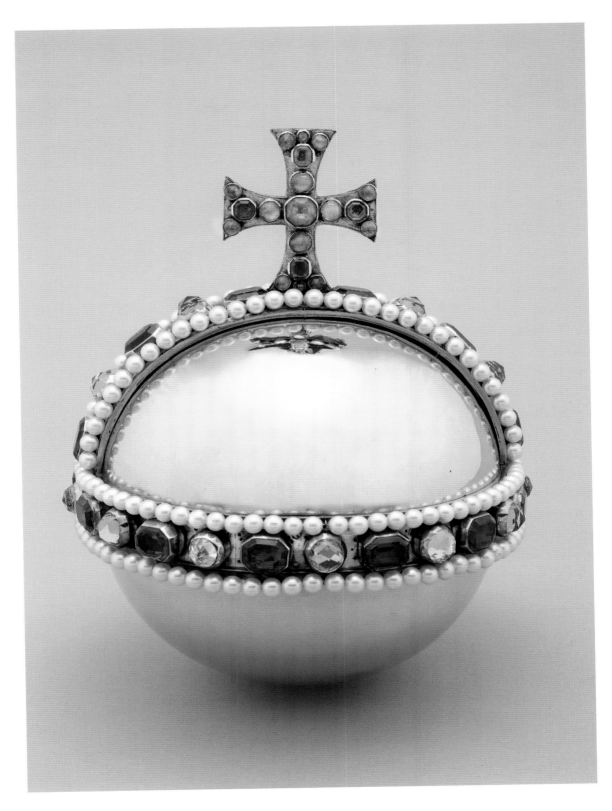

Revolution

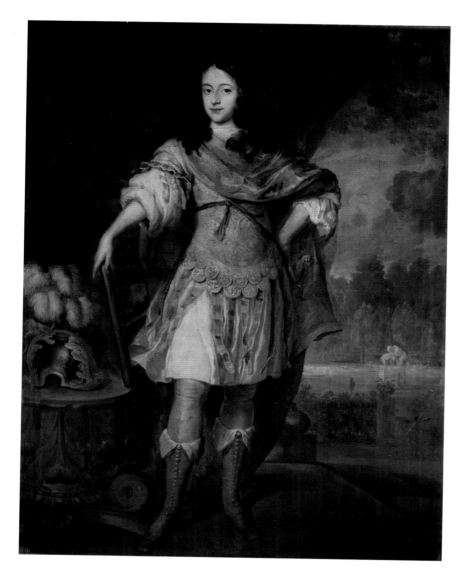

110. *William III when Prince of Orange* by Jan de Baen, *c.*1667.
Wearing fanciful Roman armour, as though about to take part in a court masque, William was 17, and not yet stadholder, when this elegant portrait was painted. In the background is a sculpture of Hercules, with whom William associated himself in his decoration of palaces and gardens, just as his great enemy, Louis XIV, liked to be seen as Apollo.
RCIN 404779

all William III's career was devoted to curbing the French King's aggressive expansionism, it may seem strange that, in visual terms, court culture in both Holland and England under William and Mary was so indebted to France. Yet the House of Orange was French in origin, and in its drive to be recognised as a princely dynasty – stadholder was in theory an elected office – it had modelled its patronage on French royal precedent. One of the finest portraits of William as a young man, by the House of Orange's court artist Jan de Baen (1633–1702), shows him decoratively dressed as a Roman soldier as though he were about to take part in a play or opera on a classical theme, like those performed at Versailles (fig.110).

The painting also demonstrates the impact of Anthony van Dyck on aristocratic portraiture in the Netherlands. William had plenty of opportunity to

see Van Dyck's work on his visits to London and clearly admired it. In 1688, as his army advanced on London, he had paused to view Wilton House, which contained the Earl of Pembroke's famous collection of family portraits by the artist. Since, out of loyalty to James II, Antonio Verrio refused to work for William and Mary, William appointed Godfrey Kneller as his principal painter (initially in conjunction with John Riley, who died in 1691). Kneller's reverence for Van Dyck made him the ideal painter for the official portraits that were required by the new monarchs. They were indebted to Van Dyck, whose influence is also evident in Kneller's group of full-length portraits known as the 'Hampton Court Beauties'.

These paintings are the result of Queen Mary's request that Kneller paint for her the most beautiful women at court, resulting in a set of eight portraits that she hung at Hampton Court. At Kneller's suggestion, the series was confined to English women (so excluding Dutch courtiers), 'for the

111. *Mary II when Princess of Orange* by Peter Lely, *c.*1677.
Perhaps commissioned by her father, the future James II, this portrait shows Mary around the time she married William. The orange colour of her silk dress is unusual and may be a reference to the Dutch flag or to her new title, which prompted her stepmother, Mary of Modena, to nickname her affectionately 'The Lemon'.
RCIN 402587

33
COUNTESS of RANELAGH.

KNELLER.

credit of the nation'. Much later it was recorded that Lady Dorchester told the Queen that limiting the series to beauties was a mistake: 'Madam, if the King were to ask for the portraits of all the wits in his court, would not the rest think he called them fools?', but even if the story is true, there is no evidence that Mary paid attention. The commission emulated Peter Lely's 'Windsor beauties', assembled by Mary's mother 30 years before. Mary herself had been painted by Lely when she was Princess of Orange, a portrait that shows that she was influenced by French fashions in dress and hairstyle, recalling the Francophile tone set at Charles II's court by the Duchess of Portsmouth when Mary was a girl (fig.111). It is notable, therefore, that the Hampton Court beauties owe so little to Lely. Kneller's portraits are not three-quarters but full-lengths (fig.112), evoking the precedent of Van Dyck's major female portraits, and Kneller – no doubt aware of the criticism that Lely made all women look alike – distinguished his sitters in pose, as well as costume and accessories.

More significantly, Kneller avoided the seductive eroticism with which Lely had depicted the Windsor beauties, which must be a reflection of the wishes of the new monarchs. On his first visit to London to meet his uncles, in 1670–71, William had been horrified by the debauchery of court life, hating in particular the heavy drinking in which he was expected to participate. Morally, he did not lead a blameless life – he kept a mistress and his favouritism towards Dutch friends led to accusations of homosexuality – but the tone of the court during the first part of his reign was as different from Charles II's as he could make it. He was encouraged in this by Mary, a pious woman who was concerned about raising standards of public morals. Her warmth of personality and candid expressions of loyalty to England helped to compensate for William's lack of charm and the suspicions of the English court that he placed Dutch needs first. As a result, although the new King was ready to stress his Stuart ancestry, he looked back primarily to his grandfather, Charles I, and the example of his decorous court and happy marriage. He commissioned a bust of Charles I, attributed to the court sculptor Jan Blommendael (1650–1707), which he paired with one of himself (they are now at Windsor) and William's full-length state portrait by Kneller is virtually identical to Van Dyck's of Charles I, painted half a century earlier. William emphasised that royal patronage of Kneller was to be compared with Charles's of Van Dyck by knighting the painter in 1692, and in 1699 he gave Kneller a gold medal with the royal image on it and a gold chain, like those Charles had given to his principal painter.

Hampton Court

Continuity with the past was also a theme of the reconstruction of Hampton Court, where work began in April 1689. Because the palace was used by the court only until 1737 and was preserved with few major changes after that,

112. *Margaret Cecil, Countess of Ranelagh* by Godfrey Kneller, 1690–91. Margaret Cecil was about 18 when she sat for this portrait, which preserved her reputation as a beauty long after her death in 1728. In Henry Fielding's novel *The History of Tom Jones* (published in 1749), the heroine, Sophia Western, is described as 'most like the picture of Lady Ranelagh' in 'the gallery of beauties at Hampton Court'. RCIN 404723

the interiors created there by William and Mary can still be experienced. Many of the original furnishings, including William III's state bed, survive in situ, and others have been brought back or reproduced as part of a restoration of the palace by Historic Royal Palaces following a serious fire in 1986. Prior to 1700 the history of the Royal Collection is one of works of art that, with very few exceptions, have become divorced from the contexts for which they were made or acquired, but from the completion of William and Mary's work at Hampton Court it encompasses surviving furnished interiors.

Wren's first proposal for the palace had been an entirely new building, with echoes of both Versailles and the Louvre, but William and Mary could not wait the many years that construction would take, and decided instead to retain a large part of the Tudor building. However, even Wren's first design had proposed keeping the great hall, almost certainly as a mark of respect for one of Henry VIII's major commissions. The architecture of the remodelled Hampton Court was intended to suggest a new dynasty emerging out of the roots of the old (fig.113).

Respect for the past is also evident in the way the new palace was furnished. The fundamental element was tapestry. William and Mary had new tapestries woven in Brussels, of which two fine armorial hangings designed by Daniel Marot are in the Royal Collection (fig.114), but at Hampton Court they used sets of Henry VIII's Brussels tapestries and some of Charles I's Mortlake tapestries. This was not necessarily simply a tribute to the past, since there was a general revival of interest in tapestry in the late seventeenth century, thanks to Louis XIV's foundation of the Gobelins factory, which made tapestries for the French royal palaces. Nonetheless, the choice

113. Detail of *A View of Hampton Court* by Leonard Knyff, *c*.1702–14. Probably based on drawings made in 1702, this painting may have been intended to form the basis of an engraving, like so many of Knyff's views, but none is known. Seen from the east, the view emphasises the additions to the palace made by William and Mary together with their formal gardens, the most ambitious ever created in Britain. The small square building by the river is William's Banqueting House. RCIN 404760

of works of art for Hampton Court suggests that William and Mary did indeed wish to acknowledge the palace's historic status. In 1689 William and his secretary Constantijn Huygens (1628–97) drew up a list of the paintings in William's apartments in all his palaces in order to allow him to allocate them to Hampton Court or Kensington Palace. With few exceptions, the most significant Old Master paintings were sent to Kensington, leaving Hampton Court as it had evolved over the past century as a setting principally for dynastic portraits.

The major exception was the choice of paintings to hang in the new galleries at Hampton Court. Since William and Mary were joint sovereigns, they were given equal accommodation, and both had large galleries. In 1689 they had the strips of the Raphael cartoons laid out for their inspection in the Banqueting House at Whitehall. Delighted with what they saw – Huygens remarked that they were 'admirably fine, far excelling the prints after them

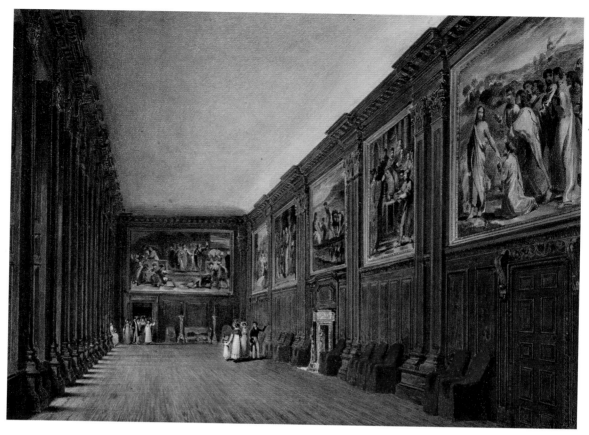

of the best masters' – they ordered the cartoons to be delivered to the royal picture restorer, Parry Walton, to be glued together and put on stretchers. Mary in addition asked for curtains to be made for them. It took some time to decide where to hang the cartoons, but in 1699 they were placed in the King's Gallery (fig.115). By then Mary was dead, having succumbed to smallpox in 1694 at the age of only 32, but her recognition that the cartoons needed to be protected from light was respected by the provision of green silk curtains that could be drawn in front of them. At Wren's suggestion the panelling was carried up behind the cartoons, to help preserve them from damp, and the King ordered a fire to be kept alight in the gallery throughout the winter for the same reason. The Queen's Gallery was treated similarly. Having taken over the room for his own use following his wife's death, William hung it with Andrea Mantegna's *The Triumph of Caesar* (see fig.46), installed in 1702 after a lengthy restoration by first Parry Walton and then Louis Laguerre (1663–1721), a French painter who had moved to England in 1684 to work as an assistant for Verrio. At the same time, Laguerre was commissioned by William to make copies of the Raphael cartoons, the beginning of a sequence of copying and reproduction in print form that continued throughout the eighteenth century. Within a few years of their installation, the cartoons had been transformed from strips of paper kept

115. *Hampton Court Palace: The Cartoon Gallery* by James Stephanoff, 1818.
In 1699 William III had Raphael's cartoons installed in the King's Gallery, which had been left unfinished when Mary II died in 1694. This was the first time the cartoons had been put on display, and they quickly became very famous and were much copied. In 1865 Queen Victoria lent the cartoons to the South Kensington Museum (now the Victoria and Albert Museum), where they remain. In 1992 a set of copies made in 1697 was placed in the gallery, so returning it to the appearance shown here. RCIN 922136

in a trunk into one of most celebrated treasures of Western art. Although the room in which they were displayed was intended for court life – William used it for meetings of the Privy Council – it was soon regarded simply as a picture gallery, a significant new development in the role of works of art in the royal palaces.

A passion for porcelain

In the early 1690s Mary visited Hampton Court regularly to inspect progress, and so needed accommodation at a convenient distance from the building works. She decided to remodel the Tudor watergate to form a substantial garden pavilion, known as the Water Gallery. The interiors were decorated by Marot to a coordinated colour scheme – chairs were painted

116. Ewer and stand (one of a pair), *c.*1694.
Like most of Mary II's Delft, which she commissioned for her palaces in the Netherlands as well as England, these ewers were designed by Daniel Marot and made in De Griexe A ('The Greek A') factory, which from 1686 was run by Adriaen Kocks. In common with many of the Delft manufactories, it took its name from the tavern in whose buildings it was founded.
RCIN 1083

blue and white, curtains were fringed with blue-and-white silk and the set of eight paintings of the Hampton Court beauties were hung here in blue-and-white frames. The reason for this choice of colour was that the decoration took its cue from Mary's large collection of Delftware, ranging from tiles to vases and dairy wares, which Marot integrated into the decoration (fig.116). The inspiration for the décor was French, in this case the blue-and white interiors of the Trianon de Porcelain built at Versailles for one of Louis XIV's mistresses, Madame de Montespan.

As Princess of Orange, Mary had developed a passion for ceramics. Delftware – tin-glazed earthenware made in imitation of oriental blue-and-white porcelain – had been developed by Dutch potters from the late 1650s onwards in response to a Chinese export ban on porcelain that lasted until the 1680s. To judge from the survivors of her Delftware, Mary commissioned pieces by leading factories, made to designs by Marot. After her death, William dismantled the Water Gallery and the Delft was redisplayed at Hampton Court. There are also a few pieces in country-house collections, notably Erddig, Denbighshire, and Dyrham Park, Gloucestershire – probably royal gifts or courtiers' perquisites of office.

Mary collected porcelain with even greater enthusiasm, and brought crates of it with her from Holland. A 1697 inventory of Kensington Palace records no fewer than 787 pieces arranged throughout all nine rooms of her apartment – on mantelpieces, over doorways, on cabinets and on specially made shelves and pedestals. All oriental, since no porcelain was yet made in Europe, it was arranged according to both shape and colour. In the largest room, the 25-feet-long gallery, porcelain took centre stage, as no paintings were hung there. Instead, the walls were covered in scarlet silk brocade spaced out by long strips of embroidery, similar to a set of eight panels designed by Marot that survives at Hampton Court (fig.117). These textiles formed the backdrop to not only the porcelain but also to imported furnishings, including lacquer furniture from Japan and carpets from Turkey or Persia. In Holland, Mary's enthusiasm for lacquer work led to her ordering imported Japanese screens to be chopped up and set into new furniture. She was chastised for this by Huygens, who, in 1685, having observed that pieces of lacquer had been 'sawed, divorced, cut, clift and slit asunder', suggested that the Queen should instead give precise measurements for what she required to the merchants who commissioned such pieces for import.

Displays of porcelain were not unprecedented in the Royal Collection – Charles I had shelves specifically made for his 65 pieces at Whitehall – but nothing on this scale had been seen in Britain before. Although it included many 'useful' wares – cups and saucers, teapots and even mustard pots – the display was designed for show. Mary kept her porcelain intended for use, notably for the new fashion of tea drinking, in a backstairs closet. It seems likely that a mid-seventeenth-century *blanc de*

117 (opposite). Wall hanging (one of eight), 1680–1720.
Embroidered in wool, these panels were made as interior decoration, to be hung like pilasters against silk wall hangings. This set was first recorded in Queen Mary's Closet at Hampton Court in the eighteenth century; similar embroideries were used in her gallery at Kensington Palace. Designed by Daniel Marot, the hangings were made by professional embroiderers in either London or the Netherlands.
RCIN 28228

118. Wine pot and cover, mid-seventeenth century.
Made in China, and intended for wine, this hexagonal white porcelain pot was used in England for tea. It can probably be identified with an item in an inventory of Mary II's porcelain at Kensington Palace, drawn up in about 1693, a 'very large white Tea Pott and cover with white figures all over the outside', which was kept 'In the Backstaires for constant use'. If so, it is one of the very few pieces of her large collection of oriental porcelain that can be securely identified today.
RCIN 1182

chine spouted vessel is the white 'teapot' decorated with figures in relief that was listed there in 1697 (fig.118). The display she created did not long outlive the Queen, since in 1699 William gave all the porcelain at Kensington to Arnold Joost van Keppel, 1st Earl of Albemarle (1670–1718), a signal mark of favour to the handsome young man who had become the King's closest friend after Mary's death. Keppel installed most of it at his country house, De Voorst, near Zutphen, to judge by the 700 pieces that were there in 1744, when his collections were sold at auction. The only pieces of Mary's porcelain that can be securely identified in the Royal Collection today are a pair of Chinese mid seventeenth-century, blue-and-white covered jars that have seals attached to their bases impressed with William and Mary's coat of arms. Nonetheless, this strongly suggests that other pieces of Chinese porcelain that are known to have been at Hampton Court since the eighteenth century also belonged to Mary.

Furnishing Hampton Court and Kensington Palace for William III

119. *Still Life with Flowers, Insects and a Shell* by Maria van Oosterwyck, 1689.

This is the last documented work by Van Oosterwyck, an acclaimed flower painter of the seventeenth century. Her works were eagerly collected by royal patrons, including Louis XIV, Emperor Leopold I and William III, although as a woman she was refused admittance to the painters' guild in Amsterdam, where she worked. In this still life she has painted various kinds of rose together with a carnation, convolvulus, ranunculus and marigold, on which have settled a bee, butterfly and dragonfly.
RCIN 405625

120. Side table (one of a pair) by Jean Pelletier, c.1701.

The Pelletier family of carvers and gilders emigrated from France to Amsterdam in the early 1680s, probably because they were Protestant. By 1682 Jean Pelletier had established himself in London, where he was joined by his sons, René and Thomas. Among the furnishings they supplied for William III's apartments at Hampton Court were side tables, of which this is one, designed to be displayed below ensuite mirrors between tall candlestands. The Pelletiers charged £35 for each table.
RCIN 21597

After Mary's death in 1694 work at Hampton Court stopped for three years, partly because the King was grief stricken, partly because, thanks to his frequent absences, he had relied on his wife to supervise the work, and partly because of a shortage of money that was not remedied until the Treaty of Ryswick in 1697 suspended the war with France. In the same year, William ordered work at Hampton Court to begin again, and it was pressed ahead so quickly that in 1700 the court was finally able to move in.

The main responsibility for organising the furnishing of the palace now fell to Ralph Montagu, later 1st Duke of Montagu, who was Master of the Great Wardrobe. He had been Charles II's ambassador to France and his strongly francophile tastes were influential in London. Most of the interiors at Hampton Court are the work of foreign or immigrant craftsmen, and even the most distinctively 'English' element, the decorative limewood carvings by Grinling Gibbons, are by a craftsman trained in the Netherlands. Gibbons's work was attuned to a characteristically Dutch enthusiasm for naturalistic paintings of flowers, birds and animals, exemplified by paintings by Maria van Oosterwyck (1630–93) that probably belonged to William and Mary (fig.119). By the late seventeenth century, this taste was well established in French, as well as English, courtly circles, and in 1690 the leading flower-painter in Paris, Jean-Baptiste Monnoyer (1636–99), moved permanently to London, and worked for William and Mary at Kensington Palace and Hampton Court. For Kensington he painted a now-lost looking glass with flowers, a novel idea that so intrigued Mary that she insisted on watching him at work. She and William also employed the flower and bird painter Jakob Bogdani (1658–1724) in both the Netherlands and England. Several of his paintings of flowers in elaborate silver or gold vases survive in situ

as overdoor paintings at Hampton Court. Montagu oversaw the repair, cleaning and relining of the tapestries William and Mary had selected for reuse at Hampton Court, many of which were given new blue and grey borders, and 6,000 hooks and tacks were ordered for hanging them. Thanks to his influence, the contract for new giltwood furniture was awarded to an immigrant Huguenot firm run by Jean Pelletier (d.1705), whose pier tables for the King's Apartment were based on published designs for furniture at Versailles (fig.120).

As originally finished, the burnished gilding of this furniture was intended to suggest gilt metal, in a relatively inexpensive echo of the French royal fashion for furniture made of precious metals that had been taken up by Charles II at Whitehall in the 1670s. Louis XIV had been forced to melt down his silver furniture to pay for his wars, which makes the survival of a spectacular suite of silver furniture created for William in emulation of his old enemy all the more precious. Supplied for Kensington Palace by the London silversmith Andrew Moore (1640–1706), the suite was almost certainly designed by Marot (fig.121).

121. Side table by Andrew Moore, 1698–9.
In 1698 William III ordered a magnificent suite of silver furniture for Kensington Palace, inspired by a fashion for furnishings in precious metal that had begun at Versailles. Probably designed by Daniel Marot, this table consists of silver legs with an oak top covered in sheets of silver engraved with the royal arms surrounded by the arms of England, Scotland, Ireland and France (the last was historically claimed by the English crown). Moore also supplied an ensuite silver mirror and pair of candlestands, of which only the mirror survives. RCIN 35301

The influence of French royal taste was also evident in William's liking for furniture inlaid with marquetry of pewter and brass, a technique associated with French royal cabinetmakers such as Pierre Golle and André-Charles Boulle. In London such work was carried out exclusively by an immigrant Dutch or Flemish cabinetmaker, Gerrit Jensen (d.1715), maker of a very fine writing desk made of ebony, rosewood and boulle marquetry (fig.122). Glass-seller as well as Cabinet Maker in Ordinary to the King, Jensen also supplied mirrors to the royal palaces. William asked him to enlarge the mirrors made for his closets at Hampton Court, presumably because he needed more light in the rooms where he transacted private business. Here also he kept other furnishings of practical use, including clocks and – a recent English invention – barometers (fig.123).

William III and painting

The final element of Hampton Court's interiors was mural painting. By about 1701 William had enticed Antonio Verrio back into royal service, overlooking both his Roman Catholicism and loyalty to James II in favour of creating the sort of relationship that Louis XIV enjoyed with the painter Charles de La Fosse in the decoration of Versailles. Indeed, De La Fosse had worked in London in 1690–92 for Montagu, but had to refuse William's invitation to participate in the decoration of Hampton Court when he was ordered back to Paris to paint the dome of Les Invalides. Among the first projects Verrio undertook for William, probably in collaboration with Monnoyer, was the decoration of a new banqueting house in the grounds, a scheme that was probably overseen once again by Marot. Verrio

then embarked on the ceilings of the King's Apartment, but only two had been completed when William died unexpectedly of pulmonary fever in March 1702.

William is not remembered as a monarch who helped to shape the Royal Collection, except in a negative way by removing paintings permanently from it. There is no doubt that he was interested in the collection: in his diary, Huygens records conversations about pictures, and William's order in 1695 that paintings in his private apartments should be hung from cords, implies a desire to be able to rearrange them easily. Although he is not known to have bought Old Master paintings for London, for his Dutch houses he acquired works by, or attributed to, Titian, Sebastiano del Piombo, Rubens and Van Dyck, suggesting a taste close to Charles I's. He also took a group of about 30 paintings from London to Het Loo. These included Gerrit Dou's *The Young Mother* (1658), which the States General had given Charles II in 1660, but the majority were Renaissance portraits, including two by Hans Holbein, one of which depicts Henry VIII's chief falconer Robert Cheeseman, and two by Piero di Cosimo (1462–1522). The latter are unattributed in the royal inventories but it is possible that William thought they were northern, since in Holland they were described as being 'in the manner

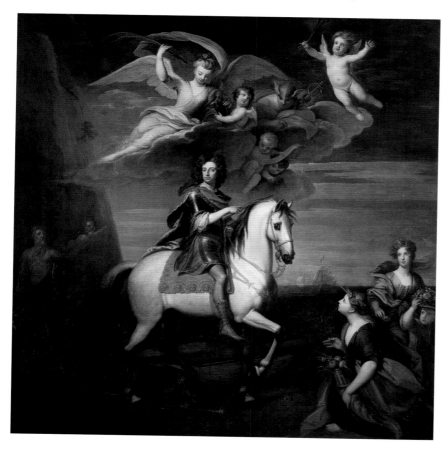

124. *William III on Horseback* by Godfrey Kneller, 1701.
In this celebration of William's return from the negotiations that led to the Treaty of Ryswick of 1697, which ended the war between France and England, Kneller depicts the King's horse trampling emblems of war. Watched by Neptune, he is greeted by Ceres and Flora with the attributes of peace and plenty. Above him is Mercury accompanied by putti and a female figure who carry palm branches, symbols of victory, together with the King's helmet, which he can now lay aside.
RCIN 403986

125. *Charles I on
Horseback* by Anthony
van Dyck, *c.*1635–6.
Although Van Dyck's
equestrian portrait of
Charles I was not
recovered after the
Commonwealth sale
(it is now in the National
Gallery, London), this
small-scale preparatory
painting remains in
the Royal Collection.
Charles's face was almost
certainly painted from
life. Treasured by
William III, the painting
clearly inspired his own
equestrian portrait by
Kneller (fig.124), who
revered Van Dyck.
RCIN 400571

of Albert Dürer'. After William's death, Queen Anne (1665–1714) tried to get the paintings returned. Although she was unsuccessful, they were, as a result, held back from the sale in 1713 of the stadholder's art collection, and so most remained in the Netherlands; the portrait of Cheeseman is now in the Mauritshuis and the Piero di Cosimo portraits are in the Rijksmuseum. There is no obvious explanation for William's choice of these portraits to take to Holland: perhaps he simply selected works of a type that he thought was abundantly represented in London but uncommon in his homeland.

William commissioned relatively few works of art, apart from the flower paintings mentioned above. Despite being a military man, he did not seek depictions of his successes in the field, nor, unlike Mary, did he show much interest in portraiture, whether of himself or others. The one major exception is the equestrian portrait of William painted by Godfrey Kneller in 1701 for the King's Presence Chamber at Hampton Court, where it remains. This enormous canvas, nearly 4½ metres square, depicts William returning to England in triumph from the negotiations that led to the Peace of Ryswick (fig.124). The painting fits well with the grand allegorical manner of Verrio's

decoration of Hampton Court, but it also looks back to Van Dyck's portrait of Charles I on horseback. Sold under the Commonwealth, the painting was then in the collection of the Elector of Bavaria, but William hung Van Dyck's modello for it in his private apartment at Hampton Court (fig.125), together with the paintings of Roman emperors by Giulio Romano that had belonged to Charles. William is largely remembered in Britain as a foreigner, Dutch in his tastes as well as by birth, but to him it was important that he was a Stuart also.

Queen Anne

Among Queen Anne's first acts, after succeeding her brother-in-law, was to refuse to pay for Kneller's equestrian portrait. This reflected her dislike of William, who had treated her husband, Prince George of Denmark, with contempt – she also rejected statues of William that he had ordered for the gardens at Hampton Court. On the whole, however, she maintained her predecessor's patronage in the visual arts, although she took much less interest in them than she did in music and theatre. She authorised Verrio to continue the painting at Hampton Court, and Kneller remained in post as her principal painter. Having produced the official portraits of the new Queen, Kneller was asked by Anne to contribute to a series of portraits of 14 of her admirals (now in the National Maritime Museum), on the model of a similar series painted by Lely for her father when he was Duke of York. Yet the fact that she divided the commission between Kneller and the Swedish painter Michael Dahl (1659–1743), who had settled in London in 1689, suggests independence of taste. Further evidence of that is a letter Anne wrote in about 1693 to her close companion Sarah Churchill, later Duchess of Marlborough, reporting on a visit to Dahl in his studio: 'there was but a few pictures of people I know but those weare very like & the work me thinks looks more like flesh & blood than Sr Godfrey Nellars'. Dahl had been taken up by Prince George, and his principal painting in the Royal Collection is a portrait of the Prince on horseback, painted in 1704 and hung in the Queen's Guard Chamber at Windsor Castle, a stolid riposte to Kneller's equestrian portrait of William III.

Although Anne's reign witnessed great military triumphs under the Duke of Marlborough, little echo of them is found in the Royal Collection. In 1703 she offered an unusual commission to a protégé of Dahl, the Swedish-born miniature painter Charles Boit (1662–1727), whose skill in enamel painting had led him to be appointed enameller to William III in 1696. She asked Boit to paint a large miniature (about 60 x 40 cm), commemorating the Battle of Blenheim. Painting and firing an enamel on such a large scale was a technical challenge that defeated even Boit, and after a decade of unsuccessful experiments he had to return his fee, whereupon debt forced him to move to France. However, he had by then produced for the Queen

126. *Queen Anne and Prince George of Denmark* by Charles Boit, 1706. Valued by his patrons for their richness of colours, Charles Boit's enamel paintings are usually copies of portraits by artists such as Kneller. However, in this unusually large example (25.4 x 18.4cm) he worked from life to produce a rare double portrait of the Queen and her husband. Despite some minor cracks in the top left-hand corner, which probably occurred before the final firing, the enamel is a technical tour de force. RCIN 421497

one of his most ambitious enamels, a double portrait of Anne and her husband, painted from life in 1706 (fig.126). It is a rare portrait of them together, partly because Anne was unable to sponsor paintings of a royal family, since her only surviving child, William, Duke of Gloucester, had died in 1700 at the age of 11.

Portraits apart, Anne's major acquisition for the Royal Collection was a group of eight paintings by Jakob Bogdani. The purchase echoed William III's liking for the artist, but there was also an added personal motive for the acquisition. The paintings record the inhabitants of an aviary that Sarah Churchill's brother-in-law, Captain George Churchill, had built in what is now the Home Park at Windsor, of which he was deputy ranger. After he retired from the navy in 1708, he commissioned Bogdani to paint these scenes of exotic birds and animals (fig.127), which Anne acquired from George's executors after his death in 1710. The high proportion of birds from South America and the East Indies in the paintings suggests a Dutch

127. *Birds in a Landscape* by Jakob Bogdani, c.1691–1710.
One of the few artists in whom Queen Anne took a particular interest was Bogdani, a Hungarian painter who moved to England in 1688. Having worked for several years in Amsterdam he brought with him a Dutch fashion for large-scale decorative paintings of exotic birds in landscape settings. In this canvas, a flamingo is accompanied by turacos, two curassows, a guan, a troupial and, on a branch, a chachalaca.
RCIN 402908

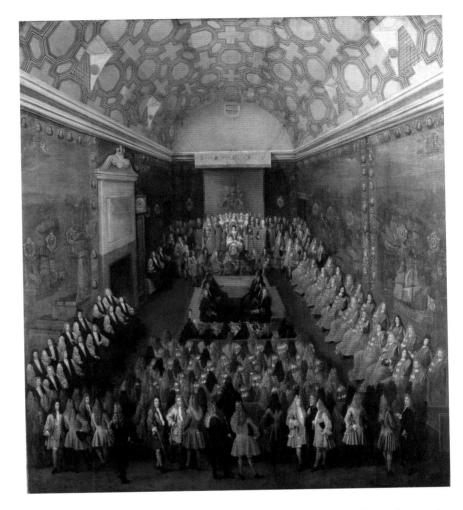

128. *Queen Anne in the House of Lords* by Peter Tillemans, *c.*1708–14. This is one of a pair of paintings by Tillemans showing the Houses of Parliament (the other depicting the House of Commons is in the Parliamentary Art Collection). The chamber is hung with the 'Armada' tapestries, commissioned in 1592 to celebrate the battle, which were lost in the fire that destroyed most of the Palace of Westminster in 1834. The coffered ceiling was designed by Inigo Jones in 1623.
RCIN 405301

source for them, perhaps via the merchants who imported exotic species into Rotterdam. The paintings are an early example of the fascination with natural history that is a prominent theme of the Royal Collection in the eighteenth century.

Anne was undoubtedly conscious of her Stuart inheritance but, unlike her predecessors, she enjoyed a largely harmonious relationship with both Church and parliament. In part due to the circumstances by which William came to the throne, and his continuous need for money for military purposes, parliament had assumed a new centrality in national life. This is conveyed in a painting of the Queen in the House of Lords by Peter Tillemans (*c.*1684–1734) that was perhaps commissioned by the House (fig.128). Reflecting the new reality of parliamentary democracy, Anne is depicted as a small figure, almost the equal of her peers. Her reign set the course for the monarchy under the Hanoverians, in which the court was no longer the principal seat of political power, and was only intermittently a leading cultural force.

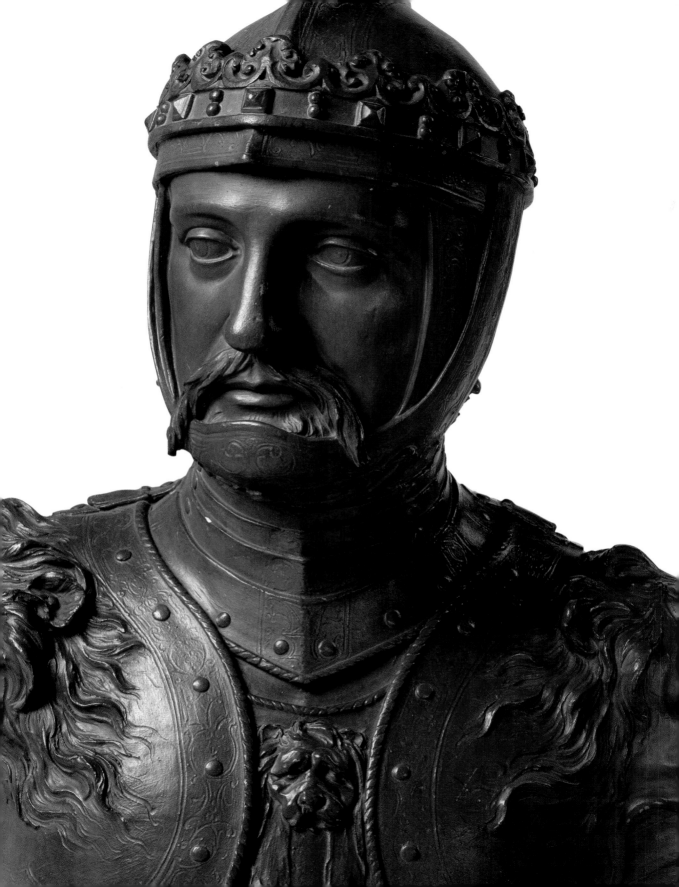

A NEW DYNASTY

From George I to Frederick,
Prince of Wales

On 18 September 1714, a little over six weeks after the death of Queen Anne, her successor alighted in Greenwich. Georg Ludwig, Duke of Brunswick-Lüneburg and Electoral Prince of Hanover (1660–1727), had last visited the country, of which he was now king, 34 years before. George, who could speak only a few words of English, spent nearly three years out of his 13-year reign in Hanover, where he continued to be Elector. This absenteeism has led to a belief that George left little mark on his adopted country and took no interest in its cultural life, apart from his patronage of the composer George Frideric Handel (1685–1759), who had worked for him in Hanover. However, George was quick to make use of the network of painters in royal service. Godfrey Kneller continued as principal painter, and he remained in post until his death in 1723, having painted every monarch from Charles II to George II. Kneller's German birth must have been an advantage, but George I clearly admired his work, since in 1715 he awarded him a baronetcy, the highest honour accorded to any artist in Britain before Frederic Leighton was raised to the peerage in 1896. The leading decorative painter at court was Louis Laguerre, but George preferred James Thornhill (1675/6–1734), whose career was boosted by a wish to employ home-grown talent. In 1714 Thornhill was commissioned to paint the Prince of Wales's bedroom at Hampton Court because, said Lord Halifax, 1st Lord of the Treasury, a failure to give such a prestigious job to a native artist 'would prevent & discourage all countrymen everafter to attempt the like again'. In 1718 he painted decorative panels for a new state coach (fig.129), and was appointed the King's History Painter in Ordinary. Two years later George knighted him, the first time a British-born artist had been so honoured, principally in recognition of Thornhill's two greatest achievements, the Painted Hall at Greenwich and the murals on the interior of the dome of St Paul's Cathedral.

George I's palaces

George disliked the formality of English court life, preferring to manage with a small household. Resentment was stirred up when he dispensed with most of his bedchamber staff in favour of two trusted Turkish servants

129. *Panel for a Royal State Coach: Britannia Receiving Homage from the Continents* by James Thornhill, *c.*1718.
A number of panels painted by Thornhill for George I's state coach have survived, scattered among several collections, but there is no record of how they were arranged. Thornhill's bravura technique was well suited to this sort of decorative art, designed to be seen from a distance. Europe is shown with her attribute of a horse, which is perhaps also an allusion to the heraldic emblem of Hanover.
RCIN 407518

brought from Hanover, Mehemet and Mustapha. Mehemet (*c.*1660–1726), who was also in charge of the King's Privy Purse, was painted in 1715 by Kneller, presumably at the King's request (fig. 130).

George's most notable architectural commission in England was the addition of state rooms to Kensington Palace. These new interiors, a Privy Chamber, Cupola Room (fig. 131) and large Drawing Room, provided space for formal court functions, so making good a lack that must have been felt since the destruction of Whitehall Palace. They are significant as embodiments of a new movement in architecture and design that was to dominate the eighteenth century, away from the dramatic Baroque style practised by such architects as John Vanbrugh in favour of an austere classicism that looked back to the sixteenth-century Italian architect Andrea Palladio, who had been so influential on Inigo Jones.

Although the reason given for not employing Thornhill to decorate the new rooms at Kensington Palace was expense, he was, in reality, a victim of this abrupt shift in taste. The commission was given instead to a younger painter, William Kent (1685–1748), who was setting out an a career that would range from painting and interior decoration to the design of furniture, buildings and gardens. Over the next 15 years he came to assume an even more significant role at court than Daniel Marot had enjoyed under

130. *Mehemet* by Godfrey Kneller, 1715.
George I brought with him from Hanover two Turkish bodyservants, Mehemet and Mustapha, both captives in the wars against the Turks. Converts to Christianity, and deeply loyal to the King, they controlled access to his private rooms, causing resentment among English courtiers. In 1716 Mehemet, who also kept the King's private financial accounts, was rewarded with an imperial title at George's request: 'von Königstreu', meaning 'loyal to the King'. Kneller's portrait may have been painted in anticipation of this honour.
RCIN 405430

A New Dynasty

131. *Kensington Palace: The Cupola Room* by Richard Cattermole, c.1817.
One of three large reception rooms added to Kensington Palace for George I in 1717–19, the Cupola Room was painted by William Kent, his first royal commission. The ceiling, painted in imitation of coffering, culminates in the Garter star. Kent also designed the tables and chandeliers. At the centre of the room is a large musical clock made by Charles Clay, which was placed here by Augusta, Princess of Wales in about 1743. This watercolour was made for W.H. Pyne's *History of the Royal Residences* (1816–19). RCIN 922156

132. The King's Gallery, Kensington Palace.
The gallery was remodelled by William Kent in 1725–7. He had to retain the cornice and William III's wind-dial over the chimneypiece, but otherwise all the fittings are his, as is the ceiling, painted with scenes from the stories of Ulysses. Kent's decoration and arrangement of the works of art was recreated in 1993–4, in part using copies of such paintings as the Van Dyck portrait of Charles I on the end wall.

William and Mary. Kent's work at Kensington Palace, carried out in 1722–7, demonstrates his authoritative knowledge of classical architecture and decoration, learned during a decade he had spent in Italy, from 1709 to 1719. Among the consequences for the display of the Royal Collection was a new stress on the importance of sculpture in interiors, following Roman precedent. In the Cupola Room gilt-lead casts of antique sculpture filled the niches, and a marble relief of a Roman marriage carved by John Michael Rysbrack (1694–1770) was placed over the chimneypiece.

Kent also redecorated the King's Gallery at Kensington, built for William III as a place to display Old Master paintings. The original treatment of the walls, green velvet hangings framed in brown wood, was replaced by red silk damask set off by white woodwork, a novel combination that was to become a customary form of decoration for picture galleries in Britain (fig. 132). Sculpture was introduced in the form of classical busts on plinths together with personifications of the seasons by the Roman sculptor Camillo Rusconi (1658–1728; fig.133). Kent also instigated a new sort of picture frame, architectural in form, like the surroundings he designed for doors and window, thereby integrating the display of paintings with interior decoration more tightly than before. Large canvases, mostly Venetian, were hung opposite the windows, with Van Dyck's 'Great Peece' and the equestrian portrait of Charles I with M. de St Antoine on the end walls (see figs 59 and 60), a tribute to the collector of these masterpieces. Kent arranged the pictures with an exacting symmetry that was recreated (in part using copies) when the gallery was restored to its early eighteenth-century appearance by Historic Royal Palaces in 1993–4.

The significance that Kent placed on the architectural disposition of pictures was so great that the frames became near-permanent fixtures, left in place when the paintings within them were changed. Another consequence was that canvases were readily altered in size to fit the requirements of the decoration. Presumably with the needs of the new state rooms at Kensington in mind, in 1723 the King bought six large paintings from John Law (1671–1729), formerly Controller General of Finances in France. They included two outstanding works by Rubens, his equestrian portrait of Don Rodrigo Calderon (then thought to represent the Duke of Alba) and *The Holy Family with St Francis* (fig.134). Kent installed the latter in the Drawing Room in a frame that formed an architectural unity with the chimneypiece, also designed by him. The painting was enlarged by no less than 60 cm at the top to give it the upright format Kent's scheme required, a change that has since been amended.

134. *The Holy Family with St Francis* by Peter Paul Rubens, 1620–30.
Bought by George I in 1723 from the financier John Law, this outstanding work was the wrong shape for its intended position, above the chimneypiece in the Great Drawing Room at Kensington Palace. William Kent had it extended by 60 cm at the top, a change that has since been reversed. It is still in Kent's original frame (also reduced in size), an early example of the way he designed frames as elements of unified architectural schemes.
RCIN 407674

George II

George I initiated a family tradition that was to last over a century: bad relations between the monarch and his heir. During his absences in Hanover George I refused to let the Prince of Wales serve as regent, and it was only with reluctance that he allowed him to be appointed 'Guardian of the Realm', a title unearthed from the fourteenth century, when it had been used by the Black Prince. In 1717 mutual resentment tipped over into a quarrel and the King ordered the Prince and Princess of Wales to move their households out of St James's Palace. From then on they lived principally in Leicester House in Leicester Fields (later Leicester Square), and spent their summers in a house bought by Prince George in 1719, Richmond Lodge, on the edge of the deer park at Richmond. It was not until 1720 that the Prince and his father were grudgingly back on speaking terms. This unhappy family saga, which was to be repeated in the next generation, had some fortunate consequences for the Royal Collection. Successive Princes and Princesses of Wales had both a practical incentive to buy and commission works of art – to furnish their independent establishments – and a motive to cultivate tastes that would distinguish them from the monarch.

135. Open armchair (one of a pair) by Henry Williams, 1737.
Supplied for the Queen's Withdrawing Room at Hampton Court, this pair of armchairs was accompanied by an ensuite set of 24 stools, all covered in 'green genoa damask'. Made by Henry Williams, whose workshop was in Long Acre, London, they were almost certainly designed by William Kent. The X-form of the front legs is derived from Italian chairs of the fifteenth and sixteenth centuries. The armchairs symbolised the presence of the King and Queen and were not for use, since the royal couple stood when entertaining in the Withdrawing Room. RCIN 31178

Prince George, who succeeded his father in 1727, participated more willingly in the ceremonial life of the monarchy. Unlike his father, who was divorced, he was happily married to Caroline of Ansbach (1683–1737), whose interest in art and scholarship impressed her contemporaries even if they sometimes baffled her husband. George II's favourite palace was Hampton Court, and for the decade between his accession and the death of Queen Caroline in 1737 it was the centre of court life. Large sums were spent on redecorating and refurnishing the state apartments under the direction of William Kent, and changes were made to the arrangement of works of art. *The Triumph of Caesar* (see fig.46), which in 1717 had been restored and reframed on George I's orders, was moved into the Queen's Drawing Room, where the now old-fashioned murals by Thornhill were covered up. The canvases were replaced in The Queen's Gallery with a set of tapestries depicting the the life of Alexander the Great, woven to a design by Charles Le Brun (1619–90) for Louis XIV, which George II bought in 1727. Below the tapestries was a new set of giltwood furniture, part of a large quantity of new furnishings for Hampton Court designed by Kent. These included a pair of magnificent armchairs (fig.135) and 24 ensuite stools made for the Queen's Withdrawing Room, where George and Caroline received large assemblies of guests.

There is little evidence that George II shared his father's interest in art. In 1734 he did, however, pay for Kent to restore Rubens's ceiling in the Banqueting House, and joined the Queen in climbing the 40-feet high scaffold to inspect the work. Like his father, the King hated having his portrait painted, but was willing to make an exception for the leading miniature painter at court, the enamellist Christian Friedrich Zincke (c.1684–1767), whose company he enjoyed. Zincke had moved to London from Dresden at the suggestion of Charles Boit, whose attempt to make an oversized enamel picture of the Battle of Blenheim for Queen Anne had been a failure. Zincke's work, although less ambitious in scale, is technically flawless and his numerous miniatures include some of the most engaging portraits of George, Caroline and their family (figs 136 and 137). The outstanding sculptor then at work in Britain, Louis-François Roubiliac (1702–62), carved a bust of George II but the initiative for that was taken by an old comrade in arms, John, 1st Earl Ligonier (1680–1770). He had fought with Prince George, as he then was, in the victory over Louis XIV at Oudenaarde in 1708. At Dettingen in 1743, the last occasion on which a British sovereign commanded troops in

136 and 137. *George II, c.1727*, and *Queen Caroline*, 1727, by **Christian Friedrich Zincke** Zincke was the best-known miniaturist working in enamel in London in the first half of the eighteenth century. George II thought his portraits were 'beautiful and like' but this miniature, although probably painted from life, makes him look much younger than his mid forties, perhaps in response to the Queen's request 'to be sure to make the King's picture young not above 25'. Caroline is shown in state robes, fastened by a gold Medusa brooch. Medusa's head was an attribute of Athena, goddess of wisdom. RCIN 421796 and 421820

138. *John, 1st Earl Ligonier* by **Louis-François Roubiliac**, *c.1760*. Ligonier was born in France to a Huguenot family that moved to England after 1685. Having joined the army in 1702 and served under Marlborough at Blenheim, among other battles, he became the outstanding commander of his generation. In 1757–9 he was Commander-in-Chief of British forces, which may have prompted the creation of this masterly bust. RCIN 35256

battle, George invested Ligonier with the Order of the Bath, which had been founded by George I in 1725. Its badge is proudly displayed in the superb bust that Roubiliac carved of Ligonier at the same time as that of the King (fig. 138).

Caroline and George had a close relationship in many ways, but the King often worked his tempers off on his long-suffering wife. There are vivid descriptions of his bad behaviour to her in the memoirs of the courtier Lord Hervey, and although Hervey played up the King's boorishness to highlight the good nature of his friend the Queen, his accounts of George's impatience with her artistic interests convincingly evoke a husband seeking to impose his authority in an area where his wife was more knowledgeable. In 1735, for example, George objected to the way that in his absence she 'had taken several very bad pictures out of the great drawing-room at Kensington, and put very good ones in their place'. Ordering that all the old paintings should be returned, George rounded on Hervey: 'I have a great respect for your taste in what you understand, but in pictures I beg leave to follow my own: I suppose you assisted the Queen with your fine advice when she was pulling my house to pieces and spoiling all my furniture: thank God, at least she has left the walls standing!' When Hervey slyly asked if the King wanted 'the gigantic fat Venus restored too', he was told, 'Yes, my Lord; I am not so nice as your Lordship. I like my fat Venus much better than anything you have given me instead of her.' It seems likely that George was referring to a large *Venus and Cupid* by Giorgio Vasari (1511–74) after a design by Michelangelo that is still in the Royal Collection.

Queen Caroline

Vasari's *Venus and Cupid* had been a gift to George from Caroline, whose degree of interest in the visual arts was unmatched by any Queen consort since the time of Henrietta Maria. Her intellectual outlook was a result of her upbringing at the court of the Elector of Brandenburg in Berlin, renowned for its artistic and architectural patronage. Her strong interest in the genealogy and history of the British royal family was reflected in her appreciation of works of art as documents that provided evidence about the past. This attitude was shared by George I, who must surely have been consulted about the choice of paintings to be hung in the redecorated state bedchamber in the apartments at Hampton Court occupied from 1714 by George and Caroline as Prince and Princess of Wales. A portrait of James I & VI by Paul van Somer was placed over the chimneypiece, flanked by portraits of Anne of Denmark by Van Somer and Elizabeth of Bohemia (George I's grandmother) by Daniel Mytens. Van Dyck's posthumous portrait of Henry, Prince of Wales, was placed over the door that led into the Privy Chamber. This arrangement laid explicit stress on George I's Stuart ancestry, and Caroline's own interest in royal portraits has been interpreted

as a desire to legitimise the Hanoverians in the face of a Jacobite threat that continued until 1745, when Bonnie Prince Charlie's uprising was crushed.

However, Caroline's interest in history was broader than that, as she sought out portraits that would form a wider visual history of the English monarchy, both for her own education and, perhaps, for that of her children. She persuaded Lord Cornwallis, whose family had a history of service to the Crown stretching back into the sixteenth century, to sell her a group of portraits of monarchs ranging from Edward II to Mary I, which she supplemented by purchases of portraits of Henry IV and Elizabeth I. Most of these were hung in her private rooms at Kensington Palace, together with some of the early portraits in the Royal Collection, including Hans Eworth's *Elizabeth I and the Three Goddesses* (see fig.23). Her interest in historical paintings also attracted gifts, notably *The Memorial of Lord Darnley* (see fig.34), given to her in about 1736 by her Master of the Horse, the Earl of Pomfret, whose wife, Henrietta, was a Lady of the Bedchamber and shared the Queen's antiquarian interests. Caroline also commissioned paintings on historical subjects: Kent painted three canvases for her depicting the life of Henry V, which were hung in her dressing room at St James's Palace.

The Queen also systematically gathered together the historic miniatures in the Royal Collection, which she hung on the walls of her Picture Closet at Kensington Palace, a small room that had previously been William III's Little Bedchamber. They were supplemented by her best-known contribution to the appreciation of the Royal Collection, the study and display of the Hans Holbein drawings. She had found these in a bureau at Kensington, and although it is sometimes assumed that they had been forgotten in some bottom drawer, an inventory of the bureau's contents reveals that it contained all Charles II's Old Master drawings, including those by Leonardo. They may have been moved here from Whitehall by William III when he reorganised the picture collections. Caroline had the Holbein volume disbound so that she could frame the drawings and hang them – not a wise move in conservation terms, but luckily George III had them put back into portfolios before they could fade. Her discovery may have prompted Caroline (or perhaps her husband) to buy Holbein's portrait of Sir Henry Guildford (see figs 14 and 15). Among the other elements of the Queen's Cabinet Room were large collections of coins, medals, cameos and gems (figs 139–142). Caroline was the first member of the royal family to show a sustained interest in historic gems, and she made interesting additions to the few that had survived in the Royal Collection from the sixteenth and seventeenth centuries. They include two cameos depicting Henry VIII, imitating Holbein portraits: it is not known whether she was aware these were in fact modern.

Caroline's independent architectural commissions were modest in scale but rich in iconographical interest. Regrettably, none have survived. On his accession, George settled Richmond Lodge on the Queen as a potential dower house. This provided her with a semi-private retreat to pursue one

139 to 142. Gems collected by Queen Caroline.
The carver of the outstanding *Adoration of the Magi* cameo is unknown, but it was probably made in northern Italy in the sixteenth century. Although the cameo of Henry VII and his son, Edward, is derived from portraits by Hans Holbein, it was almost certainly made in the early eighteenth century. The gold pendant with a bust of an unidentified woman may have been made in France in the mid sixteenth century, using a fragment of an Italian cameo. The agate bust of Hercules is probably an Italian sixteenth-century mount for a piece of furniture. RCIN 65740, 65249, 65175 and 65189

of her major interests, gardening. While still Princess of Wales she had the grounds at Richmond laid out for her by the leading designer Charles Bridgeman (1690–1738), who was at the same time overseeing large additions to the gardens at Kensington Palace. She commissioned Kent to design two garden buildings for Richmond. One was a thatched Gothic structure called Merlin's Cave, furnished with tableaux of waxwork figures from mythology and history, including Elizabeth I. These puzzled contemporaries, since no programme was provided, but the ensemble seems to have been designed to evoke Merlin's legendary prophecy of a sovereign who would unite the British people. Kent's other Richmond building was a spacious classical hermitage, equipped with a library and bedroom, built in 1731–2. Nothing of Merlin's Cave remains, but a series of five marble busts survives from the hermitage. Carved by Giovanni Battista Guelfi (1690/1–1736), who had moved to England in 1714 as a result of meeting Kent in Rome, the busts are posthumous portraits of eminent British philosophers and scientists, including Newton and Boyle (fig. 143). All had in common a belief in natural theology – that study of the laws of nature supported Christian faith. In 1735 Caroline commissioned a second series of busts, depicting royal figures from medieval and Tudor history, for a new library that Kent had designed for her at St James's Palace. Guelfi had by then returned to Italy and so the job was given to Rysbrack, who had worked at Kensington Palace for George I and had maintained a close working relationship with Kent. The 11 busts of monarchs, which included Alfred, the Black Prince (fig. 144), Henry V and Elizabeth I, were modelled in terracotta, but if there was an intention to carve them in marble, the idea was abandoned when Caroline died in November 1737.

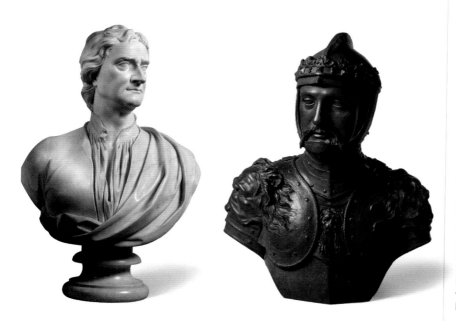

143. *Isaac Newton* by **Giovanni Battista Guelfi**, 1730–31.
Queen Caroline commissioned Guelfi to carve five busts of leading English scientists and philosophers for a hermitage that Kent had designed for her garden at Richmond. This sort of sculptural pantheon was a new idea in England, and the focus on men of learning was unprecedented. Robert Boyle was placed at the centre, flanked by Isaac Newton, John Locke and the theologians William Wollaston and Samuel Clarke.
RCIN 1392

144. *The Black Prince* by John Michael Rysbrack, c.1737.
For her new library in St James's Palace, Queen Caroline commissioned busts of figures from royal history. The library was demolished in 1825, and only three terracotta busts survive, depicting the Black Prince, Edward VI and Elizabeth I. When Prince of Wales, George II had on occasion been compared to the Black Prince, whose title of 'Guardian of the Realm' he used when his father was abroad.
RCIN 37067

Frederick, Prince of Wales

The ill feeling between George II and his father was magnified many times over in George and Caroline's relationship with their eldest son, Frederick, Prince of Wales (1707–51) and he was forced in consequence to build a public life independent of his parents. In the years between his arrival in England in 1728 and his premature death, Frederick established himself not only as a leader of fashion, but also a collector with a range and depth of interest in the arts not seen in the royal family since the time of Charles I, on whom he modelled himself.

When George I succeeded to the throne, Frederick, then just seven years old, was left behind in Hanover to represent his dynasty. From the moment he was summoned to London to meet the parents he barely knew, their favouritism towards his English-born younger brother, William, irked him. George refused to let him serve as regent when the King was in Hanover (a role assumed by Caroline) and delayed arranging his marriage – it was not until 1736 that Frederick was finally married to Princess Augusta of Saxe-Gotha-Altenburg (1719–72). They lived principally in two houses that Frederick had acquired in the early 1730s, Carlton House on the Mall and the White House at Kew, near Richmond Lodge. Both were remodelled and decorated by Kent.

Frederick's landscaping of the White House, for which he commissioned exotic garden structures, such as a 'House of Confucius', paralleled his mother's activities at Richmond Lodge. The close similarities in their interests, not only in gardening but also in collecting and Tudor and Stuart history, make it even sadder that their relationship was so poisonous. Their already fractured relationship was exacerbated by Frederick's involvement in politics. He created a party following at Westminster that was opposed to the Prime Minister, Robert Walpole (1676–1745), whom George and Caroline strongly supported. The Queen never forgave him.

Exile from court meant that Frederick, more than any other previous royal prince, lived like a commoner, albeit an aristocratic one. This suited the political message he sought to promote – that he intended to be a patriot king, who would uphold parliamentary democracy and would not be dominated by corrupt politicians, as he believed his parents to be. Such beliefs underpinned the uncourtly approachability that Frederick sought to project in his portraits from the mid 1730s onwards. In 1733 he commissioned a group portrait of himself with his three eldest sisters that has an informality unprecedented in British royal portraiture. Painted by Philippe Mercier (1689–1760), it shows Frederick playing his cello – an unusual instrument for an amateur (fig. 145). For the White House, the sporting artist John Wootton (c.1682–1764) painted several large canvases depicting the prince hunting with friends. In 1731 Frederick commissioned Kent to design a barge for travel on the Thames (fig. 147). This spectacularly decorated vessel, which was intended to draw all eyes to the Prince, was used by him for the first time

146. *Interior of a Farmhouse with Figures ('The Stolen Kiss')* by David Teniers the Younger, c.1660.
Among the very few Flemish genre scenes to enter the Royal Collection before the reign of George IV is a group of works by David Teniers the Younger purchased by Frederick, Prince of Wales. The painting's peasant characters are arranged like a scene in a theatre, inviting narrative interpretation: when the painting was hung at Carlton House by Frederick it was referred to as 'The Jealous Husband'.
RCIN 405342

145. *'The Music Party': Frederick, Prince of Wales with his Three Eldest Sisters* by Philippe Mercier, 1733.
The setting is the Banqueting House at Hampton Court, furnished with a painting of Endymion by Giovanni Antonio Pellegrini (1675–1741) that is still in the Royal Collection, as is the mirror sconce, supplied by the cabinet-maker Benjamin Goodison, who did a great deal of work for the Prince.
RCIN 402414

in March 1732, when he and his family embarked from Chelsea Hospital for Somerset House, where they visited Wootton's studio to view 'progress in cleaning and mending the Royal Pictures'.

Mercier, who was born in Berlin of French parentage, and had worked in London since about 1716, had been employed by Frederick as his principal painter since 1729. An experienced dealer, he bought art for Frederick, including paintings by David Teniers the Younger (1610–90), whose work – which Mercier had specialised in engraving – was to be a life-long enthusiasm for Frederick (fig.146). This was the beginning of a sizeable collection that played an important part in the way that Frederick wanted to be perceived. To bolster his patriotic image he wished to encourage British artists, and planned that when he was King he would establish an academy for drawing and painting – an ambition that his son, as George III, was to fulfil. Frederick had a deep interest in the Royal Collection and its history. He consulted George Vertue (1684–1756), the pioneering historian of art, for information about paintings, allowed him to copy the manuscript inventories of Charles I's collection and commissioned Vertue to list Frederick's own pictures. Vertue recorded a conversation with Frederick in 1749 in which the Prince talked about 'paintings & famous Artists in England formerly – about the Cartons of Raphael Urbin. The paintings of Rubens in the banquetting house at Whitehall', evidence that Vertue was right to claim that 'no Prince since King Charles the First took so much pleasure nor observations in works of art or artists'.

Frederick's collecting was guided in part by his royal predecessors. To judge by his purchase of a portrait of Thomas Howard, Duke of Norfolk

A New Dynasty

(*c*.1539–40), he shared his mother's enthusiasm for Holbein. He also bought miniatures by Isaac and Peter Oliver, among them self-portraits by both artists, together with one of Isaac's most celebrated works, *A Young Man Seated Under a Tree*, which may perhaps have appealed to the Prince partly because of its depiction of a garden (fig.148). Other purchases suggest a wish to emulate Charles I's collecting. The Prince bought paintings by Rubens, including scenes depicting Summer and Winter, once owned by the 1st Duke of Buckingham, and several major works by Van Dyck, including one of his finest English portraits, of the royalist poet and playwright Sir Thomas Killigrew with an unknown man (fig.149). He also bought a set of Mortlake tapestries commissioned by Charles when Prince of Wales and a portrait of Prince Henry in the hunting field painted by Robert Peake in about 1605. Frederick acquired not only Italian paintings of the six-teenth and seventeenth centuries of the sort that might have appealed to

Charles but also a set of 13 marble statues of classical deities by a pupil of Giambologna, Pietro Francavilla (1548–1615). Intended for the Prince's gardens at Kew, the sculptures arrived from Florence just after his death.

In other aspects of his collecting Frederick struck out independently. He was one of the first collectors in England to show a sustained appreciation of seventeenth-century French art, buying two superb landscapes by Claude Lorrain (1604/5–82), of the type that would soon be so influential on British artists (fig.150), as well as paintings by Gaspard Dughet (1615–75) and Eustache Le Sueur (1617–55). Another major purchase was an album of drawings by Nicolas Poussin (1594–1665; fig.151) that had been compiled during the artist's lifetime by one of his patrons, Cardinal Camillo Massimi (1620–77). The most significant addition to the royal holdings of

149. *Thomas Killigrew and an unknown man* by Anthony van Dyck, 1638. The man on the left is the royalist poet and dramatist Thomas Killigrew (1612–83), but the other figure's identity has been debated ever since the painting was acquired by Frederick, Prince of Wales. It probably shows Killigrew mourning his wife, holding a design for a monument.
RCIN 407426

Old Master drawings since the time of Charles II, the album is also compensation for the odd fact that the Royal Collection contains no painting by an artist so eagerly collected by the British.

Frederick's interest in French art extended into the eighteenth century, but like almost every English collector of his time, he was more interested in the country's luxury decorative arts than its painting. He had a taste for rococo decoration, evident, for example, in picture frames made for him

150. *Harbour Scene at Sunset* by Claude Lorrain, 1643.
Nothing is known about this painting's ownership before its acquisition by Frederick, Prince of Wales, but its evocation of an arcadian Italy and sensitively rendered effects of light exemplify the qualities that made Claude's paintings so eagerly collected by the British in the eighteenth century. It is a capriccio: the decorative structure on the right is the Arco degli Argentari (Arch of the Money-Changers), which is in central Rome, not beside a harbour. Elegantly dressed figures watch a rich cargo being unloaded, marking the end of a voyage, and a figure sleeps as night approaches.
RCIN 401382

151. *The Triumph of Pan* by Nicolas Poussin, c.1635.
Frederick, Prince of Wales laid the foundation of the Royal Collection's holdings of drawings by Poussin, which is second only to that of the Louvre, by the acquisition of an album that had belonged to the artist's pupil, friend and patron Cardinal Camillo Massimi. Among them is this pen, ink and black chalk drawing that is related to the painting *The Triumph of Pan* commissioned by Cardinal Richelieu and now in the National Gallery, London.
RCIN 911995

A New Dynasty

152. The Neptune centrepiece, 1741–2.
One of the outstanding pieces of silver of its age, this was the centrepiece of a silver-gilt table service. Its decoration with shells, coral and sea creatures, as well as the crowning figure of Neptune and detachable dishes in the form of abalone shells, implies that it was designed for serving fish soups and seafish. The centrepiece incorporates older elements, as it bears Turin hallmarks for the 1720s, as well as London marks for 1741–2.
RCIN 50282

153. Gold box, 1749.
Designed for snuff, this box was a gift from Frederick, Prince of Wales to Francis, Baron North, on his appointment in 1749 as governor of Frederick's eldest son, Prince George. The decoration of the lid and base incorporates scenes of ploughing and harvest, perhaps suggesting allegorically the effect of education on the Prince's mind. It is not known who made the box, which incorporates a miniature of Frederick by Zincke under the lid.
RCIN 3926

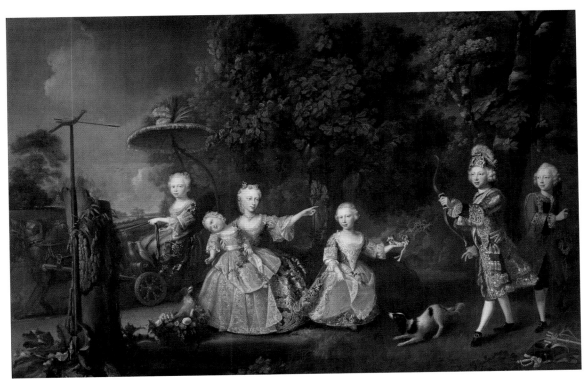

154. *The Children of Frederick, Prince of Wales* by Barthélemy du Pan, 1746.

In this life-size painting Prince George, the future George III, dressed in the uniform of the Royal Company of Archers (which incorporates the Stuart tartan) has successfully shot a wooden bird, or popinjay, while Prince Edward loads a flintlock. Princess Augusta, holding the baby Prince Henry, points to the winner and Prince William (still in skirts) holds a wreath of victory. Princess Elizabeth drives a little carriage, drawn by dogs, which is decorated with doves, probably alluding to Venus. This remarkably informal depiction of his children echoes Frederick's intention to be a demo-cratic, approachable king. RCIN 403400

by the Huguenot carver Paul Petit and gold snuff boxes (fig.153), of which there is a group associated with Frederick, made in London by immigrant French or German craftsmen in the 1740s. Most spectacular of all is the 'Neptune' centrepiece of a silver-gilt table service commissioned by the Prince in the early 1740s that is one of the pinnacles of Rococo design in England (fig.152). It appears to be a collaboration between two leading silversmiths, the Huguenot Paul Crespin (1694–1770) and the Liège-born Nicholas Sprimont (1713–71), who was to found the Chelsea porcelain factory.

This extraordinary piece of silver evokes the impressive social life of Frederick's households. The demands of both hospitality, an important aspect of his political career, and his large family – he and Augusta had nine children – prompted him to acquire new residences, including Leicester House, which had been his parents' home, and Cliveden, overlooking the Thames in Berkshire. He was devoted to his children – there was no sign that Frederick and Augusta would treat their children as he had been treated by his parents, a point that an enchanting life-size group portrait he commis-sioned of his children from the Swiss painter Barthélemy du Pan (1712–63) in 1747 may have been designed to emphasise (fig.154). On 20 March 1751 Frederick died suddenly from a burst abscess on his lung. A rhyme was soon in circulation: 'Here lies Fred, / Who was alive and is dead: / Had it been his father, / I had much rather ...'. but in fact George II defied the expectations of his son's supporters by living on to 1760.

ENLIGHTENMENT
George III and Queen Charlotte

In 1754 Augusta, Princess of Wales, commissioned the Swiss artist Jean-Étienne Liotard (1702–89) to make individual portraits of herself and her eight children, together with a posthumous portrait of her husband, Frederick. Liotard's mastery of pastel won him commissions throughout the courts of Europe, and shortly before visiting London he had made a series of portraits of the French royal family. Yet his works rarely emphasise his sitters' princely status. Exploiting the way that the softness of pastel can convey every nuance of flesh, he is direct and often unsparing in his depictions of character. This is notably the case with his portrait of Augusta (fig.155). Seeming about to speak, she looks at us sidelong, perhaps a little warily. This was well observed. The three years since Frederick's death had been full of anxiety. First she had to make her peace with George II after years of estrangement and then persuade him that she could bring up the boy who was now heir to the throne, Prince George of Wales (1738–1820), who was 12 when his father died.

The King's consent meant that she was responsible for George's education until he came of age in 1756. Fearful of corrupting influences – especially sexual – she kept him secluded in Leicester House. One of Frederick's former Lords of the Bedchamber, John Stuart, 3rd Earl of Bute (1713–92), an expert botanist, was then giving Augusta advice about the garden she was creating at the White House at Kew, which she had inherited on Frederick's death. Bute got on well with Prince George and, having been appointed his governor, managed to draw him out both socially and intellectually to the point where the Prince came to rely on his 'Dearest Friend' completely for advice, in politics and much else. Many of George's interests – notably astronomy, architecture, mechanics, natural history and book collecting – can be traced back to the influence of Bute, who also helped to develop the Prince's tastes in art and design.

A royal family

When George succeeded to the throne on his grandfather's death in 1760, he was far more sure of himself than anyone could have predicted only a couple of years before. The young King exudes confidence in his first state

portrait, painted in 1761–2 by Allan Ramsay (1713–84; fig.156). The choice of artist reflects Bute's influence: George had already sat for Ramsay in 1758 for a portrait that Bute had commissioned from his fellow Scotsman. By an oversight, the existing Principal Painter in Ordinary, John Shackleton, had been reappointed on the King's accession, but Ramsay, with the title 'one of His Majesty's Principal Painters in Ordinary' was *de facto* the King's painter until Shackleton's death in 1767. For the next 17 years Ramsay ran what was virtually a production line of official portraits of the royal family in his studio in Soho Square. The demand for them was partly a reflection of the growth of the empire. As a contemporary wrote, 'The ardour with which these beloved objects were sought for by distant corporations and transmarine colonies was astonishing.'

George's coronation on 22 September 1761 – 14 days after his marriage to Princess Charlotte of Mecklenburg-Strelitz – was an occasion of greater splendour than that of any of his immediate predecessors. It was followed

156. *George III* by Allan Ramsay, *c.*1761–2.
This magnificent painting of the King in his coronation robes was so successful that Ramsay and his studio had to make many copies. It is not known where this prime version was originally hung, but it may have been at St James's Palace. With its pair of Queen Charlotte, it is now set into a permanent frame in the State Dining Room at Buckingham Palace.
RCIN 405307

by a magnificent banquet in Westminster Hall, three courses of a hundred dishes each, lit by 3,000 candles. At their table, admired as a 'Triomfe of foliage and flowers', the royal couple were served on silver-gilt plates. Since they had not eaten since early morning they devoured their food 'like farmers', as the poet Thomas Gray waspishly commented. This occasion is commemorated in the Royal Collection by the great 'coronation service' ordered by George III in 1761–2 (fig.157). Incorporating 8 dozen plates, 72 serving dishes, 6 tureens and 16 candlesticks, it was the largest royal order of silver for decades. Most of it was made by the King's Principal Goldsmith, Thomas Heming, the first working goldsmith to hold the post since the early seventeenth century. He had been appointed in 1760 at the suggestion of Lord Bute, one of his most loyal patrons.

157. Centrepiece by Thomas Heming, 1762. Made of silver-gilt, this Rococo epergne has a pierced cover representing a vine trellis. Each of its six scroll legs supports a dish in the form of a mulberry leaf, with applied silk worms and snails. When in use as a table centrepiece, it would have been filled with fruit. Costing £241 19s, the epergne was the single most expensive item in the service, which was not finished in time for the coronation banquet. It was first used on 19 September 1768, for a banquet at Buckingham House in honour of Christian VII of Denmark. RCIN 51487

158. Gold State Coach by Samuel Butler, 1762. On the roof, the imperial crown is supported by three cherubs representing England, Ireland and Scotland, and at each corner is a triton, symbolising maritime power. The coach has been used at every coronation from George IV onwards, as well as on other state occasions, including the Golden Jubilee of 2002. Most monarchs found it very uncomfortable – Queen Victoria refused to use it – until George VI had it overhauled, and added rubber to the iron-rimmed wheels. RCIN 5000048

159. *George III, Queen Charlotte and their Six Eldest Children* by Johan Zoffany, 1770.
The King and Queen are shown with (left to right) Princes William (the future William IV), George (the future George IV), Frederick and Edward (father of Queen Victoria) and the Princesses Charlotte and Augusta. Masculine strength and female fecundity are suggested by the statue of Hercules top left and the flowers above the Queen. RCIN 400501

Shortly after the coronation George received his spectacular new state coach, an extraordinary synthesis of the arts (fig.158). Designed by the architect William Chambers (1723–96) in collaboration with the sculptor Joseph Wilton (1722–1803), it incorporates allegorical painted panels by the Florentine artist Giovanni Cipriani (1727–85). At the front are tritons blowing conch shells, announcing the appearance of the King as though he were Neptune, ruler of the seas, riding in his chariot. Delivered in time for the state opening of parliament in 1762, it is George III's most instantly recognisable legacy to the image of the British monarchy.

Within a short time of their marriage George and Charlotte had become deeply attached to each other, helped by the rapid arrival of a large family and the King's strong sense of personal morality – it was unthinkable that he might have had a mistress. The royal couple followed the precedent Frederick and Augusta had set in commissioning group family portraits. With George and Charlotte such celebrations of domestic harmony became a significant part of the iconography of the monarchy, for the first time since the reign of Charles I. It was appropriate, therefore, that the earliest large-scale family

portrait commissioned by George III (or perhaps Charlotte) was a tribute to Charles I and Van Dyck (fig. 159). It was painted in 1770 by a German artist, Johan Joseph Zoffany (1733–1810), who had settled in London in 1760, and was recommended to the King by Bute. The family are all in 'Van Dyck' dress, a popular style choice for masquerades since the 1740s but chosen here for its dynastic resonance. The painting looks back to the 'Great Peece' of Charles I and Henrietta Maria with their children (see fig. 59), and the pose of the two eldest princes, George and Frederick, is modelled on another Van Dyck portrait in the Royal Collection, that of the 1st Duke of Buckingham's sons, George and Francis Villiers.

Zoffany's painting quickly became well known: it was exhibited at the Royal Academy and an engraving of it was issued almost at once. The engraving was the basis of a further reproduction in the form of three porcelain groups, made in about 1773 by 'Mr Duesbury's Derby and Chelsea Manufactory of Porcelain' (fig. 160). This was William Duesbury (1725–86), owner of the Derby Porcelain Works, who, having bought the Chelsea factory, opened a new warehouse in Covent Garden in 1774. His models, designed to promote the new company, are today exceptionally rare, and so are unlikely to have circulated widely, but their creation links the royal family with an important aspect of national life, the encouragement of British manufacturers.

The Consul Smith purchase

At the outset of his reign it seemed possible that George III's interest in Charles I would go beyond Van Dyck portraits and dress to encompass art collecting on a scale that no British monarch had contemplated since the seventeenth century. In 1762 the King bought, for £20,000, the collection of paintings, drawings, books, coins, gems and medals formed by Joseph Smith (c.1674–1770), the British consul in Venice. It was the largest single purchase of works of art for the Royal Collection since the Gonzaga acquisition 130 years before. The collection is famous for its works by eighteenth-century Venetian artists, and in particular an incomparable group of paintings and drawings by Canaletto (1697–1768), but it seems likely that it was Smith's books that first attracted George.

160. *George III, Queen Charlotte and their Six Eldest Children*, c.1773.
Made by the newly amalgamated Derby and Chelsea manufactories, these porcelain groups were probably modelled from Richard Earlom's 1770 engraving after Zoffany's portrait (see fig.159). They were intended to show that English manufacturers could match the quality of the biscuit (unglazed) figures made as table decorations at Sèvres. In adapting the figures for the bases, the modeller, probably the sculptor John Bacon, focused the attention of the group of princes on Prince William's cockatoo, which is missing, as is the King's original blue enamelled and gilded base supported by four lions. The present base was made to match the others when Queen Mary bought these rare figures in 1924.
RCIN 37020 to 37022

161. *Portrait of a Young Man* by Giovanni Bellini, c.1505.
Part of the Consul Smith acquisition in 1762, this is Bellini's only known portrait with a landscape background. He has signed his name in a fictive label on the parapet. The sitter is unknown, but it has been suggested that he is the Venetian writer Pietro Bembo.
RCIN 405761

The old royal library, which went back to the time of Edward IV and was formerly housed at St James's Palace, had been given to the British Museum by George II in 1757. Even before his accession, George had developed an interest in books, encouraged by Bute, who was a great bibliophile, and the idea of creating a new Royal Library seems to have taken shape soon after his grandfather's sale of the old one. Smith's outstanding collection of early printed books was well known thanks to his publication of a catalogue of it in 1755, which Bute probably drew to George's attention. An early overture to Smith about a possible purchase was forestalled in 1756 by the outbreak of the Seven Years War, a conflict that badly affected Smith's finances and made him willing to contemplate the sale of his art collection as well as his books. Negotiations were reopened soon after the King's accession by Bute's brother, James Stuart Mackenzie, who was British envoy to Turin in 1758–61. By December 1762 the purchase of 'the finest Collection in Europe' was being reported enthusiastically by the London press.

If a full inventory was made of Smith's paintings and drawings at the time of the purchase it has not survived, and it is not clear whether the King bought all Smith's paintings or only a selection. Around a quarter were Italian Old Masters, but almost nothing is known about how Smith acquired them, although some may have come from the collection of the last Duke of Mantua, sold in Venice in 1710. They were uneven in quality, but did include a handful of outstanding works, notably two panels by Giovanni Bellini (c.1430–1516), his last surviving portrait (fig.161) and the *Agony in the Garden*. The King seems to have given the latter away, since it was sold from Joshua Reynolds's collection after his death, and is now in the National Gallery, London.

Smith also owned a significant group of works by northern painters. Some were probably obtained through trading contacts in Amsterdam, but others were bought by him in 1741 as part of the collection formed by Giovanni Pellegrini, who had worked in The Hague. These paintings included *Lady at the Virginals with a Gentleman* by Johannes Vermeer (1632–75; fig.162). Although now one of the most admired works in the Royal Collection, it was not singled out for special praise in the eighteenth century, when (thanks to a misreading of the signature) it was attributed to Frans van Mieris the Elder (1635–81).

Consul Smith's work as a banker had led him into picture dealing, the origin of his huge collection by contemporary Venetian painters, of which 162 can be identified in the Royal Collection today. In the 1720s Smith had begun to acquire and commission works by Sebastiano Ricci (1659–1734) and his nephew Marco Ricci (1676–1730); Smith eventually owned over 200 drawings by Ricci, some for paintings that he had commissioned. Between 1711 and 1716 the Riccis were in London, where they designed sets for theatres and opera houses. This may have led to an introduction to Smith, who was married to the leading English *prima donna* Catherine Tofts. The 26 paintings by Sebastiano in the Royal Collection (fig.163), eight of which

162. *Lady at the Virginals with a Gentleman* by Johannes Vermeer, 1661–5.
Despite its traditional title, *The Music Lesson*, Vermeer hints at a more intimate relationship between the figures: the Latin inscription on the virginal can be translated 'Music is a companion in pleasure and a balm in sorrow.' The painting was hung by George III over the chimneypiece in the King's Closet at Windsor Castle. RCIN 405346

were painted jointly with Marco Ricci, demonstrate why he was celebrated as the heir to Paolo Veronese (1528–88).

Smith also owned classical landscapes by Francesco Zuccarelli (1702–88) and paintings of architectural subjects, including English Palladian buildings, by Antonio Visentini (1688–1782), who worked for Smith in many capacities, as engraver and illustrator as well as architect. Other leading Venetian artists are more patchily represented in the purchase, but this may in part be a result of dispersals after the collection arrived in England. For example, an early nineteenth-century inventory of the Italian pictures in the Royal Collection lists seven religious paintings by Giovanni Battista Piazzetta (1682–1754), but the only works by him in the collection today are 36 drawings of heads in black-and-white chalk (fig.164). Some are portraits (including self-portraits) but most are anonymous studies, drawn with great subtlety, but elusive in mood. They were greatly admired, to judge from the copies made of them by George III's daughters as exercises in drawing.

Piazzetta never attracted much attention from English collectors but that was not the case with the most famous female Venetian artist, Rosalba Carriera (1673–1757), whose works, especially in pastel, were eagerly sought throughout Europe well before Smith met her. Acting as her agent, he also acquired a large body of her works, but only five of the 38 purchased by the King are now in the Royal Collection. As well as a self-portrait, they include a painting that became famous when it was in Smith's collection, *A Personification of Winter* (fig.165). Described at the time of the sale as 'a Beautiful Female covering herself with a Pelisse allowed to be the most excellent this Virtuosa ever painted', it was a personification of the season

163. *The Magdalen Anointing Christ's Feet* by Sebastiano Ricci, c.1720–30.
On his return to Venice from England in 1716, Ricci painted a series of seven large paintings of New Testament subjects, to which this belongs. Although the composition is indebted to Veronese, Ricci's sparkling brushwork is characteristically Rococo in feel. Consul Smith had the paintings engraved in 1742 and he owned 16 preparatory drawings for one, *The Adoration of the Magi*, which suggests that he commissioned them. RCIN 405742

that substituted a seductive young woman for the customary elderly man. George III hung in it his bedroom.

Smith owned the greatest collection ever formed of works by Canaletto, of which 50 paintings, 143 drawings and 46 etchings are in the Royal Collection. The fact that this is by far the largest group of his works in existence perhaps helps to explain why his reputation is much higher in Britain than in his native land. One factor in Canaletto's success with British collectors was his relationship with Smith. From the outset of his career in the 1720s, Canaletto suffered from a reputation for over-charging and long delays in delivering. By 1730 Smith had taken charge of his practice,

164. *A Young Moor with a Bow* by Giovanni Battista Piazzetta, *c.*1730–40. Piazzetta made his large-scale chalk studies of heads as independent works of art, and so their owners framed them to be hung. As a result, the blue paper on which they were drawn has invariably faded to brown. This may depict one of the Arabs who were a common sight in Venice, then Europe's main point of contact with the Islamic world. RCIN 990755

agreeing prices and organising framing and transportation. He also bought and commissioned works for himself, including a set of six large views of the Piazza and Piazzetta San Marco at different times of the day that are among the painter's finest early works (fig.166). Smith further promoted Canaletto by publishing in 1735 a set of engravings of views of the Grand Canal, based on 14 paintings that are all now in the Royal Collection. When the outbreak of the War of the Spanish Succession in 1740 interrupted the flow of potential clients to Venice, he encouraged Canaletto to diversify into views on the Brenta Canal, antiquities of Rome and architectural capriccios. Bearing a letter of introduction from Smith, Canaletto moved to England in 1746, where he worked on and off for the next nine years. He brought back with him to Venice paintings and drawings of London, some of which were acquired by Smith (fig.167). Canaletto's work fell out

166. *Piazza San Marco looking East towards the Basilica and the Campanile* by Canaletto, *c.1723–4.*
This is one of a set of six early paintings of the Piazza San Marco for which Canaletto's preparatory drawings are also in the Royal Collection. They show that the compositions were carefully worked out to make a harmonious unity. The pair to this evening view shows the piazza in morning light, looking west, away from San Marco.
RCIN 405934

167. *London: Westminster Bridge with a distant view of Lambeth Palace* by Canaletto, *c.1746–7.*
This was Smith's last purchase from Canaletto, who drew it while he was working in England in the late 1740s and early 1750s. It shows the not quite completed Westminster Bridge (begun in 1739), the Palace of Westminster and Westminster Abbey on the right and Lambeth Palace in the distance. Published as an engraving in London in 1747, the drawing is closely related in composition to two oil paintings by Canaletto.
RCIN 907558

of fashion around the middle of the century in favour of younger rivals such as Francesco Guardi (1712–93), whom Smith – perhaps out of loyalty to his old friend – did not collect.

Drawings

Given the international fame of the Royal Collection's Old Master draw-ings, it is surprising how quickly the collection was put together. With the exception of the drawings believed to have been acquired by Charles II, and Frederick, Prince of Wales's Poussin drawings, most of its highlights were bought by George III within a decade of his accession. The agent who

travelled the continent in search of them was the King's Librarian, Richard Dalton (c.1715–91), since drawings, like prints, coins and medals, were by tradition part of a library collection. Like many art dealers and agents in the eighteenth century, Dalton had begun as a painter, and several of the red chalk drawings of sculpture he made while in Rome in the early 1740s are in the Royal Collection. His wide knowledge of European art collections was put to good use on a tour of Italy in 1758–9, when he acquired some 700 drawings for Prince George, including 40 from the grandson of the painter whom Charles I had tried in vain to tempt to England, Guercino (fig.168). He also inspected the celebrated collection of Cardinal Alessandro Albani in Rome, which, with that of Consul Smith (also visited by Dalton), was to be acquired by George once his financial resources had been transformed by his accession.

168. *The Annunciation* by Guercino, *c.*1616–18. Perhaps a study for an otherwise unknown small devotional painting, this pen and ink drawing is one of 800 drawings in the Royal Collection by the Bolognese artist Giovanni Francesco Barbieri, nicknamed *il Guercino* (Italian for 'the squinter'). Most were acquired by George III from the collection that Guercino had bequeathed to his nephews, Benedetto and Cesare Gennari, the former of whom had worked for Charles II and James II. RCIN 902792

169. *A Roman Steelyard Balance (statera)* by Vincenzo Leonardi, c.1630–49.

A visual encyclopaedia by many draughtsmen, Cassiano dal Pozzo's 'paper museum' encompassed antiquity and natural history. This drawing, in watercolour and bodycolour over black chalk and pen and ink, depicts, at actual size (126 cm wide) and from several views, a bronze *statera* or steelyard balance for weighing goods, with three alternative fulcra and corresponding scales, with a bust of Minerva as a counterweight.
RCIN 911186

Dalton had not been impressed by the Albani collection, almost certainly because he was not shown all of it, but the King and Lord Bute were encouraged to pursue the idea of acquiring it by Robert Adam (1728–92), who in 1761 was appointed Joint Architect of the King's Works. Adam had studied the collection while he was in Rome in the 1750s, and the secret negotiations for its purchase were handled by his younger brother, James. A price of £3,500 for 200 albums of drawings and prints was eventually agreed, largely because the cardinal's mistress, the Contessa Ceroffini, wanted the money for a dowry for her eldest daughter. The collection, some of which had been inherited from Albani's uncle Pope Clement XI, was a magnificent representation of largely seventeenth-century draughtsmanship by such artists as Bernini, Domenichino (1581–1641), the Carracci, Carlo Maratti (1625–1713) and Carlo Fontana (1634/8–1714).

The purchase also included thousands of sheets from the 'paper museum' of the collector and antiquary Cassiano dal Pozzo (1588–1657), which Albani had bought in 1714 (fig.169). This unique visual encyclopaedia of contemporary knowledge consists of detailed drawings and watercolours of classical antiquities, archaeological finds and geological and natural-history specimens, supplemented by prints on topography, portraiture, costume, ceremonies and military matters. Although intended for publication, the accumulation of drawings soon outran such an idea, which was not revived until the twenty-first century, when the Royal Collection and other owners of sheets from the 'paper museum' initiated a multi-volume catalogue of this extraordinary seventeenth-century database.

Among the highlights of George III's acquisitions of Old Master drawings are groups by Raphael and Michelangelo. Dalton described one of the drawings he sent back from Italy in 1758 as a 'Rafaele', but it cannot now be identified. The first Raphael drawing known to have been acquired by the King was part of the Consul Smith purchase, *Christ's Charge to Peter* (fig.170), an appropriate acquisition since it is a working drawing for one of the 'Acts of the Apostles' tapestries, of which the cartoons are in the Royal Collection. The origins of other sheets by Raphael in the collection are mysterious: like so many of the Old Master drawings, there is no record of them in royal

ownership until they appear in an inventory drawn up in 1810. Among those listed then for the first time are some of the Collection's famous group of highly finished drawings made by Michelangelo as gifts (fig.171). Given that these were recognised from the moment of their creation as some of the greatest drawings ever made, and were much copied, it is puzzling that their whereabouts in the eighteenth century are unknown, although their immaculate condition suggests that they were well looked after.

Having acquired drawings and other works of art at a high level for the first few years of his reign the King's interest in such collecting flagged and was never to revive with any intensity. Some of the reason for that was practical, as he and the Queen had satisfied their immediate need for pictures to furnish their houses. He also focused his attentions, and budget, on book collecting. In addition, his relationship with the man who had done so much to encourage his interest in art came to an end in 1763 when Lord Bute decided to retire from public life. Yet, despite the evident pleasure the King got from many of his paintings, it might be doubted whether he ever thought of himself as a connoisseur in the mould of Bute; for him, art was just one aspect of the wide-ranging intellectual interests that made George III a monarch of the Enlightenment. It can be argued that his interest in drawings, for example, was practical rather than aesthetic. Left to himself, he acquired them largely for their subject matter. In 1755, when George was only 16, he bought at auction 95 drawings and coloured engravings by a pioneer of the science of ecology, the outstanding illustrator Maria Sibylla Merian (1647–1717), which included studies of insects and reptiles in Suriname, South America (fig.172). One of the King's last big acquisitions of drawings was of 263 watercolours made by Mark Catesby (1682/3–1749) for his *Natural History of Carolina, Florida and the Bahama Islands* (1729–47), which were bought in 1768.

Enlightenment

However, the development of his collections of atlases and maps led to the King accumulating enormous groups of drawings and watercolours of topographical, naval and military subjects, of which only the last survives in the Royal Collection (the others are now in the British Library). Designed to extend the King's knowledge of his country, its developing empire, and military and naval activities, these collections were not created for aesthetic reasons. Nonetheless, they include outstanding works by such topographical artists as Thomas Sandby (1721–98) and his brother Paul (1731–1809) that help compensate for the fact that the King showed no interest in the achievements of British watercolour artists that are such a highlight of the latter part of his reign.

Buckingham House

In 1762 the King purchased Buckingham House as a gift for his wife. Built in 1702–5 for John Sheffield, Duke of Buckingham and Normanby, with a splendid position overlooking St James's Park, the house was, the King told Bute, 'not meant for a palace, but a retreat', and was habitually referred to as 'the Queen's House'. George oversaw the alterations to Buckingham House with Sir William Chambers, who for half a century was the King's closest adviser in architectural matters. George took a great deal of care in arranging the paintings in the house. The entrance hall, for example, was hung with Canalettos and Zuccarellis; the prominence given to these works bought from Consul Smith suggests that one motive for that purchase had been to furnish the house. The new paintings were supplemented by works from his father's collection, and the Queen's Saloon was hung with the

Raphael cartoons. Their move from Hampton Court provoked criticism, because public access to them was now much more limited.

Since the house was enlarged and remodelled beyond recognition when George IV converted it into Buckingham Palace in the 1820s, our knowledge of the interiors created by George and Charlotte is based on paintings. The earliest is an enchanting portrait by Johan Zoffany of the Queen, aged about 21, with her two eldest sons, George, later George IV, and Frederick, later Duke of York (fig.173). The setting is one of the ground-floor rooms at Buckingham House, which had been specially arranged with some of the Queen's possessions for the purpose, since her rooms were in fact on the first floor. Zoffany may perhaps have chosen the setting so that he could include a view out into the garden, where a solitary flamingo is taking a stroll. Whereas the King preferred to live austerely, without carpets – he was English in his belief that there was something virtuous about physical discomfort – the Queen's rooms were furnished luxuriously. Zoffany

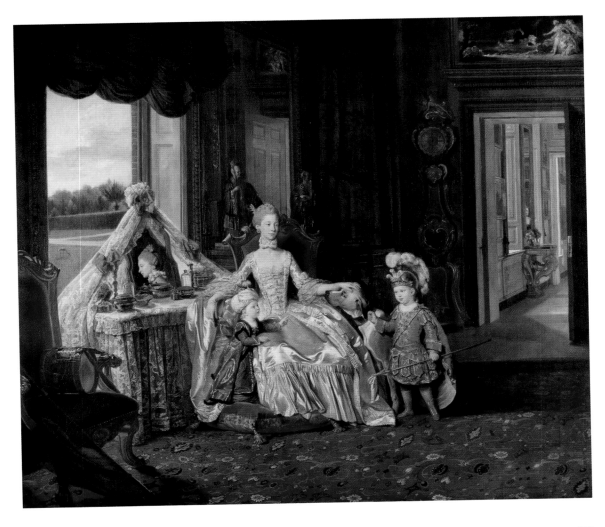

has depicted in the background a superb French longcase clock by the eminent French horologist Ferdinand Berthoud (who was elected a Fellow of the Royal Society at about the time Zoffany was painting the picture). The clock's magnificent marquetry case, lavishly mounted in ormolu, is the work of a leading cabinetmaker, Charles Cressent (1685–1768; fig.174). The Queen had a taste for richly decorated furniture to judge from her jewel cabinet, made in 1762 (fig.175). This is a masterpiece by William Vile (c.1700–67), who, with his partner John Cobb, was appointed by the King 'Joint Upholsterer in Ordinary' in 1761 but retired only two years later, possibly because of ill health. He was succeeded by John Bradburn, who had trained with Vile and Cobb.

Although bought for the Queen, Buckingham House was also a favourite of her husband. This was partly because it gave him space to pursue his consuming interest in books, which, under the guidance of Frederick Augusta Barnard (1743–1830), who replaced Dalton as King's Librarian in 1774, was developed in a systematic way. By the time of the King's death in 1820, the library contained around 65,000 printed books and 19,000 pamphlets. There were also manuscripts, as well as the bound volumes of maps and topographical views. The King first kept his books in the Old Palace at Kew, but following the arrival of Consul Smith's library, they were moved to a room added to Buckingham House by William Chambers in 1762–4. Between 1766 and 1773 three large rooms were added, of which the most impressive was the Octagon Library (fig.176), below which was the King's bindery, in operation from 1780. The King seems always to have intended

174. Longcase equation clock by Charles Cressent, 1750.
The superb case for this clock was probably made for the Trésorier-général of the French navy, Marcellin-François-Zacharie de Selle, who furnished his study in Paris in the rue Sainte Anne with pieces by Cressent. His possessions were sold in Paris in 1761, so the clock had only recently arrived in England when Zoffany included it in his painting (fig.173). RCIN 30035

175. Jewel cabinet by William Vile, 1762.
Queen Charlotte owned a large collection of jewellery, famous for its diamonds and pearls, much of which was sold after her death. Costing £138, the cabinet was the most expensive piece of furniture supplied to the Royal Household by William Vile. Made of mahogany, it is inlaid with not only exotic woods but also ivory, which is unusual in England but more common in north Germany, and so may have been specifically requested by the Queen. RCIN 35487

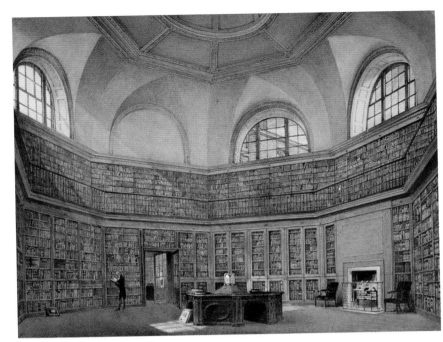

176. *The Octagon Library at Buckingham House* by James Stephanoff, 1818. Following the arrival of Consul Smith's books in 1762, William Chambers designed a new wing on the south side of Buckingham House to accommodate the King's library. It eventually encompassed four large rooms, all very plainly decorated, of which the Octagon Library was the most architecturally impressive. The octagonal desk, which was made for the room, probably by John Bradburn, is now in the Royal Library at Windsor Castle. It supports an astronomical clock supplied by Eardley Norton (fig.178).
RCIN 922147

177. *The Mainz Psalter*, 1457. Most of the books at Buckingham House were presented to the nation by George IV in 1823. Among the few that were retained is this psalter (a book of the psalms, made for liturgical use), which is one of only ten surviving copies of the second book in the world to be printed by moveable metal type. The large two-colour initials were printed from woodblocks, and the music, together with the accompanying words, was added in manuscript. Printed in Mainz by Johann Fust and Peter Schoeffer, the psalter was given to George III in 1800 by the University of Göttingen.
RCIN 1071478

that the library would have a public function – it was generally open to scholars – as George IV's gift of his father's books to the nation in 1823 acknowledged. Some items of particular interest were retained (together with all the King's books in his other residences). Among them is an extraordinary rarity, one of only ten surviving copies of the second book (after the Gutenberg Bible) to be printed by moveable metal type, the psalter issued in Mainz in 1457 (fig.177).

The library contained other collections, and in 1774 the height of one of the rooms was raised to accommodate a gallery for the King's models of ships and seaports. At the centre of the Octagon Library was an octagonal desk crowned by an astronomical clock made by Eardley Norton in 1765 for which the King paid £1,042, which presumably included its very fine mahogany case (fig.178). George had a passion for horology and he delighted in taking apart and reassembling the workings of his vast collection of clocks. They were complemented by his superb scientific instruments, now owned by King's College, London, which are on loan to the Science Museum.

Among the manuscripts in the library was the collection that George Frideric Handel had bequeathed to John Christopher Smith, one of his favourite pupils, and later his manager and principal copyist. Aware of the King's great admiration for the composer, Smith's son (who had been Princess Augusta's music teacher) gave the music manuscripts to the Royal Library in about 1773, together with a harpsichord and small house organ. It seems likely that the gift also included a marble bust of Handel by Louis-François Roubiliac believed to have been given to Smith's father by the composer (fig.179). The bust is first recorded in the King's Apartments at Buckingham House in 1783, the year before the 25th anniversary of the composer's death was marked by the great Handel Commemoration in Westminster Abbey, which the King had encouraged. The Handel manuscripts remained in the Royal Library until 1957, when they were presented by Queen Elizabeth II to the nation, and are now in the British Library.

This was not the only bust of Handel that George III owned; he placed another, also attributed to Roubiliac, on top of the organ in Queen Charlotte's Breakfast Room at Buckingham House. This makes it additionally surprising that sculpture, ubiquitous in eighteenth-century libraries, was

178. Astronomical clock by Eardley Norton, 1765.
This four-sided clock embodies George III's deep interest in science and horology. Its principal face displays the time of day on a 24-hour dial, the passage of the sun, and the time at 30 locations around the world. The left-side dial displays the date, and the right-side dial shows the position of the planets. The dial at the back shows the phases of the moon and the time of high tide at 32 ports. Its mahogany case, probably made by John Bradburn, may have been designed by Robert Adam.
RCIN 30432

179. *George Frideric Handel* by Louis-François Roubiliac, 1739.
In this bust, made for Handel, Roubiliac portrays the composer dressed informally, perhaps as he appeared when working. The loose cap, worn in the absence of a wig, and the crumpled coat, gave the sculptor the opportunity to demonstrate his virtuosity in the depiction of texture, but they also convey a sense that Handel is indifferent to worldly matters while his mind is on artistic creation. When it was carved, Handel was composing a funeral anthem for Queen Caroline, one of the many commissions that made him the favourite composer of the Hanoverians, not least George III.
RCIN 35255

180. *The Tribuna of the Uffizi* by Johan Zoffany, 1772–7.

Other contemporary views show that Zoffany's depiction of this famous treasure house is accurate, although he had to adjust the perspective and has introduced works from the Pitti Palace or elsewhere in the Uffizi. The display of paintings is dominated by Raphael's *St John the Baptist*, and Zoffany invites us to compare Titian's painted *Venus of Urbino* with a famous antique sculpture, the *Medici Venus*, evoking contemporary debates about the merits of painting and sculpture, and of ancient and modern art. RCIN 406983

absent from the King's. Perhaps the fact that George was unable to go on the Grand Tour explains why he took such little interest in sculpture, although that had not stopped his grandmother furnishing her library with busts or his mother commissioning sculptures by Joseph Wilton of Minerva and the Muses for her gardens at Kew. Queen Charlotte did not acquire sculpture either, but her curiosity about the works that travellers so much admired in Italy prompted a remarkable commission. In 1772 she gave Zoffany £300 to visit Florence and make a painting of the works of art in the famous Tribuna, the octagonal gallery in the Uffizi that contained the cream of the Medici collections in paintings as well as antique sculpture (fig. 180).

It was not a happy job. In the first place, Zoffany took seven years to complete the painting, not returning to London until 1779. He had to devise a very complex composition, and get permission to move into the Tribuna famous works hung elsewhere. He also exceeded his brief by including portraits of many celebrated connoisseurs, diplomats and visitors to Florence. The Queen, who had wanted something of a more purely documentary nature, was not pleased by the inclusion of portraits of people she had never heard of, and the King was probably aware of the sexual proclivities

of the men admiring the bosoms and buttocks on display. In any case, the painting did not suit the strait-laced nature of their court. Zoffany was not employed by the King or Queen again and had to fight to be paid for a painting that has embodied the concept of the Grand Tour ever since.

English patronage

In December 1768 George III made one of his best-known contributions to national life by approving the Instrument of Foundation of the Royal Academy, which was to be both a school of art and design, and a body that would mount annual exhibitions. In so doing, he realised a long-held ambition of his father. The King provided practical help by arranging for the Academy to be accommodated in old Somerset House, and it was to remain in the building that replaced it until 1837. George was well informed about the the new organisation, since William Chambers was one of its creators and founding members and in 1769 Zoffany (who had yet to fall from favour) was nominated as member by the King. It was hoped that the Academy would both foster a national school of art and encourage public appreciation of painting, sculpture and architecture, based on accepted canons of taste.

Among the ambitions of the new organisation was the promotion of 'history painting': the depiction of scenes from history, the Bible or classical legend. Although traditionally regarded as the most important genre in painting, it had never found many patrons in Britain. Encouraged by the debates that led to the foundation of the Royal Academy, the King decided to set a lead. His chosen artist was Benjamin West (1738–1820), born in Pennsylvania and trained in Italy, who moved to England in 1763. When in 1768 the King saw West's *Agrippina Landing at Brundisium with the Ashes of Germanicus* (1768; now in Yale University Art Gallery), he asked him to paint the departure of Regulus from Rome (fig.181). After its completion, in 1769 – in time to be shown at the first Royal Academy exhibition – the King commissioned a pendant depicting the oath of Hannibal. The eventual result was a series of six paintings, completed in 1773, hung together in one room at Buckingham House with a replica of West's celebrated *Death of Wolfe* (1771). One of the high points of European neoclassical painting – although rarely recognised as such in Britain – West's canvases owe an evident debt to the Raphael cartoons. Described from 1772 as 'Historical Painter to the King', West gave drawing lessons to the Queen and princesses. In 1791 he was appointed Surveyor of the King's Pictures and in 1792 he became President of the Royal Academy. West painted more than 60 works for the King and Queen, including two sets of paintings for Windsor Castle, eight scenes from the reign of Edward III for the Audience Chamber and 36 religious subjects for a new Royal Chapel, of which only the former remain in the Royal Collection (the chapel was never built).

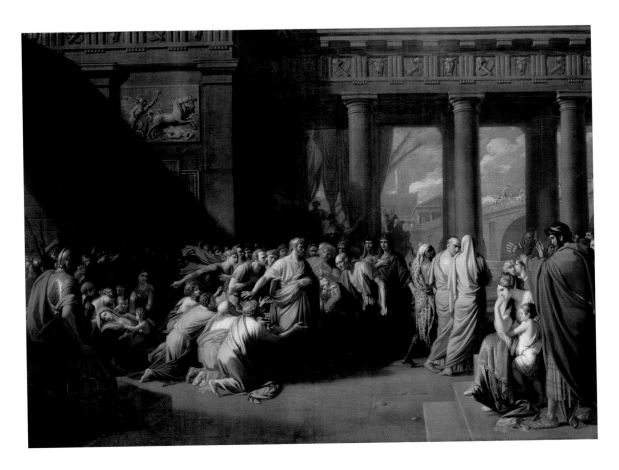

181. *The Departure of Regulus* by Benjamin West, 1769.
George III hung three pairs of history paintings by Benjamin West in the 'Warm Room' (a private sitting room) at Buckingham House. The subject of this painting, taken from the Roman historian Livy, was suggested by the King. Having been taken prisoner by the Carthaginians in 255 BC, the consul and general Regulus was sent back to Rome to discuss peace terms. Distrustful of the negotiations, he insisted on returning to Carthage, and certain death.
RCIN 405416

Although he was an accomplished portrait painter, West never monopolised royal portraiture in the way that he did history paintings. Before his accession, George sat to Joshua Reynolds (1723–92), but showed no inclination to offer him commissions thereafter, largely because he preferred Allan Ramsay, but also because it seems that he never warmed to Reynolds as a person. Nonetheless, in 1769 he knighted him, in acknowledgement of Reynolds's position as President of the Royal Academy, and in 1784 appointed him Principal Painter, following Ramsay's death. Knowing that he was never going to be a favourite, Reynolds described the post as 'near equal in dignity with his Majesty's rat catcher'. By then Thomas Gainsborough (1727–88) had established himself at court with two glamorous full-length portraits of the King and Queen that were enthusiastically received when exhibited at the Royal Academy in 1781 (fig.182). Charming, witty, and lacking Reynolds's rather ponderously intellectual approach to painting, Gainsborough knew exactly how to flatter his royal sitters.

The King's desire to encourage British painting was in part an extension of his wish to promote the country's manufacturers. As far as luxury goods were concerned, France was the main rival, although neither George nor Charlotte ventured to set up royal manufactories like Sèvres or Savonnerie.

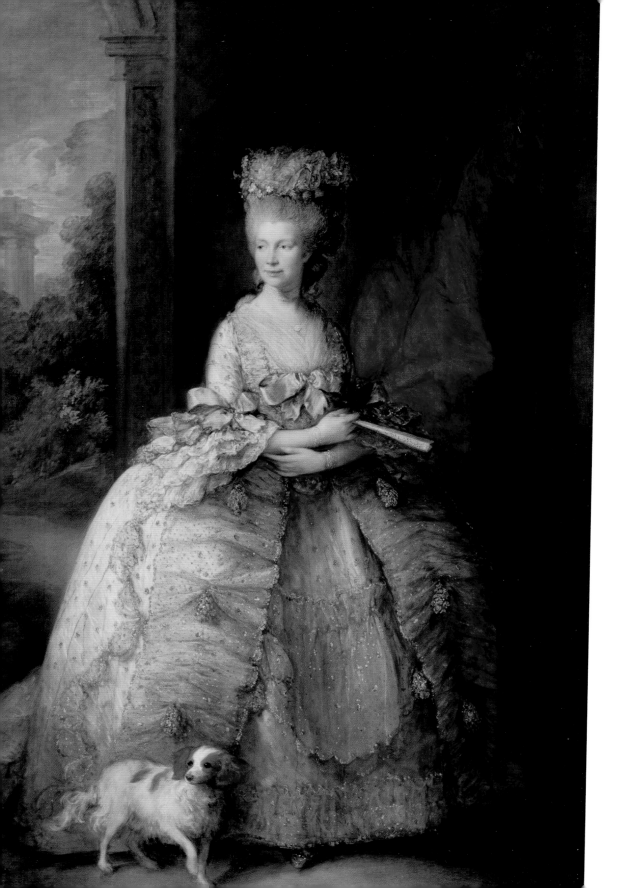

Instead they sought to offer encouragement through commissions or by public demonstrations of royal interest, such as a visit to the Worcester china factory in 1788. For the King it probably did not matter greatly what a firm was making, but Charlotte's interest in the decorative arts made her responsive to British makers of luxury items hoping to win royal approval. In 1770 the Birmingham entrepreneur Matthew Boulton (1728–1809) was given a three-hour audience by the King and Queen. His successful factory made small items in metal such as buckles and he now wanted to discuss his latest venture, the manufacture of ormolu, or gilded bronze, used in particular for decorative mounts on vases and furniture, where French supremacy seemed untouchable. As a result, an order was placed for a chimney garniture of Derbyshire blue john vases to be mounted in Boulton's ormolu, which the Queen placed in her bedroom at Buckingham House (fig.183). The vases were part of a group of pieces made for the royal family by Boulton that included a clock designed by William Chambers that was marketed (without authority) as 'The King's Clock'. These exceptionally refined items have always been greatly admired and so it is sometimes forgotten that in commercial terms Boulton's ormolu was a flop, and he made very little after 1771.

British manufacturers of ceramics mounted a more successful challenge to French dominance. In 1763 the King and Queen commissioned

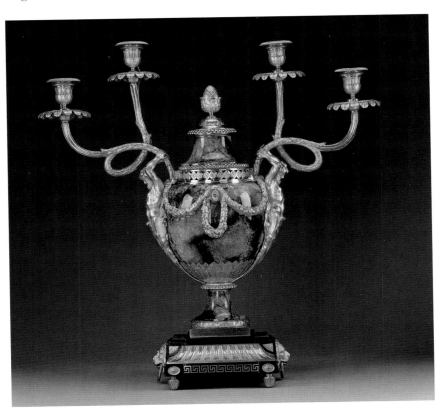

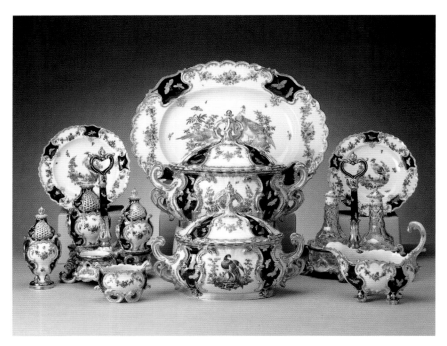

the Chelsea factory to supply a porcelain dinner service as a gift for the Queen's eldest brother, Adolphus Frederick IV, Duke of Mecklenburg-Strelitz (fig.184). The factory was then being run by Nicholas Sprimont, who had supplied silver for the King's father, and the Rococo forms of the Mecklenburg service would probably have appealed to Frederick. The service was recognised as a technical breakthrough thanks to its blue enamel, known as 'Mazarin blue', which matched in brilliance the dark blue enamels that Sèvres had made fashionable. Since the service left England immediately after its creation, it helped to advertise British porcelain abroad: the traveller Thomas Nugent thought it 'rich and beautiful beyond expression' when he saw it in the ducal palace at Neustrelitz in October 1766.

It was, however, England's simple wares that were most envied abroad, and in particular the creamware manufactured by Josiah Wedgwood (1730–95) in Staffordshire. Invented in the 1740s, creamware is a cream-coloured, lead-glazed refined earthenware that, by the end of the century, had displaced traditional tin-glazed earthenwares such as Delft. This change in taste was largely due to the commercial genius of Wedgwood, who used royal approval to promote his wares to a wide market through what would now be called branding. In 1765, the year that Wedgwood opened his first London showroom, the Queen commissioned a tea service in green and gold creamware. In the following year he was officially appointed Potter to Her Majesty and was permitted to rename his creamware 'Queen's ware'. The Queen bought Wedgwood wares, but this was no comparison with the 1773 'Frog service' of 952 pieces ordered by Catherine the Great in 1773, which Charlotte personally inspected in Wedgwood's showroom before it was sent to Russia.

Queen Charlotte and Frogmore

Almost none of Charlotte's Wedgwood can now be identified in the Royal Collection, which retains very few of her commissions and purchases. This was because, after her death, the majority of her possessions were either divided between her four youngest daughters, the princesses Augusta, Elizabeth, Mary and Sophia, or sold at auction to pay the Queen's substantial debts. Portraits apart, Charlotte would, therefore, be a largely invisible presence in the Royal Collection were it not for the survival of her private retreat on the Windsor estate, Frogmore. Bequeathed to Princess Augusta, the house remains the property of the Crown, and the decision in the 1980s that it should be restored and shown to the public opened a window into Charlotte's private world.

The acquisition of Frogmore was prompted by the unexpected revival of royal interest in Windsor Castle, which, with the exception of occasional visits for hunting or Garter ceremonies, had been neglected since the death of Queen Anne. Its long years of picturesque slumber are evocatively recorded in watercolours and drawings of the Castle and its environs by the Sandby brothers. Thomas Sandby, who from 1764 acted as deputy ranger of Windsor, collaborated with his brother Paul on a series of engraved views of the park and in the 1760s Paul made a series of views of the Castle that are among the high points of English watercolour painting (fig.185). Following the King's decision in 1776 to make greater use of Windsor, the royal family moved into buildings erected by Queen Anne on the South Terrace, the

185. *Windsor Castle: The Quadrangle Looking West* by Paul Sandby, *c.*1765. Watercolours and drawings by the brothers Thomas and Paul Sandby provide an evocative record of the Castle in the decades immediately before George III and Queen Charlotte decided to move the court back there. When Sandby painted this view of the Upper Ward, the apartments in the Quadrangle had yet to be reclaimed by the royal family and were open to the public. RCIN 914560

Castle having been judged uninhabitable. By degrees it was refurbished but was not fully occupied by the court until 1804.

Charlotte found the Castle cold and uncomfortable, as well as too public, so she often retreated to Frogmore during the day. A modest Trianon to the Versailles of Windsor, just a mile to the north, the house was probably designed by Hugh May, architect of the remodelling of Windsor Castle for Charles II. Having purchased the lease in 1792, Charlotte commissioned the architect James Wyatt (1746–1813) to remodel and enlarge the building, and, once she had acquired some more land, laid out a landscape garden. This was always the central attraction at Frogmore, as it was here that Charlotte and her daughters could pursue their enthusiasm for horticulture and botany. 'I've been spending the mornings in the company of my daughters at Frogmore, my little Earthly Paradise', wrote the Queen to her brother Prince Karl in 1802, 'amusing ourselves with a good read, working around a large table in the garden under the shade of some beautiful trees, and marvelling that the time goes by much more quickly than we would have wished'. This atmosphere of studious pleasure is well captured by Charles Wild's watercolour of the library at Frogmore, flooded by light from large windows looking into the garden (fig.186).

One of the rooms added by Wyatt was decorated to simulate a conservatory open to the sky, with flowers painted directly on the walls as well as large inset paintings that depict cascading blooms (fig.188). These are the work of Mary Moser (1744–1819), who, with Angelica Kauffmann (1741–1807), was one of the two female founder members of the Royal Academy of

188. *A Vase of Flowers* by Mary Moser, 1792–7. Queen Charlotte commissioned Moser to decorate a room at Frogmore with paintings of flowers, some on canvas, as here, and others painted directly onto the walls and ceiling. The scheme took five years to execute and cost £900. RCIN 402469

Arts. Moser also provided patterns for floral embroidery and gave drawing lessons to the princesses. Perhaps the most talented was Princess Elizabeth (1770–1840), who was to marry the Prince of Hesse-Homburg. Examples of her silhouette pictures and floral paintings for furniture are preserved at Frogmore; her proud father arranged for some of her pictures to be published as engravings. After the eldest daughter, Charlotte (1766–1828), married the Duke (later King) of Württemberg in 1797, she applied her artistic skills to decorating porcelain blanks made in the ducal factory at Ludwigsburg that she then fired in her own kiln (fig.187). In 1805 she wrote to her father that she would 'venture to bespeak some flower pots after my design which I hope your Majesty will place in your palace'.

Old age and empire

There was a dark shadow that made the Queen's 'Earthly Paradise' all the more precious to her. In the autumn of 1788 the King's mental health collapsed. Although the episode lasted only a few months, he suffered severe recurrences in 1801, 1803 and 1810, whereupon a regency was declared. The King's health never subsequently recovered, prompting much speculation ever since about the cause of his illness. Whether it was the metabolic disorder porphyria, or an acute mania, may never be known; in any case, his doctors and family were helpless.

This family tragedy struck at a time when the monarchy was beginning to embody not just a nation but also a global empire. By the time of the King's last bout of illness, Britain had recovered from the loss of the American colonies in 1776 and had defeated French imperial ambitions. These successes began to have an impact on the Royal Collection: for example, at the time of her death, Queen Charlotte owned 50 items of ivory furniture and boxes made in India. Other treasures came as booty. Determination to prevent the French forming an alliance with Tipu, Sultan of Mysore, led to war, which culminated in his death in 1799. After British troops captured his citadel, Seringapatam, Tipu's treasury and library were ransacked, and the gold coverings of his throne were cut up for distribution to the troops. Above the throne canopy was a *huma* or bird of paradise, made of gold and studded with gems (fig.190). This was obtained by the Governor-General of India, Lord Wellesley, who presented it to George III. It was explained at the time that the *huma* 'is looked upon as a Bird of happy Omen, and that every Head it overshadows will in time wear a Crown'.

An even rarer treasure of Indian art was acquired by the King as a gift. In about 1798 the Nawab of Oudh offered Wellesley's predecessor as Governor-General, Lord Teignmouth, six manuscripts from his library at Lucknow. Recognising that their superlative quality made them fit only for 'a royal library', Teignmouth declined the offer but suggested that the Nawab might give them instead to the King. Among them was the *Padshahnama* (or *Chronicle of the King of the World*), a unique official description of part of the 30-year reign of the Mughal Emperor Shah Jahan (1592–1666). Its 44 illustrations, by 14 court painters, include some of the finest Mughal paintings in existence (fig.189). Dating from 1630–57, they depict all the leading figures of Shah Jahan's court, a centre of artistic and architectural achievement that produced such monuments as the Red Fort at Delhi and the Taj Mahal at Agra.

As the British world of empire expanded, the King's contracted. By the end of his life he was no longer able to enjoy the library that he had spent so much of his life assembling. In the last decade of his life he became deaf and blind and was confined to Windsor Castle, only intermittently lucid. His last pleasure was playing the harpsichord that had belonged to Handel, telling his attendants that the music he hammered out was a favourite piece

189. From the *Padshahnama*: 'Shah Jahan Receives his Three Eldest Sons and Asaf Khan During his Accession Ceremonies' (8 March 1628), 1656–7. This page from the *Padshahnama*, illustrated by the court painter Bichitr, depicts a key ceremony following the accession of Shah Jahan as Emperor in 1627: the arrival at the fort in Agra of his four sons with their maternal grandfather, Asaf Khan, who was Wakil or Prime Minister. The eldest son, Prince Dara Shikoh, kneels before his father. The text records that 'The entire day was spent by the parents admiring the beauty of their grand sons.' Below the Emperor is a large globe, on which two lions and a lamb are seated, symbolising peace and harmony.
RCIN 1005025

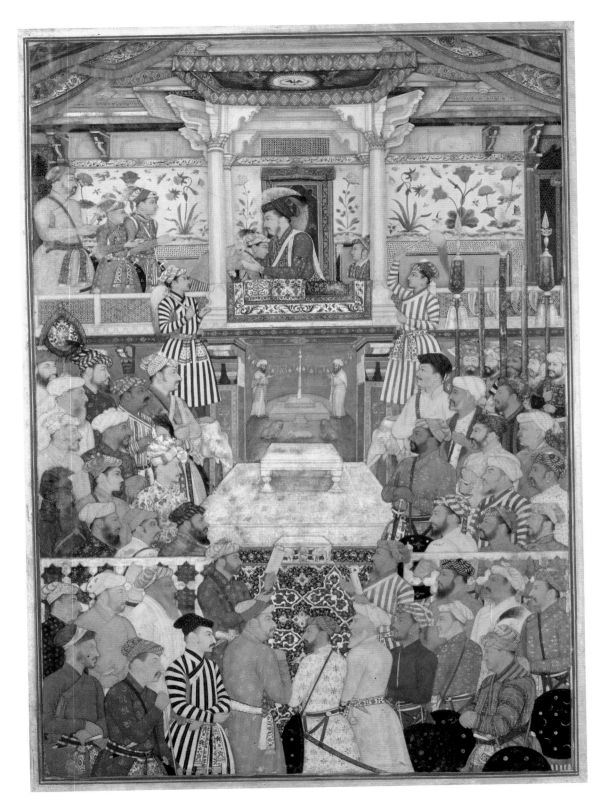

Enlightenment

190. *Huma or Bird of Paradise*, c.1787–91.
Set with rubies, emeralds, diamonds and pearls, this was the crowning ornament on the throne of Tipu, Sultan of Mysore. The throne, every element of which was covered in gold, was seized by the British as booty following Tipu's death during the fourth Anglo-Mysore war in 1799. It rested on eight supports in the shape of tiger legs, alluding to Tipu's chosen epithet, 'The Tiger of Mysore', and was surrounded by a railing with a small jewelled tiger head above each support; in the front was a life-size tiger head, also in the Royal Collection. The stand for the huma was made by Paul Storr.
RCIN 48482

191. *George III* by Joseph Lee, 1827.
Signed and dated seven years after George III's death, Joseph Lee's large enamel (22.2 cm in length) depicts the King in confinement at Windsor Castle in his final illness. Music was one of his last pleasures, alluded to by the organ pipes in the background on the left. The portrait is based on a mezzotint by Samuel William Reynolds, which in turn was derived from a sketch from life by the sculptor Matthew Wyatt. Lee later styled himself 'enamel painter' to George IV's daughter, Princess Charlotte of Wales.
RCIN 421492

of 'the late King'. His appearance in these final years is recorded in one of the most poignant of all royal portraits, a miniature on enamel by Joseph Lee, derived from a sketch made by the sculptor Matthew Wyatt when he was working at Windsor (fig.191). Although, at George IV's request, the composition was reworked to emphasise his father's royal status, the contrast with Ramsay's coronation portrait is painful to contemplate. By now the spotlight had shifted irrevocably to his heir. During George III's 60-year reign, the Royal Collection had been enormously enriched, but the sad story of his last years prematurely brought to centre stage the son who was to transform it.

Enlightenment

SPLENDOUR
George IV

Uniquely among British monarchs, George IV is best known to posterity by caricatures. From his coming of age in 1783, through his years as Prince Regent (1811–20), and then for a decade as King, he was depicted with cruel glee by Thomas Rowlandson (1756–1827), James Gillray (1756–1815) and many other artists. We now see the main events of his life through their eyes, from the financial problems that beset him from the start of his career to his scandalous entanglements with a number of mistresses and his disastrous marriage to Princess Caroline of Brunswick. For Robert Seymour (1798–1836), he was a parasite, 'The Great Joss' (fig.192), an obese mandarin figure squatting in his oriental pavilion at Brighton while converting a never-ending shower of gold from the Treasury into yet more palaces for himself.

How is such an image to be reconciled with the portraits that George commissioned of himself, such as the full-length of the new king in his coronation robes by Thomas Lawrence (1769–1830), as confident a depiction of opulent majesty as any British artist ever painted (fig.193)? How also is Seymour's contempt to be reconciled with George's spectacular legacy to

192. *The Great Joss and his Playthings* by Robert Seymour, *c.*1829.
In this etching George IV is depicted as a mandarin, holding a giraffe from his menagerie. The smoke from his pipe forming a 'C' refers to his current mistress, Lady Conyngham. Behind him is the Royal Pavilion, Brighton. Below him, the architect John Nash, in Chinese dress, offers a model of Buckingham Palace while catching gold sovereigns dispensed from the Treasury teapot.
RCIN 751279

193. *George IV* by Thomas Lawrence, 1821.
The King is dressed in spectacular coronation robes, which he designed himself. Commissioned for the throne room at St James's Palace, the portrait was hung between large paintings of British victories in the Napoleonic wars. George's right hand rests on the Sèvres porcelain *Table of the Great Commanders of Antiquity* (fig.213), on which the Imperial Crown is displayed.
RCIN 405918

the Royal Collection, the greatest by any monarch since Charles I? Even biographers sympathetic to George IV have argued that these contradictory aspects make a unity only if we accept the caricatures as reality and the portraits and palaces as fantasy. Such an attitude ignores the fundamental distinction between monarch and man that runs through the history of royal art. The emphasis George placed on splendour and ceremony was not primarily an excuse for extravagance or self-indulgence: it was appropriate to his role as the figurehead of a nation that, in his lifetime, became the richest and most powerful on earth.

This seems to have been well understood by the public, who laughed at George's personal failings, but were impressed by his public performance of kingship. That was evident at his coronation, on 19 July 1821. This enormously expensive ceremony, planned with all the rigour of a major theatrical production, was followed by a banquet in Westminster Hall of equal pomp. The Gothic Revival *mise en scène* culminated in the arrival at the banquet of the King's hereditary champion on horseback, dressed in armour (fig.194). Those spectators – and subsequent historians – inclined to find George an object of derision, thought the coronation an absurd pantomime, but it was a carefully conceived development of royal tradition and a great public success.

The way that George shaped the monarchy is symbolised by his creation of one of its best-known symbols, the Diamond Diadem (fig.195). Made for the coronation by the Royal Goldsmith, Rundell Bridge & Rundell, the King wore it for the procession to Westminster Abbey and for the banquet, although it was barely visible below a feather in his velvet cap. Its

194. *The Banquet at the Coronation of George IV* by **George Jones, 1821–2.**
The King's Champion enters Westminster Hall to challenge anyone who wants to contest the new King's right to reign. The champion on this occasion – the last time this medieval custom was observed – was Henry Dymoke, whose family held the title by hereditary right. His mounted escort included the Duke of Wellington. The King raises his glass to greet the Champion.
RCIN 404463

four *crosses-pattée* alternate, not with the conventional fleurs-de-lis, but with sprays representing the national symbols of the United Kingdom. Used subsequently by Queens consort and regnant, the crown is worn by Queen Elizabeth II in her portrait on coins and stamps. As such, it is as familiar a part of the royal image as Buckingham Palace and Windsor Castle, where George's inspired deployment of art and design of the highest order created the setting for the monarchy that has endured to the present day.

Carlton House

Many of the treasures of the present royal palaces have their origins in a building that does not survive. Today, the view down Regent Street towards St James's Park culminates in Waterloo Place, dominated by the Duke of York's Column. This was once the site of Carlton House, former home of Frederick, Prince of Wales, which in 1783 was given by George III to his eldest son. The old-fashioned house had not been lived in for over a decade, and so the Prince began to rebuild it. It is not altogether surprising that the young George reacted so strongly against his strict, confined upbringing, and it is hard to imagine him living in rooms without carpets, or devoting his leisure to taking clocks apart. The King kept the Prince on a tight financial rein, and was horrified by the escalation of his son's debts as the rebuilding of Carlton House progressed. Yet, the main difference between them – as between George II and Prince Frederick – was political. George IV become a supporter of the radical politician Charles James Fox (1749–1806), whose views (he supported the American rebels and welcomed the French Revolution) were anathema to the King, and so Carlton House came to stand for a particular political outlook. A father figure as well as political

195. The Diamond Diadem by Rundell Bridge & Rundell, 1820.
George IV's costume for his coronation was so splendid that the diamond diadem made for the occasion was barely visible. Its openwork silver frame, set with diamonds and pearls, incorporates the rose, thistle and shamrock. Probably conceived by Rundells' chief designer, Philip Liebart, the diadem cost £8,216, which included an £800 hire charge for the diamonds, but the King later decided to keep them. RCIN 31702

mentor to George, Fox was commemorated two years after his death by the prominent placing of a bust by Joseph Nollekens (1737–1823) in the vestibule at Carlton House (fig. 196).

It may seem odd that the heir to the throne should have been attracted by a radical politician, but there was a close parallel in France, where Louis XVI's cousin Philippe, duc d'Orléans (1640–1701) supported constitutional curbs on the monarch's power and after the revolution changed his name to Philippe Egalité – which failed, however, to save him from the guillotine. Orléans spent much time in London, and became a close friend of George, who commissioned a portrait of him from Reynolds. George never visited Paris, but he was well informed about the splendour in which Philippe lived, surrounded in the Palais Royal by the art collection he had inherited, one of the greatest in Europe. George took Orléans as a model, and it is no coincidence that Carlton House was a thoroughly French building. Its architect was Henry Holland (1745–1806), who came to George's attention by his remodelling of Brooks's Club in St James's; the club was a centre for radical politicians, and George, like Fox and Orléans, was a member.

In his design of the interiors of Carlton House, which began in earnest after parliament had agreed in 1787 to settle the Prince's already enormous debts, Holland worked closely with a Frenchman, Dominique Daguerre (d. 1796), who was what the French call a '*marchand-mercier*', literally a 'merchant-mercer'. The term refers to a dealer in the decorative arts who marshalled a variety of craftsmen to make works of art, often to designs that the *marchand-mercier* had commissioned. Daguerre had a shop in the rue St Honoré, and his work for the Prince of Wales, at Brighton as well as Carlton House, may have been the impetus that led him to open a branch in Chelsea in 1787. Although nominally working for Holland, Daguerre emphasised on one of his invoices that he took orders only from 'son Altesse Royale'.

Daguerre was known in particular for furniture decorated with Sèvres porcelain plaques. A prime example of the luxury furnishings he provided for the Prince is a superb cabinet supplied to Carlton House in about 1790 (fig. 197). Made by a celebrated German-born Parisian cabinetmaker, Martin Carlin (c. 1730–85), it incorporates no fewer than ten Sèvres plaques painted with flowers, those on the front of exceptional size. Equally impressive is the quality of the cabinet's delicate gilt-bronze mounts, one of the most admired aspects of French furniture. Another particularly French refinement, rarely found outside the country, was gilt-bronze firedogs (which supported logs in a fireplace). It is a mark of the Prince's Francophilia – and indifference to cost – that firedogs at Carlton House (fig. 198) were made by

196. *Charles James Fox* by Joseph Nollekens, 1808. Between 1805 and 1815 the Prince Regent commissioned Nollekens to carve a series of busts of his friends and political allies for display at Carlton House. This posthumous portrait of Fox, politician and celebrated orator who was a father figure to George, was greatly admired: 11 copies by Nollekens are known. When, in 1811, the Prince took the oaths of office as Regent, the bust of Fox was at his side. RCIN 35430

197. Cabinet by Martin Carlin, *c.*1783.
George IV owned a large collection of furniture mounted with Sèvres porcelain plaques, of which this is an especially opulent example. In the 1780s, such furniture was a speciality of the *marchand-mercier* Dominique Daguerre, who commissioned the leading furniture maker Martin Carlin to make the cabinet. The plaques' distinctive blue ground (*fond Taillandier*) takes its name from the Sèvres painter Vincent Taillandier, who may have invented it. RCIN 21697

198. Pair of firedogs by François Rémond, *c.*1780–5.
Probably supplied to the Prince of Wales for Carlton House in the 1780s by Dominique Daguerre, these firedogs in the form of an eagle clutching a thunderbolt and dragon are made of gilt bronze, an extravagant material for such a functional piece. RCIN 21664

François Rémond (*c.* 1747–1812), one of the leading Parisian bronze casters and gilders of the second half of the eighteenth century.

George also received some notable gifts for Carlton House, among them a set of four tapestries depicting the story of Don Quixote, woven at the Gobelins, the French royal manufactory. Louis XVI had given them in 1788 to the artist Richard Cosway (1742–1821), who generously passed them on to the Prince. Cosway was by then the leading painter of miniatures in the country, thanks largely to George's patronage. A worldly and witty fop, he was a man after the Prince's heart. Allowed from 1785 to sign his miniatures

Primarius pictor serenissimi Walliae principis (Principal painter to His Royal Highness the Prince of Wales), Cosway painted not only his royal patron, but almost every leading member of his social set, including the Prince's mistresses (fig. 199). Cosway gave George advice about the display of works of art and probably influenced his taste in pictures. They certainly shared an enthusiasm for seventeenth-century Dutch and Flemish paintings; Cosway's own distinguished collection included works by Rubens and Rembrandt, who were to be so magnificently represented at Carlton House.

It is hard to get a clear idea of the appearance of the house's interiors as completed by Holland in the mid 1790s because the Prince changed them so quickly. Over the next 15 years he extended, remodelled and redecorated the house almost continuously under the direction of successive architects. Depictions of Carlton House in about 1816 show, for example, that Holland's rooms, admired for their elegant restraint, had been embellished

199. *Elizabeth Milbanke, Viscountess Melbourne,* by Richard Cosway, c.1784. Lady Melbourne became the Prince of Wales's mistress in 1782. Cosway depicts her in Jacobean dress, perhaps an allusion to the seventeenth-century paintings that he and the Prince admired. Renowned not only as a society hostess but also for her interest in agricultural improvement, Lady Melbourne was remembered by Lord Byron as 'the best friend I ever had in my life, and the cleverest of women'. RCIN 400967

with lavish upholstery in a manner that became fashionable during the Regency (fig. 200). George's never-ending alterations to his houses undeniably had a capricious element – he seems sometimes to have thought of his residences as being as temporary as the backdrops to the fêtes and parties he enjoyed staging – but they were also a consequence of a restless urge towards perfection, evident also in his collecting.

Despite these frequent changes, George's tastes altered little over his lifetime. He never abandoned his youthful enthusiasm for French furniture, bronzes and porcelain, combined with Dutch, Flemish and English paintings. From the outset, he happily and creatively mixed styles, from Gothic to Rococo to neoclassical. The resulting ensembles formed a unity, thanks above all to his preference for highly finished, superbly made objects, whether pictures or porcelain. He was not drawn to artists who eschewed immaculate surfaces: for example, he commissioned only one painting by J.M.W. Turner, *The Battle of Trafalgar* (1823–4), which he then gave away, because, it was said, he became exasperated by criticisms of the artist's faulty depiction of the rigging of the ships (it is now in the National Maritime Museum, and the Royal Collection still lacks a painting by Turner).

200. *The Crimson Drawing Room, Carlton House*, by Charles Wild, 1816.
A watercolour made for reproduction in W. H. Pyne's three-volume *History of the Royal Residences* (1816–19), which is the best visual record of the interiors of Carlton House. On the wall at far left is Rubens's *Landscape with St George and the Dragon* (fig. 52), which the Prince had bought back for the Royal Collection in 1814. RCIN 922176

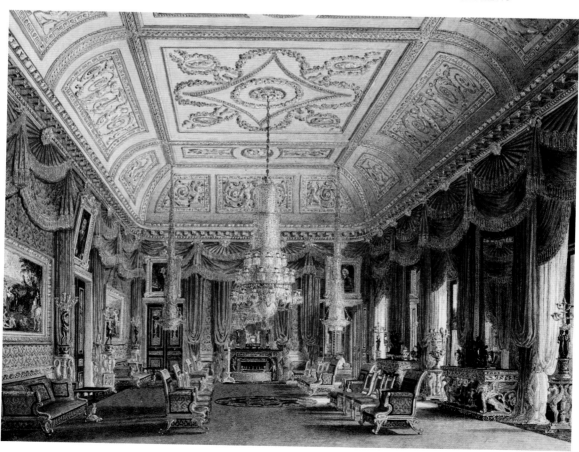

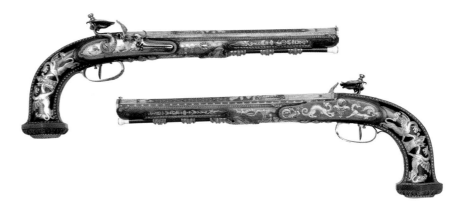

201. Pair of pistols by
Nicolas Noël Boutet,
c.1802.

Given to the Prince of
Wales in 1810 by the
Marquess Wellesley,
brother of the Duke of
Wellington, this pair of
very finely decorated
duelling, or target, pistols
are by the director of the
factory established at
Versailles in 1792 to
manufacture arms for the
revolutionary army. It later
came to specialise in
luxury weapons for
presentation as gifts.
RCIN 61152

Although historians have fruitfully explored the influences on George's collecting, he was not always swayed by his friends and advisers. He did not share Holland's love of antique sculpture and showed no interest in Cosway's greatest enthusiasm, Old Master drawings. He was also distinctive in combining a love of the luxury arts with an enthusiasm for arms and armour, forming an enormous collection, which by 1819 extended over five rooms of the attic floor of Carlton House. Many of these objects were as beautifully crafted as the works of art in the drawing rooms (fig.201). Although the Prince wrote hardly anything about his collecting, there is no doubt that he was driven principally by an appetite for visual enjoyment. In 1804 the painter and diarist Joseph Farington (1747–1821) recorded a conversation with the Prince, in which he 'spoke of the pleasure He derived from works of art and mentioned the advantage He had over His brothers in this respect as they had no feeling for it'.

A taste for the exotic

Among the most admired interiors at Carlton House was Holland's Chinese Drawing Room. There was nothing new in the 1790s about a taste for oriental decorative arts or Western interpretations of them. In the background of Zoffany's portrait of Queen Charlotte at her dressing table (see fig.173) are two Chinese figures, and the Queen's liking for oriental luxuries – she had a room at Buckingham House panelled with Japanese lacquer and she furnished Frogmore with Indian ivory chairs – may perhaps have influenced her son. Oriental porcelain had been eagerly collected in Europe for centuries, and George owned many fine examples, for which Daguerre and others supplied exquisite gilt-bronze mounts (fig.202). However, he was exceptional in the systematic way he created richly decorated interiors of oriental inspiration. The Chinese Drawing Room was soon to be eclipsed by one of the most extraordinary architectural creations by any British monarch, the Royal Pavilion at Brighton.

George's decision to build a house by the sea was influenced by his desire to escape his parents' disapproving eyes, something that became a matter of urgency when, in 1785, he illegally married a Roman Catholic widow, Maria Fitzherbert. In 1786–7 Holland extended and remodelled the existing building on the site in the style of Carlton House. The great transformation of the pavilion into an exotic pleasure palace was undertaken by the architect John Nash in 1815–17. The principal interiors, the Banqueting Room and Music Room, were designed by Robert Jones (active 1815–33), who may have begun as a painter of wallpapers. He proved as expert in mixing styles – Chinese, Indian, Gothic and classical – as he was at coordinating the many craftsmen of the first rank employed by the Prince. The quality of what was achieved is evident in the surviving furnishings that were specially made for the Pavilion, such as an extraordinary barometer and thermometer (fig. 203) and matching clock supplied for the Banqueting Room's two chimneypieces (themselves decorated with colourful Chinese figures). To these, the Prince added *objets d'art* in the Chinese taste originally at Carlton House.

By the 1840s, the arrival of the railway and encroachment of the town had destroyed the last remnants of the Pavilion's secluded character, and so in 1846 Queen Victoria and Prince Albert decided to sell it to the town of

202. Chinese porcelain jar and cover, 1720–40, mounted as a pot-pourri in the mid eighteenth century.
Made in Jingdezhen in south China, a centre for porcelain manufacture since the eleventh century, this jar depicts the 'three friends of winter': pine, prunus and bamboo, hardy plants that symbolise steadfastness. It was imported into France, where it was fitted with gilt-bronze mounts that convert it into a holder for pot-pourri. The eight holes in its neck allowed the perfume to permeate a room.
RCIN 2306

Brighton to be used for civic purposes. Most of the furnishings and many of the fittings, such as the chimneypieces in the Banqueting Room, were removed to Buckingham Palace, where they were used to furnish a suite of rooms in the east wing. From the 1920s, however, encouraged by Queen Mary, and with loans from the Royal Collection, successive curators of the Pavilion have restored the interiors to their appearance in George's lifetime.

Dutch and Flemish pictures

Independence of taste is also evident in the Prince's collecting of Old Masters. He showed little interest in Italian Renaissance and Baroque paintings of the sort that became available in great quantities on the market thanks

Splendour

to the break-up of aristocratic collections in France after the Revolution (although in 1788 he did unsuccessfully attempt to form a syndicate to purchase the duc d'Orléans's paintings). George may perhaps have felt that the Royal Collection was already well supplied with such works. Instead, he focused on Dutch seventeenth-century paintings, following a tradition established by wealthy French collectors, for whom these works had many attractions. They were usually small, so were easy to display in the interiors of Parisian town houses or apartments at Versailles (one of the criticisms of Carlton House was that most of the rooms were not large). Often pointing to an obvious moral or telling a simple story (fig.204), the paintings were predominantly secular; like most aristocratic collectors in France as well as England the Prince avoided religious subjects (more surprisingly, he did not care for still lifes). Paintings had been produced in large numbers in the

204. *The Game of 'Lady, Come into the Garden'* by Godfried Schalcken, late 1660s.
Bought by the Prince of Wales in 1803, the painting shows the artist and his friends playing a game in which men had to sacrifice an item of clothing if they failed tests set by women. Schalcken is the young man on the floor. He uses the subject to demonstrate the mastery of realistic detail he had learned from his master, Gerrit Dou; Schalcken is said to have spent a whole month painting just the tapestry on the right of the painting. RCIN 405343

Netherlands in the seventeenth century, and so were readily available, and the leading artists worked in distinctive styles, allowing collectors to demonstrate a gentlemanly level of connoisseurship – there are obvious parallels with the collecting of Impressionist paintings by American millionaires in the twentieth century.

George acquired Dutch paintings for Carlton House from the outset, demonstrating a particular enthusiasm for military, sporting and hunting scenes. However, the collection as its exists today began to coalesce only around 1800, as he steadily increased the quality of what he owned in response to the advice and encouragement of friends. For his acquisitions in the saleroom during the Regency he was guided by Lord Yarmouth, Vice-Chamberlain of his Household (1777–1842; and from 1822 3rd Marquess of Hertford), whose own purchases were to form the basis of the Wallace Collection. With Yarmouth's help, the Prince began to acquire some major masterpieces. At Christie's on 12 June 1811, just a week before the inauguration of the Regency, Yarmouth purchased on George's behalf a group of works that included Rembrandt's *The Shipbuilder and his Wife* (fig.205). At 5,000 guineas, it was the most expensive painting the Prince ever bought.

Yarmouth was succeeded in his role as principal adviser to the Prince on artistic matters by Sir Charles Long, later Lord Farnborough (1760–1838), a well-known arbiter of taste, who was to play a major role in the creation of the National Gallery in 1824. Long was closely involved in the purchase that

205. *The Shipbuilder and his Wife* by Rembrandt van Rijn, 1633.
In one of his most famous portraits, Rembrandt depicts the Dutch East India Company's master shipbuilder, Jan Rijcksen, working on what appears to be a treatise on shipbuilding, while his wife, Griet Jans, interrupts him brandishing a note. It was unusual at this time for married couples to be shown in a single image rather than two separate paintings.
RCIN 405533

formed the climax of the Prince's collecting of Dutch art, the acquisition in 1814 of 86 paintings that had been inherited by Sir Thomas Baring from his father, the founder of Barings Bank. Apart from a few fine Flemish works, mostly by Teniers, they were all Dutch and of very high quality, but despite this, as Long remarked afterwards, 'Sir Thos. had asked a moderate price.' There were three works by Gerrit Dou, perhaps the Prince's favourite artist after Rembrandt, six by Adriaen van Ostade (1610–85) and an outstanding group of landscapes by such artists as Cornelis van Poelenburgh, Aelbert Cuyp (1620–91; fig.206) and Meindert Hobbema (1638–1709). The purchase also included a gentle domestic scene by Gerard ter Borch, *The Letter* (fig.207), that is now one of the best-loved works in the Royal Collection.

The Prince did not keep all the Baring paintings. Some he gave away, such as a pair of flower pictures by Jan van Huysum (1682–1749), which he presented to his mother, and others were sold as part of a group of 75 despatched to Christie's only three weeks after the purchase. This was partly a matter of upgrading his collection, and partly a matter of space – the acquisition of Baring's paintings meant that there were over 200 Dutch paintings at Carlton House. Two years later, when the Prince was going through a period of public unpopularity, thanks to the failure of his marriage, Farington recorded that 'being uncertain what Mobs might do at this disturbed time', George 'had thought it prudent to have his pictures at Carlton House valued, and an insurance made upon them'. The resulting catalogue reveals that 170 paintings were on display, of which nearly 100 were Dutch, and a further 250 were in storage. From that point, George could be persuaded to buy a painting only if it was exceptional, and completely in tune with his well-established tastes. For example, in 1816 he turned down the opportunity to purchase Jan van Eyck's *Arnolfini Marriage* (now in the National Gallery, London); and in 1819, when he was offered the chance to

206. *An Evening Landscape with Figures and Sheep* by Aelbert Cuyp, *c.*1655–9. The painting is characteristic of Cuyp's work after the mid 1640s in its combination of a Netherlandish landscape with Italian sunlight. Virtually unknown outside his native Dordrecht in his lifetime, Cuyp was discovered by collectors in France and England towards the end of the eighteenth century, and by the time the Prince Regent bought this painting in 1814, his works were fetching very high prices. RCIN 405827

207. *The Letter* by Gerard ter Borch, *c.*1660–65. After a peripatetic early career, which included a year working in London in 1635–6, Ter Borch settled in 1655 in Deventer, where he painted the genre scenes for which he is best remembered. The woman reading the letter is the artist's step-sister Gesina ter Borch, herself an artist, who was his favourite model. The subtly depicted responses of her audience are as much a tour de force of painting as her shimmering silk dress. RCIN 405532

buy any paintings he wanted from the Aynard family collection, one of the finest in France, he chose only Rubens's glorious *Milkmaids with Cattle in a Landscape* (fig. 208). Nonethless, he was still willing to pay a very high price if the painting was as covetable as Van Dyck's triple portrait of Charles I (see fig. 68), which he bought in 1822 for 1,000 guineas.

The arts of France

Despite the number of paintings in storage, the Prince bought works of art principally to furnish his houses. Although it is convenient to analyse his purchases of paintings, furniture and ceramics separately, they were intended to function within unified decorative ensembles. Such works might also have been linked in his mind by historical or dynastic associations. This is especially true of his French decorative arts, since the Prince was collecting during the period when such works were beginning to appeal not only for their intrinsic quality but also for their value as relics of the French monarchy and aristocracy.

In particular, George's appetite for portraits of the Bourbons suggests a desire to emulate their achievements. The centrepiece of the armoury at Carlton House was a bronze equestrian sculpture of Louis XIV, bought by the Prince in 1817 (fig. 209). Moved in 1826 to the Green Drawing Room at

208. *Milkmaids with Cattle in a Landscape* by Peter Paul Rubens, *c.*1617–18. This radiant landscape, painted early in Rubens's career, is often known as *The Farm at Laken* because it was described in the seventeenth century as a 'view of Laken', a village near Brussels. The church, which housed a girdle of the Virgin, was a place of pilgrimage for women wishing to conceive, which suggests that this scene of fruitful harvest has an allegorical undertone. RCIN 405333

209. *Louis XIV* by François Girardon, *c*.1696.
This is one of the bronze casts of the small-scale model that Girardon made for his colossal equestrian statue of Louis XIV. Louis is depicted as a military commander, wearing Roman armour and a full-bottom wig. The bronze statue, seven metres high, was erected in 1699 in the new square in Paris that was to become the Place Vendôme.
RCIN 31359

Windsor Castle, this small-scale version by François Girardon (1628–1715) of his 1692 colossal statue of the King in the Place Louis-Le-Grand (now the Place Vendôme) in Paris was probably a gift from Louis to the marquis de Phelypeaux. Had George been aware of that royal provenance, it would have increased the appeal to him of this superb bronze, but its main interest, apart from its quality, was that it depicted the greatest monarch of a dynasty that for over a century had been Britain's most formidable rival. In the armoury at Carlton House it would have recalled the British military campaigns against Louis; at Windsor Castle it implied that George IV was the successor of *Le Grand Monarque*, a view of history made all the more pointed by the fact that Girardon's statue in Paris was destroyed by revolutionaries in 1792.

Thanks to George, the Royal Collection owns the finest group of porcelain outside France made in the royal manufactory at Sèvres, for which he had a voracious appetite. Some of this was for use at the table, other pieces

210. Vincennes sunflower clock, *c.*1752.
In the late 1740s and early 1750s there was a fashion for porcelain flowers made in the royal factory at Vincennes, the forerunner of Sèvres. This is one of the most spectacular results, and the profusion of blooms (which may originally have been combined with real flowers) means that it is not immediately obvious that the gilt-bronze sunflower is a clock face. RCIN 30240

were designed for display on cabinets and chimneypieces, and, as described above, he also owned furniture mounted with Sèvres plaques. George's enthusiasm for Sèvres had been shared by his mother, and he bought back pieces from Queen Charlotte's collection of Sèvres at the sale of her effects in 1819. With her love of horticulture, she would certainly have approved of another purchase by him in the same year, a Vincennes porcelain clock in the form of a vase of flowers (fig.210). The Prince was probably drawn to this spectacular object not only by its quality but also by the information

recorded when the clock was received at Carlton House that, 'This Article is Said to have belonged to Madame Pompadore.' Although undoubtedly an object that reflects her taste, it is not known if the clock had in fact been owned by Louis XV's mistress (the Prince did own other pieces of porcelain that are now known to have belonged to the Marquise de Pompadour), but the statement is significant as an early manifestation of the way dealers would use such associations to tempt purchasers of old-fashioned pieces.

One of the Prince's major purchases of Sèvres had an exceptional royal provenance. In 1783 Louis XVI commissioned the factory to make a complete service for his personal use at Versailles. It was the most expensive ever made at Sèvres and so extensive that the King ordered it to be delivered in batches over a period of 23 years (fig.211). Recognising that it was a showcase for the factory's skills in painting and gilding, he placed each consignment on public view at Versailles as it was delivered, but only half had been completed at the time of his execution in 1793. In 1810 George bought 12 pieces that had never reached Versailles, and then a year later he acquired – for the enormous sum of £1,973 – the whole service.

In the nineteenth century collectors of Sèvres placed most value on the factory's mid eighteenth-century Rococo productions – the earlier wares were thought to lack perfection and the later pieces, after about 1770, were

211. A plate from the Louis XVI Sèvres service, 1783.
Painted by Charles-Nicolas Dodin with a scene of an offering to Bacchus, this plate is part of the enormous service ordered by Louis XVI in 1783. Each plate required at least seven separate firings, explaining why each was 13 times as expensive as those in a usual well-decorated service made at Sèvres. Such plates were for display; plain plates with borders were provided for eating.
RCIN 58027

believed to be debased in style. George was strikingly unbothered by such distinctions. His purchases of decorative arts encompassed the most florid Rococo pieces and the most stark neoclassical designs, which he then combined. There could hardly be a greater contrast between the Vincennes flower clock, on display in the Ante Room at Carlton House, and the superb mantel clock by Claude Galle (1759–1815) in the Crimson Drawing Room (fig.212), a dramatic sculptural representation of the Oath of the Horatii, based on the 1784 painting by Jacques-Louis David (1748–1825).

One of the leading Parisian makers of gilt bronzes, Galle was patronised as eagerly by Napoleon as he was by the royal family, and the clock, made in the first decade of the nineteenth century, embodies the style now called 'Empire'. George IV's fascination with the Emperor is one of the most unexpected aspects of his collecting. Once Napoleon had been banished to Elba, George's agents scoured Paris for works of art that had belonged to him. In May 1814 Sir Thomas Tyrwhitt wrote to the Prince, 'I have been collecting here everything I could find appertaining to the family of the exiled monster.' By the time of his death, George owned Napoleon's sword as First Consul, a cloak he was reputed to have worn during his Egyptian campaign, a leather map-case he used in his march on Moscow, and even the imperial porcelain travelling wash basin.

Judged as a work of art, the most significant memorial to Napoleon in the Royal Collection was given to the Prince Regent in 1819 by Louis XVIII (younger brother of Louis XVI), who, with George's support, had been restored to the throne in 1814. This was the *Table of the Great Commanders of Antiquity*, which depicts famous military leaders (fig.213). Made almost entirely of Sèvres porcelain, it took nearly six years to create and is a

212. Mantel clock by Claude Galle, 1800–9.
The three Horatii brothers raise their arms to receive their swords from their father Tatius, as they swear their oath to Rome at an altar before going into battle. Their fate is shown at the front of the green *verde antico* marble base: Tatius greets his victorious, but only surviving, son.
RCIN 2761

213. *Table of the Great Commanders of Antiquity*, **1806–12.**
Commissioned by Napoleon in 1806, this Sèvres porcelain table was designed to celebrate the Emperor's place in history. The top depicts the profile head of Alexander the Great, surrounded by 12 smaller heads of commanders and philosophers from antiquity, painted in imitation of cameos.
RCIN 2634

technical as well as an artistic tour de force. The value George placed on it is evident from its appearance in his state portraits from then onwards. In the painting by Lawrence, for example (see fig.193), his crown rests upon it and he touches it with his left hand – undoubtedly a gesture of triumph over a great enemy, but also, perhaps, a mark of respect.

A patron of British art

George IV's love of French design was not accompanied by any great interest in the nation's fine arts. For contemporary painting and large-scale sculpture, he looked to British artists, for whom he was one of the leading patrons of the age. It may perhaps have been his desire to emphasise his independence from his parents that led him at the outset of his collecting career to turn to painters they had ignored, such as Cosway, or disliked, most

214. *Self-portrait* by Joshua Reynolds, *c*.1788. One of 27 self-portraits by Reynolds, this shows the artist in his mid sixties, and is the only one in which he is wearing glasses – his sight deteriorated badly in old age and by 1791 he was blind. After his death the painting was given to George IV by the artist's niece, Mary Palmer, Marchioness of Thomond, in recognition of his support for her uncle. RCIN 400699

notably Joshua Reynolds (1723–92). The numerous portrait commissions given by the Prince to Reynolds in the last few years of the artist's career, and the eagerness with which he bought earlier works as they came on the market, reveal a deep appreciation of the painter. In 1813 he lent nine works to a retrospective exhibition of 200 of Reynolds's paintings staged by the British Institution, an organisation for promoting British art, of which the Prince was patron. Among the paintings he owned was Reynolds's penultimate self-portrait (fig.214). Described by his first biographer, Edmond Malone, as 'exactly as he appeared in his latter days, in domestick life', this unsparing study was painted in about 1788.

Perhaps the fact that he had been so greatly favoured by George III and Queen Charlotte might help to explain why George sat only occasionally to Reynolds's great rival, Thomas Gainsborough, most famously for a full-length portrait of 1781 (now at Waddesdon Manor, Buckinghamshire). He did, however, acquire some inexpensive paintings from the studio sale of the artist's nephew, Gainsborough Dupont (1754–97), in 1797, including – for just £2 3s – Gainsborough's only surviving mythological painting, *Diana and Actaeon* (fig.215). Its shimmering, loose brushwork, more typical of eighteenth-century French painting than British, is unlike the sort of highly finished work the Prince normally favoured, and he later consigned this magical canvas to storage.

After collecting and building, George's favourite pastimes were hunting, carriage driving and racing. One of his legacies to the monarchy is Royal Ascot, since he commissioned Nash to design a royal stand and instituted

215. *Diana and Actaeon* by Thomas Gainsborough, c.1785–8.
Probably stored in the artist's studio at the time of his death in 1792, this sketch-like painting depicts the moment when the hunter Actaeon was turned into a stag as punishment after he had stumbled across the goddess Diana and her nymphs bathing. He was then killed by his own hounds.
RCIN 405077

216. *The Prince of Wales's Phaeton* by George Stubbs, 1793.
Stubbs was commissioned to paint the Prince of Wales's fashionable new 'high-flyer' phaeton, ordered in 1792, together with Samuel Thomas, his State Coachman. He includes a 'tiger-boy', employed to crouch on the bar behind the back wheels in case of an accident, and the Prince's dog Fino, a black-and-white Spitz, who had already been the subject of a portrait by Stubbs in the Royal Collection.
RCIN 400994

the carriage procession along the course. Sporting subjects feature prominently in his collecting and commissioning, and it is thanks to him that the Royal Collection contains so many notable horse paintings by Sawrey Gilpin (1733–1807), George Garrard (1760–1826), Benjamin Marshall (1768–1835) and Henry Chalon (1770–1849). He owned no fewer than 14 canvases by the most celebrated of all sporting artists, George Stubbs (1724–1806), beginning in 1791 with a portrait of the Prince dressed as a dandy on horseback. Two years later, Stubbs painted the Prince's newly acquired phaeton (fig.216), a fast, open, two-horse carriage designed to be ridden by George himself. This celebration of an accoutrement of a young man of fashion with a taste for the fast lane is elevated by Stubbs into high art, partly by his sensitive portrayal of the two servants and partly by the way he has arranged the figures and horses with a dignity that lends this scene of contemporary life the timeless authority of a classical relief.

George's enormous expenditure on horses (his debts by 1787 included nearly £29,000 on his stable account) resulted in some notable successes on the turf – in the 1790s his horse 'Escape' was reckoned the finest in England – but the masterpiece of horse portraiture that he commissioned when

King, James Ward's *Nonpareil* (1824), depicts a stallion that had an undistinguished career (fig.217). Ward (1769–1859), who was appointed Painter and Engraver in Mezzotint to the Prince of Wales in 1794, demonstrates an understanding of horse anatomy equal to Stubbs's, but the painting's romantic atmosphere could not be more different from *The Prince of Wales's Phaeton*. Posed against a beautifully painted view of Windsor Castle, the horse looks tense, as though anticipating a race, and the overarching rainbow gives the painting an unearthly quality.

Nonpareil is imbued with the influence of the artist whom Ward admired above all others, Rubens. There are many links between George's enthusiasm for Flemish and Dutch painting and his patronage of English artists. This is especially evident in the works he commissioned from David Wilkie (1785–1841), which inventively continued the tradition of Dutch seventeenth-century paintings of peasant life. Born in Fife, and trained in Edinburgh, Wilkie came to London in 1805 and caught the Prince's eye when he began exhibiting at the Royal Academy. George greatly admired his benign depictions of the everyday life of the poor; in 1823 Wilkie was appointed 'Limner to the King' in Scotland and in 1830 Principal Painter in Ordinary. One of Wilkie's most characteristic works is *The Penny Wedding* (fig.218), painted in 1818 as a pendant to his *Blind-Man's Buff* (1812), which the

217. *'Nonpareil'* by James Ward, 1824. Nonpareil's anxious expression and placement in a dramatically lit landscape are characteristic of Ward's portraits of horses. Nonpareil was probably foaled in 1806. In 1824 Ward painted Napoleon's horse Marengo and Wellington's Copenhagen, so this painting, showing Windsor Castle in the background, may allude to the Napoleonic wars. RCIN 405018

Prince already owned. Hung at Carlton House alongside works by Adriaen and Isaac Ostade and Jan Steen (c.1626–c.1679), it is a modern version of a seventeenth-century wedding scene. Even the form of Wilkie's signature is a pastiche of that by David Teniers the Younger.

The pull of the past

218. *The Penny Wedding* by David Wilkie, 1818.
Wilkie depicts a tradition, associated with Scotland, whereby each guest contributed a penny towards the expenses of a wedding. This idealised image of communal self-support among the poor includes a portrait of a famous fiddler and composer, Niel Gow, who played for dances all over Scotland and visited London to play at balls held by his patron, the Duke of Atholl.
RCIN 405536

Wilkie's best-known painting of a contemporary event depicts George IV arriving at Holyrood House in August 1822 on the occasion of the first visit to Scotland by a reigning monarch – excepting the exiled Charles II – since the coronation of Charles I in Edinburgh two centuries earlier (fig.219). Like his tour of Ireland in 1821, the first by a British King since Richard II in the fourteenth century, the visit was intended to demonstrate the reality of the relationship between the monarch and the constituent realms of the United Kingdom, as symbolised by the emblems on George's coronation coronet. The event was prompted in part by the rediscovery by the novelist and poet Walter Scott in 1818 of the Scottish regalia, locked away in a chest in Edinburgh Castle. The King greatly admired Scott's work – he unsuccessfully offered him the poet laureateship – and was enticed northwards by his proposal to stage a ceremony in which the King would be presented with the ancient crown of Scotland.

As Wilkie's painting demonstrates, the royal visit caught the fashion for Highland romance stimulated by the publication in 1821 of Scott's bestselling novel *Kenilworth*. Despite the many absurdities emphasised by historians, such as the King's enormously expensive Highland outfit, in which a Royal Stewart tartan kilt was worn over flesh-coloured tights (designed to hide his gouty knees) – the visit was a great success, and laid the foundations for the monarchy's acquisition of a Scottish identity under Victoria and Albert. There was also a serious political purpose behind George's visit. With the death in 1807 of the last Stuart claimant to the throne (Bonnie Prince Charlie's younger brother Henry Stuart, Cardinal York – Henry IX to his supporters), the Jacobite threat faded into history. In the eyes of Scott and others, the King's visit to Scotland was a mission of reconciliation.

George took a great interest in the exiled Stuarts. He made a contribution to their monument in St Peter's, Rome, designed by Antonio Canova, and arranged for the Stuart archive that had been in the care of Cardinal York to be brought to Windsor. In return for the generous pension he had been granted by the Crown, the Cardinal bequeathed to the King some important family heirlooms, including jewels and a beautiful early fifteenth-century illuminated French manuscript, known as the Sobieski Hours (fig. 220). It had belonged in the seventeenth century to Jan Sobieski, King of Poland, whose granddaughter Clementina married the Cardinal's father, James Stuart, the Old Pretender.

219. *The Entrance of George IV at Holyroodhouse* by David Wilkie, 1822–30. Wilkie shows the scene at Holyroodhouse on George IV's visit to Scotland in August 1822 when the keys to the palace were presented to the King by its hereditary Keeper, Alexander, 10th Duke of Hamilton. The royal tour was organised by Sir Walter Scott, who is shown in the painting at far left, next to the man in the ruff. RCIN 401187

220. *The Sobieski Hours*
by the Bedford Master,
*c.*1430–40.
Three illuminators
contributed to this superb
Book of Hours, a collection
of prayers for different
hours of the day, made
in Paris. They include the
artist who takes his name
from the British Library's
Bedford Hours, made for
Henry V's brother, John,
Duke of Bedford. One
of the miniatures in the
Sobieski Hours depicts
a woman who is probably
Isabelle of Brittany, a
granddaughter of Charles
VI of France, suggesting
that the book was made
for her.
RCIN 1142248

George did not otherwise collect medieval manuscripts, but he was drawn
to the decorative arts of the past where they satisfied his taste for glamour
and superb craftsmanship. He greatly admired goldsmiths' work of the
Renaissance, and especially standing cups, which he used for the purpose
for which they made, for display on a buffet or sideboard during dinners.
Among his finest acquisitions is a spectacular cup incorporating a nautilus
shell, made in about 1600 (fig.221). Like so much outstanding Renaissance
plate, it was associated with Benvenuto Cellini by the nineteenth century,

221. Nautilus Cup by Nikolaus Schmidt, *c.***1600.**
Nautilus shells, found in the western Pacific, were eagerly sought by sixteenth-century European collectors, who often had them embellished with richly decorated silver-gilt. The shell has been turned by Schmidt into a drinking cup – intended for display – appropriately supported by the god of the sea, Neptune. The lid is crowned by a figure of Jupiter, wielding a thunderbolt.
RCIN 50603

but it bears the mark of one of the leading goldsmiths in sixteenth-century Nuremberg, Nikolaus Schmidt (1550/55–1609), whose work is also found in the royal treasuries in Dresden and Vienna. The King's appetite for such pieces led him to commission plate in historical styles by such designers as John Flaxman (1755–1826) and the young A.W.N. Pugin (1812–52), whose skill in Gothic design was to be employed in the creation of furniture for the great project that occupied most of George's reign, the remodelling and furnishing of Windsor Castle.

Windsor Castle

George III's decision in the 1770s to move into Windsor Castle had initiated a programme of building works that was abruptly terminated by the final onset of his mental illness in 1811. When George IV began work there in 1824 he was, to some degree, continuing his father's work, emphasised by the fact that his architect Jeffry Wyatt, who took the name Wyatville (1766–1840), was the nephew of George III's architect, James Wyatt. The work begun in 1824 was far more ambitious than anything contemplated in the previous reign, as George embarked on an ambitious programme of not only completely remodelling the state apartments in the north range of the Upper Ward, which were still largely in the state left by Charles II in the 1680s, but also creating new private apartments in the east and south ranges. All this had to be achieved within the shell of a medieval building that was in poor state of repair.

This complex and expensive project – it eventually cost £771,000 – was carried out almost exactly as George had envisaged, thanks to the efficiency of his architect and the clarity of the initial brief, drawn up in 1823–4 by his adviser on art, Sir Charles Long. Almost everything was achieved, from the planning of the private apartments, to the laying out of a terrace garden on the east front, and the heightening of the Round Tower to create the dramatically picturesque silhouette that is one of the most admired features of Wyatville's work.

The private apartments, which were ready to be occupied in 1828, form a sequence of interiors, the semi-state rooms, that are decorated and furnished to the highest standards of glamour and luxury. The firm responsible was Morel & Seddon (fig.222), who employed the leading cabinetmaker in Paris, F.-H.G. Jacob-Desmalter, to supply furniture. The quality of these rooms owes much to the King's exacting oversight; as early as 1824 the Duke of Wellington found him 'not to be the least interested in public affairs & to be thinking of nothing but his improvements & alterations at Windsor'. As the new interiors were created in a medieval range that was only one room deep, Wyatville linked them by an enormously long 15-feet wide corridor, which formed an ideal setting for works of art. The Grand Corridor, as it became known, was hung with a large part of George III's collection of paintings

222. *Design for the East Elevation of the Crimson Drawing Room* by **Morel & Seddon, Windsor Castle,** *c.***1827.**
In 1827 the designer Nicholas Morel and furniture maker and upholsterer George Seddon formed a partnership to furnish George IV's new apartments at Windsor. This is one of the designs submitted for the King's approval. The Crimson Drawing Room was upholstered with a striped poppy-coloured velvet that cost £3 13s a yard, the most expensive fabric used in the project.
RCIN 931280

223. Jewel cabinet by Jean-Henri Riesener, 1787.
The cabinet's first owner was Marie-Joséphine-Louise of Savoy, who married Louis XVI's younger brother, the Comte de Provence in 1771. She died in exile in England, four years before her husband returned to France as Louis XVIII. The cabinet is a masterpiece by Riesener, but the creator of its magnificent gilt-bronze mounts has not been identified.
RCIN 31207

by Canaletto, spaced out by 33 busts on plinths and opulent pieces of furniture, most notably three newly purchased Boulle armoires.

The major source of acquisitions for these apartments was the sale by Christie's in 1825 of the outstanding collection of furniture and decorative arts formed by the MP George Watson Taylor (1771–1841). The King bought 31 lots at a total cost of £4,868. His purchases included such great treasures as Leone Leoni's bronze bust of Philip II (fig.22) and the jewel cabinet made by Jean-Henri Riesener in 1787 for Louis XVI's sister-in-law the Comtesse de Provence (fig.223). Confiscated in 1793, it was later offered to Napoleon, who rejected it as 'du vieux' – part of a former world that he had superseded. For George IV, being 'du vieux' was part of its attraction. The cabinet stands in the White Drawing Room, amid a beautifully orchestrated ensemble of superb architectural carving and chimneypieces (many brought here from Carlton House), French furniture, bronzes and porcelain, and eighteenth-century and Regency English portraits: a combination that set a model for aristocratic and plutocratic interiors for generations to come.

After the completion of the private apartments, George turned his attention to the state rooms. It has become *de rigueur* to lament the way that, with the exception of a few ceilings, he and Wyatville swept away the painted interiors created by Verrio for Charles II, but it is often forgotten that they were much damaged and overpainted, as well as structurally unsound. The new St George's Hall, created by throwing together the former hall and chapel, is a Gothic banqueting chamber almost 200 feet long. The former King's Guard Room, now known as the Grand Reception Room, was remodelled as a ballroom in French style, fitted out with newly acquired Gobelins tapestries and eighteenth-century French panelling. The other state rooms were less drastically treated and a great deal of seventeenth-century panelling and carving remains. The King continued his parents' policy of hanging the upper part of the walls with silk to form a backdrop for pictures, many of which were arranged in groups according to period or artist. As a result, the King's Drawing Room was renamed the Rubens Room and the Queen's Ballroom became the Van Dyck Room. The state apartments, their original functions now largely forgotten, thus acquired the character they have retained, of a gallery of Old Master paintings.

The Waterloo Chamber

Among Wyatville's major changes was the infilling of an internal courtyard to create a top-lit gallery, decorated with carvings by Grinling Gibbons removed from the old chapel (fig.224). This was initially intended to house sculpture, and the King commissioned for it a massive vase carved by Richard Westmacott (1775–1856) with a relief depicting the Battle of Waterloo (1815), carved from a block of Carrara marble reserved by Napoleon for a vase celebrating his expected victory over Russia. Far too heavy for its

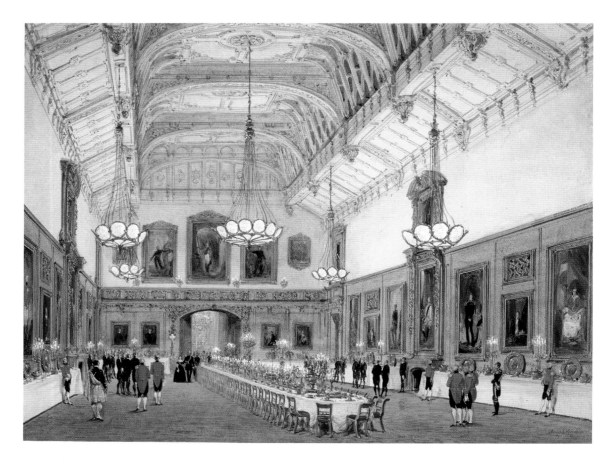

intended position at Windsor, it is now in the garden at Buckingham Palace (see fig.294), but the idea of dedicating the new gallery to a commemoration of Waterloo was preserved when it was decided shortly before George's death to install here a series of 28 portraits by Thomas Lawrence of the European leaders of the alliance that had defeated the Emperor.

Although Lawrence was widely regarded as the leading portrait painter of the age, he had been kept at arm's length by the Prince Regent because of his close friendship with Princess Caroline, which had led to unsubstantiated rumours of an affair. Lawrence owed the commission that developed into the Waterloo Chamber to his friendship with Charles Stewart, later 3rd Marquess of Londonderry, who was Britain's representative at the Congress of Vienna in 1814–15, a meeting of ambassadors to plan the post-war shape of Europe. Having invited several of the allies to London in 1814 for celebrations of their victory, the Prince asked Lawrence to paint full-lengths of the Prussian Field-Marshal Gebhardt von Blücher (fig.225), Tsar Alexander I and the Cossack general Count Platov, as well as the Duke of Wellington.

Progress on the scheme – interrupted by Napoleon's escape from Elba and the Waterloo campaign – was resumed when Lawrence, who by then had been knighted, joined Stewart at the peace congress at Aix-la-Chapelle

224. *The Waterloo Chamber* by Joseph Nash, Windsor Castle, 1844. Created in the 1820s, the Waterloo Chamber was fitted out by William IV with the series of portraits of the allied leaders that Thomas Lawrence had painted for George IV. From Queen Victoria's reign onwards, the room was used for banquets; this watercolour commemorates a visit by Nicholas I of Russia, who is shown entering the room with the Queen.
RCIN 919785

in 1818. The Prince Regent then sent him to Rome to paint Pope Pius VI I and Cardinal Consalvi. This was a happy commission, partly because the Pope was deeply grateful to the Prince for his support in arranging the return to the Vatican of works of art looted by Napoleon. Lawrence was delighted with his portrait, declaring, 'I have completely succeeded in the

225. *Field-Marshal Gebhardt von Blücher* by Thomas Lawrence, 1814. One of the Waterloo Chamber's most dramatic portraits depicts the commander of the Prussian forces that defeated Napoleon at the Battle of the Nations in 1814. The portrait was painted when Blücher (1742–1819) attended the Congress of London in 1814; less than a year later he achieved even greater fame by leading the Prussian army at Waterloo. His commanding gesture echoes a famous ancient statue of the Emperor Augustus in the Vatican. RCIN 405148

picture of His Holiness ... to the utmost of my expectation' (fig.226). Admired ever since for its masterly combination of brilliant technique and shrewd portrayal of character, this painting alone explains why contemporaries thought that Lawrence ranked with Rubens and Van Dyck as both artist and ambassador.

Buckingham Palace

Thanks to the Waterloo Chamber, Windsor Castle was identified as the seat of the monarchy that had presided over the country's greatest military and

226. *Pope Pius VII* by Thomas Lawrence, 1819. Pope Pius VII (1742–1823), elected in 1800, was imprisoned by Napoleon in 1809 for defying the French annexation of the Papal States. His triumphant return to Rome in 1814 made him a symbol of peace over war. In a portrait widely regarded as his finest achievement, Lawrence depicts the Pope with the papal collection of classical sculpture, recently returned to the Vatican after being looted by the French. RCIN 404946

naval triumphs. The iconography of victory was to be even more important in George IV's other great architectural project, the rebuilding of his parents' old home as Buckingham Palace from 1825 onwards. It was designed by John Nash, whose work had included the Royal Pavilion and the laying out of Regent Street to connect Regent's Park with Carlton House. The provision of a new palace, which would at last make good the loss of Whitehall over a century earlier, was another enormously expensive undertaking, and by the time of the King's death, when the Palace was far from finished, the costs had careered out of control. Yet, although Nash lacked Wyatville's managerial skills, it is doubtful whether any other architect of the age could have risen with such brilliant flair to the challenge of creating a palace that satisfied George's expectations.

Nash extended the old house by adding a suite of opulent staterooms to the garden front, colourfully fitted out with marble, scagliola and gilding. These were to be the setting for many of the furnishings from Carlton House, demolished in the year the Palace was begun, although the King did not live to arrange them. Nash also created a new entrance courtyard facing the Mall, entered through a triumphal gateway modelled on Napoleon's Arc du Carrousel in Paris. Clad in marble, decorated with reliefs by Westmacott commemorating the Napoleonic wars, and intended to be topped by a bronze equestrian statue of George IV by Francis Chantrey (1781–1841) (now in Trafalgar Square), the 'Marble Arch' was not completed as George

227. Detail of *Mars and Venus* by Antonio Canova, 1815–19.
In 1815 Canova visited London to see the Elgin Marbles. While he was there, the Prince Regent commissioned this monumental work, which was intended to symbolise War and Peace. Although Canova completed the full-size clay model within a year, the sculpture was not delivered until 1824, partly because of the labour required for its high finish, but also because the King was slow to pay. RCIN 2038

had intended. Nonetheless, it formed a prelude to the important role that architectural sculpture was intended to play in the Palace: from the pediment sculpture, designed by Flaxman and executed by a team of younger sculptors, to the friezes in the throne room depicting the Wars of the Roses, designed by Thomas Stothard (1755–1834).

The Palace also provided space for independent works of sculpture to assume a greater role than they had at Carlton House, although this was not fulfilled until after Queen Victoria had taken up residence in 1837. Despite his general indifference to large-scale sculpture, George IV shared with several contemporary aristocratic collectors an admiration for the work of Europe's most famous contemporary sculptor, Antonio Canova (1757–1822), whose voluptuous nude of a fountain nymph was delivered to Carlton House in 1819. In 1824 she was joined by two further works by the sculptor, *Dirce*, another reclining female nude, and *Mars and Venus* (fig. 227).

The most novel aspect of Nash's planning of the Palace was the designation of two superimposed spaces at the centre of the building for the display of art: a ground-floor hall for sculpture – principally the Canovas – and above it a grand, top-lit gallery for paintings (fig.228). The Picture Gallery prefigured aspects of the development of public art galleries in the Victorian period. In its innovative – but, as it turned out, unsuccessful – roof of glazed saucer domes (they cast light on the floor, rather than the walls), it anticipated numerous experiments with the lighting of paintings. In addition, the carved profiles set into its chimneypieces of Leonardo, Dürer, Titian, Rubens and Van Dyck foreshadowed the way that such Old Masters were to be hallowed in the decoration of galleries throughout Europe and America in the coming century.

The gallery was not fully furnished until the 1830s, but George IV had probably given the matter some thought. Among the paintings he bought when plans for Buckingham Palace were well advanced was *Cardplayers in a Sunlit Room* by Pieter de Hooch (1629–84; fig.229), and in 1829, a year before his death, he matched it with another masterpiece by the same artist, *A Courtyard in Delft at Evening*. In the same year he ordered from Rundell Bridge & Rundell a wine cistern that forms the culminating item in the 'Grand Service', a 4,000-piece silver-gilt dining service that he had begun to assemble in 1806 (fig.230). At 8,000 oz it is the largest piece of wrought English plate in existence. Like its enormous price – £8,500 – this seems to sum up the extravagance that the King's contemporaries so often mocked. Yet, at exactly the same moment, he was demonstrating his appreciation of De Hooch's exquisitely understated art. It is the way he encompassed such extremes, high in quality but so different in character, that makes George IV's collecting and patronage endlessly intriguing, as well as deeply impressive.

228. *The Picture Gallery, Buckingham Palace* **by Douglas Morison, 1843.** John Nash's experimental roof structure for the 47 metre-long gallery failed to light the pictures well, and so, as shown here, an additional row of skylights was introduced along the centre of the ceiling. This watercolour shows Prince Albert's picture hang, with the paintings in the new uniform frames he ordered. The ceiling was replaced with a new design in 1914. RCIN 919916

229. *Cardplayers in a Sunlit Room* **by Pieter de Hooch, 1658.** Painted in Delft, this is one of the earliest dated works by De Hooch. It depicts a room in an inn; in the background a maid walks across a courtyard bringing wine in a jug. The man on the right may be spying on the woman's hand of cards, but any narrative element is subordinate to the painting's exquisite study of light and atmosphere. RCIN 405951

William IV

George was succeeded by his brother William, Duke of Clarence (1765–1837), whose naval career had left little time for art. He enjoyed playing the philistine, dismissing George IV's picture collecting as 'damned expensive'. There was a certain amount of bluff about this: he shared his brother's admiration for Lawrence and Wilkie, commissioned Martin Archer Shee (1769–1850) to paint state portraits of himself and his wife, Queen Adelaide, and encouraged both Clarkson Stanfield (1793–1867) and Edwin Landseer (1802–73) early in their careers. Among the commissions that reflect his earlier life are large paintings of the Battle of Trafalgar by William Huggins (1781–1845) and a colossal bust by Francis Chantrey of Admiral Nelson, with whom William had served in the West Indies.

The new King disliked Buckingham Palace, refused to move in, and offered it to the government for the Houses of Parliament when the old ones burnt down in 1834. As is less well known, he loved Windsor Castle, and continued George IV's work there. His greatest contribution to the Royal Collection was to assemble all the books and manuscripts that had remained after his brother's gift of George III's library to the nation. With them, he created the present Royal Library, which Wyatville installed in a sequence of Tudor and Jacobean rooms at Windsor, including Elizabeth I's long gallery (fig. 28).

230. *The Grand Punch Bowl* by John Bridge, 1829.
This enormous silver-gilt wine cistern is decorated with Bacchanalian groups; the handles, cast as lion and unicorn supporters, mark it out as a royal commission. Designed by the artist Thomas Stothard, it is the climax of George IV's silver and silver-gilt dining service, the Grand Service. Converted into a punch bowl for Queen Victoria, it was used to celebrate the christening of her eldest son, the future Edward VII, in 1842. RCIN 31768

231. *Mrs Jordan as the Comic Muse* by John Hoppner, *c.* 1785–6. Mrs Jordan is portrayed as Thalia, the muse of Comedy, seeking refuge from a lustful satyr with Euphrosyne. Hoppner's painting is part of a late eighteenth-century fashion for portraits of actresses; Mrs Jordan was also painted by George Romney and William Beechey. She had ten children with the Duke of Clarence, subsequently William IV, while still working and supporting the Duke with her income. RCIN 404611

William's most interesting act of artistic patronage concerns the woman who was at the centre of his life for 20 years. Dorothy Bland, the most famous comic actress of the age, whose stage name was Mrs Jordan (Mr Jordan was a fiction), became William's mistress in 1791. Although they had ten children together, he discarded her in 1811 in the hope of marrying a rich princess, and she died in poverty in 1816. Following his accession, William, perhaps pricked by a guilty conscience, commissioned Chantrey to carve a touching statue of her with two of their children, now at Buckingham Palace, and he expressed a wish 'to have all the pictures of Mrs Jordan, knowing and therefore admiring her public and private excellent qualities'. Among them was almost certainly *Mrs Jordan as the Comic Muse* by one of his brother's favourite painters, John Hoppner (1758–1810; fig. 231). The acquisition of this ebullient painting was the last glint of a Regency world of high living and brazen immorality that faded into the past almost overnight with the accession in 1837 of William IV's niece.

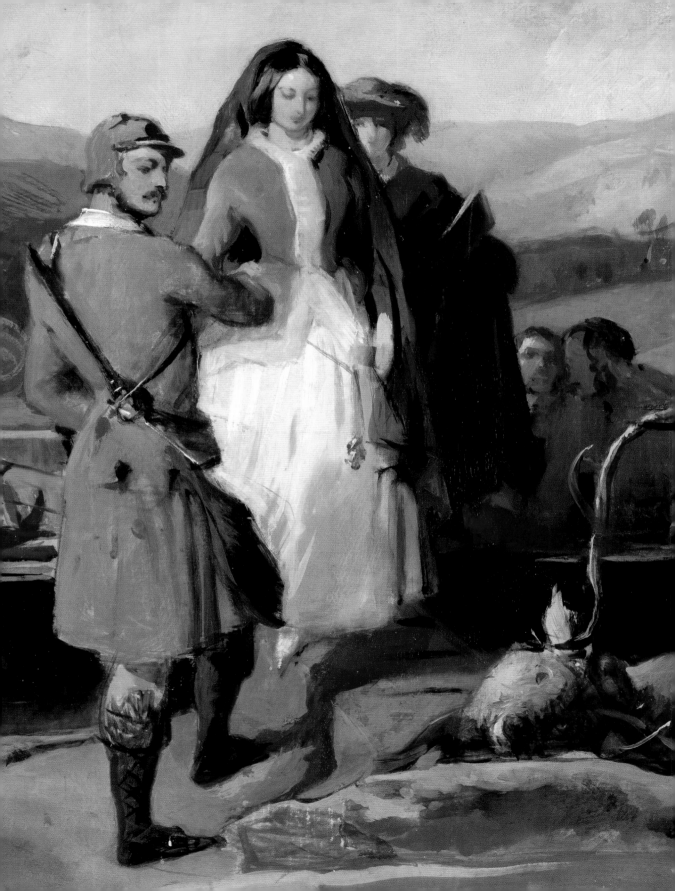

ROMANCE
Queen Victoria and Prince Albert

When, on 10 October 1839, the 20-year-old Queen Victoria set eyes on her cousin Prince Albert, younger son of the Duke of Saxe-Coburg-Gotha, it was not quite love at first sight – they had spent a few days together when he had been in England three years before – but the attraction was instantaneous. 'Albert really is quite charming, and so excessively handsome', wrote Victoria in her journal: 'such beautiful blue eyes, an exquisite nose, and such a pretty mouth, with delicate moustachios, and slight but very slight whiskers'. A day later they were engaged. She at once had his youthful good looks recorded by her official Miniature Painter William Ross (1794–1860; fig.233): 'It is quite speaking, and is my delight – the dear angelic, beautiful eyes looking at me so dearly.' After Prince Albert (1819–61) had returned to Coburg to prepare himself for the marriage that was to take place in February 1840, the Queen sat for her own miniature by Ross (fig.232): it shows her wearing a glass pendant containing a lock of Albert's hair.

These beautiful little portraits inaugurate the greatest partnership in the history of the Royal Collection, which has left a rich legacy that ranges from paintings and sculptures to jewellery, miniatures, watercolours and photographs. These represent the shared enthusiasms of a couple in love: together Victoria and Albert painted, drew and etched, visited exhibitions, sat for painters and photographers, and commissioned artists and craftsmen. Every birthday, anniversary and Christmas was marked by gifts of works of art, a custom that was eventually extended to their nine children. The Queen and Prince Albert also initiated the rigorous cataloguing and photographing of the collection, instituted the regular opening of some of the palaces to the public and lent frequently to exhibitions in Britain and abroad.

One consequence of this is that their collecting is far better documented than any of their predecessors. In the course of a reign of nearly 64 years, the Queen wrote many millions of words on all subjects. Her letters and her incomparable daily journal, kept continuously from 1832 onwards, include innumerable lively observations about art and artists. Victoria was always a little in awe of her husband's expertise, but her own upbringing had introduced her to art at an early age, and she had developed strong tastes and enthusiasms. The combination of her spontaneity of response with Albert's more intellectual approach to art helps to explain why their collecting had such energy and enterprise.

Victoria and art before Albert

Victoria's father, Edward, Duke of Kent, fourth son of George III, had died in January 1820, when she was only eight months old, and she was brought up by her mother at Kensington Palace. Although it was a sheltered childhood, she began to show an interest in paintings when only eight years old, encouraged by her mother's brother, Leopold, King of the Belgians. In 1827 he gave her a view of Ischia, the first work to be recorded in her 'catalogue of private pictures', which she diligently maintained until 1862. In the same year she began to receive twice-weekly drawing lessons from Richard Westall (1765–1836), who in 1830 painted a delightful portrait of her with a sketching book (fig.234). She continued to paint and draw for most of her life. Westall was the first artist Victoria knew well, and the relationship set the pattern for her lively interest in the personalities and lives of the painters and sculptors who worked for her. She records in her journal her distress, at hearing in December 1836, that her old master had 'died in the *greatest* state of *pecuniary* distress; this killed him. It *grieves* & *pains* me *beyond measure* that I could not alleviate his sufferings.'

When she succeeded to the throne in 1837 Victoria was only 18, but in matters of art that directly affected her she already had a clear sense of what she wanted. She maintained the tradition of paintings of royal ceremonies begun by George Jones's depiction of George IV's coronation (see fig.194), by commissioning a painting of the meeting of her Accession Council from

232. *Queen Victoria* by William Ross, 1839. Commissioned by the Queen as a gift for Prince Albert on their engagement, the miniature, in watercolour on ivory, is one of over 50 painted for Victoria and Albert by Ross. The Queen's admiration of his work led to royal commissions throughout Europe. RCIN 420260

233. *Prince Albert* by William Ross, 1839. The Prince sat for this miniature shortly after he had become engaged to Victoria. She and Albert's brother, Ernest, took great interest in its progress; the Queen wrote in her journal that 'Ernest brought a brush and some stuff with which he made Albert brush his whiskers in order that they might lie smoother'. RCIN 420268

234. *Queen Victoria when a Girl* by Richard Westall, 1830.
Victoria was 11 years old when she and her terrier, Fanny, were painted by her drawing master, in a commission by her mother, the Duchess of Kent. The Princess's lace and silk summer dress is in the Royal Collection. RCIN 400135

David Wilkie, whose appointment as Principal Painter in Ordinary she had confirmed. She was initially pleased with it, despite her disappointment with the likeness of her beloved Prime Minister, Lord Melbourne (1779–1848), but when in 1839 she saw Wilkie's state portrait of her in her coronation robes she was appalled, writing in her journal that it was 'too atrocious'. The Queen never forgot this debacle: in 1899 she intervened to prevent the National Portrait Gallery buying a version of Wilkie's portrait.

By contrast, when C.R. Leslie (1794–1859) showed her his painting of her taking the sacrament at the coronation, a work that he had embarked on without a commission, she was enthralled (fig.235). Although it was not finished, and Leslie had been told not to hope for a sitting from the Queen, she declared immediately: 'I like it so much that I have said I will buy it.' She took control of the project, sitting for Leslie several times, taking care

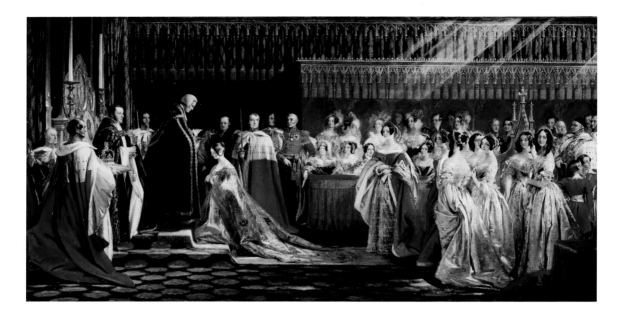

to have her hair arranged exactly as it had been for the coronation, and marshalling the other participants for sittings. Although she was influenced by Lord Melbourne's admiration for Leslie – and was delighted that he had captured the Prime Minister's 'fine features and the noble expression, which no-one has done yet' – the story demonstrates that when her interest was aroused, she enjoyed collaborating with an artist to achieve a work that would please her.

An artistic partnership

Albert returned to England to marry Victoria in February 1840 in the chapel at St James's Palace. In its description of the ceremony, *The Times* mentioned that 'Her Majesty wore no diamonds on her head, nothing but a simple wreath of orange blossom'. Orange blossom was the traditional symbol of chastity, and one of the Prince's first gifts to his future bride was a pair of earrings in gold and white porcelain in the form of sprigs of orange blossoms. This was the origin of a set of orange-blossom jewellery in enamel, gold and porcelain given by the Prince to his wife at intervals between 1839 and 1846 (fig.236). It culminated in a headdress wreath, incorporating four small green enamel oranges, representing the couple's first four children, Victoria, Albert Edward, Alice and Alfred, which the Queen wore on her wedding anniversary from then until Albert's death. This careful compilation of a suite of jewellery was to be typical of the way that she and the Prince built up their collections – steadily and without extravagance.

From the outset, Albert understood their regular exchange of gifts to be an opportunity for artistic patronage. His education had prepared him

235. *Queen Victoria Receiving the Sacrament at her Coronation*, by C.R. Leslie, 1838–9. The Queen kneels before the Archbishop of Canterbury, William Howley, to receive the sacrament. The Prime Minister, Viscount Melbourne, stands behind her, holding the Sword of State. Queen Victoria wrote that 'the group of my youthful trainbearers is excessively pretty' and was delighted that Leslie 'has got me so like'. RCIN 406993

236. *The Orange Blossom Parure*, 1839–46.
Queen Victoria's choice of a white silk wedding dress, worn with orange blossom, set a fashion for brides for generations to come. The parure, by an unknown maker, has its origins in one of Prince Albert's first gifts to Victoria, a gold and porcelain brooch in the form of a sprig of orange blossom. It was followed in December 1845 by another brooch and matching earrings and, on their wedding anniversary in February 1846, a headdress.
RCINs 65305 to 65307

well for this. Albert had been to university in Brussels and Bonn, where he attended a series of lectures in art history – a discipline that was largely a German invention – and in 1838–9 he spent six months in Italy. In Rome he was introduced to the large expatriate community of German painters, sculptors and archaeologists. The Prince was deeply influenced by their enthusiasm for the art and architecture of the High Renaissance, and in particular the work of Raphael. While in Rome Albert sat to the German sculptor Emil Wolff (1802–79) for a bust that he gave to Victoria in 1839. The success of this commission prompted the now much wealthier Prince to ask Wolff to carve a full-length statue of himself in Greek armour. Although intended as a birthday gift for Victoria in 1842, it was not completed until 1844 (fig.237). The Queen thought it 'most beautiful', but Albert appears to have been a little disconcerted by Wolff's frank depiction of male beauty. After discussion about where it might be placed, Victoria noted that Albert thought 'the Greek armour, with bare legs & feet, looked too undressed to place in a room'. As a result, Wolff carved a second version, with the Prince in a longer kilt and wearing sandals, which was installed at

237. *Prince Albert* by Emil Wolff, 1844.
This depiction of Albert in Greek armour incorporates symbols of his role as defender of his wife and country, such as the image of Victory (Victoria) on his breastplate. Deciding that the short kilt and bare feet of the original version were indecorous, Albert commissioned Wolff to carve a second version, shown here: the kilt is longer and he wears sandals.
RCIN 42028

Buckingham Palace. The original was finally placed in Victoria and Albert's new seaside retreat, Osborne House on the Isle of Wight, the difference between the two statues neatly symbolising the divison between their public and domestic worlds.

Palaces and homes

Although William IV had refused to live in Buckingham Palace, work on the building had continued under the architect Edward Blore (1787–1879). However, much remained to be done when at the outset of her reign Victoria decided to move in. The service quarters were finished at great speed and the Palace fitted out, mostly with surplus furnishings that had been ordered by George IV for Windsor, combined with furniture from Carlton House that he had left in storage. Within only eight years, the Queen decided that the Palace was too small for official functions and did not provide sufficient accommodation for her growing family. In 1846 Blore was commissioned to add a new range facing onto the Mall, converting Nash's three-sided palace into a quadrangle.

By then, she and Prince Albert had commissioned new schemes of painted decoration, notably for the entrance hall and staircase. These were designed by Ludwig Grüner (1801–82), who had been appointed their Adviser on Art in 1845. Grüner had made his reputation by reproductive engravings of Italian art and decoration, notably of works by Raphael, on which he was working in Rome at the time of the Prince's visit. After Grüner had settled in London in 1841, Albert and Victoria employed him to give advice on the purchasing and display of works of art and to design interiors, decoration

238. Jewel cabinet designed by Ludwig Grüner, 1851.
Made by Elkington, Mason & Co. and designed by Victoria and Albert's Adviser on Art, this gilt-bronze and electro-plated white metal cabinet was shown at the Great Exhibition in 1851. It incorporates Berlin porcelain plaques after miniatures by Robert Thorburn of the Queen (with the Prince of Wales) and Prince Albert, together with profile portraits of the six children born by 1851. RCIN 1562

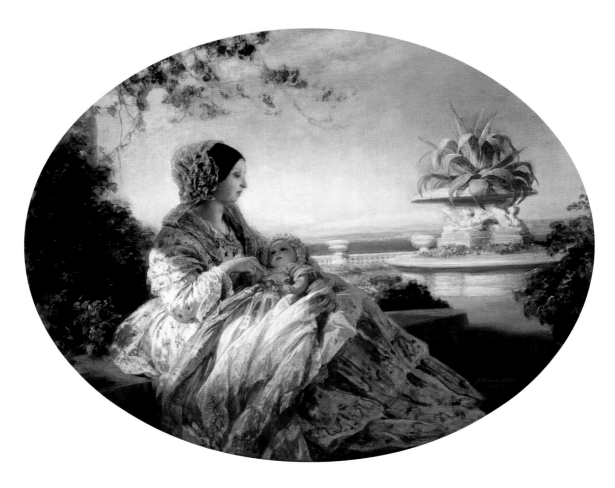

and furnishings, inspired largely by Italian Renaissance sources. He quickly assumed a role at court not unlike that which Daniel Marot had played for William and Mary, providing designs that ranged in scale from enormous bronze candelabra for a new ballroom at Buckingham Palace, completed in 1854, to a jewel case of exceptional refinement (fig. 238).

Grüner's influence permeates the one building that above all others embodies the way that art was integrated into Albert and Victoria's domestic life, Osborne House. After they had decided in 1843 to give up the Royal Pavilion at Brighton, enquiries were made about purchasing a house on the Isle of Wight, where the Queen had spent childhood holidays. The following year Prince Albert visited Osborne and was struck by the beauty of its setting overlooking the Solent, which reminded him of the Bay of Naples. The small eighteenth-century house was replaced by a much larger building in an Italianate picturesque style, designed by the Prince in collaboration with its builder, Thomas Cubitt (1788–1855), with advice from Grüner. Set in terraced gardens, furnished with casts of classical statues, and incorporating belvedere towers, Osborne does indeed evoke a Renaissance summer villa. The setting it formed for family life is captured in a portrait

239. *Queen Victoria and Prince Arthur* by F.X. Winterhalter, 1850.
Born in May 1850, Prince Arthur (later the Duke of Connaught) was only a couple of months old at the time of this portrait, described by the Queen as 'perhaps one of Winterhalter's most charming pictures'. She placed it in her sitting room at Osborne, which has a balcony overlooking the Upper Terrace, shown here.
RCIN 405963

of the Queen nursing her seventh child, Arthur, painted by Franz Xaver Winterhalter (1805–73) in July 1850, just a few months after the prince's birth (fig.239). It shows the Queen on the Upper Terrace at Osborne, intended by Albert for enjoyment of the view out to sea. In the background is a large vase embellished with sphinxes, designed by Grüner in 1849. The light has the Mediterranean quality that the Queen often mentioned in her journal: during the hot summer of 1852, for example, she described 'the calm deep blue sea, the balmy air, *all*, quite Italian'.

Osborne was also designed for art. The cool, spacious interiors that Albert and Grüner created were essentially neoclassical, in which richly coloured textiles, marbles and Minton tiles were combined with Italianate painted decoration. The layout of the house includes a long L-shaped corridor, which linked the family rooms to a large wing for the household and guests. This corridor was treated as a gallery, which Albert and Victoria slowly filled with classical sculptures. Only one, a standing Venus, bought by Grüner at

240. *Psyche Lamenting the Loss of Cupid* by William Theed, 1847. Prince Albert commissioned two sculptures by Theed, of Narcissus and Psyche, for Osborne. In Victorian England, the story of Cupid and Psyche was often treated as an allegory of profane and sacred love. Theed based his design on a work by the Danish sculptor Berthel Thorvaldsen, under whom he is thought to have studied in Rome. RCIN 2044

the Stowe House sale in 1848 for Victoria to give to Albert, is ancient in date. The rest are modern, both British and continental, forming an exceptional assembly of nineteenth-century sculpture. The collection was begun in 1844, when Albert asked the sculptor John Gibson (1790–1866), a leader of the British artistic community in Rome since 1817, to send proposals by sculptors working in the city for statues for Osborne. Among the designs that were accepted were two by William Theed (1804–91), *Narcissus at the Fountain* and *Psyche Lamenting the Loss of Cupid* (fig.240). The success of this commission encouraged Theed to return to England after 22 years in Italy, and he became a favourite sculptor of the royal family.

Osborne was matched at the far end of the British Isles by a second private home for the royal family. First leased by Victoria in 1848, the Balmoral estate in Scotland was bought in 1851 and the existing house was replaced by a much larger one. Once again, the designer was Albert himself, this time working with the Aberdonian architect William Smith (1817–91). Unlike Osborne, however, Balmoral was not conceived of as a setting for significant art. It was furnished simply. Tartan – including the Balmoral tartan designed by Albert – was used for curtains and upholstery, and its walls were hung mostly with framed prints. Nonetheless, Albert and Victoria's love of the Highlands, and of the sport Balmoral

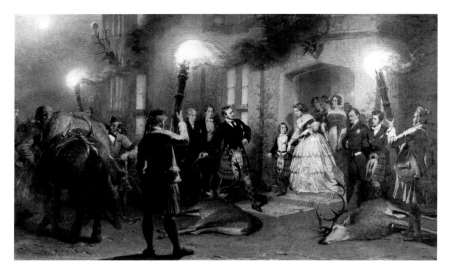

241. *Evening at Balmoral Castle* by Carl Haag, 1854.
This is one of a pair of watercolours by Haag depicting life at Balmoral (the other is *Morning in the Highlands*), which the Queen commissioned in 1853 as a birthday present for her husband. Outside the old castle at Balmoral, Prince Albert presents the stags he has shot. In the foreground, holding a torch, is the gillie John Brown. The Queen and Prince of Wales are accompanied by ladies-in-waiting and the Queen's mother.
RCIN 451255

242. The Atholl Inkstand, designed by Prince Albert, 1844–5.
Made as a Christmas present for the Queen, who described it as 'a stag in frosted silver standing on Scotch stones, & at the sides views in silver bas reliefs of Blair castle &c', this inkstand was conceived by Prince Albert as a sculpture rather than an item for use. It was a collaboration between several craftsmen, including John Wornell, Modelling Master at the Government School of Design at Somerset House, who sculpted the stag, and George Ivory, who cast it in silver. Its frosted finish was created by treatment with heated sulphuric acid.
RCIN 15955

offered in the form of stalking and fishing (fig. 241), prompted many commissions and purchases of paintings and works of art on Scottish subjects, although they were often kept at other residences as a reminder of happy holidays. Among such items at Osborne, for example, was a monumental inkstand designed by Albert as a Christmas gift for his wife (fig. 242). A memento of one of their first visits to the Highlands, at Blair Castle in 1844, it incorporates teeth from stags shot by Albert and granite pebbles picked up on walks beside the River Dee.

Favourite artists

243. *Prince Arthur* by Carlo Marochetti, 1853. Having carved a bust of Prince Albert in 1849, and impressed the Queen by being 'very agreeable, pleasing & gentlemanlike', Marochetti became the royal family's favourite sculptor until his death in 1867. He excelled at portraits of children, as is demonstrated by this statue of the Queen's third son standing by a sword in a pose that recalls Michelangelo's *Risen Christ*. RCIN 2076

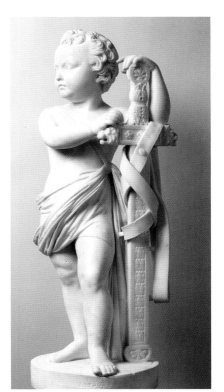

Prince Albert had to endure criticism from the press because of his nationality, and among the potential objections to him was a concern among 'enlightened and able men', as Lord Melbourne put it to Queen Victoria in 1841, that he would favour foreign artists over native ones. There was an element of truth in that, but the favouritism was as much, if not more, Victoria's. In 1845 she startled one of her maids of honour, Eleanor Stanley, by a 'terrible broadside' about the low achievements and 'outrageously high' prices of English artists. She was less exacting about sculptors, but once she and Albert had discovered the Italian-born Carlo Marochetti (1805–67), who had settled in London in 1848, she never wavered in her belief that he was superior to his British rivals. His first work for the royal family was a bust of Albert, which the Queen thought 'extremely successful'. When, in 1862, she gave Theed the task of carving a posthumous bust of Albert based on his death mask, the result was praised for its accuracy by their eldest daughter, Victoria (Vicky), Crown Princess of Prussia, but she thought Marochetti's bust 'a better work of art'. The Queen agreed, and after the sculptor's death she told Albert's former secretary, Charles Grey, that 'Marochetti was the only Sculptor – positively the *only* one in England of really transcendent genius.' Her assessment of his powers may have been exaggerated but it is hard to imagine another sculptor who could so successfully have risen to the challenge the Queen set him in 1853, to carve a full-length statue of her three-year-old son Prince Arthur supporting an enormous sword, symbol of his late godfather, the Duke of Wellington (fig.243).

Before moving to England, Marochetti had worked in Paris, where he was much favoured by Louis Philippe (1773–1850), and so he shared with many of the foreign artists who worked for Victoria a cosmopolitan familiarity with court life that almost no British artist could match. This was equally true of the painter who, more than any other, was Victoria's court artist – the German-born Franz Xaver Winterhalter. As well as being a model courtier, he demonstrated many of the qualities that endeared foreign artists to Victoria. On his prearranged visits to England he worked exclusively for her. He was thoroughly professional and efficient, could make amusing conversation during sittings, and his fees were agreed before he arrived. As well as turning out pictures to time, he gave the Queen lessons in oil painting, provided advice on art for Albert and helped him to acquire paintings.

Drawn to Victoria and Albert's attention by their Uncle Leopold, King of the Belgians, Winterhalter first visited England in 1842 to paint separate portraits of the Queen and Prince, which were greatly admired, and the following year

he painted a new state portrait of the Queen, with a matching portrait of Albert in Garter robes. In 1844 Louis Philippe commissioned Winterhalter – who was his court painter – to record his reception at Windsor Castle on his state visit to England, and this may have encouraged Albert and Victoria to offer Winterhalter an ambitious commission in 1845, a large family group (fig. 244). Winterhalter received more sustained patronage from Victoria than any artist had enjoyed from any British monarch since Van Dyck, and so it is appropriate that he conceived the work as part of a tradition of royal portraiture that went back to the 'Great Peece' (see fig. 59).

The painting delighted the Queen; on 18 December 1846 she wrote in her journal that it is 'a "chef d'oeuvre", like a Paul Veronese – such beautiful, brilliant, fresh colouring'. Criticism by the press, when the portrait was publicly exhibited at St James's Palace in 1847, can be put down to xenophobia: in these 'sensual and fleshy visions of these distinguished persons', wrote the *Athenaeum*'s critic, there is 'such want of taste – as make us frankly rejoice that it is not from the hand of an Englishman'. Yet there is something about the portrait that does not quite work. Winterhalter has failed to achieve the miraculous fusion of office and personality, monarch and

244. *The Royal Family in 1846* by F.X. Winterhalter. In 1846 Queen Victoria asked the French king, Louis Philippe, to relieve Winterhalter temporarily of his duties as court artist so that he could visit England to paint this large family group, intended for the dining room at Osborne. Seated on chairs made by Morel & Seddon for Windsor Castle, and surrounded by their five eldest children, Victoria wears an emerald and diamond diadem designed by her husband in 1845 and Albert is in court dress; both wear the riband and star of the Garter. RCIN 405413

human being, that came so instinctively to Van Dyck. Fatally for the success of an official portrait, Victoria and Albert look as though they have dressed up especially for the occasion. The most successful parts of the painting are the portraits of the children, for which Winterhalter had a particular skill. This is evident in his spirited portrait of the four-year-old Prince of Wales in his sailor suit (fig.245), in which, it seems, artist and sitter have amused each other.

245. *Albert Edward, Prince of Wales* by F.X. Winterhalter, 1846. Aged four, the future Edward VII wears a brand new sailor suit ordered for him by his mother from the tailor who made uniforms for ratings on the royal yacht. The Queen thought the portrait 'a perfect likeness' and the Prime Minister, Robert Peel, described it as 'the prettiest picture he had ever seen'. RCIN 404873

The Queen's easy and untroubled relationship with Winterhalter was very unlike her dealings with the other artist who fulfilled a role akin to court painter, Edwin Landseer. With him, the problem was not his nationality but a combination of a highly strung, insecure personality and an unease about the principal task expected of him, portraiture – unless, that is, the portraits were of animals. Landseer's first royal commission, in 1836, was to paint the 17-year-old Princess Victoria's spaniel, Dash; she thought it 'most beautifully painted' and 'extremely like'. Although in 1839 she was annoyed at 'his idleness and laziness, not coming to Windsor when I said he might to paint me', the relationship continued and Landseer gave her and Prince Albert lessons in etching.

Part of Landseer's attraction was his high reputation as a painter of Scottish scenes, and in 1850 – the year she knighted him – the Queen offered him a major commission for a group portrait set in the countryside near Balmoral. In her words, 'It is to be thus: I, stepping out of the boat at Loch Muick, Albert, in his Highland dress, assisting me out, & I am looking at a stag which he is supposed to have just killed'. In 1851 Landseer presented an oil sketch of the intended picture, *Queen Victoria Landing at Loch Muick* (fig. 246). 'Albert was enchanted with it', wrote the Queen, adding, 'The solitude, the sport, and the Highlanders in the water &c. will be, as Landseer says, a beautiful historical exemplification of peaceful times, & of the independent life we lead in the dear Highlands.' Yet from then on the project caused Landseer nothing but agony, for when he came to work the sketch up into a large painting, his inability to capture accurate likenesses became painfully apparent. The Queen watched with dismay as the inspiration of the original sketch was almost literally erased: she noted during her sittings

246. *Queen Victoria Landing at Loch Muick* by Edwin Landseer, 1850. The Queen was delighted with Landseer's conception of a painting depicting her with Prince Albert after a day's sport in the Highlands: 'I think the manner in which he has composed it, will be singularly dignified, poetic & totally novel, for no other Queen has ever enjoyed, what I am fortunate enough to enjoy in our peaceful happy life here.' But despite the success of this sketch, the final picture, finished many years later, was a disappointment. RCIN 403221

that he kept 'washing out what he paints in, so that he gets the faces too faint & weak'. Despite the Queen bringing in Winterhalter to help, by 1870 she had long given up hope of seeing the painting and asked to buy the sketch because it was it was 'valuable to her as a remembrance of happy times'.

When 'the boat picture', as it was by then wearily known, was delivered to the Queen after Landseer's death she recognised that it was a failure and had it put into store, where by the twentieth century it had deteriorated so much that George V ordered it to be burnt. Despite this tragic failure, the Queen's treatment of Landseer was consistently thoughtful and understanding. The many works by him in the Royal Collection demonstrate that – like Winterhalter – Landseer was at his best in intimate works, such as his 1842 painting of Albert's favourite greyhound, Eos (fig. 247), one of the masterpieces of animal portraiture of any century – or nationality.

Building the Collection

Victoria and Albert's great expansion of the Royal Collection was put together in a methodical and frugal way. To begin with, this may have been a reaction to George IV's extravagance, but it was also a matter of resources.

247. *Eos* by Edwin Landseer, 1841. Prince Albert's favourite greyhound bitch accompanied him when he moved to England in 1840. She stands guardian over her master's possessions in an evocation of loyalty and love that is also a brilliant study in scarlet and black. After Eos's death in 1844, the portrait was the basis for bronze memorial statues at Windsor and Osborne, modelled by the Prince himself, working with the sculptor John Francis. RCIN 403219

When the Queen heard – to her intense annoyance – that Albert had been granted an income of only £30,000 a year by parliament on his marriage, rather than the £50,000 requested, she commented that it would hamper his ambition to buy works of art. In 1847 she explained to his private secretary, George Anson, that her gifts to the Prince of works of art were 'useful & lasting ones, & have the advantage of encouraging deserving talent, – for which the Prince has done wonders, & with such *small* means'. At the outset of her reign she set herself an annual budget for buying 'Pictures Statues &c' for herself of £2,000, with an additional £300 for miniatures. She maintained this self-denying limit until 1854, when she raised it to £3,000, which was to include prints.

Although the Queen made gifts of Old Master paintings to Albert she bought very few for herself or the Royal Collection. The most significant was the large *Pythagoras Advocating Vegetarianism* (*c.*1618–30) by Rubens and Frans Snyders, which she bought in 1841 for the Picture Gallery at Buckingham Palace; it reveals a taste for succulent treatment of paint evident also in her purchases of modern pictures. She was more ready to buy significant works of art with royal connections, such as J.M. Wright's painting of Charles II enthroned (see fig.79). Among her most inspired purchases were two treasures that had been in the sale of Horace Walpole's collection at Strawberry Hill in 1843, *The Family of Henry VII with St George and the Dragon* (see fig.4) and the Lennox or Darnley locket, one of the Royal Collection's finest renaissance jewels (fig.248).

Prince Albert's tastes in Old Masters reveal the impact on him of his visit to Italy. He conceived a plan 'to assemble together, if possible, all Raphael's works now existing in England', presumably as a temporary exhibition. His widow may have recalled this wish when in 1865 she decided that the Raphael cartoons should – for the convenience of artists as well as scholars – be moved from Hampton Court to the South Kensington Museum, now the Victoria and Albert, where they remain. Another result of the Prince's wish to bring together works by Raphael for purposes of study was his ambitious project, begun in 1853, to assemble images of all the artist's works, including not only frescoes and easel paintings but also drawings, of which an important group is in the Royal Collection, 'to illustrate the growth and progress of his genius as completely as possible'. The collection eventually numbered 5,400 prints and photographs mounted in 50 portfolios, housed in a specially made cabinet in the Royal Library at Windsor. The work of arranging and cataloguing the collection was begun by the Prince as an after-dinner occupation that he could share with his wife. She described their work several times in her journal, writing, for example, in 1853, 'We dined alone & were again employed almost the whole evening in going on with the arrangement of the Raphaels & really <u>did</u> make some progress'.

248 . The Darnley Jewel, *c.*1571–8.
Set with rubies and an emerald, this gold and enamel locket, believed to have been made in Edinburgh, is thought to have been commissioned by Lady Margaret Douglas, Countess of Lennox, for her husband, Matthew Stewart, Earl of Lennox and Regent of Scotland. Both are portrayed in *The Memorial of Lord Darnley* (see fig.34). The locket is inscribed with admonitions directed at their grandson, James VI & I, although much of its symbolism is mysterious.
RCIN 28181

249. *Triptych: Crucifixion and Other Scenes* by Duccio di Buoninsegna, *c*.1302–8.
This small triptych by one of the most innovative painters of fourteenth-century Italy, was intended for private devotional use. The inclusion of St Francis on the right-hand wing implies that it was created for a Franciscan patron. It was painted while Duccio was at work on his greatest achievement, the *Maestà*, a many-panelled altarpiece for the high altar of Siena Cathedral, completed in 1311.
RCIN 400095

Albert's financial resources did not extend to buying a painting by Raphael, but instead he struck out in a direction that was completely new for the Royal Collection: Italian and north European paintings of the fourteenth and fifteenth centuries. This was not unprecedented in England, but it was still an uncommon taste in the 1840s, which makes it frustrating that Albert left no written clue about the nature of the attraction that such paintings had for him. Most of his purchases in this field were small in scale and were hung in the modest setting of his dressing room at Osborne. He may, therefore, simply have felt that such works were appropriate for a house in an Italian Renaissance style, but it is more likely that he conceived of them as having an educational purpose, as illustrating the early development of European painting. Mostly bought by Grüner in Italy on his behalf (or on the Queen's, as gifts for her husband), they include some outstanding treasures, notably a triptych by Duccio (d.1319), believed to be the first work by this founder of Western painting to have entered Britain (fig.249). Grüner also used his German contacts to buy north European Renaissance paintings for the Prince, of which the outstanding example is *Apollo and Diana* by Lucas Cranach the Elder (1472–1553; fig.250). Albert's liking for Cranach is easily explained: his family's collection included numerous works by the painter, who had worked in Coburg.

Prince Albert assumed a prominent role in the public art world when in 1841 the Prime Minister, Robert Peel, invited him to chair a royal commission 'to promote and encourage the fine arts' by commissioning works of art to decorate the new Palace of Westminster. Albert took this task – his first major appointment – as an opportunity to encourage fresco painting in England, and although the medium proved problematic in that damp, riverside setting, the result was the greatest cycle of mural decoration in Britain. Several artists who worked at Westminster are represented in the Royal

250. *Apollo and Diana* by Lucas Cranach the Elder, *c.*1526.
When Ludwig Grüner bought this painting on behalf of Prince Albert in 1844 it was said to depict Adam and Eve, a subject that Cranach often painted. It may in fact have a Christian meaning since, at this date, Apollo and Diana were occasionally regarded as pagan prefigurements of Christ and the Virgin Mary. RCIN 407294

251. *The Madonna and Child* by William Dyce, 1845.
It is not surprising that this painting appealed to Victoria and Albert, as it is strongly influenced by the artist they most admired, Raphael. The Virgin is reading a Bible passage referring to the ancestry of Christ. In 1846 Prince Albert commissioned Dyce to paint a companion picture, *St Joseph*.
RCIN 403745

Collection, notably Daniel Maclise (1806–70) and William Dyce (1806–64), who painted a fresco over the stairs at Osborne depicting Neptune resigning control of the seas to Britannia. The enthusiasm that Dyce shared with Albert for Italian Renaissance painting is evident in his *Madonna and Child* (fig.251), bought by the Prince in 1845. As the Queen, who hung it in her bedroom at Osborne, commented, it is 'quite like an old master, & in the style of Raphael – so chaste & exquisitely painted'.

Decorative arts were almost as important a part of the couple's joint purchasing and commissioning. Here they were influenced by the central role that international exhibitions came to have in the dissemination of design

252. *The Opening of the Great Exhibition* by Eugène Lami, 1851. Throughout her life the Queen commissioned watercolours of key events or places in her life, which she placed in albums. One of the most significant was the opening of the Great Exhibition in the Crystal Palace on 1 May 1851, which she described as 'one of the greatest and most glorious days of our lives'. RCIN 452380

and craft, beginning with the most celebrated of all, the Great Exhibition of 1851 (fig.252). Although Albert did not conceive the idea of the exhibition, and was not the first to recognise the genius of Joseph Paxton's design for the Crystal Palace, without his chairmanship of the Royal Commission that oversaw the project and his ability to attract funds, the Exhibition would not have been such a triumph. Its core purpose was to encourage manufacturing and design, and this may have prompted Victoria to think of her own purchasing and commissioning in a similar light, rather as her grandparents, George III and Queen Charlotte, had done. For example, having purchased a dessert service on Minton and Co.'s stand at the Great Exhibition (fig.253), she gave 69 pieces to the Austrian Emperor, Franz Josef I, and then commissioned more from Minton for herself.

The Queen and Prince Albert also made loans to the exhibition. Among the most prominent was an extraordinary carved ivory throne and footstool (fig.254), enriched all over with small gemstones, that had been given to the Queen shortly before the exhibition opened by Martanda Varma, the Maharaja of Travancore (1814–60), in south India, to draw attention to the skill of local ivory workers. Having been a centrepiece of the exhibition's Indian section, it was Prince Albert's throne at the closing ceremony in the Crystal Palace and in 1876 it was used by the Queen when she sat for the official photographs marking her assumption of the title Empress of India.

253. 'Four Seasons' centrepiece from the 'Victoria' pattern dessert service by Minton and Co., 1850–51.
The Queen's purchase of a 116-piece bone china dessert service for 1,000 guineas from Minton and Co.'s stand at the Great Exhibition secured the firm's reputation as the leading British maker of luxury tableware. The service was greatly admired for its combination of a vibrant turquoise ground, imitating the *bleu céleste* of Sèvres, with white unglazed figures modelled by the French sculptor Pierre-Emile Jeannest. RCIN 58226

An especially popular element in the Indian section was the display of jewels from the treasury of the Maharaja of Lahore, which had been ceded to the East India Company under the terms of the 1849 treaty that concluded the second Anglo-Sikh War, whereby the Punjab was transferred to the Crown. Under the treaty, the most celebrated gem in the treasury, the Koh-i-Nûr diamond, passed directly to the Queen (it now forms part of the Queen Mother's Crown). To mark her patronage of the Great Exhibition, the directors of the East India Company gave her a selection of the Lahore gems that had been on display, including a enormous ruby – in fact a spinel – which, with three other stones, she had set in a necklace made by the Crown jewellers, Garrard & Co., in 1853 (fig.255). The stone is of great historical interest because it is engraved with the names of its previous owners, including the Mughal emperor Shah Jahan (see fig.189).

254. Ivory Throne, 1840–50.
A gift from the Maharaja of Travancore, the throne was lent by the Queen to the Great Exhibition, where it formed a highlight of the Indian section. The throne's form is of European origin, but its decoration blends Western motifs, such as heraldic lions, dragons and unicorns, with Indian ones, including elephants and conch shells, the emblem of Travancore.
RCIN 1561

Contemporary art

255. The Timur Necklace.
Engraved with the names
of the Persian Shahs and
Mughal emperors who
owned it between 1612
and 1771, this giant spinel
(352.5 carats) takes its
name from the Emperor
Timur (or Tamburlaine),
who is believed to be its
first known owner. The
necklace was designed
to allow the Queen to
substitute the Koh-i-Nûr
diamond for the
principal gem.
RCIN 100017

**256. *Ramsgate Sands*
(*Life at the Seaside*) by
William Frith, 1851–4.**
One reason for the
Queen's eagerness to buy
this painting when it was
exhibited at the Royal
Academy in 1854 was her
memories of childhood
visits to Albion House,
shown by Frith as the
highest building looking
onto the beach.
RCIN 405068

Among the most familiar elements of Victoria and Albert's collecting are modern British paintings. The most important source of these was the annual exhibition at the Royal Academy, which they rarely visited without making a purchase. Many contemporary artists – such as Augustus Egg, John Martin, William Mulready or Frederick Pickersgill – are represented in the Royal Collection by a single work, suggesting that the Queen and Prince sought to spread the benefits of royal patronage as widely as possible. Among the artists from whom they purchased just one outstanding work was William Frith (1819–1909), whose *Ramsgate Sands* was the sensation of the Royal Academy in 1854 – famously, a guard rail had to be installed to protect it from the crowds poring over its every detail (fig. 256). The Queen was disappointed to learn that it had already been sold to the dealers Messrs Lloyd, for £1,000. She asked Frith for a similar painting for herself, but when Lloyd offered to sell *Ramsgate Sands* to her for cost (retaining the valuable reproduction rights), she cancelled the request.

As that acquisition shows, even Victoria and Albert had to compete for purchases at the Royal Academy. After a visit to the annual exhibition in April 1847 the Queen recorded in her journal that 'there are some very clever ones by new artists. There is one in particular, "Una Amongst the Fauns" by Frost, which we intend to buy. He is a student of the Academy and shows immense talent.' The painting by William Edward Frost (1810–77), *Una Among the Fauns and Wood Nymphs* (fig. 257), was a subject from Edmund Spenser's *The Faerie Queene* (1590). Although Victoria does not mention the fact, Albert would have known that four years earlier Frost had entered the competition for murals for the Houses of Parliament, winning a third-prize premium for his cartoon of a closely related subject, *Una Alarmed by the Fauns*

and Satyrs. A new departure in a career previously dominated by portraiture, the Royal Academy picture had been commissioned by a significant patron of modern British art, the businessman Elhanan Bicknell (1788–1861), who agreed that the Queen could have it. Having given the painting to Albert as a birthday present, she commissioned for him a pendant, *The Disarming of Cupid*, a subject from Shakespeare's sonnet 154, to give to him for Christmas

1848. Both works prominently feature female nudes, a subject to which neither she nor her husband had any objection, although Frost's cool handling of paint gives the paintings a slightly frigid eroticism that seems more characteristic of the Prince's tastes than Victoria's.

Albert and Victoria have been taken to task for showing little interest in the avant-garde art of the Pre-Raphaelites. In fact, as will be discussed, the Queen bought paintings by two founding members of the group, John Everett Millais (1829–96) and William Holman Hunt (1827–1910), but not until after Albert's death. Some purchases, such as Dyce's *Madonna and Child*, share the Pre-Raphaelite assertion that modern painting could be revitalised by a study of early Italian art. This belief was reflected in one of the great Victorian tributes to the art of medieval Italy, *Cimabue's Madonna Carried in Procession* (fig.258), which the Queen bought – at her husband's insistence – at the Royal Academy exhibition in 1855. This enormous canvas made the reputation of its painter, the 25-year-old Frederic Leighton (1830–96). As the Queen wrote in her journal, 'The young man's father, said that his future career in life would depend on the success of this picture', although even he could not have foretold the future Lord Leighton's dominant position in the late Victorian art world.

Photography

Under Albert's guidance, the Royal Collection took on many of the characterstics of well-run museum. At Hampton Court, for example, regular public openings from 1838 onwards necessitated the repair, cleaning and rehanging of its paintings, neglected for almost a century. As the Queen wrote, 'My care, or rather my dearest Albert's, for he delights in these things, [is] ... to have them restored, to find places for them.' Albert also reorganised the Old Master drawings, gathered the miniatures together in a purpose-built cabinet, and installed George IV's great collection of arms and armour at Windsor. With the appointment in 1856 of the artist and arts administrator Richard Redgrave (1804–88), the post of Surveyor of the Queen's Pictures began its transformation from picture cleaner and restorer into curator. Albert commissioned Redgrave to catalogue both the Royal Collection's paintings and the family's private pictures, a task he completed in 34 manuscript volumes in 1879.

At the outset, Redgrave recommended that each entry be accompanied by a photograph, for which he was allowed an annual budget of £100. This was a mark not just of the significance of photography to art history but also of the important place the new medium had come to play in the life of the royal family. Their interest in the subject had begun almost casually in 1842, three years after photography was established as a commercial practice, when Prince Albert visited the Brighton studio of William Constable (1783–1861) to sit for a daguerreotype. By the end of the decade photography had

257. *Una Among the Fauns and Wood Nymphs* by William Edward Frost, 1847.
In this scene from Book I of Edmund Spenser's *The Faerie Queene*, Una appears in the centre, dressed in white to symbolise virtue; her beauty has overawed the pagan woodland deities, including the normally lustful satyrs. Queen Victoria commissioned two further paintings from Frost, one on a theme from Shakespeare's sonnets and the other based on John Milton's 'L'Allegro', thus forming a trilogy derived from eminent English poets.
RCIN 407162

258. *Cimabue's Madonna Carried in Procession* by Frederic Leighton, 1853–5.
A procession takes an altarpiece of the Virgin and Child – the 'Rucellai Madonna', now in the Uffizi – to Santa Maria Novella in Florence. Painted by Duccio, it was thought in the nineteenth century to be by Cimabue, who is shown in the centre holding the hand of his pupil Giotto. At the far right is Dante, an allusion to the comment on worldly fame in his *Divine Comedy*: 'Once Cimabue thought he held the field in painting; Giotto now is all the rage'.
RCIN 401478

extended to every aspect of the royal household. On 3 May 1848 the Queen recorded in her journal: 'We went to the stables to see the horses daguerreotyped, which really was curious, particularly to see how badly the horses placed themselves, when they had to stand still'.

Both Albert and Victoria regarded photography as a supplement to their life-long practice of collecting or commissioning watercolours or drawings of significant people or occasions in their lives. Victoria was drawn mostly to portraits and scenes of human interest, whereas Albert collected architectural views and landscapes, as well as photographs of public events (fig.259). In this way, works by many leading photographers were acquired. The couple were encouraged to take a deeper interest in the medium by their sons' tutor, Ernest Becker (1826–88), who taught photography to the Prince of Wales and Prince Alfred and helped Albert buy photographs. He was also a founding member of the Photographic Society of London (later the Royal Photographic Society), which was established in 1853; Victoria and Albert visited its inaugural exhibition., having agreed to be patrons of the new society. Among the works they admired was a set of studies of animals in London Zoo by Juan de Bourbon, Comte de Montizón (1822–87) – a claimant to the thrones of Spain and France as well as an accomplished amateur photographer – and the Queen subsequently bought 43 examples (fig.260).

Their guide round the exhibition was one of the great photographers of the day, Roger Fenton (1819–69), a council member of the Photographic Society. In 1854 they commissioned him to take photographs of their children dressed up for *tableaux vivants* that could be used as the basis for watercolour portraits. This was the first of nine photographic sessions for the royal family that year (fig.262), in which he also made photographs of

260 (top left). *Don Juan, Comte de Montizón, Obaysch, the Hippopotamus, London Zoo*, 1852.
Among Victoria and Albert's early acquisitions of photographs was a group of 43 salt prints depicting animals at London Zoo by Montizón.
RCIN 2905523

261 (top right). *Cooking House, 8th Hussars* by Roger Fenton, 1855.
Fenton spent four months in the Crimea in 1855, photographing the allied forces. Here he shows soldiers at a field kitchen with a canteen worker.
RCIN 2500384

262 (bottom). *Queen Victoria and Prince Albert* by Roger Fenton, 1854.
The Queen and Prince Albert are in court dress, having just attended a Drawing Room at St James's Palace, at which people were formally presented to the Queen. This is the first known photograph of Victoria as a monarch rather than wife or mother.
RCIN 2906513

Romance

works of art for Albert's Raphael project. For a time he was in effect court photographer, and although his most famous work, the photographic coverage of the Crimean War in 1855 (fig.261), was not a royal commission, it was facilitated by letters of introduction to the military commanders supplied by Prince Albert. No subsequent photographer was favoured by the royal family to the same degree, partly because, by the 1860s, a medium that had initially required considerable technical expertise had evolved into a popular pastime.

Tragedy

Prince Albert's death in December 1861, either from typhoid, as was said at the time, or from an abdominal illness, as historians have speculated, came as a complete shock to the Queen. In her overwhelming grief, art came to her aid: at Windsor Castle on 20 March 1862 she wrote, 'After a great effort, brought myself to go to the Print Room, the favourite resort of my dearest Albert. When I went in first, I was much upset & could say nothing. There were all the miniatures & the beautiful & unique collection of Raphael cartoons and drawings.' She was comforted also by the great number of monuments to Albert that were raised throughout the empire: a typical entry in her journal shortly after his death records that, 'After luncheon saw

263. *Royal Mausoleum, Frogmore* by Arthur Croft, 1863.
Queen Victoria's sole major independent act of architectural patronage is the Royal Mausoleum at Frogmore, near Windsor, where she and Prince Albert are buried. This watercolour was painted to show the Queen the decorative scheme proposed by the designer, Ludwig Grüner. It was executed almost exactly as depicted.
RCIN 919739

264. *Queen Victoria at Osborne* by Edwin Landseer, 1865–7.
In 1865 the Queen commissioned Landseer to paint a pair of watercolours, *Sunshine*, showing Albert at Balmoral in 1860, and *Shadow*, the Queen in mourning at Osborne. The latter formed the model for this oil painting. The Queen is seated on her pony, Flora, held by John Brown, with Princesses Louise and Helena in the background. Landseer described the painting as a 'truthful and unaffected representation of Her Majesty's unceasing grief'. RCIN 403580

2 models of statues of beloved Albert, for Salford & for Leeds, as well as a photograph of the one by Noble, for Manchester.'

The Queen's own memorial to Albert is one of the nineteenth century's most impressive work of funerary architecture. Less than a week after Albert had died, she summoned his old Adviser on Art, Ludwig Grüner, out of retirement in Dresden to design a mausoleum, to be built in the grounds of Frogmore House in the park at Windsor (fig.263). It was sufficiently ready for Albert's body to be placed inside it on the first anniversary of his death. Eventually he and Victoria would lie together in a great granite double sarcophagus under white marble effigies by Marochetti, the centrepiece of an extraordinarily elaborate decorative scheme, based, at the Queen's instruction, on works by Raphael.

The Queen's mourning for her husband was to be life-long, but in the decade immediately after his death she suffered such acute depression that she found it difficult to maintain her public duties, with potentially worrying consequences for the monarchy. Fearing for her health, her doctors advised that her Highland servant, John Brown, and favourite pony, Lochnagar, should be brought from Balmoral to Osborne, so that Victoria could take more exercise. Brown rapidly became indispensable to the Queen. It may, perhaps, have been a wish to share her mourning with the public that prompted her to commission Landseer to paint *Queen Victoria at Osborne*,

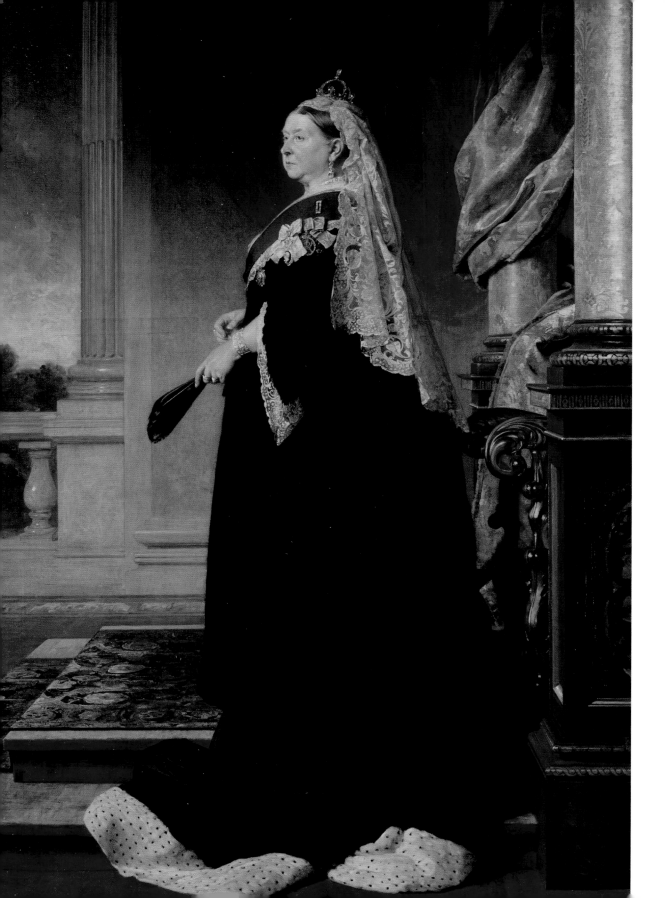

exhibited at the Royal Academy in 1867 (fig.264). Received in public with muted sympathy, in private the painting inflamed prurient gossip about the Queen's relationship with Brown. Given Landseer's failure with the 'boat picture', the degree of his success in this very difficult commission is impressive: 'the likeness of herself (rather a portly elderly lady)', wrote the Queen, 'and her good faithful attendant and friend are both, she thinks, *very* good'.

Old age

Queen Victoria at Osborne was Landseer's last major royal commission. In 1873 there was a major break in the traditions of royal portraiture when both he and Winterhalter died; the Queen described them as 'our personal, attached friends of more than 30 years standing'. By then she had recovered much of her old interest in public life and responded favourably to her daughter Vicky's suggestion that the young Hungarian painter Heinrich von Angeli (1840–1925), who was based in Vienna, might be tried out as a possible successor to Winterhalter. Angeli painted a three-quarter-length portrait of the Queen, yet, although it greatly pleased her, it was not until 1884 that he returned to paint a new state portrait. The Queen wrote to her private secretary Henry Ponsonby about 'that strange man Angeli who with great difficulty has been persuaded to come when we return to Windsor to paint that long *intended* State Picture'.

By now Angeli had plenty of experience of court life, at St Petersburg as well as Berlin and Vienna, and he managed not only to please the Queen but also to charm her: when the painting was completed she wrote to Vicky, 'Angeli (who was as funny as ever) has really outdone himself in my Picture' (fig.265). When it was admired by Joseph Edgar Boehm (1834–90), who had become the most favoured royal sculptor after Marochetti's death, she allowed herself a modest boast: 'he says I sit wonderfully well'. Her admiration was justified: Angeli convincingly translated his rather unpromising subject matter – by now unquestionably 'a portly elderly lady' – into a figure of imposing majesty. The portrait incorporates one of the most familiar royal props of the Queen's old age, a small diamond crown (fig.266). Made in 1870 by the Crown Jewellers, Garrard & Co., and worn by the Queen for the first time at the state opening of parliament in 1871, it became so identified with her that it was placed on her coffin at Osborne before her funeral.

265. *Queen Victoria* by Heinrich von Angeli, 1885.
The Queen is dressed in back satin – which she thought Angeli had painted 'most marvellously' – and wears the riband and star of the Garter, with the badges of the Order of Victoria and Albert and the Crown of India. Many copies of the portrait were made by Angeli and other artists. RCIN 403405

266. Queen Victoria's Small Diamond Crown by Garrard & Co., 1870.
An openwork silver frame set with 1,187 brilliant-cut and rose-cut diamonds, the crown was designed to be light, as the Queen wore it over her widow's cap at court and state occasions. Subsequently worn in turn by Queen Alexandra and Queen Mary, it now forms part of the Crown Jewels, having been added to the regalia in the Tower of London by George VI. RCIN 31705

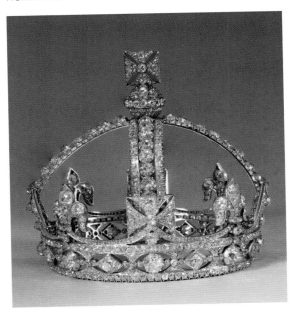

Although the heroic days of royal commissions died with Prince Albert, and although her appetite for art declined with her eyesight in advanced old age, the Queen initiated some notable additions to the Royal Collection in the four decades of her widowhood. For example, although she refused to sit to Millais for a portrait, in 1882 she asked him to paint her seven-year-old granddaughter, Princess Marie of Edinburgh. When, in 1873, she saw William Holman Hunt's painting of the young Christ, *The Shadow of Death* (now in Manchester Art Gallery), she instructed her lady-in-waiting Lady Stanley to write to Hunt to express the Queen's '*great* admiration of the Work and interest in it in its every aspect', and to request him – or a copyist he recommended – to make a copy for her of just the head. Hunt elected to do this himself, but the Queen must have long given up hope of receiving it when the painting, entitled *The Beloved*, was finally delivered to Osborne in

267. *The Beloved* by William Holman Hunt, 1873–98.
This copy, by Hunt, of the head of Christ in his painting *The Shadow of Death* was not delivered until 25 years after the Queen had requested it. Inscriptions on the frame explain that the subject is Christ as the fulfilment of prophecy, symbolised by the scroll he clasps. Edward VII hung the painting in the chapel at St James's Palace. RCIN 406027

1898 (fig. 267). A little known work, it is even more intense than the painting from which it is derived.

In 1886 the Queen invited a group of native people who had taken part in the Colonial and Indian Exhibition at South Kensington to lunch with her at Windsor, and decided to commemorate the occasion by having their portraits painted. At Angeli's suggestion, one of his protégés, a young Austrian painter named Rudolf Swoboda (1859–1914), undertook the task. The Queen was so pleased with the results that she gave Swoboda an ambitious commission: he was to go to India and paint a series of portraits of 'the various types of the different nationalities' in their native dress or military uniform. Swoboda returned in July 1888 with 43 paintings (figs 268 and 269), all painted to the same small format (around 30 x 19 cm) that he had employed for the earlier set of portraits.

The Queen had envisaged asking him to work up these sketches into more finished paintings, but when she saw the portraits, 'such lovely heads … *beautiful* things', she recognised that they were works of art in their own right. Despite the somewhat anthropological terms of the commission – to portray 'types' – Swoboda recorded strongly characterised individuals, each of whom is named. He went on to paint similar portraits of the Queen's Indian servants and members of Indian regiments, after which she gathered all his paintings together to hang in the corridor leading to the Durbar Room at Osborne. This large banqueting hall in Indian style, completed in 1891, was designed by John Lockwood Kipling of the Lahore School of Art (with one of his staff, Bhai Ram Singh); Kipling had given Swoboda much help while he was in India.

268 and 269. *Makkan Singh* and *Sirinbai Ardeshir* by Rudolf Swoboda, 1886–8. These are two of the 43 identically sized portraits painted by Swoboda as a result of the Queen's commission for him to travel around India making a record of native 'types'. Makkan Singh was a 45-year-old Hindu from Kiario, Jodhpur District, and Sirinbai Ardeshir was a 14-year-old Parsi from Neemuch. RCIN 403793 and 403796

The Durbar Room was a tribute to the Queen's imperial role, which was emphasised in the two great jubilees she celebrated in 1887 and 1897. By now the Royal Collection was growing more quickly from gifts, rather than purchases, and for the jubilees the gifts arrived in a seemingly endless torrent. One of the most spectacular in terms of quality was an enormous table centrepiece, presented by the officers of the British army to mark the Golden Jubilee (fig.270). Made of silver and rock-crystal on a marble base, it was designed by a pupil of Boehm's, Alfred Gilbert (1854–1934), who was then at work on his best known commission, the 'Eros' fountain in Piccadilly Circus. Although its swirling, *fin de siècle* forms, suggestive of French Art Nouveau, seem uncharacteristic of her taste, the Queen wrote that she was 'delighted' with this work, by 'a young artist of great promise'.

Her own major commission for the Golden Jubilee was a painting depicting her family assembled in the Green Drawing Room at Windsor Castle by

270. Centrepiece by Alfred Gilbert, 1887–90.
Nearly three feet high, this massive silver, silver gilt and rock-crystal centrepiece on the theme of the 'Realm of Britannia' was described by Gilbert as 'the supremest effort of my life'. His interest in contrasts of materials, colour and texture has been partially obscured by gilding added at Queen Mary's request in the twentieth century.
RCIN 74418

271. *The Family of Queen Victoria in 1887* by Laurits Tuxen.
The Prince of Wales stands behind the Queen, facing his wife; the seated figure in the foreground is Victoria's eldest daughter, Vicky, Crown Princess of Prussia. The Queen is being presented with flowers by Princess Alice, daughter of her son Leopold.
RCIN 400500

the Danish artist Laurits Tuxen (1853–1927; fig.271). When the Queen saw the preliminary sketch she remarked, 'I think it will be very pretty. It is not to be stiff & according to *Etiquette*, but prettily grouped'. Nonetheless, Tuxen faced several delicate issues in placing the figures. The prominence he had given to the Marquess of Lorne, husband of Princess Louise, on account of the picturesque qualities of his Highland dress, had to be amended, and the Princess of Wales, who for political reasons was anti-German, refused to be placed near her brother-in-law, the Crown Prince of Prussia.

Tuxen painted almost all the 55 individual figures from life – completing as many as eight portraits in a day – giving the painting a spontaneity rarely matched in the Queen's commissions of records of family events since C.R. Leslie had painted her at her coronation 49 years previously (see fig.235). At the Queen's request he made one change to the room's furnishings: a bust of Albert was substituted for the clock on the mantelpiece. The Queen, as always by now, had at least one eye on the past, but the painting also casts the mind forwards. This gathering of the royal and imperial houses of Europe looks to posterity like a cast of actors preparing to take their bow before the final curtain.

ART FOR A MODERN MONARCHY
Edward VII to Elizabeth II

When he came to the throne in January 1901 Edward VII (1841–1910) was in his sixtieth year and in a hurry. He at once turned his attention to the redecoration and rearrangement of the royal palaces, where much had been left untouched since his father had died nearly 40 years before. He had 'a quick trained eye and instinct for what was right and what pleased him', recalled his newly appointed Surveyor of the King's Pictures, Sir Lionel Cust (1859–1929). '"I do not know much about Arrt," he would say with the characteristic rolling of his r's, "but I think I know something about Arr-r-angement".' The King has perhaps been taken too much at his word. In 1870 he wrote that his favourite artists were Raphael and Paul Delaroche (1797–1856) – a safe choice, but one that suggests that his tastes were not far removed from his parents'. Although he swept away many of the objects that his mother had accumulated, and gave Osborne to the nation for use as a naval training college, when it came to art he was essentially a Victorian. Edward's rackety life as Prince of Wales has tended to obscure deeper aspects of his personality: his High Church piety, for example, or his love of Wagner. Although he was neither a connoisseur nor, with few exceptions, a collector, his contributions to the Royal Collection spring several surprises, especially on those who think of him only as that n'er do well, 'Bertie'.

Albert Edward, Prince of Wales

In January 1862, only a few weeks after Prince Albert's death, the Prince of Wales embarked on a six-month tour of the Near East that had been planned for him by his father. It may have been Prince Albert's idea that Edward should be accompanied by a photographer, and it is possible that he selected Francis Bedford (1816–94), since in 1857 The Queen had sent Bedford to Coburg to take photographs of her husband's birthplace. The Prince of Wales had been taught photography by his tutor Ernest Becker, and, although he did not pursue it as a hobby in the way that his brother Alfred did, it remained a life-long interest. Aged only 14, he had subscribed to Roger Fenton's record of the Crimean campaign, and by 1863 he owned over 1,000 photographs. Bedford returned from the Near Eastern tour with around 180 plates, many of outstanding quality (fig.272). He focused on

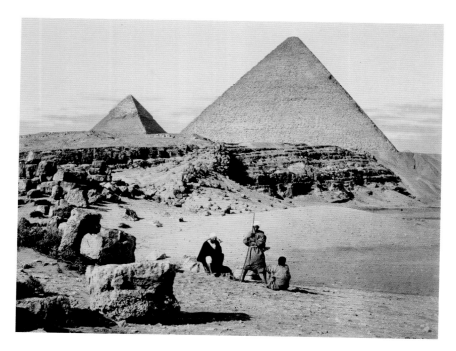

272. *Pyramids of Cheops and Cephrenes* by Francis Bedford, 1862.
In March 1862, during his tour of the Near East, the Prince of Wales climbed the Great Pyramid for the view. In his journal he described the ascent, begun at 5.30 in the morning, as 'rather serious and difficult'. RCIN 2700868

monuments rather than daily life, but that was because of the educational nature of the trip, designed by Prince Albert in part to instruct his son in the early history of Christianity.

Long foreign tours, a new element of royal life in the mid nineteenth century, have left a rich legacy of gifts and purchases in the Royal Collection. The Prince of Wales's best known tour was his visit to India in 1875–6. Intended to improve relations between the Crown and the Indian rulers, it culminated in the announcement of the Royal Titles Act, which made Queen Victoria Empress of India. A large durbar was held in Calcutta, and the Prince also visited Benares, Lucknow, Cawnpore and Delhi, as well as Goa and Ceylon. Part of the behaviour expected of a royal guest was the exchange of gifts. At the suggestion of the Viceroy, Lord Northbrook, Indian gifts to the Prince were limited to 'curiosities, ancient arms, and specimens of local manufacture'. As a result, Edward returned to England with a substantial collection of works of art, notably luxury arms and armour (fig.273). At his request, they were exhibited at the Indian Museum at South Kensington, now part of the Victoria and Albert Museum, both to reveal to the British public the achievements of Indian craftsmen and to inspire British designers and manufacturers – an ambition of which his father would have approved. Many of the gifts were subsequently installed in the Prince's London home, Marlborough House, where cases were specially made to display them.

Other items were used to decorate the ballroom at Sandringham, the Prince of Wales's country house in Norfolk, purchased for him by the Queen in 1862, shortly after he had married Princess Alexandra of

Denmark. Valued by the Prince for its sport, it was not intended as a place to display significant works of art, but it rapidly became a receptacle for gifts from royal visitors to Britain, ranging from tapestries after designs by Goya, given by Alfonso XII of Spain in 1876, to a Dresden china chandelier from Edward's nephew Kaiser Wilhelm II of Germany. Even the dinner gong was a gift, presented to the Prince on his Indian tour by the Maharaja of Tripura.

In 1873 the Tsarevich, the future Tsar Alexander III (1845–94), and his wife, Marie (who was the Princess of Wales's sister), were entertained at a

273. *Shield* (*dhal*), 1800–75. Presented to the Prince of Wales during his four-month tour of India in 1875–6 by Ranbir Singh, Maharaja of Kashmir, a *dhal* (shield) is traditionally made of painted and lacquered hide. This elaborate version is made of silver gilt, enamelled and inlaid with more than 800 diamonds. RCIN 11278

ball at Marlborough House. The guests wore historical dress – the Prince of Wales appeared as Charles I – and the décor was supervised by Frederic Leighton, whom the Prince had known since 1859, when they had met in Rome. Edward's familiarity with many of the leading artists in London was not unusual, since they were part of fashionable society: Alexandra visited Leighton's studio eight times, and she and the Prince entertained him, and also Lawrence Alma-Tadema (1836–1912), to dinner. The Prince's purchase of two of Leighton's beautiful studies of heads of young women was more than a gesture of friendship (fig.274). In 1878 he wrote to his mother urging that Leighton be appointed President of the Royal Academy, since he was 'the only man in this Country who has a thorough knowledge & apprecia-tion of art'.

The Queen would have agreed, if only because of Prince Albert's admi-ration for Leighton's painting *Cimabue's Madonna Carried in Procession* (see fig.258). In 1868 she was delighted by the Prince of Wales's birthday gift

to her of Leighton's portrait of the artist John Hanson Walker as a shepherd boy, but his presentation to her in 1873 of a portrait of the Princess of Wales by William Blake Richmond (1842–1921) was not well received (fig.275). Although the Queen had agreed in advance to the choice of artist, she disliked the result so much – 'so flat & so green & deathlike' – that she immediately consigned to store this rare royal venture into the Aesthetic Movement. It is perhaps surprising, therefore, that she admired the sculptor Alfred Gilbert, but she knew that he had been a pupil of the sculptor she most favoured in later life, J.E. Boehm. The success of Gilbert's Golden Jubilee centrepiece (see fig.270), together with his friendship with Edward's sister Princess Louise, were among the factors that led the Prince and Princess of Wales to offer Gilbert his greatest commission, the tomb in the Albert Memorial Chapel, Windsor, for their eldest son, the Duke of Clarence and Avondale, who died of influenza in 1892.

275. *Queen Alexandra when Princess of Wales* by William Blake Richmond, 1872–3.
Eager for a portrait of her famously beautiful daughter-in-law, Queen Victoria sent Richmond photographs to show the pose she wanted, together with instructions about her dress and hair style – it was not to be too curled. She disliked the result, however, and particularly objected to the Aesthetic Movement colouring: 'Chinese sorts of leaves as a background ... I cannot hang it up anywhere.'
RCIN 404362

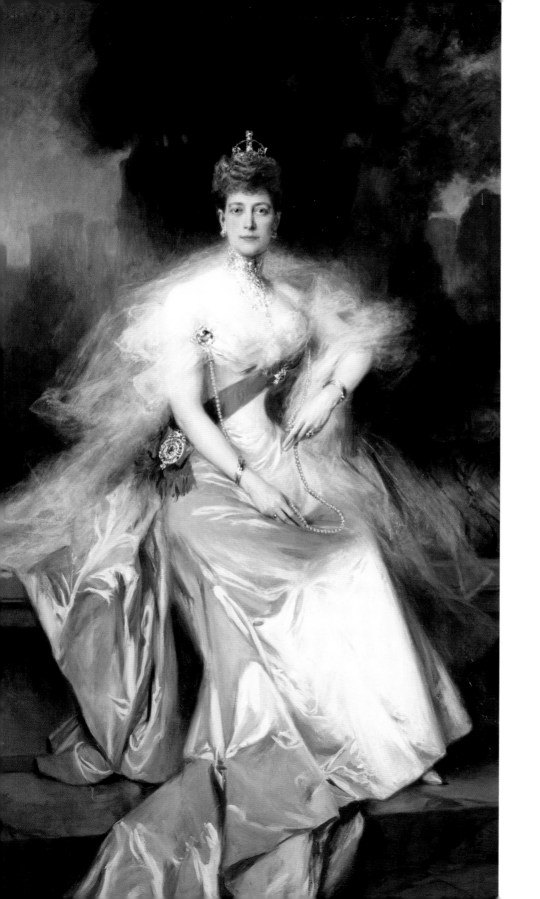

One reason for choosing Gilbert may have been a wish to use a sculptor who was both British and a Royal Academician: Cust records that the Prince's frequent choice of foreign artists for private commissions caused ill-feeling at the Royal Academy. Yet, when the Prince gave British painters their chance, they were often outshone by foreign rivals. The state portraits of the King and Queen commissioned in 1902 and 1905 respectively from Luke Fildes (1843–1927) lack the dazzling technique of the full-length of Alexandra by the Frenchman François Flameng (1856–1923; fig.276), which both captures her famous beauty and makes one regret that, unlike so many of their friends, neither she nor the King ever sat to the greatest master of such swagger portraits, John Singer Sargent.

The King's passion for 'Arr-r-angement' extended to every part of the collection. For example, having appointed Sir Guy Laking (1875–1919) to the new post of Keeper of the King's Armoury at Windsor Castle, he ordered a complete redisplay of the armour, and he also created displays of porcelain in the museum rooms on the ground floor, in cases previously occupied by his mother's jubilee gifts. His refurbishment of the Castle's private apartments excited Alexandra, who wrote to her daughter-in-law, the Duchess of York, later Queen Mary, 'Our rooms will be beautiful when furnished with all the splendid, fabulous furniture in the Castle. I have been fishing out such beauties from every imaginable corner. I do not think even the Rothschilds could boast of anything better or more valuable.' This was a justified assessment of George IV's collections, as Mary would have appreciated.

Queen Alexandra

Alexandra (1844–1925) had been taught to sketch and paint, and she took these pastimes seriously, as the 'painting rooms' she installed at Marlborough House and later Windsor Castle demonstrate. She enjoyed embellishing albums of family photographs with her own, often whimsical, watercolour decorations. This may have inspired her to take up photography, although it is possible that her husband's interest in the subject was also an encouragement. Having been taught by one of the servants at Sandringham, Frederick Ralph, who was also a professional photographer, she bought a No. 1 Kodak, one of the early hand-held cameras that helped to make photography a ubiquitous pastime. The earliest surviving results date from around 1886–7. Since her subjects were mostly her family and friends, her photographs inevitably have a strong biographical and historical interest (fig.277), but Alexandra's style, incorporating unusual cropping and a liking for silhouette and *contre jour* effects, resulted in a body of work that is distinctive and memorable in its own right. It also reached a very wide audience, since a selection of her photographs was published in 1908 as a Christmas gift book to raise money for charity, becoming one of the bestsellers of the Edwardian age.

276. *Queen Alexandra* by François Flameng, 1908. The Queen's choice of Flameng for this opulent portrait may have been influenced by his full-length of her younger sister, the Tsarina Maria Feodorovna, painted in 1894 (now in the Hermitage, St Petersburg). As well as the riband and star of the Order of the Garter, she is wearing a necklace, made for her by Cartier in 1904, and the Koh-i-Nûr set as a brooch. RCIN 405360

The Queen was not greatly interested in collecting, but she helped to lay the foundation of the Royal Collection's famous group of some 500 works by the Russian jeweller Carl Fabergé (1846–1920), which is not only the largest collection of his work outside Russia but also the most varied. It has its origins in gifts to the Queen from her sister, Marie (from 1881 the Tsarina), which the King supplemented by purchases from Fabergé's shop in Moscow on his visits to the city. After Fabergé opened a branch in London in 1903, Alexandra developed a fondness for the useful items it sold, such a bell-pushes, paper knives and photograph frames. The scope of the Collection was transformed in 1907 by a major commission by the King. According to the shop's manager, H.C. Bainbridge, 'the idea came to me to model all the animals at Sandringham in wax, and have them cut in some semi-precious stone of the colour of the animal'. Delighted with the idea, the King placed a large order, remarking that 'we do not want any duplicates' – every piece had to be unique.

Fabergé sent two of his sculptors, Frank Lutiger (1871–1931) and Boris Frödman-Cluzel (1878–1969), to Sandringham, where they stayed for several weeks modelling portraits in wax of the royal pets and farmyard animals. Edward made them welcome and even took them shooting, prompting Frödman-Cluzel to write home about the 'praise which is generously splashed on me by this amiable and rare king!' The wax models were taken to Moscow (none are known to survive), where they were copied in hard-stones such as agate, chalcedony, obsidian, jasper, purpurine and bowenite in the workshop run by Henrik Wigström (1862–1923). These were kept in stock in London for the King and Queen to purchase over a number of

278 (opposite). *Caesar*, *c*.1908; *Pig*, *c*.1907; *Norfolk Black Turkey*, *c*.1908; *Dormouse*, *c*.1910, by Fabergé.
Edward VII's Norfolk terrier Caesar is made of chalcedony with ruby eyes and wears a gold collar inscribed, 'I belong to the King'. The pig and Norfolk turkey, based on farmyard animals at Sandringham, are of aventurine quartz and black obsidian respectively, embellished with rose diamonds. The dormouse nibbles gold straws.
RCIN 40339, 40422, 40446 and 40261

277. *Princess Victoria and Grand Duchesses Marie, Olga, Anastasia and Tatiana* by Queen Alexandra, 1908.
In the centre is the Queen's daughter Princess Victoria with four of the daughters of Tsar Nicholas II: left to right, the Grand Duchesses Anastasia (moving out of the picture), Marie, Tatiana and Olga. The photograph was taken on the Imperial Yacht *Standart*, at what is now Tallinn, Estonia. This meeting between Edward VII and the Tsar was intended to affirm the Anglo-Russian Convention of the previous year.
RCIN 2917018

years, or for friends to buy for them as gifts. Full of life and charm, this jewelled menagerie was added to, with further commissions by the King and other members of his family, with the result that the Royal Collection now has over 200 of these miniature masterpieces, which Edward and Alexandra displayed in cases at Sandringham (fig. 278).

Enthusiasm for Fabergé runs through the Royal Collection in the twentieth century, since every successive generation to the present has added examples. The greatest highlights were acquired by Queen Mary, following the dispersal of the Russian imperial collection by Antikvariat, the bureau established by Lenin to sell state treasures after the Revolution. In the 1930s she and George V helped to set a fashion for collecting Fabergé with an imperial provenance by purchasing three of the eggs that had belonged to the last Tsarina, Alexandra, daughter of Edward VII's sister Princess Alice. The most famous is the 'Mosaic Egg' given to Alexandra by her husband, Nicholas II, as an Easter gift in 1914 (fig. 279).

279 (right). *Mosaic Egg* by Fabergé, 1914.
Inside the egg, made by August Wilhelm Holmström, is an ivory medallion painted with portraits of the five children of Nicholas II and Alexandra. The egg, formed of a platinum mesh into which tiny gemstones are fitted, was designed by Alma Theresia Pihl.
RCIN 9022

Queen Mary

Given that George V had – for reasons of political expediency – avoided giving asylum to the Russian imperial family after the Tsar's abdication in 1916, it may seem odd that Queen Mary should have sought out their expropriated treasures. It is likely, however, that she regarded her purchases as a way of rescuing works of art intimately associated with both her family and the way of life in the network of European courts that she had known

280. Fan depicting 'Blind
Man's Bluff', c.1700.
Queen Mary believed
that this Italian fan,
depicting nymphs and
shepherds playing
blind-man's bluff, was
used by Queen Charlotte
when visiting Worcester
in August 1788. Queen
Mary had a particular
interest in acquiring
objects that had belonged
to Charlotte, partly
because she thought they
resembled each other.
RCIN 25063

281. Tureen with stand
and cover by Paul Storr,
1818–19.
Embossed with leopards,
putti and foliage, this
silver-gilt tureen and cover
has a finial cast as St
George and the dragon,
and handles in the form
of figures of Victory. It is
supported by the lion and
unicorn flanking the royal
coat of arms.
RCIN 50470

so well before the First World War. She is the best-known royal collector of the twentieth century, but her motivation went well beyond a love of beautiful objects – her wish not only to acquire works with a royal provenance but also to catalogue and arrange them may perhaps suggest a desire to bring order to a world very different from the one in which she had grown up (fig.280).

Queen Mary (1867–1953) was the daughter of Prince Francis of Teck and Princess Mary Adelaide of Cambridge, a cousin of Queen Victoria. By royal standards her parents were poorly off, and in her teens Mary lived in Florence, to where her parents had moved for reasons of economy. Her interest in art began with visits to Italian museums and churches, but it was not until 1893, when she married Prince George of Wales, subsequently George V, that she could afford to buy works of art. Her collecting was shaped in part by the death in 1904 of her mother's brother, the Duke of Cambridge. He had no legitimate children and so his possessions were scattered. Much was sold at auction, and although Mary was allowed to buy in anything she liked at valuation, she lamented that, 'there is no real catalogue of where the things came from, which rather takes away from the interest of some of the smaller *bibelots* … The sons do not even know by whom some of the pictures are'.

From then on, she sought to reassemble as much of her family's collection as she could, and to research it thoroughly. Among the works that eluded her at the sale was her uncle's magnificent silver-gilt tureen by Paul Storr (1771–1844), but she seized the opportunity to buy it when it came

up at Christie's in 1916 (fig.281). She was well-informed about the salerooms and also developed close relations with the leading West End antique dealers, such as Frank Partridge for furniture, S.J. Phillips for jewellery and John Sparks for oriental works. A regular visitor to London's museums, she took a particular interest in the creation of the Museum of London, which was established in 1911 in the state rooms of Kensington Palace. Her arrangements of her own collections, which resulted in the creation at Buckingham Palace of an Eighteenth-Century Room, Chinese Chippendale Room and Wedgwood Room, were influenced by, and may even have influenced in turn, the way works of art were displayed at the Victoria and Albert Museum.

After her husband's accession to the throne in 1910, Queen Mary broadened the range of her collecting to objects with a royal provenace, especially those that had belonged to Queen Charlotte, with whom she felt a particular affinity. She was assisted by the Royal Librarian, Owen Morshead (1893–1977), appointed in 1926, who shared her tastes and drew her attention to works of art on the market. He also helped her to compile private catalogues of her collections, a distinctive element of Queen Mary's collecting, but one that had a precedent in initiatives by her father-in-law. Edward VII had built on the achievement of the manuscript inventories compiled for his parents by Richard Redgrave by commissioning a series of published catalogues of the Royal Collection, beginning with the armour, by Laking, followed by volumes on the porcelain and furniture. Similarly, when Queen Mary put on display at Windsor her collection of Stuart relics – which contained such remarkable treasures as jewels that had belonged to Mary, Queen of Scots (fig.282) – she was following a precedent in Edward and Alexandra's creation of the Castle's Holbein Room, which by 1907 contained 44 Tudor portraits and objects.

282. Parure with necklace, brooch and earrings, late sixteenth century with later additions.
Although this set of jewellery has been altered and added to (the earrings are nineteenth century), the brooch and part of the necklace are believed to have been given by Mary, Queen of Scots to her attendant Mary Seton, who had accompanied her into exile. Sold by Seton's descendants in the nineteenth century, the parure was a gift to Queen Mary from Countess Bathurst in May 1935, on the occasion of George V's Silver Jubilee.
RCIN 65620

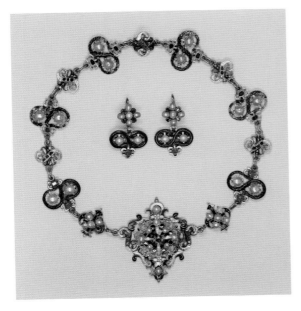

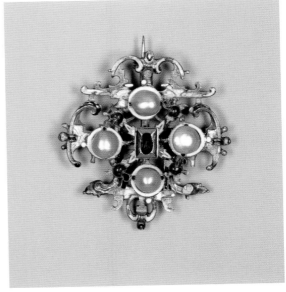

Two myths have attached themselves to Queen Mary's collecting. The first is that she was a quasi-kleptomaniac, who, on visits to country houses or other private collections, twisted their owners' arms into giving her their treasures. The truth is more likely that few royal or aristocratic owners shared Queen Mary's intense interest in works of art, and so mistook her informed admiration of their possessions as a hint that she would like to be given them. The second myth is that her tastes were conventional. This is a misunderstanding based on the fact that by the time of her death in 1953, her principal enthusiasms, for eighteenth-century and Regency furniture and decorative arts, and for small eighteenth-century Chinese jades (fig.283), were a commonplace of educated taste. That was not the case when the Queen was first collecting: in the 1920s a love of Georgian design was fresh and unexpected, especially in someone of her generation and

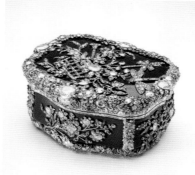

283. 'Peachbloom' brush washer with stand and mounts, *c*.1710–20.
This Chinese porcelain vessel, in the shape of a flat peach, is decorated with 'peachbloom' pink glaze and mounted in gilt bronze. Its cover and stand are of carved white jade. 'Peachbloom' wares were probably commissioned for a special occasion at the Kangxi emperor's court. Exemplifying Queen Mary's taste for small Chinese decorative objects, the brush washer was given to her by the Royal Household on her birthday in 1933.
RCIN 11695

284. Table snuff box, *c*.1770–5.
Made of green bloodstone, set with nearly 3,000 diamonds and mounted with chased vari-coloured gold borders, this magnificent box was made in Berlin, probably for Frederick the Great of Prussia. Having passed to the Russian imperial collection, it was bought by Queen Mary in 1932.
RCIN 9044

285. One of a pair of chests, attributed to Benjamin Goodison, 1730.
Made for Rokeby Hall, Yorkshire, this chest – like the house – was probably designed by its owner, the amateur architect Sir Thomas Robinson. One of a pair, it is attributed to Benjamin Goodison, a cabinetmaker who often worked for Lord Burlington.
RCIN 4649

286. *The Queen's Boudoir* by Arthur Smith, *c.*1912.
Part of her private suite, the boudoir at Buckingham Palace demonstrates the Queen's approach to designing interiors. A much-thinned down and refined version of the Edwardian arrangements that she had inherited, the room incorporates vitrines for displaying small decorative objects. RCIN 926104

background. In his biography of Queen Mary, published in 1959, James Pope-Hennessy took her to task for never buying an 'important' picture, but it is arguably more interesting that she bought, for example, eighteenth-century gold boxes (fig.284) and furniture of outstanding quality (fig.285). Her interest in arranging and cataloguing may suggest a museum-like approach to her possessions, but a sequence of watercolours of her private rooms at Buckingham Palace painted by Arthur Smith around 1912 reveals that her vitrines and cabinets of *objets d'art* were integrated into interiors of orderly prettiness (fig.286).

Queen Mary's Dolls' House

The best known commission associated with the Queen was not her idea. In 1920 she purchased a Victorian dolls' house, which she furnished and gave to the Museum of Childhood at Bethnal Green, East London. It contained several miniature objects that had been given to her by George V's aunt Princess Christian of Schleswig-Holstein. This gave the Princess's daughter, Princess Marie Louise (1872–1956), the idea of commissioning a dolls' house for the Queen as a gift from the nation in thanks for her service during the war. She asked an old friend, the architect Edwin Lutyens (1869–1944), to design it and persuaded the President of the Society of Industrial Artists, Sir Herbert Morgan, to establish a committee to oversee a project that evolved into a showcase of British design and craftsmanship. According to Princess Marie Louise, Lutyens expressed a wish to 'devise and design something which for all time will enable future generations to see how a King and Queen of England lived in the twentieth century, and

287. *Queen Mary's Dolls' House*, designed by Edwin Lutyens, 1921–4.
The house consists of a shell that can be raised by a mechanism to reveal the interiors in the round. Incorporating around 1,000 works of art, the rooms reflect the taste of the Queen in the use of Georgian furniture and *objets d'art*. The furniture is accurately made, with dovetailed joints and proper upholstery. RCIN 5000050

what authors, artists, and craftsmen of note there were during their reign'.

Completed in 1924, and unveiled at the British Empire Exhibition at Wembley in north-west London, which Morgan had helped to organise, the dolls' house – more properly, since it has no inhabitants, a fully furnished architectural model – is a remarkable feat of design, decoration and even engineering on the scale of one inch to a foot. Not quite a palace, as there are no state rooms, it is instead an Edwardian town house for a royal family (fig. 287). From the start, Lutyens was determined that everything in it would work, and so it has a functioning lift and working electric light. The library is furnished with miniature books, specially written by leading authors, including Thomas Hardy, Edith Wharton, Aldous Huxley and M.R. James (*The Haunted Dolls' House*). The paintings form a microcosm of artistic life in Britain, with even a scattering of works by the avant-garde, including Laura Knight, Paul Nash and Mark Gertler, and there is also sculpture by Charles Sargeant Jagger and W. Goscombe John. Other artists, including Edmund Dulac, William Nicholson and Glyn Philpot, were commissioned to paint murals or ceilings. Even the folio cabinets contain real etchings and watercolours. A few elements of the house are directly inspired by the Royal Collection, including tester beds based on examples at Hampton Court and copies of the silver sconces ordered for Whitehall Palace by James II (see fig. 105). The dolls' house was placed on permanent display at Windsor Castle to raise money for the Queen's charities (as it continues to do) and the room in which it was installed – the former telegraph and post office in the north range – was decorated with murals by the Royal Academician Philip Connard (1875–1958), who also provided decoration for the Cunard liner RMS *Queen Mary*, launched in 1936.

George V and George VI

Neither George V (1865–1936) nor George VI (1895–1952) had more than a polite interest in art – and in the case of George VI, a short reign dominated by war provided little opportunity for collecting. George V inherited the collecting gene, but it was expended on the minor art of stamps, of which he formed one of the greatest collections in private hands (now the Royal Philatelic Collection, which is not part of the Royal Collection). He also collected gold boxes, his greatest overlap of interest with Queen Mary. George V's outstanding artistic commission was Alfred Gilbert's highly imaginative monument to Queen Alexandra in Marlborough Road, outside St James's Palace, unveiled in 1932. The choice of Gilbert – and the bestowal on him of a knighthood – was a tribute to his parents' enthusiasm for a sculptor whom George himself disliked. Perhaps George's greatest service to the Royal Collection was the trouble he took in 1934 to persuade the director of the National Gallery, Kenneth Clark (1903–83), to accept the Surveyorship of the King's Pictures. Thanks to Owen Morshead, Clark had earlier been

commissioned to catalogue the drawings by Leonardo da Vinci in the Royal Library. Published in two volumes in 1935, this was the first in a long series of scholarly catalogues of the Old Master drawings at Windsor, and Clark's appointment as Surveyor introduced a new level of academic expertise into the management of the Royal Collection.

Clark was one of many who recorded the King's occasional blimpish outbursts about contemporary art, but George V's tastes were not consistently reactionary. In 1918 his uncle Prince Arthur, Duke of Connaught, gave the King and Queen, as a silver wedding gift, a painting by one of the leading war artists, John Lavery (1856–1941). It depicts the air station at North Queensferry, a temporary airfield established to support the warships of the Grand Fleet, which the King would have known from his tours of the home front (fig.288). It has been doubted whether the King would have liked this mildly avant-garde painting, but he admired Lavery, whom he had commissioned in 1913 to paint a family group at Buckingham Palace (now in the National Portrait Gallery). George V continued Queen Victoria's tradition of commissioning paintings of state occasions. One of the most memorable is the depiction by Frank Salisbury (1874–1962) of the procession bearing the coffin of the Unknown Warrior to Westminster Abbey in 1920, with George V as chief mourner, set against Lutyens's newly erected cenotaph in Whitehall (fig.289). The painting is a reminder that presiding over commemorations for the country's war dead was a significant new role for the royal family.

The King's great interest in stamps – and by extension coins and medals – meant that, for the first time, there was sustained royal interest in their artistic quality, and it is, in part, thanks to George V that the quality of royal portraiture on British stamps and coinage in the twentieth century was so outstanding. Like Queen Mary's tastes in the decorative arts, this

289. *The Passing of the Unknown Warrior* by Frank O. Salisbury, 1920. Salisbury attended the ceremonies in Whitehall on 11 November 1920, when the Cenotaph was unveiled and the body of an unkown soldier was taken to Westminster Abbey, marking the origin of the Armistice Day ceremonies. When shown the sketches Salisbury had made, George V ordered this painting of the procession, which he hung at Buckingham Palace. RCIN 404458

290. *George VI* by
Gerald Kelly, 1938–45.
Like its pair, of Queen
Elizabeth, this state
portrait was intended
for Windsor Castle, and
Kelly at first intended to
show the King and Queen
against the backdrop of
the Crimson Drawing
Room. Instead, he asked
his friend Lutyens to
devise architectural
settings based on the
Viceroy's House at Delhi.
The King is wearing his
coronation robes, and the
Imperial State Crown rests
on a cushion on the table.
RCIN 403422

was connected to the classical revival of the inter-war years; in architecture and design, the reigns of the two Georges could be regarded as a neo-Georgian age. This cultural moment is captured in the state portrait of George VI painted by an artist recommended by Kenneth Clark, Gerald Kelly (1879–1972), in which the King is set against an imaginary classical interior designed by Lutyens (fig. 290). The portrait was a success despite its troubled gestation: the King hated posing in his coronation robes and the painting took years to complete. Since it was unfinished when war was declared, Kelly asked if he might take it, and its pair of Queen Elizabeth, to

291. *The Dethick Garter Book*, 1551–8.
Largely written by the antiquary Sir Gilbert Dethick, the manuscript records the business of the chapter of the Order of the Garter and the coats of arms of those appointed to the Order from the reign of Edward VI into that of Elizabeth I. The arms shown here are chiefly of prominent Catholics during Mary's reign. The book was bought by George VI at the sale of the library of the Dukes of Newcastle in 1938. RCIN 1047416

Windsor Castle for its finishing touches. He worked on them there for the entire war, and the paintings were not exhibited until 1946.

Partly because of the King and Queen's residence there during the war, Windsor Castle acquired a new prominence in the life of the royal family – which had been renamed the House of Windsor by George V in 1917. One manifestation of that was a revival of interest in the Order of the Garter, which celebrated its 600th anniversary in 1948. Appointments to the Order had customarily been made on the recommendation of the Prime Minister, but since 1947, at George VI's initiative, they have been bestowed at the discretion of the Sovereign alone. In December of that year the King held a chapter of the Order at Buckingham Palace – the first since 1911 – and on St George's Day 1948 the anniversary was marked by the installation at Windsor Castle of Princess Elizabeth and the Duke of Edinburgh, inaugurating the annual ceremonies of the Garter in the form in which they have continued to the present day. George VI's deep interest in the Order was marked by his purchase for the Royal Collection of the beautifully illuminated Garter Book compiled by the antiquary Sir Gilbert Dethick (*c.* 1499–1584) in the 1550s (fig.291).

Queen Elizabeth

No member of the royal family since Victoria and Albert has demonstrated such consistent enthusiasm for contemporary art as Queen Elizabeth (1900–2002; from 1952, the Queen Mother). A daughter of the Earl and Countess of Strathmore, she was taken on several occasions as a child to Florence, where Lady Strathmore's mother lived. Queen Elizabeth's life-long love of *quattrocento* Italian art is evident in a commission she made

in 1928, a marble relief sculpture of herself and Princess Elizabeth, born two years before (fig.292). Carved by Arthur Walker RA (1861–1939), it imitates sculptures in extremely low relief (*rilievo schiacciato*) by Renaissance artists such as Donatello, often for images of the Virgin and Child. Nothing indicates the rank of the sitters, but in the 1920s there seemed to be little likelihood that this child would ascend the throne.

In 1936 Edward VIII (1894–1972) abdicated in order to marry Wallis Simpson, whereby the crown passed to the reluctant George VI. In the brief interval before the war, Queen Elizabeth helped to create a novel, romantic image for the royal family that was as different as possible from the rather hard-edged glamour of the Duke and Duchess of Windsor, as Edward VIII and his wife had become. Less than a year after the abdication, Rex Whistler (1905–44) drew a portrait of the King and Queen with their two daughters that deploys an idealised, Rococo charm unprecedented in depictions of British royalty in the twentieth century (fig.293). Whistler, who also designed

292. *The Duchess of York and Princess Elizabeth* by Arthur Walker, 1928. Walker, who is best remembered for the statue of Florence Nightingale in Waterloo Place, exhibited this marble carving at the Royal Academy in 1928, shortly after Princess Elizabeth of York, the future Queen Elizabeth II, celebrated her second birthday.
RCIN 95575

ciphers for the King and Queen, might well have had a significant artistic role at court had he not been killed in action in France in 1944.

It was, however, photography, rather than painting, that was to shape the image of the royal family during the reign of George VI. In 1938 the couturier Norman Hartnell (1901–79) was asked to design the Queen's wardrobe for a forthcoming state visit to Paris, and the King suggested that he might take a cue from the Royal Collection's portraits by Winterhalter. The result was made all the more romantically glamorous because the Queen's dresses were white, chosen as a colour of mourning for her mother, who had recently died. Their ethereal, fairy-tale appearance was captured in a series of photographs of the Queen at Buckingham Palace in July 1939 (fig.294), taken by Cecil Beaton (1904–80), who – like Hartnell – was to be repeatedly employed by the royal family in the decades to come.

The photographs taken on that occasion were not released at the time (they were not published until the 1960s) because their mood was felt to be out of step with a country on the brink of war. When war finally broke out, there was immediate concern about protecting the Royal Collection. In May 1940 Clark discussed with Morshead shipping items to Canada, but Winston Churchill ordered that 'not a picture shall leave these islands', and instead major paintings and part of the Royal Library were sent to the Manod slate quarry at Blaenau Ffestiniog, where they joined the collections of the National Gallery. At the same time, the most precious Old Master drawings were stored in the National Library of Wales.

293. *George VI and Queen Elizabeth with the Princesses Elizabeth and Margaret* by Rex Whistler, 1937.
Whistler had been a friend of Queen Elizabeth for several years when he made this drawing, depicting the new royal family in the manner of an eighteenth-century conversation piece, against an imaginary landscape. RCIN 452649

294. *Queen Elizabeth* by Cecil Beaton, 1939.
Queen Elizabeth is standing beside the Waterloo Vase in the grounds of Buckingham Palace. The vase, carved by Richard Westmacott from a single piece of Carrara marble, was commissioned by the Prince Regent in 1815 to form the centrepiece of the Waterloo Chamber at Windsor Castle, but never installed. RCIN 2315149

295. *Windsor town, railway and the Curfew Tower and Horseshoe Cloister, Windsor Castle* by John Piper, c. 1941–4.
In this painting, one of 26 of the Castle commissioned by the Queen, Piper has depicted, in watercolour, pen and ink and gouache, the view from the ramparts south-west across Windsor and its railway lines. The stormy sky perhaps embodies the threat of aerial bombardment that prompted the commission. RCIN 453335

Justified fear for the safety of the royal palaces – Buckingham Palace took several direct hits in September 1940 – prompted an imaginative act of artistic patronage. In August 1941 the Queen visited an exhibition at the National Gallery of watercolours and drawings commissioned by Clark as part of the 'Recording Britain' project, designed to create a record of buildings threatened by bombing. This gave her the idea of commissioning a sequence of topographical paintings of Windsor Castle, which would recall the famous group of mid eighteenth-century depictions of the Castle by Thomas and Paul Sandby (see fig.185). Clark recommended John Piper (1903–92) as 'a really beautiful romantic watercolourist, & a sort of re-incarnation of Cotman & Cozens without being at all "Ye Olde" – I mean artificially old fashioned'. The result was the most famous sequence of paintings of a single building in British art, but Piper's stormily atmospheric approach initially disconcerted the Queen, who had expected something of a more conventionally documentary nature (fig.295). Having painted 15 watercolours in 1941–2, Piper was invited to return in May 1942 to paint a second sequence in summer, but the results were much the same, prompting

the King's well-known joke, 'You seem to have very bad luck with your weather, Mr Piper.' In her widowhood, living in Clarence House, the Queen hung all 26 paintings together to powerful effect; by then she had no doubt that they were masterpieces.

Queen Elizabeth had begun to lay the foundation of a collection of pictures by contemporary artists in 1938 with the purchase of a portrait of Bernard Shaw by Augustus John (1878–1961). This was thought to merit an editorial in *The Times*, which declared, 'The Queen has decided that contemporary British painting matters – irrespective of subject represented or fashionable tendency in style; and it will be against all experience if, according to their means, the decision is not followed by many of her subjects.' Having turned to Clark for advice, she began to acquire works by such artists as William Nicholson (1872–1949), Walter Sickert (1860–1942) and Graham Sutherland (1903–80). As Queen Mother, Queen Elizabeth carried on buying modern paintings, creating a substantial collection that reflects her personality in its bias towards art with a light and spontaneous touch – she preferred an impromptu sketch to a finished oil, and loved watercolours and drawings. She was also drawn to the mystical quality of works by such artists as David Jones (1895–1974) and Paul Nash (1889–1946), whose *Landscape of the Vernal Equinox* she bought in 1943 (fig.296). That purchase attracted a great deal of public comment, justifying Clark's flattering remark to the Queen in a letter of two years before: 'There has, in fact, been a really remarkable increase in the appreciation of art during the last three years & to this (I would venture to say) Your Majesty's interest & understanding has contributed very greatly.'

Elizabeth II

In October 1946, the Royal Academy staged the first post-war blockbuster exhibition, of 500 paintings from the Royal Collection. By the time it closed in March 1947, it had been seen by nearly 367,000 people, setting the direction of the Collection in the reign that began in 1952, towards ever greater public access to what was now recognised as an incomparable national asset. Increased access has come about through opening buildings that house parts of the Collection to the public, notably Queen Victoria's private rooms at Osborne in 1954, the state rooms at Buckingham Palace in 1993 and the semi-state rooms at Windsor Castle in 1998. An additional level of access was provided by The Queen's decision to rebuild the bomb-damaged chapel at Buckingham Palace as a gallery for temporary exhibitions of works from the Royal Collection. Opened in 1962, The Queen's Gallery has staged many exhibitions, which, together with hundreds of loans over the years to institutions in Britain and abroad, have brought the treasures of the Royal Collection to millions of people.

Some 2,500 works have been added to the Royal Collection and Royal Library during the present reign. In particular, the tradition of buying works with royal associations has been sustained. Some of these additions, such as an early Vincennes porcelain broth bowl, almost certainly made for Bonnie Prince Charlie, bought in 1964, were not previously in the Collection (fig. 297), but other acquisitions are repatriations of works that had been sold or given away. In 1921, for example, temporary lack of storage space in the Royal Library led to the sale of George IV's collection of caricatures (now in the Library of Congress) and a part of the Cassiano dal Pozzo 'paper museum' (see fig. 169), several sheets of which have since been reacquired.

297. *Broth basin and cover with stand, c.1748.*
Made at the French royal factory at Vincennes, this porcelain broth basin is decorated on its cover with the Stuart royal arms. It was probably made for Charles Edward Stuart, the 'Young Pretender'. The finial in the form of a fish suggests it was intended for fish bouillons, served on Fridays and holy days. The stand re-entered the Collection in 1997.
RCIN 19605

298. *Self-portrait* by David Hockney, 2012.
Appointed to the Order of Merit in 2012, Hockney executed this iPad drawing (in a unique print) for the Royal Collection. Established by Edward VII in 1902, the Order of Merit is an honour in the personal gift of the monarch and is limited to 24 members. Its award is marked by the commissioning of a portrait drawing for the Royal Collection.
RCIN 812508

299. *Bowl* by Lucie Rie, *c.*1930–60.
Having left her native Austria in 1938, Lucie Rie settled in Kensington after a period working with Bernard Leach in Devon. This bowl is decorated with a bronze glaze (manganese and copper carbonate) that she had developed herself as the basis for sgraffito (scratched) ornament.
RCIN 35060

Among the initiatives taken to acquire contemporary art was the purchase in 1960 by The Queen and the Duke of Edinburgh of a group of paintings by living artists, including Barbara Hepworth, Mary Fedden, Ivon Hitchens and Sidney Nolan, to decorate a private suite of rooms at Windsor Castle that had been remodelled by the architect Hugh Casson (1910–99). The rooms also contain decorative arts by such leading makers as Lucie Rie (1902–95; fig.299), displayed in cases made by Gordon Russell. This was a one-off, but there have been more systematic efforts to acquire new works, notably in the form of commissioned portraits of men and women awarded the Order of Merit – among them a self-portrait of David Hockney (b. 1937; fig.299). Other works have come as gifts, and, as in the nineteenth century, foreign tours have contributed many works of art to the Royal Collection, although few so striking as the Yoruba thrones given to The Queen and the Duke of Edinburgh on a visit to Nigeria in 1956 (fig.300). Perhaps the most notable recent gift was the portfolio of works by Royal Academicians presented to The Queen for her Diamond Jubilee in 2012 (fig.301).

300. *Yoruba Thrones*, *c*.1956.
Presented to the Queen during her Commonwealth visit to Nigeria in 1956, these two thrones are covered with glass beadwork. Beadwork and royalty are closely associated in Yoruba culture, and the act of creating patterns for beadwork and their embroidery is a spiritual exercise. The patterns have specific meanings, notably respect for ancestors and descendants.
RCIN 74685 and 74686

There are many reasons why contemporary art and royal patronage began to steer divergent paths from 1918 onwards. Monarchy is, by its very nature, conservative, and sits uneasily, if at all, with the modernist emphasis on the avant-garde, which has dominated all the arts since the 1920s. Nonetheless, the gulf that opened up between contemporary practice and the monarchy can be exaggerated. In 2012 four screen prints of The Queen by Andy Warhol (1928–87) were purchased for the Royal Collection (fig.302). Made as part of his 1985 'Reigning Queens' portfolio, and based on a photograph taken in 1977 for The Queen's Silver Jubilee, they exemplify his fascination with the traditions of portraiture and, in particular, the way that images can be multiplied across media. It seemed surprising to some people that The Queen should have bought a portrait of herself by Warhol, but it is no more remarkable than the fact that, in 1978, Warhol bought for his own collection two replicas by Allan Ramsay of his state portraits of George III and Queen Charlotte.

301. *Untitled* by Anish Kapoor, 2011.
To mark her Diamond Jubilee, the Royal Academy gave the Queen 97 works of art on paper by Academicians, including Tracey Emin, David Hockney, Grayson Perry and Tom Phillips. This gouache is by an artist best known for his sculpture. RCIN 212752

302. *Queen Elizabeth II* by Andy Warhol, 1985.
Warhol's 'Reigning Queens' series is a portfolio of 16 monumental (82.1 x 60 cm) screen prints of the four female monarchs of the day. The prints of Elizabeth II in the Royal Collection are part of the 'Royal Edition', embellished with 'diamond dust'. RCIN 507013.d

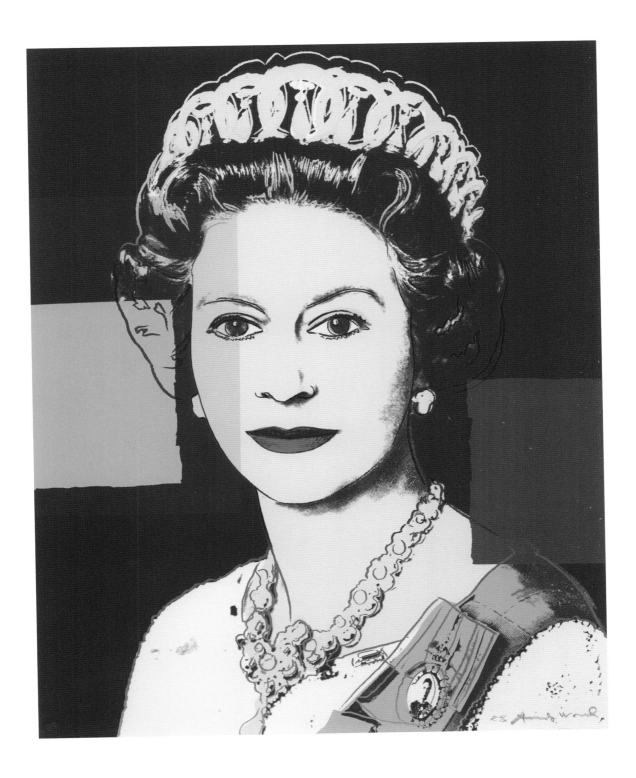

Art for a Modern Monarchy

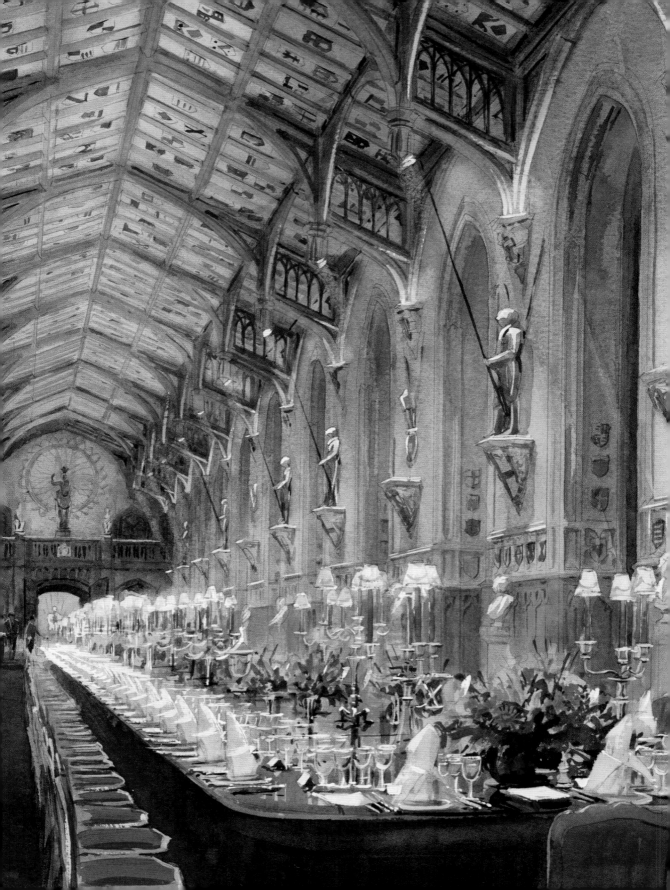

THE ROYAL COLLECTION TODAY

Among the most striking works of art commissioned by The Queen is a set of watercolours by Alexander Creswell (b.1957), depicting the state apartments of Windsor Castle in ruin (fig.303). Anyone visiting the Castle today might assume that they were a modern capriccio, a vision of Britain after an apocalypse. In fact, they depict the aftermath of what could easily have been the worst disaster ever to have struck the Royal Collection. In the morning of 20 November 1992, a curtain in the Castle's private chapel was set on fire after prolonged exposure to a spotlight. The resulting conflagration, which was not finally extinguished until early the following morning, gutted many of George IV's finest interiors, most significantly St George's Hall, the Grand Reception Room, State Dining Room and Crimson and Green Drawing Rooms. By a near-miraculous stroke of luck, almost all the contents of these rooms were in store at the time, since the Castle was reaching the end of a five-year project to renew its services – in part, for reasons of fire prevention. The only major losses were two items that had been too big to move, a 5.5-metre long sideboard by Morel & Seddon in the State Dining Room and the large painting that had hung over it, *George III and the Prince of Wales Reviewing the Troops* by William Beechey (1753–1839), painted in 1798.

The ensuing restoration project, which was completed in 1997, triumphantly combined an inspired recreation of George IV's lost interiors with a creative element of new design, most notably in St George's Hall (fig.304). Before reconstruction began, it was decided that its cost – which turned out to be £36.5 million – would be largely met from admission fees for Windsor Castle, and, also, for the first time ever, the opening to the public of the state rooms at Buckingham Palace. This revenue finally accounted for some 70 per cent of the cost of the restoration. This income was channelled through an organisational structure that took its present shape in the aftermath of the fire.

Like the royal palaces themselves, the Royal Collection is not the private property of The Queen, but is held by her as sovereign. For most of its history, its maintenance was considered part of the monarch's official expenditure, and it was administered by the Lord Chamberlain's Office. In 1987 this changed when the Royal Collection Department was established as one of the five divisions of the Household, financed entirely by trading activities, which are undertaken by Royal Collection Enterprises Ltd. In 1993

303. *Windsor Castle: St George's Hall, After the Fire* by Alexander Creswell, 1993.
Part of a sequence of views painted by Creswell after the fire of 20–21 November 1992, this watercolour shows one of the interiors that was not precisely recreated in the restoration of 1992–7.
RCIN 932536

304. *Windsor Castle: St George's Hall, After Restoration* by Alexander Creswell, 1999.
St George's Hall, as reconstructed to a new Gothic design by Giles Downes, working for the architects Siddell Gibson. The watercolour shows the hall prepared for a state banquet.
RCIN 933491

it was announced that The Queen would pay tax on her private income, and in order that she would not be taxed on assets that pertain to the Crown, The Royal Collection Trust, a registered charity, was established to receive the income from Royal Collection Enterprises. These changes were purely administrative: ownership of the Royal Collection did not change.

Care of the collection

A fundamental aspect of The Royal Collection Trust's work, conservation, is largely done in house. The development of the conservation of the Collection to museum standards, and the provision of the necessary resources, has been an achievement of the present reign. At Windsor there are separate studios for paintings and works on paper, and a new facility for the conservation of furniture and works of art was completed nearby in 2017. Clocks and armour have specialist conservators, as does the bindery established by George III for the Royal Library, and the need to perpetuate these highly specialised skills is recognised through internship and apprenticeship schemes. Much of the work of conservators is unacknowledged, since it is intended to be invisible to the public, but it can have a transformative effect on works of art. One spectacular recent example is George IV's extraordinary sunflower clock. Over the past two centuries, some of the Vincennes porcelain flowers had been lost or broken – they are exceptionally fragile, and the clock had to be repaired three times in the first three years that George owned it (fig.305). The only comparable example is in the Porzellansammlung in the Zwinger in Dresden, which provided a guide for conservators about how the piece was originally constructed. Using the evidence of a watercolour of the clock in George IV's 1826 Pictorial Inventory, they dismantled the bouquet, and combined original flowers, carefully repaired, with recently acquired eighteenth-century Vincennes flowers and newly modelled pieces. Few visitors admiring this extraordinary masterpiece today realise that they are the first for many generations to see it as George IV did.

305. *Sunflower clock*, c.1752, before (left) and after (right) restoration. Made of Vincennes porcelain, this extraordinary clock had been repaired many times after it entered the Royal Collection in 1819, and the loss of some of the original blooms had left it looking wilted. The effect of the restoration undertaken in 2014–15 is dramatic. RCIN 30240

Conservation has also played a major role in reattributing paintings and drawings. For example, the fact that the Royal Collection contains two paintings by the most famous Italian artist of the seventeenth century, Caravaggio, has been established only in the present century thanks to cleaning, conservation and technical examination. One of them, *The Calling of Saints Peter and Andrew* (fig.306), which was bought by Charles I from the dealer William Frizzell in 1637, has for almost all its history been regarded as a copy – one of 12 that are known – of a lost original. The suggestion that the Royal Collection's painting was that original was first made in 1987, and was finally confirmed in 2006, when cleaning revealed that an apparent furrow in Christ's brow was in fact an early repair of the paint surface. This 'frown' occurs in two late seventeenth-century versions of the painting, which must, therefore, have been copied from the work in the Royal Collection. The cleaning also revealed a vigorous three-dimensionality, typical of Caravaggio, which had been obscured, and allowed convincing comparisons to be made between the painting's technique and that of the artist's acknowledged works.

306. *The Calling of Saints Peter and Andrew* by Caravaggio, c.1602–4. Conservation confirmed what many scholars had suspected: that this is the original by Caravaggio of a much-copied composition. In particular, cleaning revealed that Peter's right arm, clutching the fish, projects boldly out of the composition towards the viewer. RCIN 402824

Access to the Royal Collection

The Royal Collection still fulfils the role for which it was acquired – furnishing and decorating the monarch's houses and palaces. This is true not just of those owned by the Crown – including Frogmore House in Windsor and Clarence House, but also The Queen's private homes, Balmoral and Sandringham, which are opened to the public when she is not in residence. In addition, Osborne House, run by English Heritage, and several of the unoccupied royal palaces (which are in the care of an independent charity, Historic Royal Palaces), notably Hampton Court, the state rooms at Kensington Palace and the Banqueting House at Whitehall, are almost entirely furnished with works from the Royal Collection.

The public can also see works of art from the collection in ideal museum conditions in exhibitions in the two Queen's Galleries, at Buckingham Palace and Holyroodhouse, both opened in 2002 to mark The Queen's Golden Jubilee. At Buckingham Palace, the 1960s Gallery, which no longer met modern conservation or display standards, was replaced with a much larger building. Whereas the old Gallery was almost invisibly reticent, the new, designed by John Simpson, is a sumptuous classical statement (fig.307). The most significant addition to the palace since the building of the ballroom wing for Queen Victoria and Prince Albert in 1853–5, it takes its stylistic and decorative cues from John Nash and Edward Blore, in such features as the Greek Doric portico, the luxurious fittings – which include green scagliola columns, bronze balustrades and mirrored mahogany doors – and its imaginative use of sculpture, both friezes and free-standing figures, modelled by the Scottish sculptor Alexander Stoddart.

The Queen's Gallery at Holyroodhouse is very different. Housed in two conjoined 1840s buildings, it stands at the entrance to the palace, opposite the Scottish Parliament. The conversion, carried out by Benjamin Tindall

307. One of the interiors in The Queen's Gallery at Buckingham Palace, opened in 2002 for temporary exhibitions of works from the Royal Collection. Its design recalls John Nash's Picture Gallery in the palace (fig.228).

Architects, incorporates work by contemporary Scottish artists and craftspeople, including metalwork by Jill Watson, stone carving by Graciela Ainsworth and stained glass by Christian Shaw. The opening of these new galleries inaugurated a more ambitious programme of exhibitions: between 2002 and 2017 there were 40 exhibitions in The Queen's Gallery in London and 30 in Edinburgh, compared with just 40 in the old gallery at Buckingham Palace between 1962 and 2002 (there were none in Edinburgh before 2002). Drawn exclusively from the Royal Collection, they have often transformed understanding of the monarchs who created it. Before the 2010 exhibition *Victoria & Albert: Art & Love*, for example, only specialists fully appreciated the range and depth of The Queen and Prince Consort's love of the visual arts.

As all this suggests, the single greatest achievement of The Royal Collection Trust since its creation has been the widening of public access to the works in its care. By 2012, there were 2.59 million annual visitors to the royal palaces and galleries, a figure that rises to 3.64 million if visits to Osborne House and the properties of Historic Royal Palaces (apart from the Tower of London) are included. These figures have continued to grow. In addition, The Queen agrees every year to the loan of hundreds of objects to exhibitions in the UK and other countries, and Royal Collection Trust stages travelling exhibitions in the UK and abroad. Virtual access is of ever-growing significance, both through Royal Collection Trust's own website and by collaborations. In 2016, for example, Buckingham Palace became the first landmark in the country to be part of 'Google Expeditions', which allows teachers anywhere in the world to take their students on a virtual tour of the state rooms.

One of the greatest attractions of the Royal Collection is that most of it is displayed in historic settings, which are often the very interiors for which a work of art was acquired or created. Some of these buildings, such as Hampton Court, are in effect museums, but others, most notably Buckingham Palace and Windsor Castle, are royal residences with a role of fundamental importance in the daily working of the monarchy. The balance that has to be struck by Royal Collection Trust – displaying to the public the art collection of the Crown while respecting its role as furnishings of palaces that are in use – is comparable to that in private country houses open to the public, but the Royal Collection far outstrips them in size. The Collection includes some 5,500 paintings, more than twice the number in the National Gallery in London. Despite its great size, there is regular public access to a higher proportion of the Royal Collection than most public collections can offer.

Seeing the Royal Collection in the settings for which it was intended emphasises its importance as an embodiment of royal history. The Collection's idiosyncrasies highlight the fact that it has not been built up by curators seeking to create comprehensive overviews of an artist or period, nor have monarchs or their families ever concerned themselves much with 'gaps' in the collection. Part of the fascination of the way the collection has been, and is still being, formed is its unpredictability, yet through it all unwinds a narrative that spans over 500 years of acquisitions.

308. *Sketch of Charles I and Queen Henrietta Maria with their two eldest children, Prince Charles and Princess Mary* by Anthony van Dyck, 1632. Quickly sketched in tones of brown and grey oil paint on an oak panel, this is a preliminary study for Van Dyck's portrait known as the 'Great Peece'. Among the details that suggest the sketch was painted from life, is the depiction of Princess Mary asleep; in the finished painting she is wide awake, standing on her mother's lap. RCIN 408584

It is impossible to sum up so vast and diverse a collection of such quality, but there are some continuous threads in its story that help. One example is Anthony van Dyck. His work for Charles I created an image of majesty to which successive generations have returned again and again, from Lely and Kneller to Zoffany and Lawrence, Lavery and Cecil Beaton. Van Dyck is also significant because his achievement marks the moment when the visual identity of royalty in Britain decisively shifted. Gold, jewels and lavish dress were no longer sufficient expressions of magnificence: monarchs were now expected to attract the genius of artists. That complex, intertwined relationship, which runs throughout the Royal Collection, is summed up in a recent acquisition (fig. 308). In 2016 the Trustees of The Royal Collection Trust bought an oil sketch made by Van Dyck in 1632 in preparation for his family portrait of Charles I and Henrietta Maria with their two eldest children, the painting known as the 'Great Peece' (see fig. 59). The sketch – the first by the artist to enter the Royal Collection – was made with such speed that it seems almost certain that it was painted from life. Few paintings so vividly capture that charged moment when an artist looks at a monarch, and the gaze is returned.

FURTHER READING

The best way to start studying the Royal Collection is via the Royal Collection Trust website, which has over a quarter of a million entries, all with short descriptions and most with illustrations. The following suggestions for further reading are confined to recent books that deal specifically with the Royal Collection, together with a few other works that I have found especially helpful.

For highlights of the collection, see the catalogue of the exhibition that opened The Queen's Gallery at Buckingham Palace in 2002, *Royal Treasures: A Golden Jubilee Celebration*, edited by Jane Roberts, which includes very useful introductions on the history of the collection, by Hugh Roberts; on its display, by Jonathan Marsden; and on the history of its conservation, by Christopher Lloyd.

The catalogues of the exhibitions *The Art of Italy in the Royal Collection: Renaissance & Baroque* by Lucy Whitaker and Martin Clayton (2007), *Bruegel to Rubens: Masters of Flemish Painting* by Desmond Shawe-Taylor and Jennifer Scott (2007) and *The Northern Renaissance: Dürer to Holbein* by Kate Heard and Lucy Whitaker (2013) encompass some of the collection's greatest treasures. For a thought-provoking introduction to British art in the collection, see Christopher Lloyd's *The Quest for Albion: Monarchy and the Patronage of British Painting* (1998). A central theme of the collection, royal portraiture, is the subject of Jennifer Scott's *The Royal Portrait: Image and Impact* (2010).

The Royal Collection has a long tradition of publishing catalogues of its collections. Among recent volumes are those covering the later Flemish paintings (2007) and the Dutch paintings (2015), both by Christopher White. There are also recent catalogues of the European arms and armour (by Ian Eaves and A.V.B. Norman, 2016) and Chinese and Japanese works of art (by John Ayers, 2016). The collection's Old Master drawings are the subject of a long series of catalogues; an overview is provided by Martin Clayton in *Holbein to Hockney: Drawings from the Royal Collection* (2004).

1 From the Middle Ages to Elizabeth I

The Crown Jewels by Anna Keay (2011) is a well-illustrated introduction, based on the research by several authors published in the two-volume catalogue

raisonné of the same title, edited by Claude Blair (2008). The early paintings are catalogued in *Tudor, Stuart and Early Georgian Pictures* by Oliver Millar (1963) and the sixteenth- and seventeenth-century miniatures have been catalogued by Graham Reynolds (1999). There is a great deal of information about royal patronage of artists in *Dynasties: Painting in Tudor and Jacobean England 1530–1630*, edited by Karen Hearn, the catalogue of an exhibition at Tate in 1995; see also *Holbein and England* by Susan Foister (2005). The Royal Collection Trust exhibition catalogue *In Fine Style* by Anna Reynolds (2013) is an excellent study of the language of dress in the Tudor and Stuart periods. The decoration and furnishing of the palaces is discussed in Simon Thurley's *The Royal Palaces of Tudor England: Architecture and Court Life, 1460–1547* (1993). Thomas P. Campbell's *Henry VIII and the Art of Majesty: Tapestries at the Tudor Court* (2007) is both definitive and highly readable. *Selling the Tudor Monarchy: Authority and Image in Sixteenth-Century England* by Kevin Sharpe (2009) discusses the way the Tudors used art for political ends.

2 The Early Stuarts

For the artistic patronage of James I & VI's family, see *Anna of Denmark, Queen of England: A Cultural Biography* by Leeds Barroll (2001), *Henry, Prince of Wales and England's Lost Renaissance* by Roy Strong (1986) and *The Lost Prince: The Life and Death of Henry Stuart* by Catharine MacLeod, Malcolm Smuts and Timothy Wilks, the catalogue of an exhibition at the National Portrait Gallery in 2012.

3 Charles I and Henrietta Maria

For a comprehensive overview of the King's collecting see the catalogue of the 2018 exhibition *Charles I: King and Collector* at the Royal Academy, London, edited by Desmond Shawe-Taylor and Per Rumberg. Abraham van der Doort's inventory of Charles I's collections was edited by Oliver Millar (The Walpole Society, volume 37, 1960). *The Late King's Goods: Collections, Possessions and Patronage of Charles I in the Light of the Commonwealth Sale Inventories*, edited by Arthur MacGregor (1989), is an indispensable volume of essays. Two of the King's greatest purchases are the subject of individual Royal Collection catalogue volumes: the Raphael cartoons by John Shearman (1972) and Mantegna's *The Triumph of Caesar* by Andrew Martindale (1979). For the Queen's patronage, see *On Display: Henrietta Maria and the Materials of Magnificence at the Stuart Court* by Erin Griffey (2015). Rubens's work for Charles is discussed in two books by Gregory Martin, *Rubens: The Ceiling Decoration of the Banqueting Hall* (2005) and *Rubens in London: Art and Diplomacy* (2011). Van Dyck's work in England was the subject of an exhibition at Tate in 2009, with a catalogue edited by Karen Hearn.

4 The Collection in the Commonwealth

The inventories and valuations of the King's goods, 1649–51, were edited by Oliver Millar (The Walpole Society, volume 43, 1972). His long introduction is the most authoritative account of the dispersal of the Royal Collection. In *Image Wars: Promoting Kings and Commonwealths in England, 1603–1660* (2010) Kevin Sharpe surveys the use of all media, including art, to promote the political ideals of James I, Charles I and Oliver Cromwell.

5 Charles II and James II & VII

The catalogue of an exhibition at The Queen's Gallery, Buckingham Palace, in 2017–18, *Charles II: Art & Power*, edited by Rufus Bird, is a comprehensive overview. Portraiture of women by Lely and others was the subject of a National Portrait Gallery exhibition in 2001, *Painted Ladies: Women at the Court of Charles II*, with a catalogue by Catherine MacLeod and Julia Marciari Alexander. Kenneth Clark's catalogue of the Royal Collection's drawings by Leonardo da Vinci first appeared in 1935 and was revised by Clark and Carlo Pedretti in 1968–9. A selection of 100 of the drawings is presented in *Leonardo da Vinci: A Curious Vision* by Martin Clayton (1996) and the anatomical drawings are the subject of *Leonardo da Vinci: The Mechanics of Man* by Martin Clayton and Ron Philo (2010).

6 From William III and Mary II to Queen Anne

The second half of Kevin Sharpe's *Rebranding Rule: The Restoration and Revolution Monarchy, 1660–1714* (2013) is the fullest published study of the artistic patronage of William and Mary and Queen Anne. Simon Thurley's *Hampton Court: A Social and Architectural History* (2003) includes a detailed account of the furnishing and decoration of William and Mary's palace.

7 From George I to Frederick, Prince of Wales

The First Georgians: Art & Monarchy 1714–1760, edited by Desmond Shawe-Taylor, the catalogue of an exhibition at The Queen's Gallery in 2014, is the essential introduction to this period. Patronage by royal women has been the subject of several illuminating recent studies, notably *Queen Caroline: Cultural Politics at the Early Eighteenth-Century Court* by Joanna Marschner (2014) and *Enlightened Princesses: Caroline, Augusta, Charlotte, and the Shaping of the Modern World*, edited by Joanna Marschner (2017). *A Life of Frederick, Prince of Wales, 1707–1751: A Connoisseur of the Arts* by Frances Vivian (2006) is the best account of this major but under-studied patron.

8 George III and Queen Charlotte

For a very full survey, see the exhibition catalogue *George III & Queen Charlotte: Patronage, Collecting and Court Taste*, edited by Jane Roberts (2004). For specific aspects of George III's collecting and patronage see the catalogue of the exhibition *Canaletto & the Art of Venice* by Rosie Razzall and Lucy Whitaker (2017); *The Architect King: George III and the Culture of the Enlightenment* by David Watkin (2004); and *Maria Merian's Butterflies* by Kate Heard (2016). For Windsor Castle in George III's reign, see *Views of Windsor: Watercolours by Thomas and Paul Sandby* by Jane Roberts (1995).

9 George IV

George is one of the few monarchs to have received a biography that focuses on collecting and patronage, *George IV: The Grand Entertainment* by Steven Parissien (2001), but it is not sympathetic to the King. Almost every aspect of George IV's collecting is addressed in the exhibition catalogue *Carlton House: The Past Glories of George IV's Palace* (1991–2). His Dutch paintings are discussed in the exhibition catalogue *Masters of the Everyday: Dutch Artists in the Age of Vermeer* by Desmond Shawe-Taylor and Quentin Buvelot (2015). Specialist studies include Geoffrey de Bellaigue's *French Porcelain in the Collection of Her Majesty the Queen* (2009) and Hugh Roberts's *For the King's Pleasure: The Furnishing and Decoration of George IV's Apartments at Windsor Castle* (2001).

10 Queen Victoria and Prince Albert

Victoria & Albert: Art & Love, edited by Jonathan Marsden, the catalogue of an exhibition at The Queen's Gallery in 2010, is essential reading. The principal catalogues of the collection's Victorian art are *The Victorian Pictures* by Oliver Millar (1992), *The Victorian Watercolours and Drawings* by Delia Millar (1995) and *Victorian Miniatures* by Vanessa Remington (2010). *The Early Italian Pictures* by John Shearman (1983) covers an important aspect of Prince Albert's collecting. *Crown & Camera: The Royal Family and Photography 1842–1910* by Frances Dimond and Roger Taylor (1987) is the standard account of the subject, supplemented by *Roger Fenton, Julia Margaret Cameron: Early British Photographs from the Royal Collection* by Sophie Gordon (2010).

11 Edward VII to Elizabeth II, and Conclusion

The Royal Collection after the death of Prince Albert has yet to receive a scholarly overview. Books dealing with specific aspects include *Cairo to*

Constantinople: Francis Bedford's Photographs of the Middle East by Sophie Gordon (2013); *Splendours of the Subcontinent: A Prince's Tour of India 1875–6* by Kajal Meghani (2017); *Fabergé's Animals: A Royal Farm in Miniature* (2010) and *Royal Fabergé* (2011), both by Caroline de Guitaut; and *Developing the Picture: Queen Alexandra and the Art of Photography* by Frances Dimond (2004). *Unfolding Pictures: Fans in the Royal Collection* by Jane Roberts, Prudence Sutcliffe and Susan Mayor (2005) covers a important element of Queen Mary's collecting. For Queen Mary's Doll's House, see John Martin Robinson's official guidebook, published in 2004. The Queen Mother's collecting is discussed in John Cornforth's *Queen Elizabeth the Queen Mother at Clarence House* (1996) and the catalogue of the exhibition *Watercolours and Drawings from the Collection of Queen Elizabeth the Queen Mother* by Susan Owens (2005). The impact of the Windsor Castle fire is graphically represented in Alexander Creswell's *Out of the Ashes: Watercolours of Windsor Castle* (2000) and the story of its aftermath is told in Adam Nicolson's *Restoration: The Rebuilding of Windsor Castle* (1997). The best source of information about the development of the Royal Collection today is the annual reports of the Royal Collection Trust.

ACKNOWLEDGEMENTS

I would like to thank Jonathan Marsden, Director, Royal Collection Trust and Surveyor of the Queen's Works of Art, and Jemima Rellie, Director of Content and Audiences, for suggesting that I write this book, and Albert DePetrillo, Publishing Director at BBC Books, for giving me the opportunity. Jonathan read the text in draft and greatly improved it. I am indebted to Desmond Shawe-Taylor, Surveyor of the Queen's Pictures, and Rufus Bird, Deputy Surveyor of the Queen's Works of Art, for discussing the collection with me, answering queries, and giving me access to works on display and in conservation. The Librarian, Oliver Urquhart Irvine, introduced me to the Royal Library, where I was guided by Elizabeth Clark, Curator of Books and Manuscripts. Kate Heard, Senior Curator of Prints and Drawings, showed me works in the Print Room. It was a pleasure to tour the palaces on research trips with Sebastian Barfield, director of the BBC series that this book accompanies, and I learned a great deal from discussions with him about the collection and the monarchs who made it. I am grateful also to Steven Brindle for kindly allowing me to read a typescript of the definitive history of Windsor Castle that he has edited, which will be published by Royal Collection Trust in 2018. I would also like to thank Jacky Colliss Harvey and David Tibbs in Royal Collection Trust's publishing section for their help. Finally, I am most grateful to my editor at BBC Books, Bethany Wright, the copy-editor, Anjali Bulley, and the designer, Linda Lundin, for their patience and encouragement at every stage of a very tight schedule.

INDEX

Index